ITALIAN DRAWINGS IN OXFORD

ITALIAN DRAWINGS
IN OXFORD

FROM THE COLLECTIONS OF
THE ASHMOLEAN MUSEUM
AND
CHRIST CHURCH

TEXT AND COMMENTARY BY
TERISIO PIGNATTI

PHAIDON

OXFORD

Photographs by Mario Carrieri

Translated from the Italian by Barbara Luigia la Penta

Phaidon Press Limited, Littlegate House, St Ebbe's Street, Oxford

First published in English 1977

Originally published as *I Grandi Disegni Italiani nelle Collezioni di Oxford,*
© 1976 by Silvana Editoriale d'Arte, Milan

Translation © 1977 by Silvana Editoriale d'Arte, Milan

ISBN 0 7148 1764 3

Printed and bound in Italy by Amilcare Pizzi SpA, Milan

The University of Oxford is justly famous for its thirty-one Colleges, which form the basis of a unique system of education and study. Many of these institutions are of medieval foundation and many can boast artistic legacies, historical collections, and libraries of unrivalled riches. The Bodleian Library, with its collection of rare early manuscripts and books provides an incomparable treasury of material for study. To these venerable institutions were added in more recent times the museums, which bring together artistic collections of great importance. In the field of drawings two ·Oxford collections are outstanding: that of Christ Church and the more recent graphic collection of the Ashmolean Museum.

Christ Church was founded by Cardinal Wolsey, who in 1525 named it Cardinal College. It received its present name only in 1546 from King Henry VIII. At that time the chapel of the College became the Cathedral of the city.

Widely known is the architecture of Christ Church with its great entrance, the turreted Wolsey Gate, bearing an 13th-century statue of the Cardinal and surmounted by a tower with a huge 17th-century bell weighing more than six tons, known as Great Tom. Every evening at 9.05 Great Tom sounds a hundred and one strokes, giving the traditional signal for the closing of the College. Passing through Tom Tower one enters the Great Quadrangle, popularly called Tom Quad, which is eighty metres square. In the centre of this imposing courtyard is a reproduction of Giambologna's statue of *Mercury*. From the corners of the quadrangle one enters the various buildings of the College, the chapel, the library, and the Hall. This last, a huge room illuminated by windows and with an impressive ceiling of carved beams, was built in 1529. Its walls are lined with portraits of the most outstanding persons connected with Christ Church, painted by the greatest English portraitists, including Lely, Kneller, Romney, and Reynolds, and later Gainsborough and Lawrence. The chapel was founded in the early Middle Ages and rebuilt about the year 1000. It has a 13th-century tower, but the building itself was very much altered in the time of Cardinal Wolsey and again in the 19th century. The choir has a magnificent ribbed vault with large pendent rosettes.

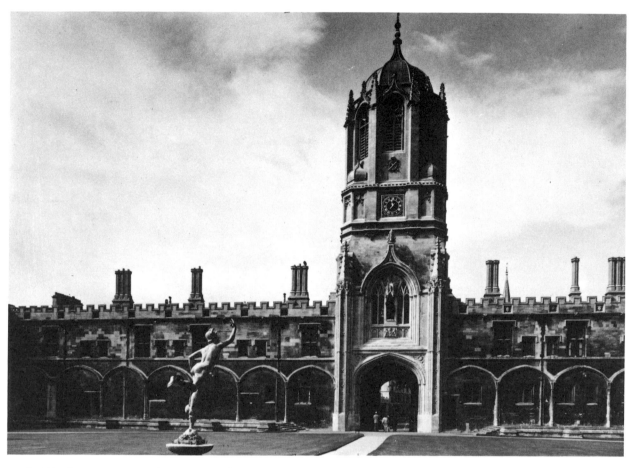

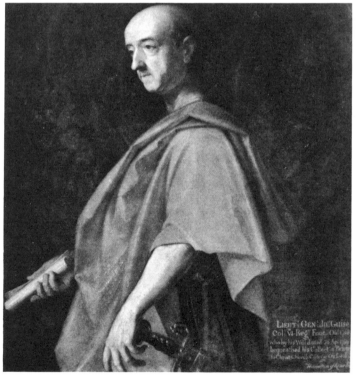

I. Christ Church, Tom Tower viewed from the Great Quadrangle.

II. General John Guise, founder of the Christ Church collection.

6

The drawings are kept in the new wing, next to the library, which was built specially to house the art collections. These were formed relatively recently, in the 18th century, and consist of a sizable gallery of pictures, recently catalogued by J. Byam Shaw, and the outstanding collection of drawings. The history of this collection of drawings is of special interest, since its formation as well as its contents and quality are unique among the artistic institutions of modern Oxford (1).

The Christ Church collection contains about 2000 drawings. The first of its unusual features and one of special importance is the fact that it was formed by a single collector, who in 1765 left it to the College where he had been a student. This benefactor was General John Guise, a valiant soldier with long periods of active service to his credit, who was also and basically a scholar marqué, as fully revealed by his recent biographer, Byam Shaw, in the comprehensive catalogue of the collection (2). Guise's father had been neither a military man nor an aristocrat, but a distinguished orientalist who spent his life in the university milieu of Oxford and was the friend of the greatest scholars and antiquarians of his time. In particular, he was a friend of the famous classical antiquarian, Thomas Hearne, who collected many of the antiquities at present at Oxford. The studies and writings of John Guise's father were well known among orientalists. It was also because of the fame of these studies that the young John, destined to a military career, won the high esteem of the English court. And during his army service he accomplished the unusual feat of matching his brilliant performance as a soldier with an equally, or perhaps more, brilliant activity as a scholar in the field of art. He, in fact, became artistic adviser to the Prince of Wales, and such 18th-century English writers as Vertue and Walpole commented upon his outstanding gifts as a connoisseur (3). Even Dézailler d'Argenville, in his *Abrégé de la vie des plus fameux peintres* of 1745, spoke of Guise's merits as a connoisseur (4).

When did John Guise begin to collect drawings? Almost certainly at an early age. He was born in 1682 and from 1697 to 1701 he studied at the Colleges of Oxford (5). At Christ Church, as in the academic circles of Oxford in general, some form of collecting was practically the rule. It is therefore not surprising that as early as 1724 George Vertue spoke of Guise's paintings, and also noted that 'besides these he has a fine collection of drawings of the Italian Schools'. Certainly the years spent at Christ Church at the beginning of the century were pleasant for John Guise and there, because of his good record and the standing of his family, his status as Gentleman Commoner was changed to that of Nobleman, which gave him certain privileges. It is quite probable that the generous bequest of his whole collection to Christ Church, made in his will of 1760, was greatly influenced by the treatment he had received there in his youth.

The 18th century, like the late 17th century, was a propitious period in England for the collecting of drawings. This had been demonstrated by numerous great collectors, such as the famous painter Sir Peter Lely, the Duke of Devonshire, and the Earl of Leicester, as well as by the painter Jonathan Richardson, and later by Sir Joshua Reynolds and Sir Thomas Lawrence. In this period even the Royal collections were greatly enlarged and

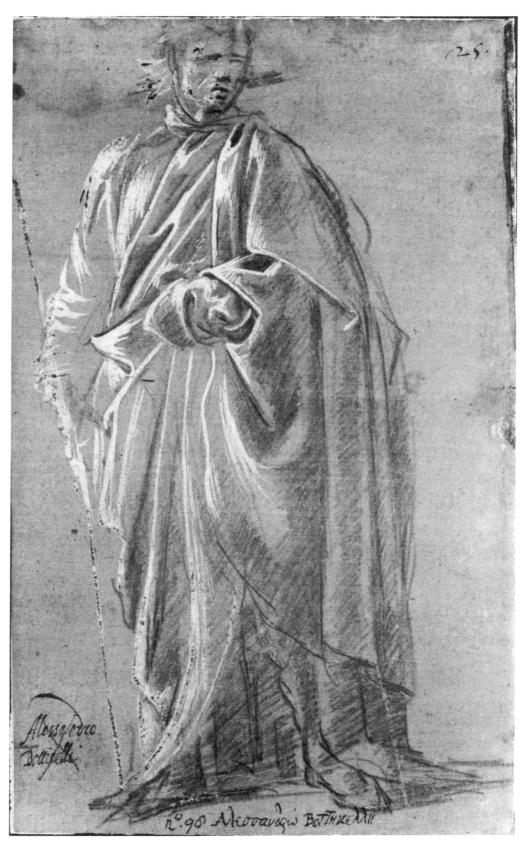

1. Filippino Lippi. *Man in Heavy Drapery*. Silverpoint, heightened with white, on paper primed blue. 209 x 127 mm. Inv. 32. Christ Church.

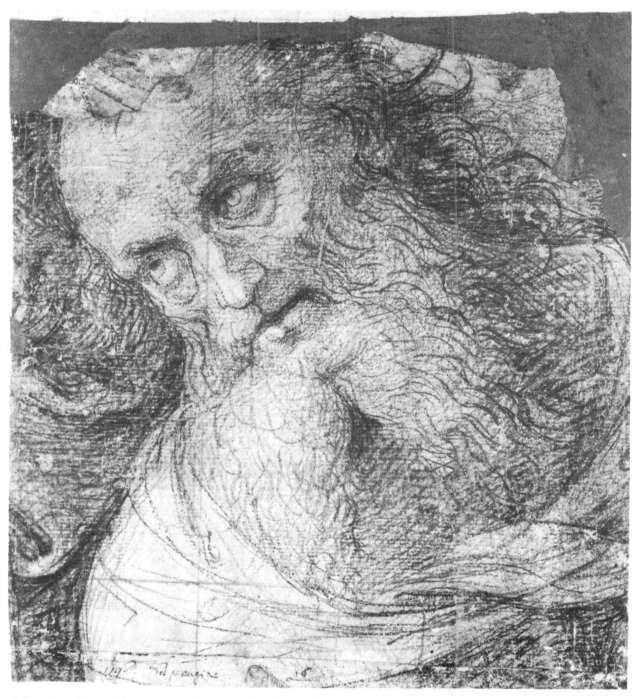

2. Perugino. *Joseph of Arimathaea*. Black chalk. 270 x 250 mm. Inv. 8. Christ Church.

3. Leonardo da Vinci. *Grotesque Bust*. Black chalk. 382 x 275 mm. Inv. 19. Christ Church.

4. Follower of Giorgione. *A Pair of Lovers in a Landscape*. Pen and grey ink, on paper primed light-red. 188 x 322 mm. Inv. 717. Christ Church.

enriched, not least by an extraordinary collection of drawings, principally through the acquisition of the collection of Joseph Smith, the English Consul in Venice. But none of these collectors had Guise's twofold qualification of soldier and art lover. His drawing collection, as already noted, contains about 2000 items. But despite its impressive quantity it is clear that the General never lost sight of certain basic historical principles and qualitative criteria deriving from his cultural outlook, which was really that of a scholar.

Guise obviously wanted to make a special collection, not just any collection, and still less one that was merely prestigious or includes examples of every school. He set out to collect the Italian school and in his albums none of the famous Italian masters – from Giotto to the Carracci – were missing, even if his attributions have, of course, often been corrected or modified by modern research. A study of the earliest list of his collection makes it clear that Guise actually wanted to cover the entire historical range of Italian drawing. He must indeed have chosen as his models the most celebrated collectors of the past and of his own time: Giorgio Vasari in his famous 'Book of Drawings' (a few items of which found their way into Guise's own collection), the Venetian painter Carlo Ridolfi, Filippo Baldinucci, and the Milanese Padre Resta.

Having seen that Guise's basic plan of collecting was, like that of his great antiquarian predecessors, the complete coverage of a particular school, we may now try to discern

11

5. Gerolamo Romanino. *The Holy Family*. Red chalk. 170 x 160 mm. Inv. 736. Christ Church.

some of his personal preferences by considering the subject matter of the drawings. Byam Shaw, in his recent catalogue, has perceptively noted a certain penchant on the part of General Guise for battle scenes and martyrdoms. But he devoted still greater attention to Roman, Greek, and Egyptian themes. These were, of course, subjects of special interest to the antiquarians of his time and are related to that familiarity with the ancient past which was associated with the sense of beauty – in other words, just the sort of programme to be expected from the mid 18th century, the period when Neoclassicism came to maturity. Indeed, there were many special boxes in the collection containing drawings of ancient remains, architectural fragments, goldsmith's work and gem carving, which further confirm Guise's marked Neoclassical orientation. This taste, however, in no way restricted his breadth of interests and studies.

We must now consider the question of the origins of Guise's drawings. These can be fairly well identified on the basis of documents and collectors' marks, which Byam Shaw has very carefully studied (6). The oldest collections from which some of Guise's drawings derive are that of Vasari, some of whose drawings still have their characteristic framings (7), that of the Viti-Antaldi family of Rome, and, among French collections, that of Lanière. Following these in time are the great 17th-century collectors, among them Ridolfi, three hundred of whose drawings finally became the property of Guise, and Padre Resta, from whom come about seventy sheets. The other major sources are certain English collections. Let us now examine some of the sources in detail.

Foremost among the English sources are drawings formerly in the collections of artists. Fifty-six come from the collection of Peter Lely, twenty-two from that of the painter Lankrink, and over a hundred from that of the two Richardsons. Many of Guise's drawings were acquired from abroad. A few come from France, such as those from Lanière and those from Crozat, from whom Guise also acquired a painting (8). Some of the Crozat drawings even bear inscriptions by the famous Mariette and one can therefore well imagine that others may also have belonged to this great French connoisseur of the 18th century.

Because of his concentration on the Italian school, the greater part of Guise's acquisitions derive from Italian sources. Among these, unquestionably of the greatest importance was the Ridolfi collection (9). The Venetian painter Carlo Ridolfi is known, perhaps more than for his painting, for his penetrating critical works, including the famous *Maraviglie dell'Arte* of 1648, which are basic to the study of Venetian painting of the 16th and 17th centuries. It seems that Ridolfi formed a collection of drawings that, after his death in 1658, according to Byam Shaw's recent studies, passed into the possession of his family and were at that time marked with the famous italic *R*, which has hitherto always been considered his own personal collector's mark. However, it is clear today that many of the drawings bearing the *R* were executed only after Ridolfi's death and we must therefore conclude that this family inheritance was added to after the death of the Venetian painter and critic. In any case, the entire collection is not later than the mid 17th century and is remarkably accurate and authoritative in its attributions, especially in the case of the

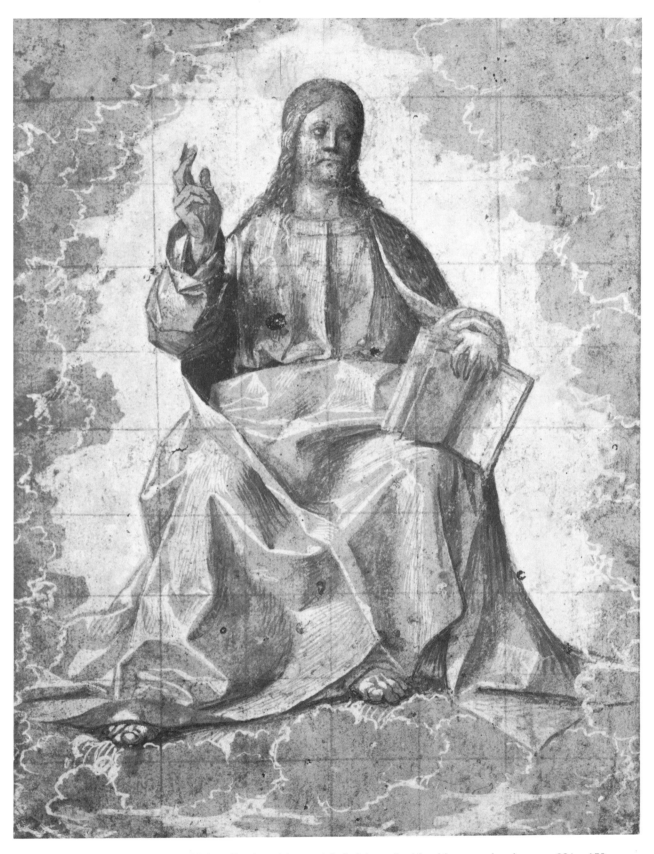

6. Boccaccio Boccaccino. *Christ in Majesty*. Brush and brown ink, heightened with white, on primed paper. 234 x 179 mm.
Inv. 5. Ashmolean Museum.

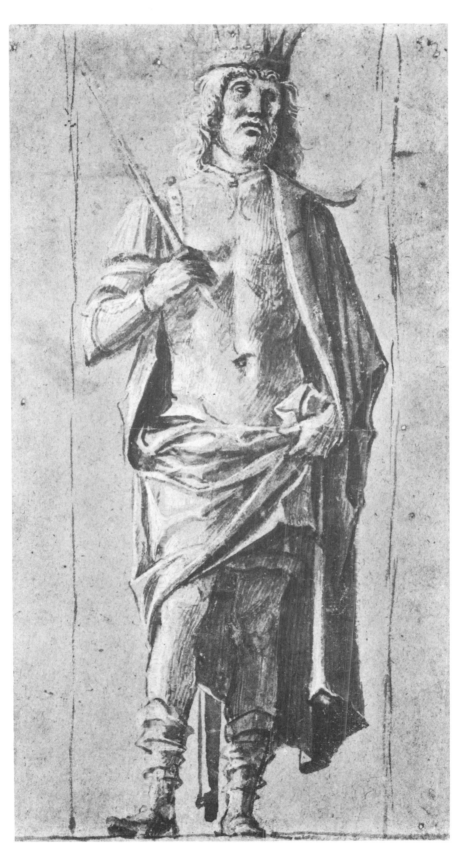

7. Bartolomeo Montagna. *Constantine*. Brush and blue watercolour, heightened with white, on blue paper. 26~ x 141 mm. Inv. 25. Ashmolean Museum.

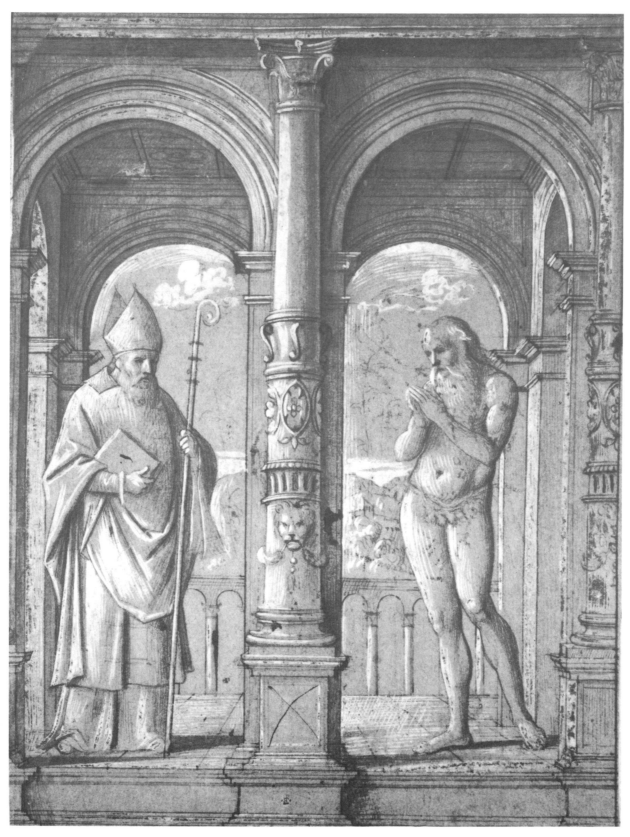

8. Gerolamo Santacroce. *Two Saints*. Pen and black ink, brush and grey wash, heightened with white, on paper primed dull-green. 270 x 200 mm. Inv. 712. Christ Church.

Venetian drawings. The attributions for the other Italian schools are less accurate. This is seen in the fact (not, it should be remarked, observed by Guise) that of the sixteen 'Leonardo da Vinci' drawings which passed to Guise from the Ridolfi collection only one, or possibly two, can aspire to that attribution and, still worse, none of the numerous 'Michelangelo' and 'Raphael' drawings are from the hands of these masters. But among the approximately three hundred drawings from the Ridolfi collection, the attributions of the numerous Venetian works are substantially valid. Firmly established also is the authenticity of the provenance of the Ridolfi albums. These were acquired by Guise not, it seems, in the original seven albums but rebound and collected in two albums. In these two volumes, however, there are indications of the frontispieces of the original seven, marked with the letters A to G and dated between 1630 and 1638. One may suppose that the division into two albums was a later decision carried out by the heirs at the moment when all, or the greater part, of the Ridolfi drawings were marked with the famous *R*.

After this Venetian collection, the most important source is the Tuscan collection of Baldinucci, from which come about two hundred of the Guise drawings, all recognizable from their characteristic mounts (10). Filippo Baldinucci, a great connoisseur of drawings and generally well schooled in artistic matters, collected graphic masterpieces for Cardinal Leopoldo de' Medici, who died in 1675. Baldinucci had also his own personal collection of about 1200 drawings, bound in four volumes, which in its entirety was acquired by the Louvre in 1806. The collection that Baldinucci had made for Leopoldo passed to the Uffizi, but not in its entirety. In fact, thousands of these drawings, apparently 4700, were previously sold and dispersed. The group of two hundred drawings that came into the hands of Guise probably belonged to this dispersed portion of the collection. Guise, moreover, must have had agents working for him in Italy and particularly in Tuscany, because other Tuscan drawings, six to be precise, come from the Florentine collector Gabburri. This further confirms the presence of an agent in the 18th-century Medici capital, which was at that time very alert in matters of art and the centre of a rich graphic production.

Guise's third major source of Italian drawings was the collection of the Milanese Padre Resta, whose drawings are easily recognized by their inscriptions (11). At least seventy drawings derive from Resta, who died in 1714. A few years earlier part of his collection had gone to England. It had been acquired in about 1710 by Lord Somers, who had the sheets mounted by the painter and collector Jonathan Richardson. This group of drawings, which was certainly much larger than the group which eventually came into Guise's possession, had attracted the interest of Christ Church in the person of its Dean, Rev. Aldrich. Dean Aldrich was an art lover and obviously eager to create a graphic collection at Christ Church. Aldrich's interest, however, came to nothing. When Lord Somers died in 1716 his drawings, including those acquired from Resta, were sold at auction. It was at this auction, perhaps through Jonathan Richardson, that Guise acquired about seventy works which had once belonged to Resta.

Another very important source of Italian drawings was the dealer Gautier of Amsterdam, from whom Guise acquired some sixty of unusual interest. Drawing 886 of Byam Shaw's

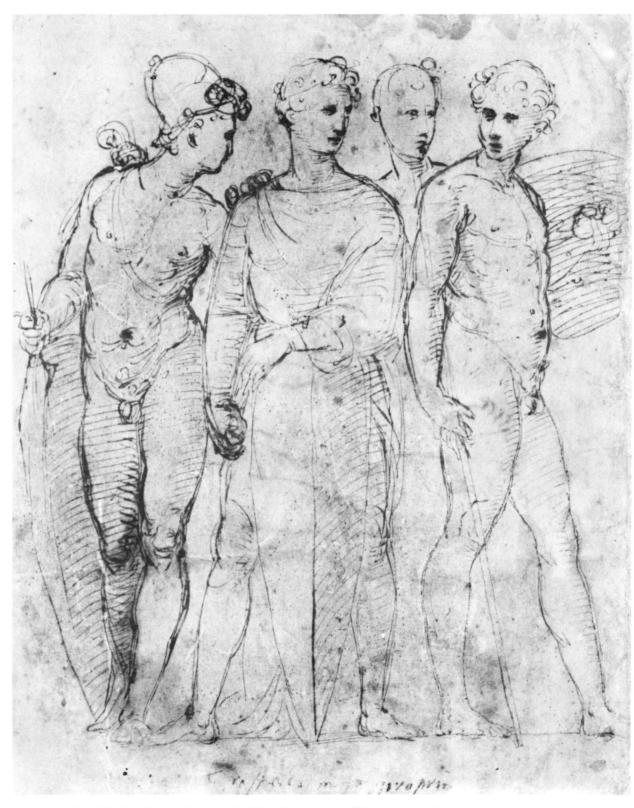

9. Raphael. *Four Warriors*. Pen and brown ink. 271 x 216 mm. Inv. 523. Ashmolean Museum.

18

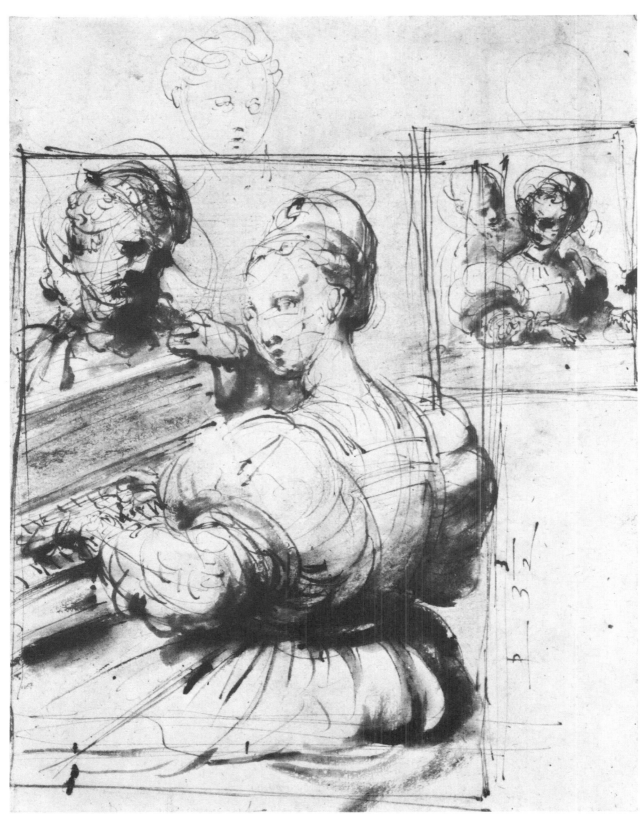

10. Perin del Vaga. *Young Lady Playing the Virginals*. Pen and brown ink, with ink wash. 255 x 201 mm. Inv. 64.
Ashmolean Museum.

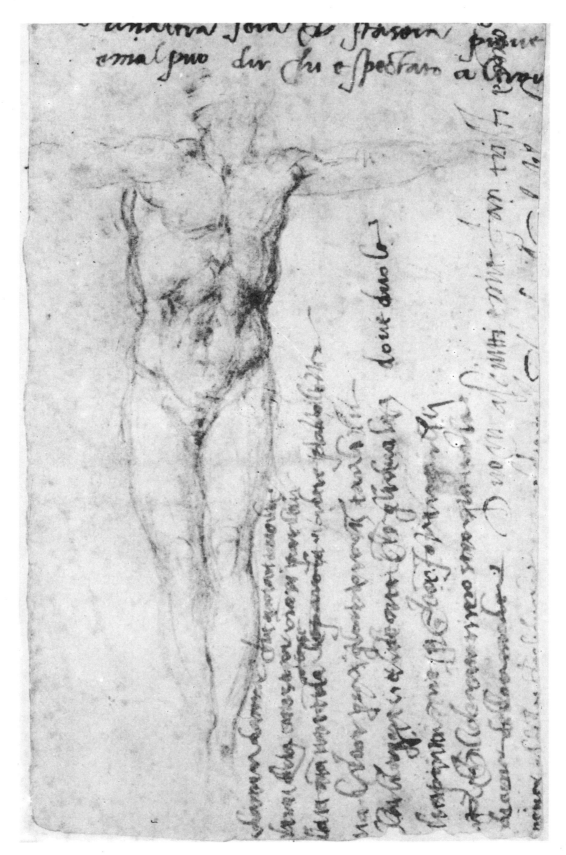

11. Michelangelo. *The Good Thief*. Black chalk. 162 x 101 mm. Inv. 63. Christ Church.

catalogue is actually a representation of Gautier himself in the act of receiving a purse of money from Guise. In his study of Guise's sources and methods of collecting, Byam Shaw has brought to light some highly interesting unidentified personalities. Most remarkable among them is an agent or collector, probably an Englishman, whom Byam Shaw has baptized 'the illiterate connoisseur' because of a series of misspellings in his attributional inscriptions. At least one hundred and sixty-five of Guise's drawings come from him, among them the Tinorettos and the famous drawing by Vasari of the cameo of Cosimo I de' Medici (12).

From this brief account one can see that the sources which Guise drew upon were unusually varied and widespread, and yet he never lost sight of his original intention of concentrating on the Italian school. Among 18th-century collections what makes his unique is the fact that it still exists as a whole. It is very hard, if not impossible, to find today a collection still intact, and of which we know the whole history and so many details of its owner's life and culture, as in the case of John Guise. The two thousand drawings of the Christ Church collection have precisely this outstanding merit.

When the collection became the property of Christ Church, in 1765, provisions were immediately made for its ordering. The first scholar to take charge of the drawings was the College librarian, Dr. Smallwell (13). He had probably been Guise's friend, and had helped him in establishing relations with the last fellow collectors of Guise's time. It is also possible that he played a significant part in persuading Guise to favour Christ Church in his will of 1760. During Dr. Smallwell's custodianship various connoisseurs visited the collection and left their trace in written notations on the portfolios and mounts. Among these was the Venetian Anton Maria Zanetti, who died in 1767. Passing through England in the last years of his life, Zanetti had the opportunity of examining at least twenty drawings of the Guise collection on which he made changes in attribution (14). Yet another visiting connoisseur saw the collection either when it was still in Guise's possession or immediately after it entered Christ Church. This was an unknown Italian who annotated about one hundred and forty drawings with a characteristic $B°$ in red chalk, which signified *bello* or *bellissimo*, and also corrected a few attributions. It is obvious that Guise took great pleasure in his hobby and encouraged famous scholars and illustrious guests to share in it. And occasions were certainly not lacking, since, as mentioned earlier, his collection was already known and referred to by the 18th-century English diarists.

Numerous other visitors passing through Oxford after the bequest of the collection made a point of inspecting it and left their judgements and annotations. We know, for example, that Passavant saw it in 1831 and Waagen in 1850 and commented on it enthusiastically. In 1856 Cavalcaselle made use of some of the drawings for his attributions (15), and in 1868 J. C. Robinson saw at least one or two hundred of the most important drawings and annotated and initialled them (16).

By the end of the 19th century the collection, which had essentially been known and studied only within the College, began to be presented to a wider public through exhibitions: A first exhibition of ninety-one drawings was held at the Grosvenor Gallery in

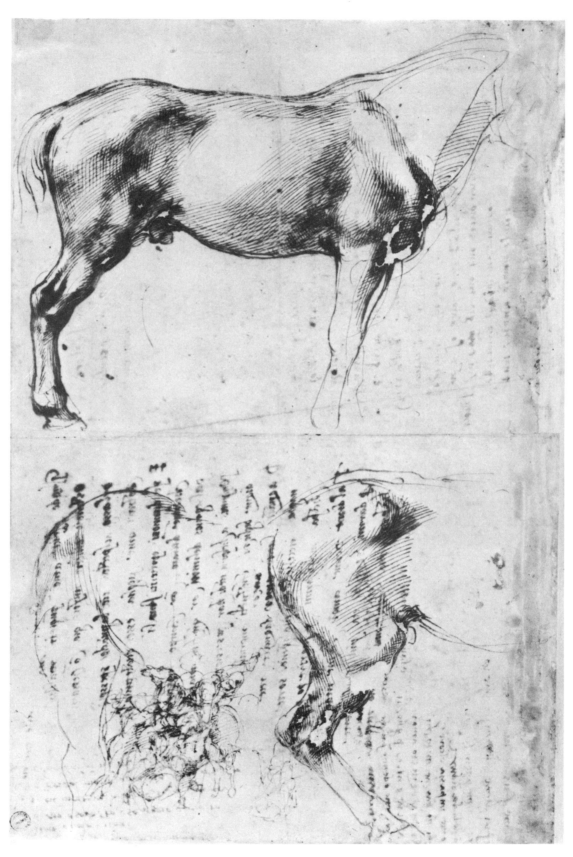

12. Michelangelo. *Studies of a Horse and Sketch of a Battle*. Pen and brown ink. 427 x 233 mm. Inv. 293*r*. Ashmolean Museum.

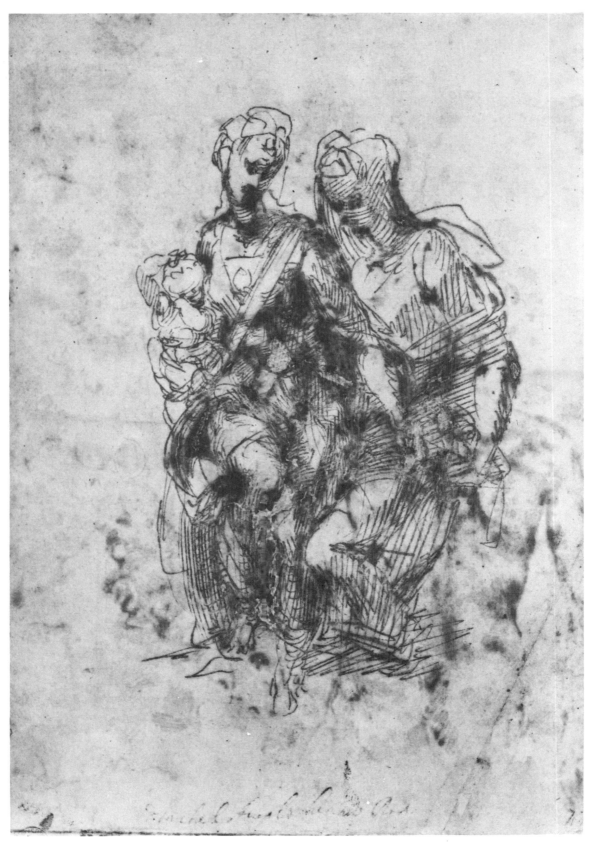

13. Michelangelo. *Madonna and Child and Saint Anne*. Pen and brown ink. 257 x 175 mm. Inv. 291*r*.
Ashmolean Museum.

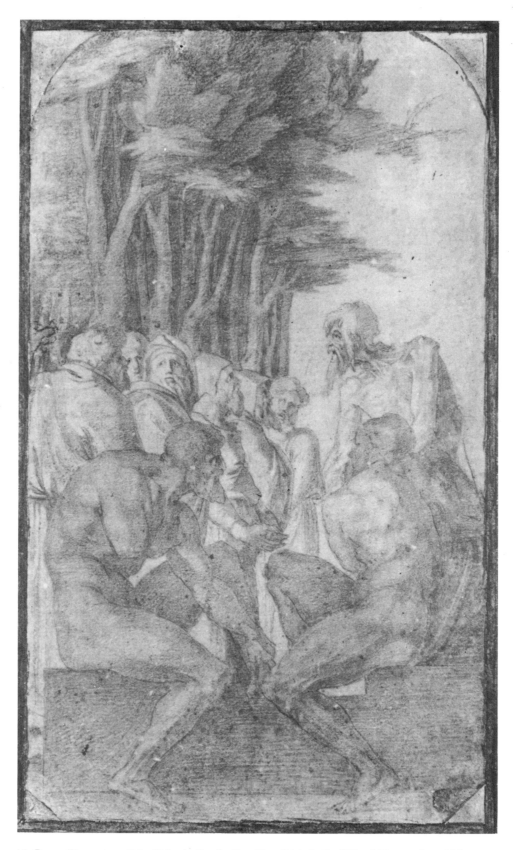

14. Rosso Fiorentino. *Saint John the Baptist Preaching*. Red chalk. 263 x 152 mm. Inv. 124. Christ Church.

London in 1878–79 (17), followed by an exhibition of some hundred other drawings, displayed on rotating lecterns, at Christ Church itself.

At this time the problem of making the examination of the collection, hitherto largely contained in albums, more convenient came under consideration. Thus began a vast project for the unbinding, separation, and mounting of all the drawings. Between 1890 and 1904 this project was directed by Professor York Powell, who arranged the mounting of some thousand drawings, then considered the best (18). Unfortunately these mounts were not made of suitable materials and some drawings absorbed the colour of the mounting paper. However, it was certainly this greater accessibility of the collection that in 1903 enabled Sidney Colvin to publish a series of portfolios with drawings of the old masters in the Oxford collections, including more than fifty of the best drawings of Christ Church, along with others that by then formed part of the Ashmolean Museum (19). These portfolios contained annotations that were to be very useful also to scholars. While not a catalogue, since it included only about fifty items, this was the first scientific publication of the Christ Church drawings. During the same period, Bernard Berenson made use of numerous Tuscan sheets in the collection in the first edition of his work on Florentine drawings, published in 1903, and still others were recorded by Oskar Fischel in his *corpus* of Raphael drawings (20). Thus, by the beginning of the 20th century the Christ Church collection had become a point of reference for scholarly research.

It was at this stage that a catalogue was deemed a necessity. Its preparation was entrusted, in the early years of this century, to C. F. Bell, a scholar of exceptional dedication and a reasonable competence in the field of graphic art. Bell's work, however, cannot really be called a modern catalogue. His little book, published in 1914 and still a valuable source, did not cover all the drawings in the collection. It included only about half, essentially the 1051 mounted drawings, of the present total of about 2000 (21). Moreover, Bell's catalogue inevitably suffered from the prevailing practice in studies of the graphic arts at the time of concentrating on the most outstanding figures, such as Raphael or Michelangelo, the great Florentines, or Leonardo. There was as yet no real understanding of certain schools, such as that of Venice or that of Emilia in the second half of the 16th century, and still less was known of the 17th century. This was a serious limitation since Guise's collection was remarkably rich in these areas, not least because its sources included the Ridolfi, Baldinucci, and Resta collections. It is also relevant that, when Bell published his book in 1914, Venturi's volumes on Italian art had not yet appeared, and thus his work suffered greatly from a lack of comparative material. Also there were very few of the particular studies of the kind Voss and Hadeln were to publish in the second and third decades of this century. Bell can therefore hardly be blamed if instead of a real catalogue his work was but a hand-list. Nevertheless, the alphabetical cataloguing of over a thousand drawings and the reproductions of those considered most important were of great value and interest. Bell's list acquired added merit from the fact that the attributions taken from Guise's original notations were apt to be more exact precisely in those areas where the compiler's competence was less. Furthermore, Bell was aware that by cataloguing only the mounted

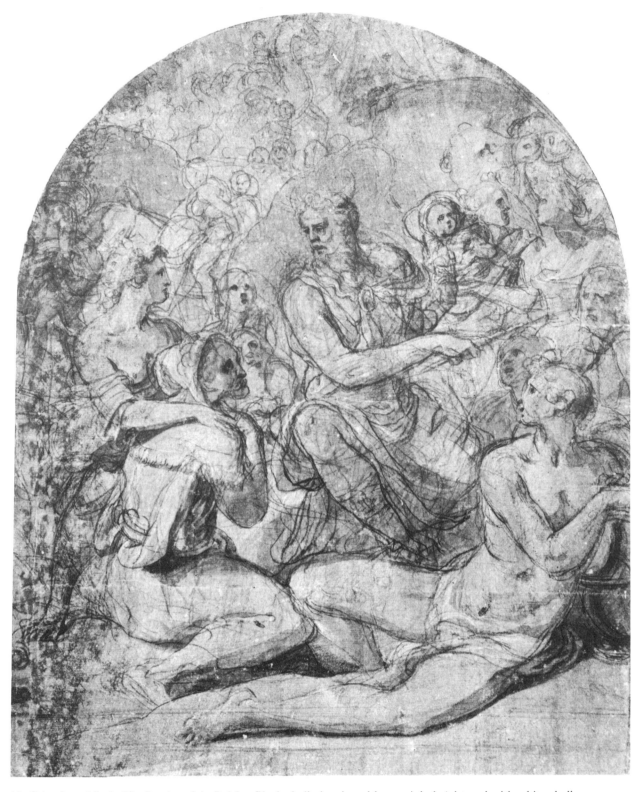

15. Cristofano Allori. *The Crossing of the Red Sea*. Black chalk, brush and brown ink, heightened with white chalk, on paper primed greyish-blue. 312 x 250 mm. Inv. 133. Christ Church.

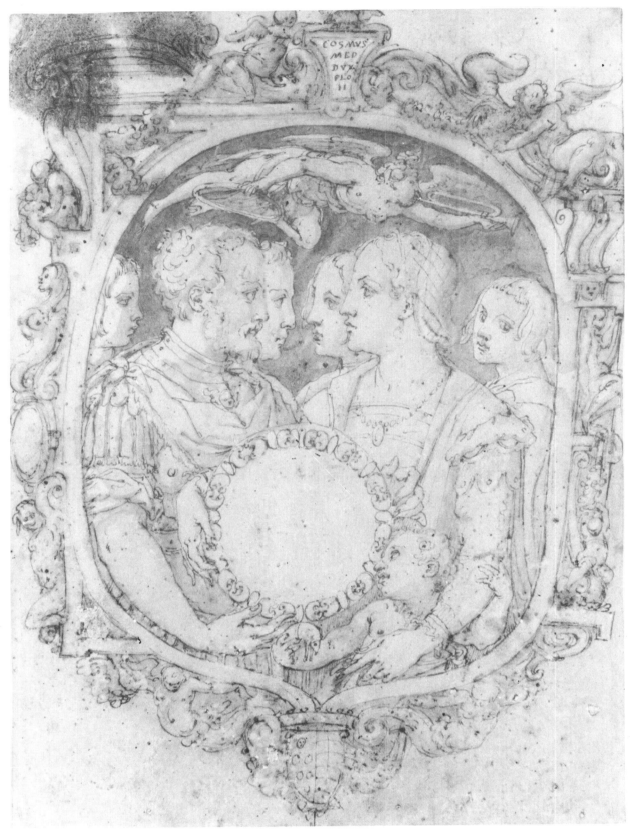

16. Giorgio Vasari. *Design for a Cameo of Duke Cosimo I de' Medici*. Pen and brown ink, with ink wash. 283 x 210 mm. Inv. 161. Christ Church.

sheets his description of the collection was not comprehensive, and he explicitly stated that it contained another seven hundred drawings. But he referred to this remaining group as of little importance, whereas (amounting not to seven hundred but, in fact, to about a thousand items), it contains numerous drawings of outstanding interest, including works by such artists as Pontormo and Bronzino, the Carracci and Domenichino, Sebastiano del Piombo and Jacopo Bassano.

After the publication of Bell's list very little work was done on the Christ Church collection for fifty years, and it remained perhaps the least known of the great public collections. In fact, practically all the more recent studies relating to it date from the past decade, first and foremost the fundamental work of a great English expert on the graphic arts, J. Byam Shaw. A former student of Christ Church, Byam Shaw returned to his College in 1960 charged with the task of cataloguing the collection of paintings and that of the drawings, in other words, the whole Guise bequest. With the help of Professor Bueno de Mesquita, Curator of the Picture Gallery, in which the drawings are contained, the collection was first given a new installation. Byam Shaw then undertook an exhaustive study of the graphic collection, dividing it into schools and cataloguing it chronologically. In this way its value as a source of reference was enormously increased, both for scholars and for the students of the University for whom the collection is principally intended. Byam Shaw's definitive catalogue was preceded by a series of articles, beginning with that published in *Master Drawings* in 1968 (22), up to the catalogue prepared for an exhibition of a hundred and fifty of the most important drawings that travelled in the United States in 1972 (23). Reflecting the circumspect scholarship and sensitivity of this great connoisseur, his catalogue of the entire two thousand drawings of the Guise collection of Christ Church, published in 1976, fully reveals the number of works of supreme importance, which, just as Guise had desired, cover the entire range of Italian art.

From these riches a selection has been made for the plates of the present volume, where individual drawings are more amply discussed in the commentaries. Here, to give a brief summary of the collection as a whole, we will mention but a few of the masterpieces.

Of the Tuscan school of the 14th and 15th centuries, Christ Church possesses marvellous works by Filippino Lippi, all the more valuable for their technique of silverpoint heightened with white (fig. 1, pl. 3). Some of the figures in these drawings are related to contemporary personages depicted in his paintings. Such is the case of the figure at the lower left in plate 3, probably a portrait of Botticelli. The collection also contains a stupendous drawing by Perugino of a 'Joseph of Arimathaea' who appears in the artist's painting of the *Lamentation over the Dead Christ* in Palazzo Pitti (fig. 2). In addition, among the 14th-century works, we may point out an exceptional youthful drawing by Lorenzo di Credi of 'David with the Head of Goliath' (pl. 4), a young warrior who brings to mind the sculptures of Donatello and Verrocchio. By Verrocchio himself there is a 'Head of a Young Woman' (pl. 2), which has been related to the artist's *Madonna and Child in a Landscape* in Berlin.

The Christ Church collection does not contain many drawings by the very greatest masters of the 15th and 16th centuries, who are so well represented in the Ashmolean

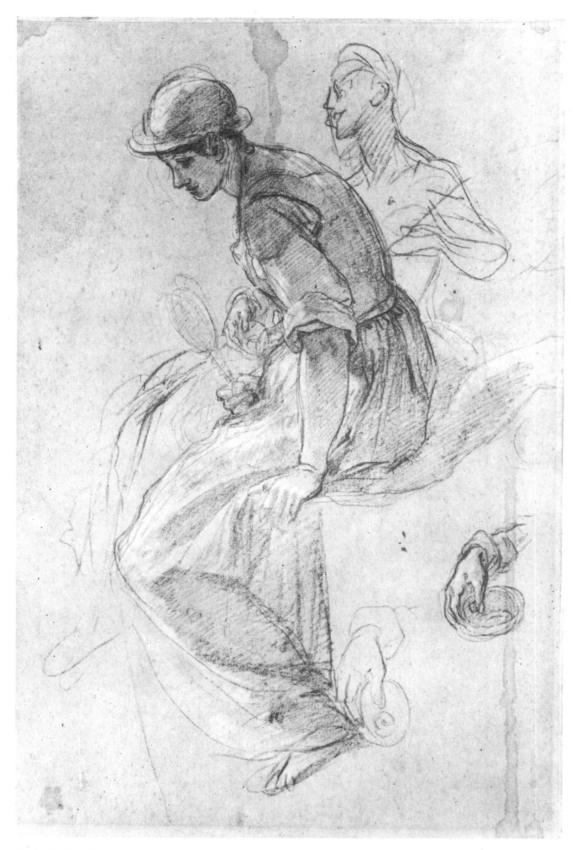

17. Lodovico Cigoli. *Two Celestial Virtues*. Black and red chalk, heightened with whi e chalk, on blue paper. 390 x 265 mm. Inv. 256. Christ Church.

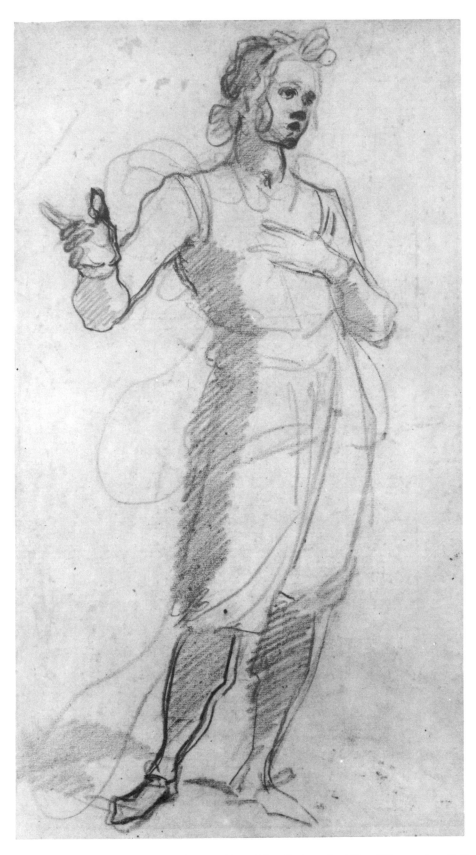

18. Jacopo da Empoli. *Study of a Standing Young Man*. Red chalk. 411 x 225 mm. Inv. 240. Christ Church.

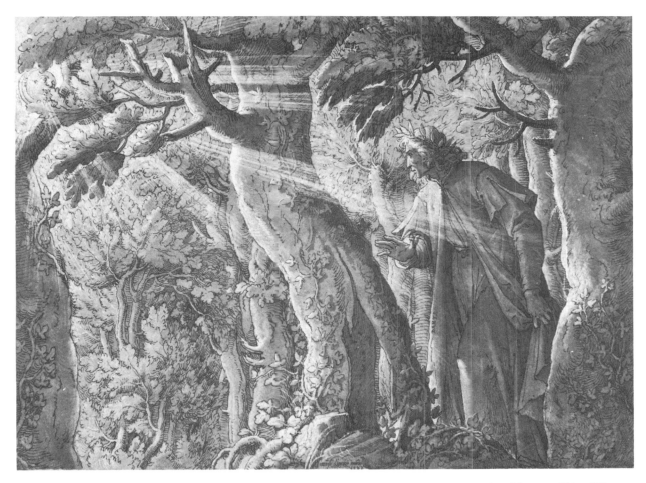

19. Jacopo Ligozzi. *Dante*. Pen and brush with brown ink, heightened with white, on paper primed brown. 201 x 275 mm. Inv. 215. Christ Church.

Museum. Nevertheless, there are some highly interesting sketches by Leonardo with annotations in the artist's hand, such as the work shown in plate 13, or the famous drawing of a grotesque head, the so-called caricature of Scaramuccia, which has been recorded ever since Vasari (fig. 3). From Raphael's hand is a very beautiful drawing representing a group of seven putti who play at judge and prisoner and seem in part inspired by Donatello's cantoria for the Florence cathedral (pl. 17). Michelangelo, too, is represented by a few works, among them the stupendous drawing of the 'Good Thief' (fig. 11), which is related to a *bozzetto* in the Casa Buonarroti.

The collection also contains a group of drawings by the great Tuscan Mannerists. These include a preparatory sketch for Pontormo's *Deposition* in the Capponi chapel in Santa Felicità in Florence (pl. 25), as well as a drawing by Rosso, apparently a preparatory sketch, representing 'Saint John the Baptist Preaching' (fig. 14) and very close in style to his *Descent from the Cross* in Volterra.

For scholars of the Venetian school the Christ Church collection is of unusual importance for minor items, such as the drawing of 'Two Saints', probably for the doors of the old organ in San Giovanni Crisostomo in Venice, attributed to Gerolamo Santacroce (fig. 8), or the beautiful 'Head of the Madonna' attributed to Montagna (pl. 10). From the late 15th and the 16th century we can cite far more famous examples of Venetian drawing. These include the portrait of a strong-willed individual in classical costume and cap, alternatively attributed to Gentile or Giovanni Bellini, which is certainly one of the finest drawings of the whole collection (pl. 8). The 'Bust of a Young Man' by Carpaccio, for one of the personages in his *Legend of Saint Ursula* series (pl. 11), belongs among the graphic masterpieces of this artist, who was relatively prolific as a draughtsman but rarely achieved such quality. The technique of white highlights applied with hatching strokes of the brush on a dark paper strikingly enhances the volumes of this figure. An extraordinarily evocative red chalk drawing representing a philosopher type has recently been attributed to Giorgione (pl. 33). Byam Shaw, however, now tends to consider this the work of a follower of Giorgione, close in style to Gerolamo Romanino. Romanino himself is represented in the collection by a very charming small drawing of the 'Holy Family' (fig. 5). Also to be

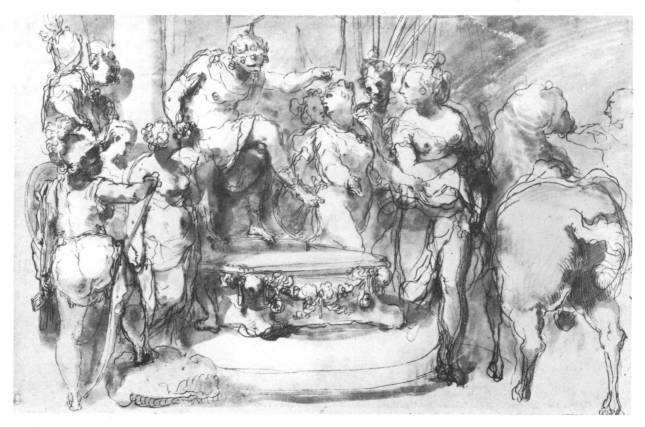

20. Taddeo Zuccari. *Alexander and Bucephalus*. Pen and grey ink, with ink wash. 376 x 429 mm. Inv. 532. Christ Church.

21. Giulio Campi. *The Obsequies of Saint Agathe*. Pen and black ink. 346 x 244 mm. Inv. 140. Ashmolean Museum.

mentioned is a drawing from the hand of a follower of Giorgione, very close to Giulio Campagnola, representing a 'Man and Woman in a Landscape' (fig. 4). The Christ Church collection also contains a drawing by Titian from his youthful period, similar in conception to his Madonna in Vienna known as the *Gipsy Madonna* (pl. 35). This drawing seems to have been used later by his brother, Francesco Vecellio, as the *modello* for an altarpiece of the Madonna with angels playing music at her feet, and the drawing, too, was erroneously attributed to him. Byam Shaw has recently discovered also an extremely beautiful 'Head of a Woman' by Sebastiano del Piombo, related to his painting of the *Madonna del Velo* in the Naples gallery, dating from the artist's Roman years (pl. 39). Other Venetian drawings of the collection are the work of artists of the second half of the 16th century. These begin with some landscapes by Domenico Campagnola from his late period (fig. 22). Also included here is Tintoretto's famous 'Head of Giuliano de' Medici' after the sculpture by Michelangelo, a drawing that recent scholarship has firmly attributed to the hand of Jacopo (pl. 41). By Jacopo's son, Domenico Tintoretto, there is a sketch for the altarpiece of the *Martyrdom of Saint Stephen with the Ascension* in San Giorgio Maggiore in Venice, which demonstrates the strong chiaroscuro quality of his brush drawings (pl. 43). A large drawing of 'Diana' by Jacopo Bassano, in black chalk heightened with white chalk, offers one of the

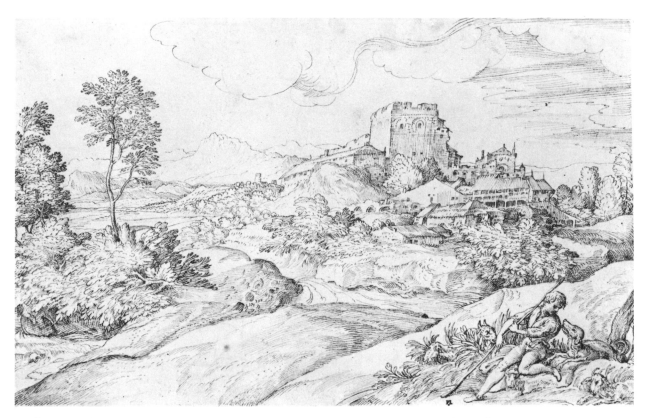

22. Domenico Campagnola. *Landscape*. Pen and brown ink. 243 x 388 mm. Inv. 723. Christ Church.

34

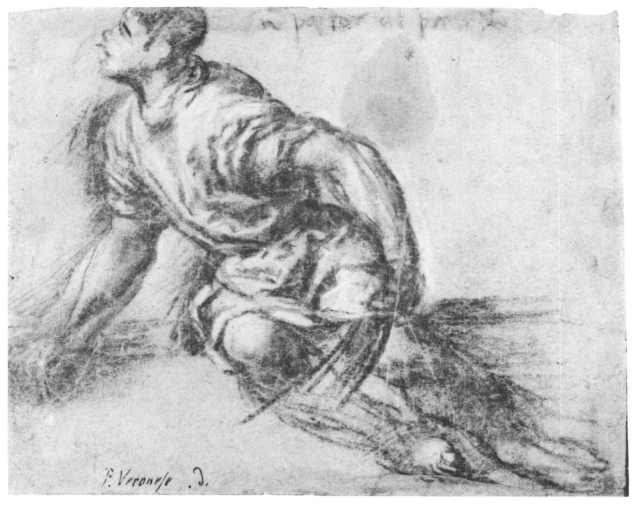

23. Paris Bordone. *Study of a Seated Boy*. Black chalk, heightened with white chalk, on blue-grey paper. 190 x 242 mm. Inv. 120. Ashmolean Museum.

characteristic *modelli* that were so essential to the working method used in the production of paintings in Jacopo's studio (pl. 44). The final drawing that must be mentioned from the Venetian 16th century is the highly important study by Paolo Veronese for his altarpiece of the church of the Ognissanti in Venice, today in the Accademia. The sheet, drawn on both *recto* and *verso* and bearing inscriptions that describe the various groups, is one of the most outstanding graphic works of this great decorator of the Venetian Cinquecento (pl. 45).

Another notable group of drawings is formed by those of the Emilian, Roman, and Tuscan schools of the later 16th century. Among these are sheets by Parmigianino, some related to his late work in the Madonna della Steccata in Parma (pl. 31). This group also includes the famous drawing by Vasari of the cameo that Antonio dei Rossi was to execute for Duke Cosimo I de' Medici (fig. 16). Other Tuscans of the period are Jacopo da Empoli,

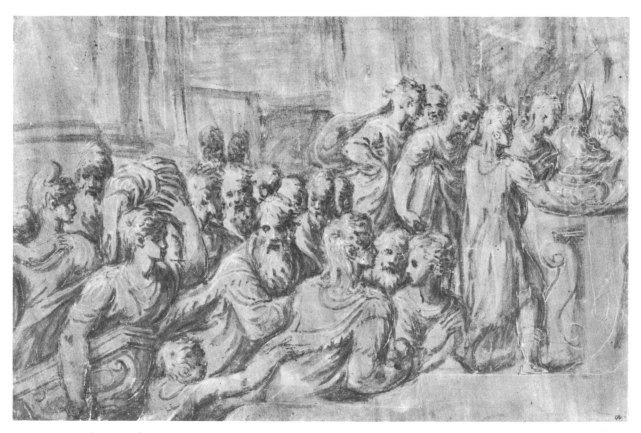

24. Andrea Schiavone. *The Presentation in the Temple*. Brush and grey ink, heightened with white, on paper primed mauve. 184 x 276 mm. Inv. 695. Ashmolean Museum.

Cristofano Allori, Lodovico Cigoli and Andrea Boscoli (figs. 15, 17, 18, pl. 54). From the Roman school are some beautiful drawings by Taddeo and Federico Zuccari (fig. 20, pls. 51, 53). Other extremely interesting works are those by the Genoese Luca Cambiaso, among which is a fine 'Madonna and Child' from his youthful period, published for the first time now by Byam Shaw (fig. 31).

The chronologically latest works collected by Guise are drawings by the Roman and Bolognese masters of the early and mid 17th century. The Christ Church collection is indeed particularly interesting in this field. There are sheets by Annibale Carracci with various figures, perhaps for the Camerino of Palazzo Farnese (pl. 56), as well as a very interesting drawing by Agostino Carracci of 'Anchises and Venus' for the fresco of this subject in the Galleria of Palazzo Farnese, which had long been attributed to Annibale (pl. 57). Of the major Bolognese artists who worked in Rome in the early 17th century we find sheets by Guido Reni, among them a 'Saint Proculus' for the artist's well known *Madonna del Rosario* in the Pinacoteca of Bologna (fig. 36). By Domenichino is a 'Putto' that was probably the working cartoon for his fresco of the *Chariot of Apollo* in the Palazzo Costaguti

36

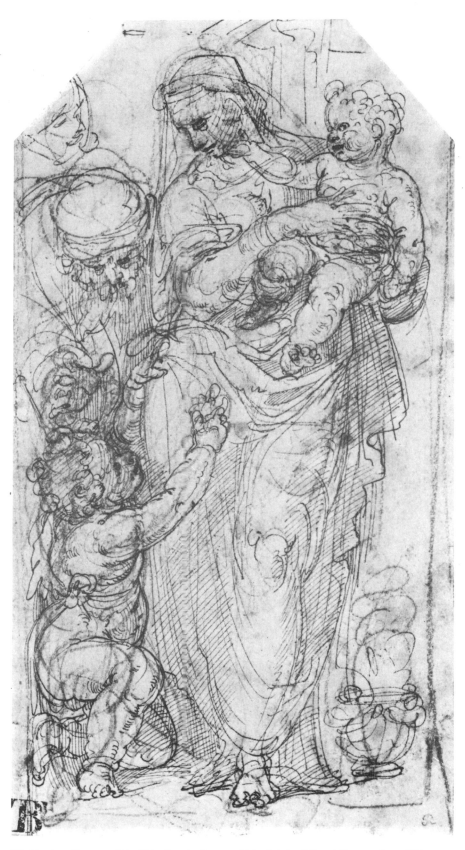

25. Battista Franco. *The Holy Family*. Pen and black ink. 222 x 120 mm. Inv. 233.
Ashmolean Museum.

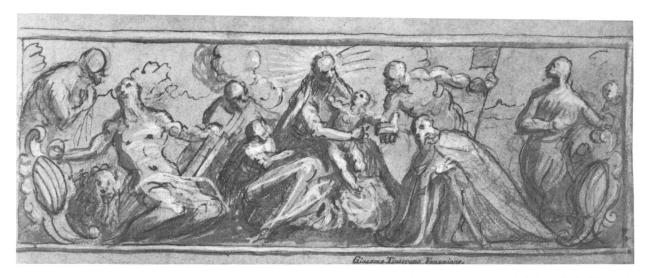

26. Domenico Tintoretto. *Doge Marino Grimani in Adoration before the Virgin.* Pen and brown ink, with ink wash, heightened with white, on bluish paper. 164 x 409 mm. Inv. 710. Ashmolean Museum.

in Rome and is one of a group, nine others of which are in the Royal collection at Windsor (fig. 37). There are also drawings by Guercino, including one of a swooning female figure that was probably for the painting of *Esther* in the Museum of Art at Ann Arbor, Michigan (fig. 41). Lesser figures of the Bolognese school are also represented: for example, there are some beautiful drawings by Simone Cantarini (fig. 43). Still other drawings are by artists of the Roman school of the mid 17th century and these are among the very latest works of the Guise collection. They include drawings by Domenico Fetti, in particular a very beautiful 'Portrait of Catherine de' Medici' (pl. 62), and a study by Pietro da Cortona for the Galleria of Alexander VII in the Quirinal Palace (pl. 64).

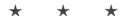

On the corner of Beaumont Street and the beautiful, tree-lined St. Giles' rises the Neoclassical building of the Taylor Institution, which since 1845 has housed the Ashmolean Museum, one of the oldest Museum collections in the world. It was bequeathed by its founder Elias Ashmole to the University in 1677, enriching Oxford with exceptional collections of classical and oriental antiquities, paintings, sculptures, and objects of European minor arts of the medieval and modern periods. The Ashmolean also contains the collection of drawings that, along with the collection of Christ Church, constitutes one of the major cultural attractions of Oxford.

Oddly enough this drawing collection was formed only in relatively recent times. It was begun essentially in the first half of the 19th century with a series of bequests, and almost up to our own time it consisted of fewer than five hundred drawings. Its greatest growth has, in fact, taken place in the last fifty years, principally owing, as we shall see, to the activity of the Keeper, Sir Karl Parker, a man of exceptional merits both as curator and scholar (24).

38

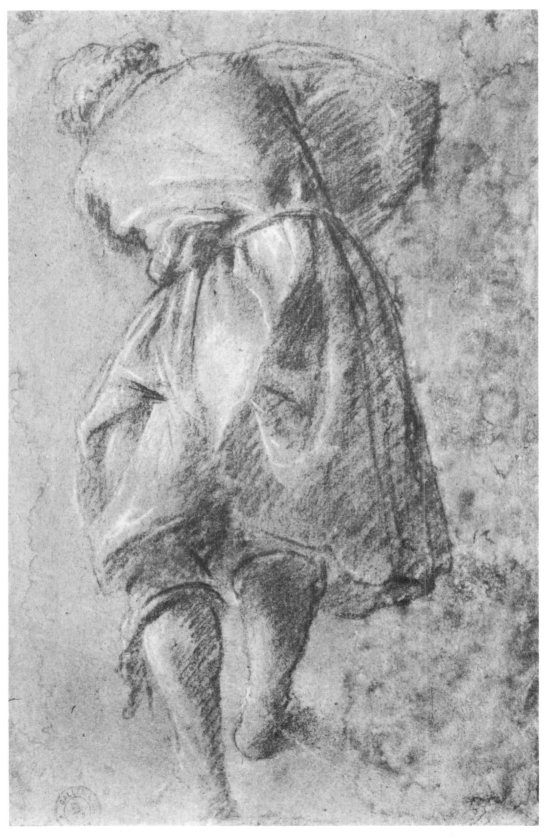

27. Jacopo Bassano. *Figure of a Gondolier*. Black and red chalk, heightened with white, on brown paper. 415 x 273 mm. Inv. 110. Ashmolean Museum.

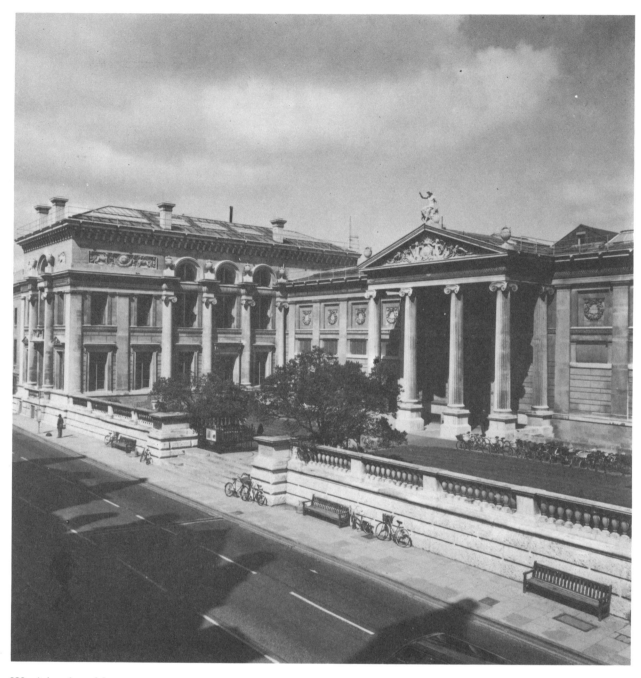

III. Ashmolean Museum.

Facing page

top left: IV. Sir Thomas Lawrence, collector of the Michelangelo and Raphael drawings now in the Ashmolean Museum.

top right: V. The Rev. Dr. Henry Wellesley, promoter of the public subscription for the purchase of the Michelangelo and Raphael drawings for the Ashmolean Museum.

bottom: VI. Samuel Woodburn, Lawrence's principal dealer, who also disposed of the artist's collection after his death.

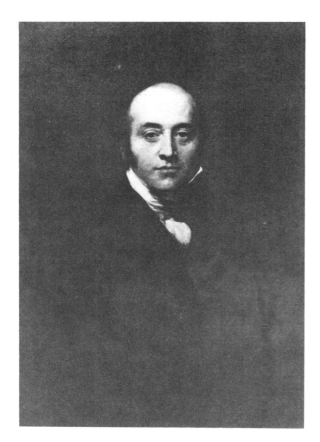

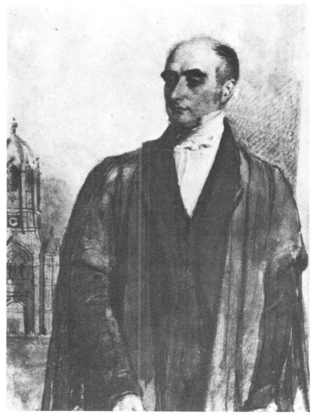

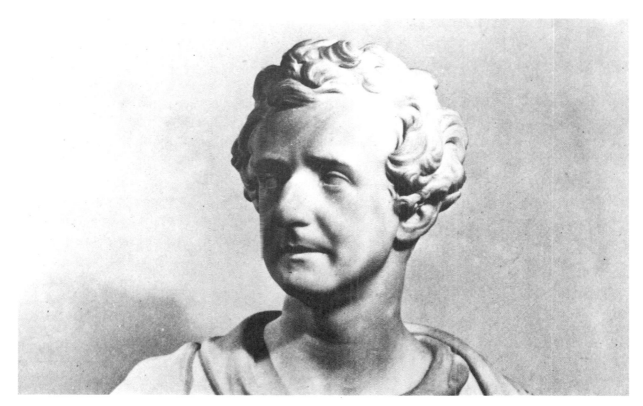

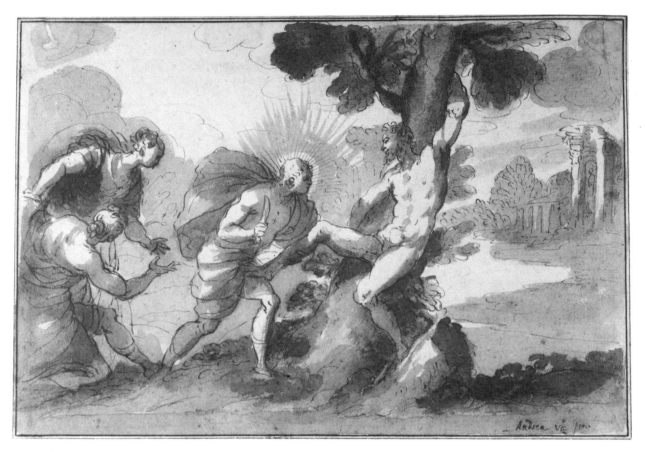

28. Andrea Vicentino. *Apollo and Marsyas*. Pen and brown ink, with ink wash. 160 x 234 mm. Inv. 746. Ashmolean Museum.

Today the Ashmolean Museum contains some 1100 drawings. But as a result of the unusual circumstances of its formation it offers for study a collection of exceptional quality. For only half the collection has been casually acquired through gifts whereas the other half was carefully selected with a view to study and research.

Just as at Christ Church, so too at the Ashmolean the Italian school predominates, and this was so from the beginning of the collection. The Ashmolean, in fact, contains about two hundred and seventy drawings by Michelangelo and Raphael, acquired in the mid 19th century from the collection of the painter Sir Thomas Lawrence. And indeed these drawings by the two greatest artists of the central Italian school of the 16th century constitute the largest such holding in the world.

The formation of the collection through donations began in 1834 with the bequest of Francis Douce, the famous scholar of antiquity and Curator of Manuscripts at the British Museum. At first, however, the Douce drawings went to the Bodleian Library, together with the manuscripts and books from the same bequest, and were transferred to the Ashmolean Museum only in 1863. The Douce collection was important above all for the works by

42

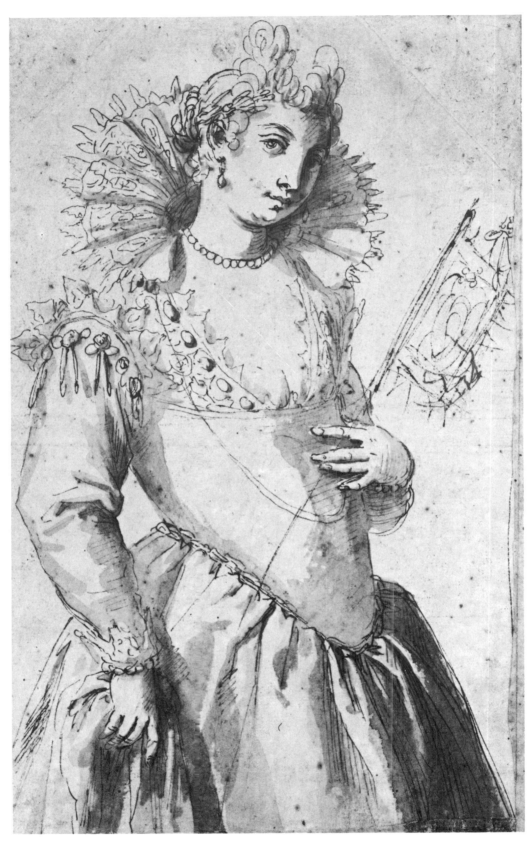

29. Palma Giovane. *Venetian Lady*. Pen and brown ink, with ink wash. 237 x 150 mm. Ashmolean Museum.

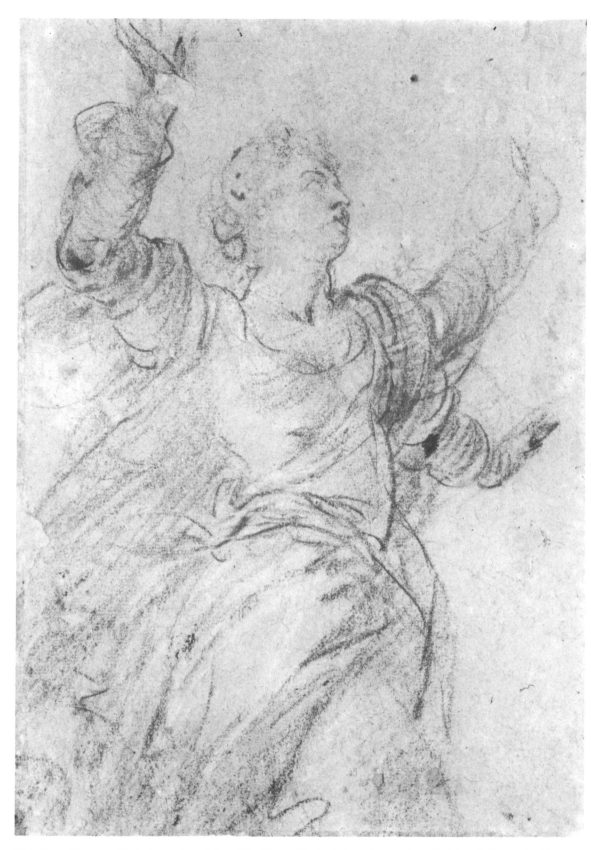

30. Palma Giovane. *Study for an Assumption of the Virgin*. Black chalk, with touches of white chalk, on bluish-grey paper. 326 x 227 mm. Inv. 424. Ashmolean Museum.

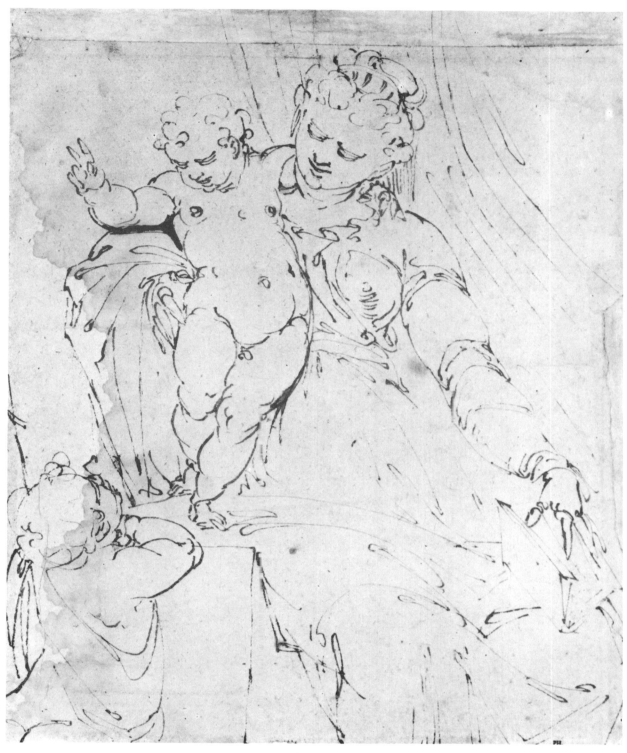

31. Luca Cambiaso. *Madonna and Child with Saint John.* Pen and brown ink. 338 x 287 mm. Inv. 1221. Christ Church.

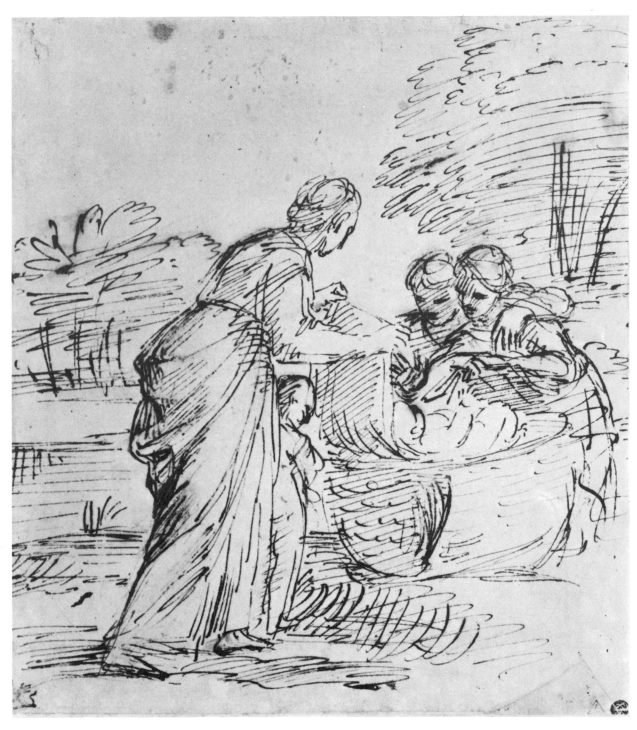

32. Domenichino. *The Finding of Moses*. Pen and brown ink. 205 x 182 mm. Inv. 839. Ashmolean Museum.

German primitives and Dutch and Flemish masters. Nonetheless, it also included a notable number of Italian drawings, especially primitives. Indeed, the Ashmolean drawings by Pisanello, Filippo Lippi, and Carpaccio come from the Douce bequest. What guided Francis Douce in the formation of his collection must have been a decided interest in early works, which was in keeping with the widespread taste of his time for 'primitives'. This explains not only his preference for the northern schools, but also his choice among the Italians of artists of the 15th century.

The second important bequest of drawings to the Ashmolean Museum came in 1855 from the collector Chambers Hall, a noted connoisseur and landscape painter. With a decided taste for landscape, Hall followed that great English tradition of artists who collected drawings, among them Richardson, Peter Lely, Reynolds, and Lawrence. He collected stupendous examples of the works of Claude Lorraine and Richard Wilson, and showed a singularly intelligent appreciation of Francesco Guardi and Canaletto, who at that moment, certainly, did not enjoy great fame. The schools of the Low Countries were represented in his collection by works of Rembrandt and Rubens, along with those of Dürer. The Chambers Hall collection did not give great weight to the Italians and only a few Italian works in the Ashmolean derive from this source. Some of these, however, are of outstanding importance, such as a few works by Raphael and those attributed to Leonardo, Correggio, and Sodoma.

The great moment of expansion of the Ashmolean's Italian collection, however, came not with a bequest but with an extraordinary purchase. And here we must recount, at least summarily, the long and chequered tale of the acquisition of the collection of Sir Thomas Lawrence (25). The great early 19th-century painter and portraitist of aristocratic society was also a collector and dedicated his entire life and means to the amassing of a collection of drawings vast in range, including not only all the Italians, but artists of other schools as well. To form his collection he apparently spent £40,000. This vast sum may seem exaggerated, but is perhaps explained if, as recorded, in order to acquire a single Raphael drawing he sometimes bought an entire lot containing a great many other items, thus having to pay an exorbitant price. His principal agent was Samuel Woodburn, who at Lawrence's death in 1830 was the only person in a position to dispose of the entire collection.

Lawrence, who attached the greatest importance to this collection, specifically stated in his will that it should not be dismembered, but should be sold in block for £18,000 pounds, which was far less than he had paid to acquire it. He even listed four preferred destinations. These were, in order of preference: the reigning sovereign, George IV, the British Museum, and two famous collector friends, Sir Robert Peel and Lord Dudley. At that time, George IV was approaching the end of his life and the moment was hardly propitious for attracting his interest in the offer. As for the British Museum, the director was not in favour of this type of acquisition and, in any case, from the documents it appears that there was never any possibility of the British Museum's requesting and obtaining from the Treasury the sum of £18,000 for the acquisition of a collection, no matter how marvellous. Equally negative,

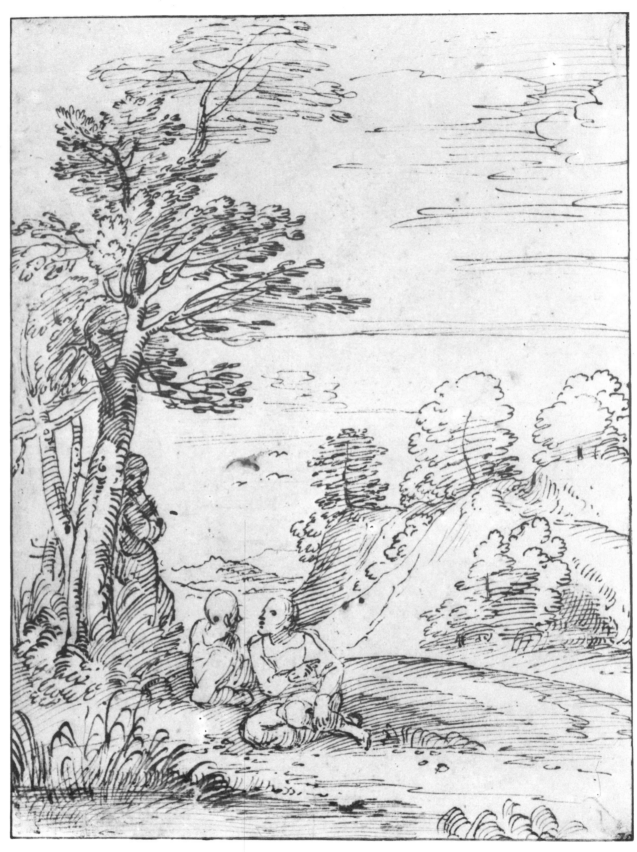

33. Annibale Carracci. *Pastoral Landscape*. Pen and brown ink. 244 x 183 mm. Inv. 165. Ashmolean Museum.

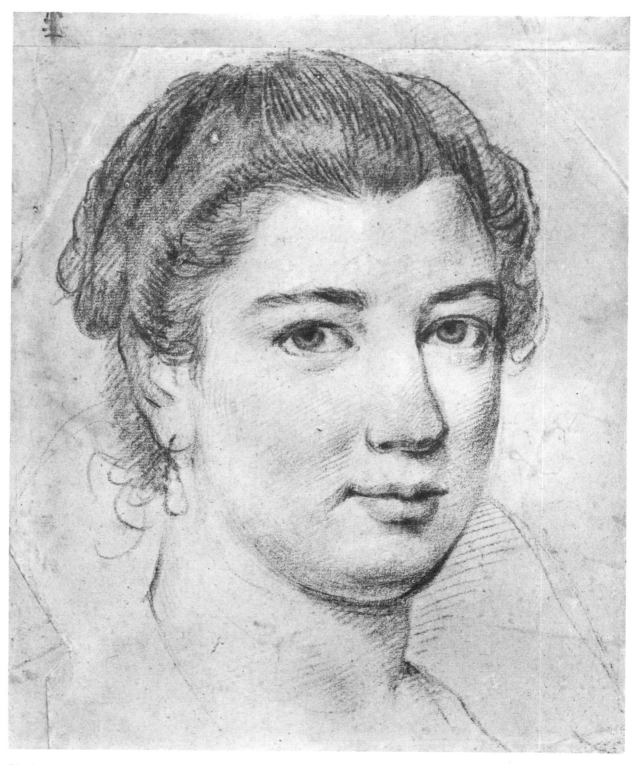

34. Agostino Carracci. *Portrait of a Lady*. Black and red chalk, with touches of white chalk. 272 x 228 mm. Inv. 144.
Ashmolean Museum.

unfortunately, was the response of Sir Robert Peel and Lord Dudley, the two friends on whom Lawrence had counted.

Thus, strange as it seems, Lawrence's plan of assuring a public destination for his collection failed completely. His will stated that, if in two years time it was not possible to sell the collection according to the above mentioned conditions, it should be sold at public auction, either as a whole or in parts, at the discretion of the executor.

This was the starting point for perhaps the most extraordinary sequence of events ever to befall an art collection. The fate of the Lawrence collection at once aroused enormous interest in the English art world, which was intent upon respecting the painter's wish that his collection should not be dispersed. The Royal Academy was the first to come forward in a rescue attempt and appropriated £1,000 towards the acquisition of the collection in its entirety, on the condition that in the meantime the drawings be made accessible to the public. Unfortunately, this generous offer was invalidated for legal reasons. The Royal Academy could appropriate money only to acquire for itself a particular work or collection and it was obvious that it would never succeed in raising the sum of £18,000. Despite its failure, the Royal Academy's initiative was instrumental in bringing strong pressure to bear on the Government from all cultural circles. The greatest collectors and museum men of the time, among them Charles Eastlake, the Director of the National Gallery, appealed to the Chancellor of the Exchequer to appropriate the total sum, which was hardly excessive for the acquisition of this extraordinary collection. The Government did appoint commissions to ascertain the value of the Lawrence collection and received the most encouraging judgements. Nevertheless nothing was done. In 1834 the last of these commissions declared the asking price to be at least fifty percent lower than the actual value. At this time one of the commissioners, the famous French collector Prince Talleyrand, wrote to the Government: 'Si vous n'achetez pas ces choses-là, vous êtes des barbares''. But neither pressures nor accusations succeeded in moving the Government. This was certainly due also to the economic and social situation in the 1830s. With the growth of the industrial revolution England found itself in an uncertain and unstable economic situation and, moreover, the country was plagued by the fear of popular revolts, of upheavals that might be violent. Reverberations of this fear even affected the fate of the Lawrence collection. In a document relating to these negotiations, the acquisition of such a collection of art was stated to be inadvisable at a time when it could so easily be destroyed 'at the hands of a skilfully-incited mob'. Towards the middle of 1834 the executor of Lawrence's will, Archibald Keightley, decided that he had already waited too long and began to take steps to sell the collection. The buyer was the same Samuel Woodburn who had been the principal agent in acquiring the drawings in Lawrence's own time. Woodburn paid about £16,000 pounds, but the actual price was lower because that amount covered a series of unpaid debts Lawrence had incurred when he originally acquired his drawings. Samuel Woodburn, a man of very unusual personality, was to play an absolutely essential role in this whole affair. Although a professional art dealer, who with his brother directed a very active and highly respected company, in the affair of the Lawrence drawings

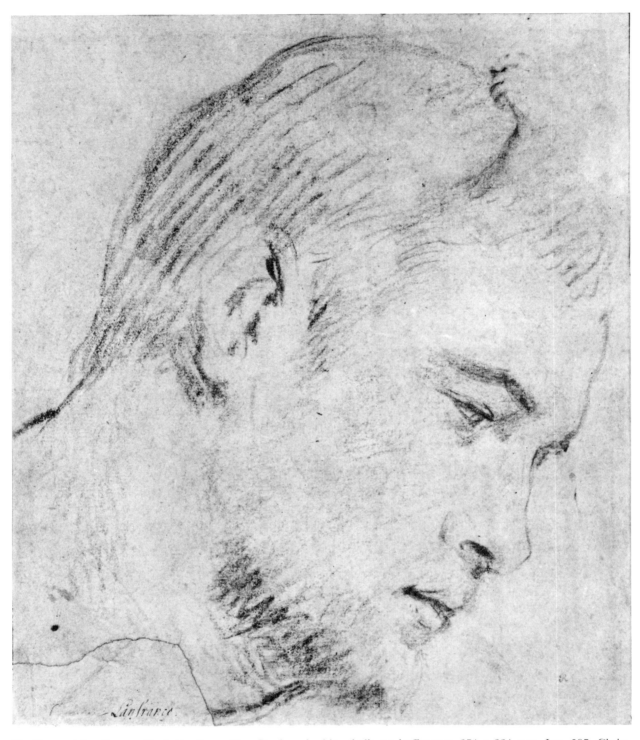

35. Giovanni Lanfranco. *Head of a Young Man*. Black and white chalk, on buff paper. 274 x 234 mm. Inv. 597. Christ Church.

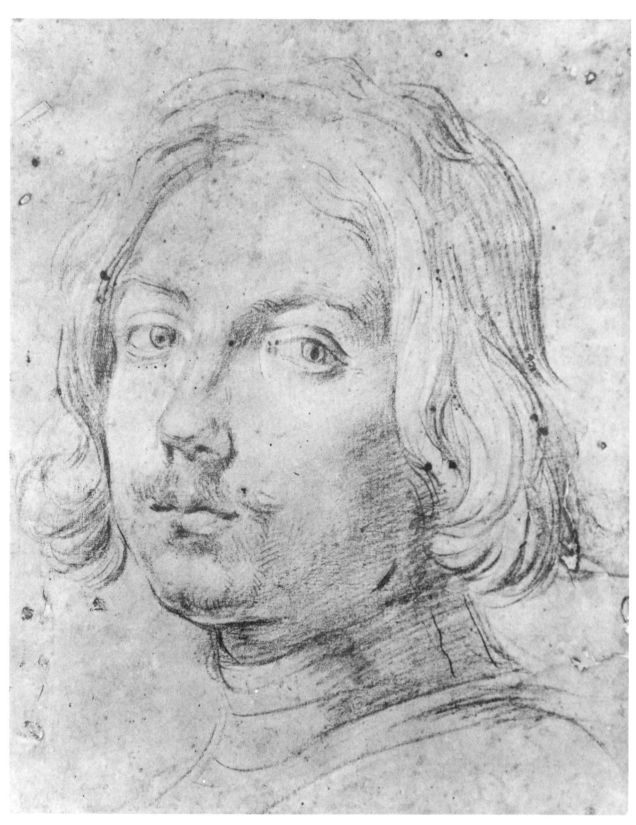

36. Guido Reni. *Head of Saint Proculus*. Black, red, and white chalk. 338 x 260 mm. Inv. 966. Christ Church.

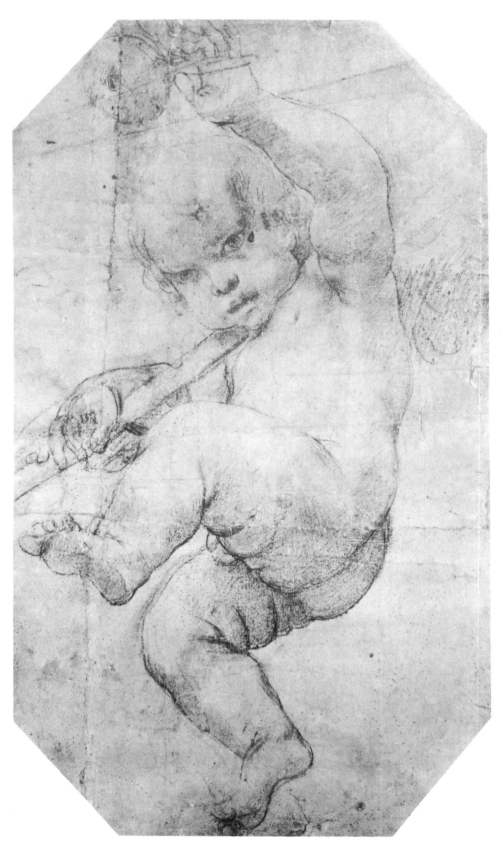

37. Domenichino. *Putto*. Black chalk. 770 x 447 mm. Inv. 983. Christ Church.

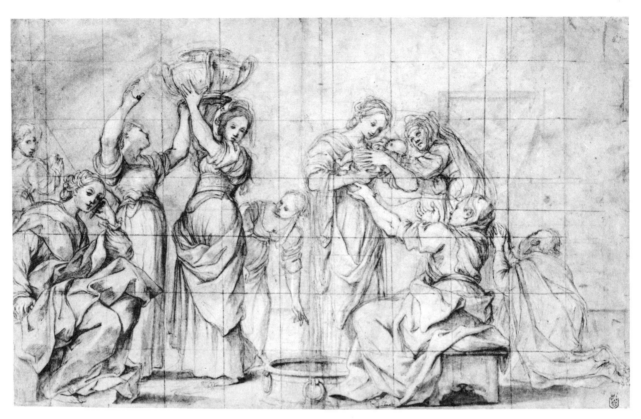

38. Lodovico Carracci. *The Birth of Saint John the Baptist.*

Woodburn most certainly assumed a disinterested position. He persistently sought to respect the wishes of his deceased friend and to make these artistic treasures available to the public, and he tried in every way possible to keep the collection from dispersal.

In fact, as soon as he came into possession of the drawings he reopened negotiations with the Government for a sale *en bloc.* From 1834 to 1836, amidst pressures from various sources, poor Woodburn had nothing but promises, hopes and disappointments, until he had to recognize that no possibility remained of an acquisition on the part of the State. He then thought of trying to sell at least the best part of the collection to a museum. With this goal in mind he thought it useful to make the drawings known through exhibitions. Thus in 1835 and 1836 he organized small shows of about a hundred items each, selected from among the most important works of the collection. The first show was devoted entirely to Rubens, the second to Rembrandt and Van Dyck, and the third to Claude Lorraine and Poussin. The exhibitions were naturally a great success, but no buyer presented himself immediately, although shortly thereafter the Rembrandt and Claude drawings were to be acquired by William Esdaile. The most important part of the Lawrence collection was, of course, the two hundred and seventy drawings by Michelangelo and Raphael. Having completely lost

54

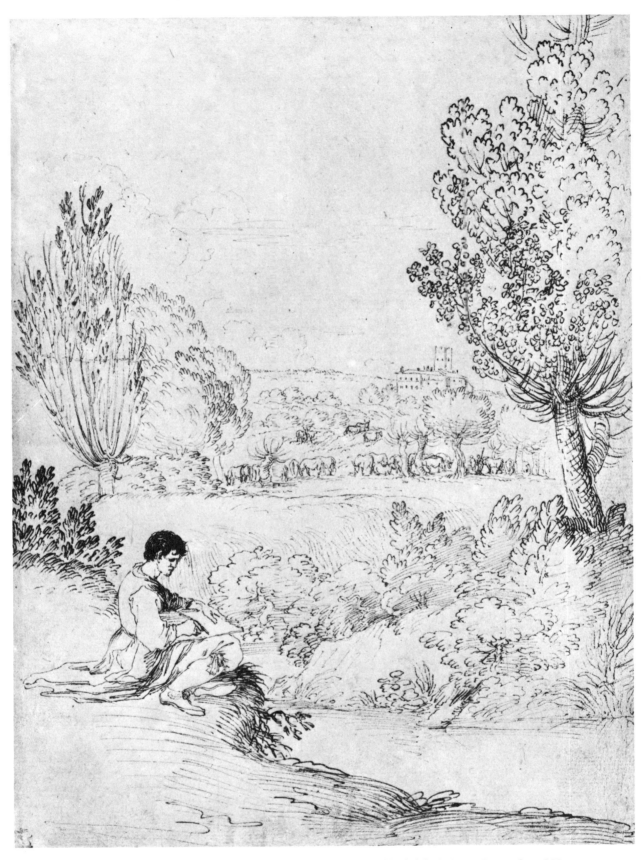

39. Giovanni Francesco Grimaldi. *Landscape with Artist Sketching*. Pen and black ink. 289 x 215 mm. Inv. 851. Ashmolean Museum.

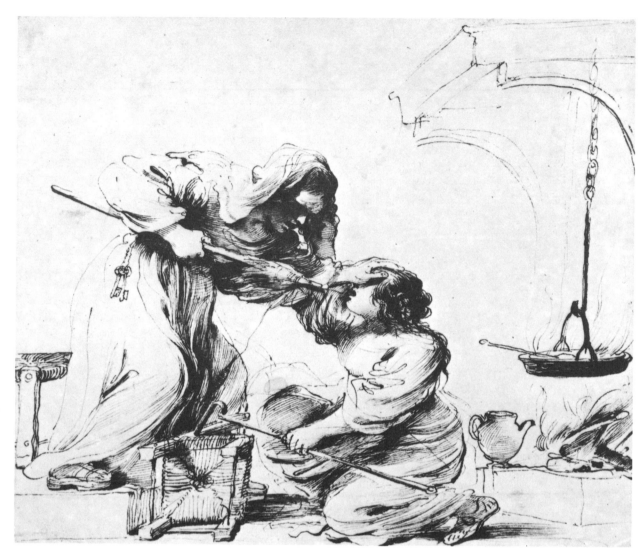

40. Guercino. *Two Women Fighting*. Pen and brown ink, with ink wash. 238 x 277 mm. Inv. 868. Ashmolean Museum.

hope of a block sale, it was upon this group that Woodburn now concentrated his attention. The last of the ten exhibitions he organized was devoted to the works of these two great masters. But as no buyer came forward Woodburn again began to urge the Government to acquire at least the Michelangelo and Raphael drawings, to go either to Oxford or the British Museum. In the meantime, however, the Prince of Orange, destined to become King William II of Holland, arrived on the scene and bought some fifty of the Raphael and Michelangelo drawings. Fortunately, this dispersal of the original group of sheets by the two great masters eventually proved not so disastrous. Woodburn, in fact, managed to buy a series of Raphael and Michelangelo drawings from the Harman collection in Holland and

56

41. Guercino. *Swooning Woman.* Pen and brown ink. 188 x 156 mm. Inv. 997. Christ Church.

42. Bartolomeo Schedoni. *Madonna and Child with Saints*. Black and white chalk, on greyish paper. 182 x 182 mm. Inv. 697. Ashmolean Museum.

thus in part made up for the loss. And later, when the collection of King William II of Holland was sold, many of the drawings returned to England, some of them to Oxford, where they were reunited with Lawrence's original collection.

Meanwhile, in 1838, negotiations with the Government were finally broken off and it appeared that any hope for the acquisition of the remaining drawings of the two great masters had now vanished. But unexpectedly, in 1841, a new initiative was launched

43. Simone Cantarini. *Madonna and Child*. Red chalk. 272 x 210 mm. Inv. 1016. Christ Church.

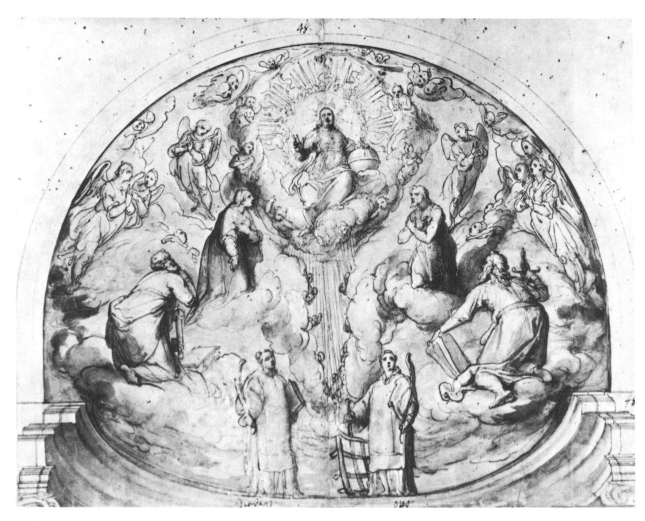

44. Giovanni de Vecchi. *Design for an Apse Decoration*. Pen and brown ink, with ink and watercolour washes. 387 x 490 mm. Inv. 558. Christ Church.

by a group of important people at Oxford. The real force behind this renewed interest in the remaining Michelangelo and Raphael drawings (more than two hundred from the Lawrence collection were still in Woodburn's hands) was a most unusual individual, the Rev. Dr. Henry Wellesley. As the natural son, by a French woman, of the Marquis of Wellesley he was closely related to the Duke of Wellington, and thus had access to the most exclusive circles. Wellesley was a man of great refinement and culture and himself a collector. He had studied at Oxford and had then taken Holy Orders. After a period spent in country parishes, he returned to Oxford in 1842 as Vice Principal of New Inn Hall and in 1847 became Principal of the College. An accomplished scholar, versed in both classical and modern literature, Wellesley had an outstanding reputation in university circles. He had earlier played a part in the affair of the Lawrence drawings as an expert at the first valuation of the Michelangelo and Raphael works, when the Prince of Orange had come

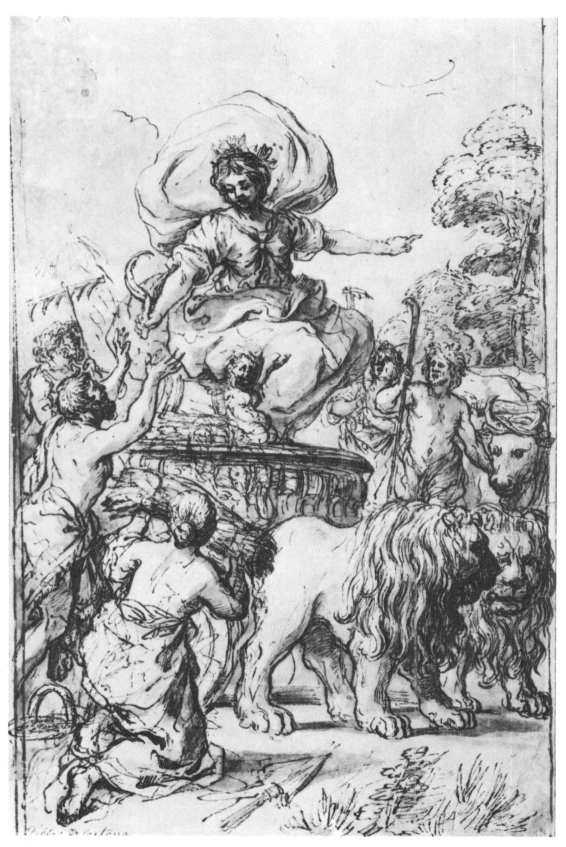

45. Pietro da Cortona. *The Triumph of Ceres*. Pen and black ink, with grey wash. 351 x 228 mm. Inv. 846.
Ashmolean Museum.

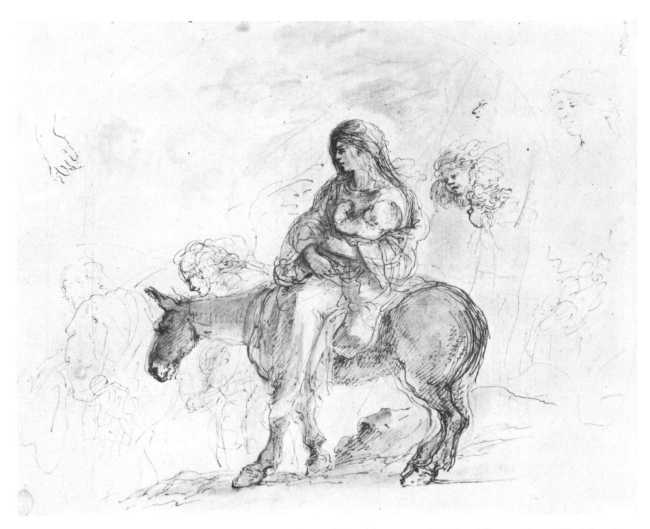

46. Stefano della Bella. *The Flight into Egypt*. Pen and brown ink, with grey wash. 190 x 238 mm. Inv. 788. Ashmolean Museum.

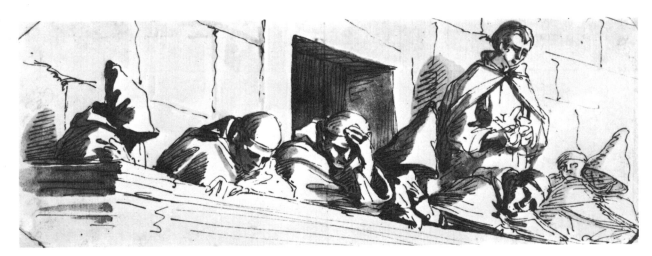

47. Pier Francesco Mola. *Monks on a Balcony*. Pen and brown ink, with ink wash. 98 x 264 mm. Inv. 911. Ashmolean Museum.

62

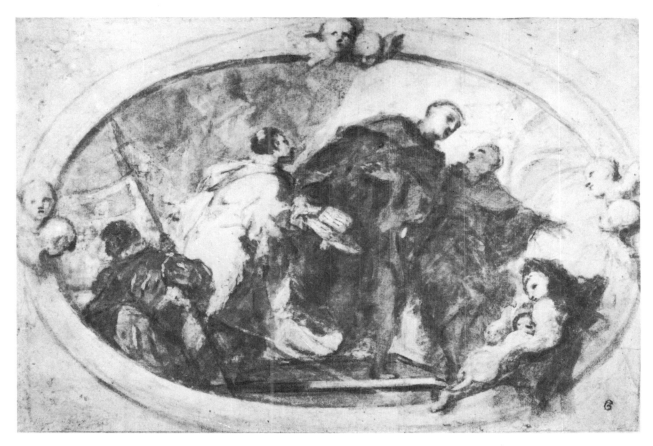

48. Francesco Maffei. *Design for an Oval Ceiling Decoration with Saints*. Brush with dark-brown and reddish wash, heightened with white, on greyish paper. 295 x 444 mm. Inv. 896. Ashmolean Museum.

forward as a buyer of at least a part of the group. At that time Wellesley had not only approved the sum of £20,000 requested by Woodburn, but had declared the drawings to be worth much more.

When negotiations were interrupted between Woodburn and the Government, Wellesley conceived a project to acquire the drawings for Oxford University. At that time the building of the Taylor Institution, destined to house the Ashmolean Museum, was under construction and the drawings could thus be assured a magnificent display, but first the financial means had to be found for this acquisition. To this end Wellesley had from the start thought of a public subscription and he now contacted the foremost personalities of Oxford to interest them in the formation of an official committee that could appeal for subscriptions. In the meantime Woodburn had reduced the price of the Raphael and Michelangelo drawings to £10,000 and this was the sum the committee aimed to raise. Wellesley found strong support in the Principal of New Inn Hall, John Anthony Cramer, Regius Professor of Modern History and a personality of great authority in the academic world. Another outstanding figure extremely active in this initiative for a public

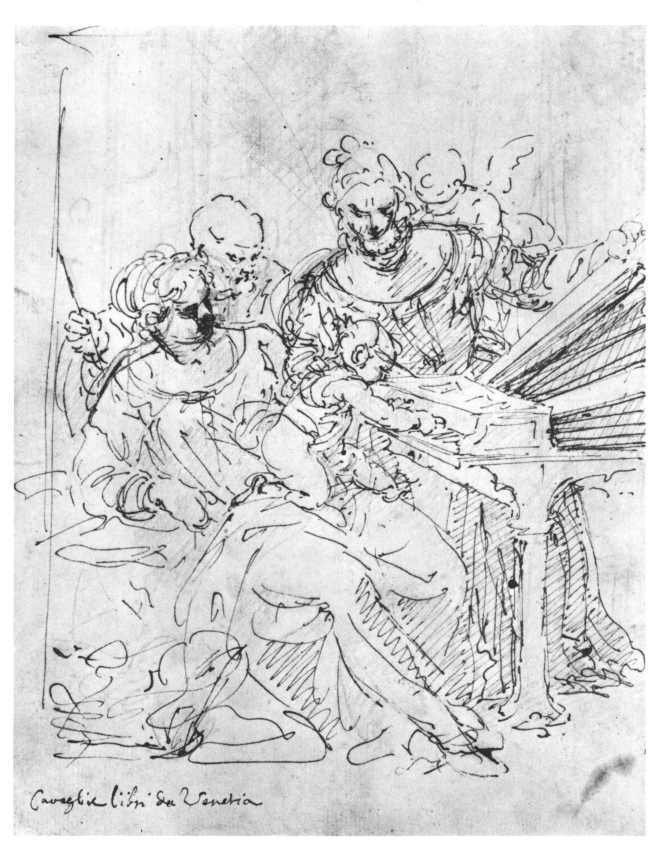

Cavaglia libri da Venetia

49. Pietro Liberi. *The Holy Family with Saint Cecilia*. Pen and black ink. 182 x 141 mm. Inv. 894. Ashmolean Museum.

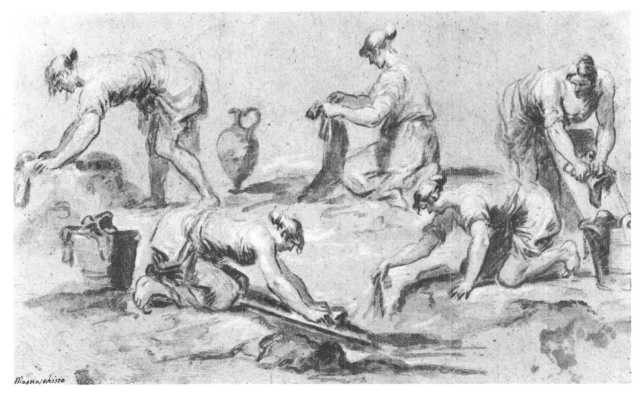

50. Alessandro Magnasco. *Studies of Washerwomen at Work*. Brush and brown wash, heightened with white, on buff paper. 168 x 278 mm. Inv. 1025. Ashmolean Museum

subscription was Dr. Philip Bliss, who was soon to become the Principal of Saint Mary's Hall. But the subscription proved difficult from the very beginning. This was due mainly to the fact that the drawings had to be bought from the same man who had sold them to Lawrence and then reacquired them. The objection can almost be called a psychological one, but it undoubtedly complicated the public response to Wellesley's generous initiative.

In any case, after numerous encounters with Government representatives, who declined to help, and after continual pressure on the academic authorities, who proved rather difficult, the subscription finally got under way and raised about £3,000. Meanwhile Woodburn, increasingly eager to conclude the affair, was pressing very hard. By now he saw himself not only cheated of any profit but even faced with an enormous loss for having been faithful to his idea of establishing the collection at Oxford. In one of his last letters, written in 1842, he threatened to pack up the drawings and take them for sale abroad. He concluded his letter by again stating his price of £10,000 and claiming that he could absolutely not reduce it further. The subscription fund still lacking £7,000, the difference was too great to arrive at any compromise. But by great good fortune, in June of this same year 1842, quite unexpectedly an incredibly generous offer of £3,000 was made to the fund. The remarkable benefactor was the Earl of Eldon, who had studied at New College, and who not only knew the

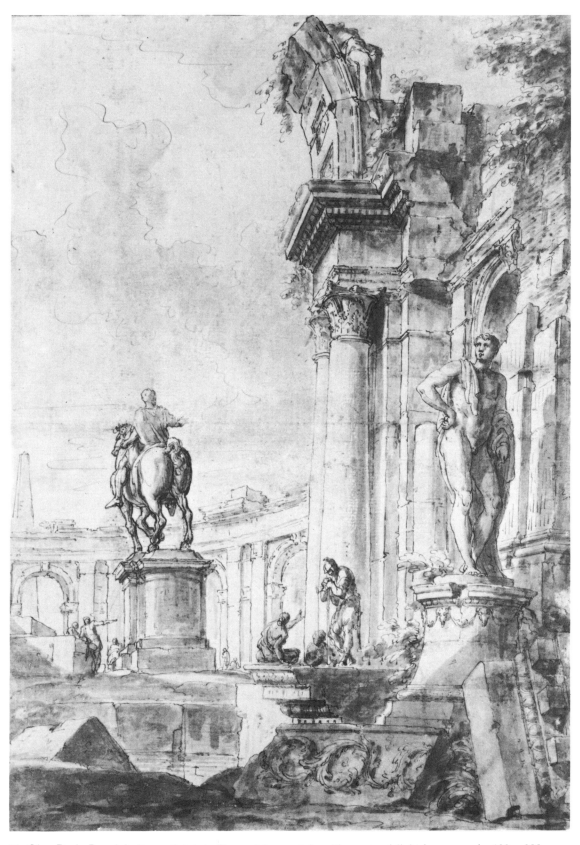

51. Gian Paolo Pannini. *Roman Capriccio*. Pen and brown ink, with grey and light-brown wash. 432 x 298 mm. Inv. 1031. Ashmolean Museum.

importance of the collection but also appreciated the liberal spirit of Lawrence and Woodburn's constancy in offering the drawings to Oxford. At this point Woodburn was so touched that he reduced the price to £7,000. With this gesture the goal was now very near and the Earl of Eldon himself completed the sum by increasing his offer to £4,000. The Michelangelo and Raphael drawings were thus finally purchased from Woodburn. They became the property of Oxford University and entered the Ashmolean Museum, where they constituted the basis of the graphic collection then in course of formation.

We must now, at least summarily, examine the content and quality of the Michelangelo and Raphael drawings. Almost all the ninety-eight Michelangelo drawings in the Ashmolean Museum come from the Lawrence collection, and form a consistent group of exceptionally high quality. Twenty-five of them are today classified as contemporary copies, but even these are of great importance since they reproduce drawings, paintings, or sculptures by the artist. Seven are classified as by followers. The group as a whole perhaps derives its greatest importance from the variety of the master's periods it covers and the diversity of techniques and particular phases of development of his graphic art it reveals. Indeed, for these reasons, the Michelangelo drawings of the Ashmolean Museum can easily take their place alongside the three major such collections in the world, those of the Casa Buonarroti in Florence, at Windsor, and in Haarlem.

To obtain some idea of the works contained in this group we may follow Parker's catalogue of 1956, examining the sheets according to the chronology of the artist's activity. From his earliest period and from his first stay in Rome, where he arrived in 1496 and completed, among other works, his famous *Pietà*, the Ashmolean collection actually has no drawings. The earliest works of the Ashmolean come from the master's second Florentine period, between 1501 and 1505. Returned from Rome to Florence in 1501, Michelangelo began the *David* and designed the famous fresco of the *Battle of Cascina*. The *David* was finished in 1504, but the fresco project was unfortunately abandoned and the work essentially lost to posterity. The preparation of the cartoon, however, required numerous drawings. To this second Florentine period also belongs the drawing of the *Madonna and Child and Saint Anne* which also contains some sketches related to the *David* (no. 291, fig. 13). For the cartoon of the *Battle of Cascina*, which is dated by the most recent students to about 1505, the Ashmolean has two drawings: one with studies of a horse and a sketch of horsemen attacking foot soldiers, exactly as happened at the battle of Cascina (no. 293, fig. 12), and the other an overall sketch of the battle (no. 294). Because of the disappearance of the fresco, these sketches are obviously of extreme importance.

In 1505 Michelangelo was called back to Rome to begin the fateful *Tomb of Julius II*. After a series of initial difficulties and disputes with the pope, work was quickly begun. The project, however, was to be repeatedly modified, until the year 1545 when, long after the pope's death, an unfortunate and completely different version was finally put together. It was also in this second Roman period that Michelangelo undertook the fresco decoration of the *Sistine Ceiling*, which was begun in 1508 and completely finished and inaugurated in

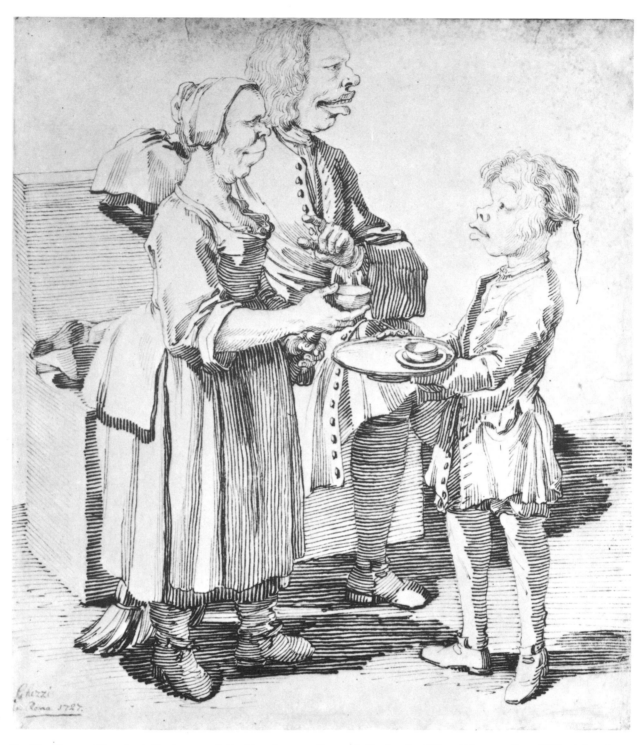

52. Pier Leone Ghezzi. *A Gentleman and his Two Servants*. Pen and black ink. 298 x 261 mm. Inv. 1003. Ashmolean Museum.

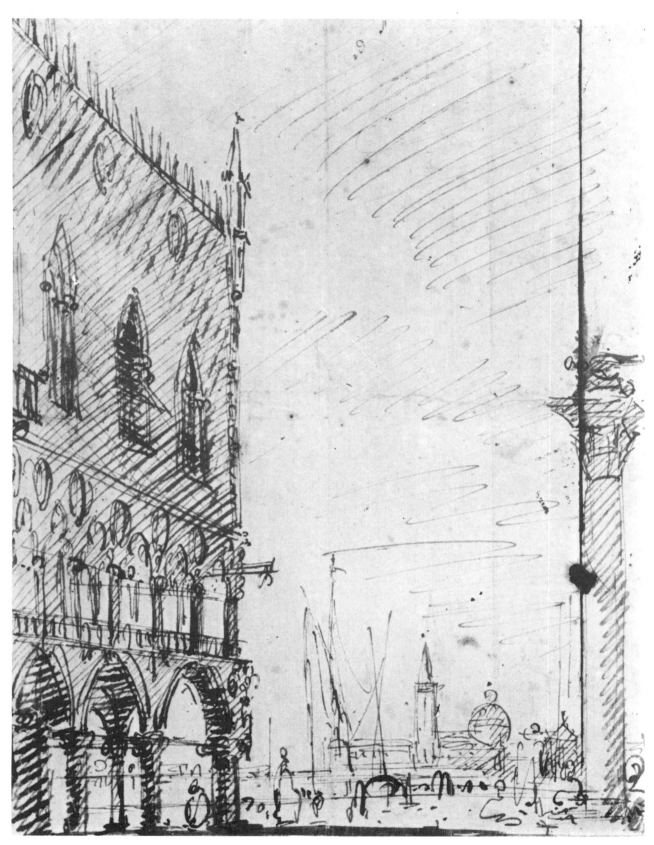

53. Canaletto. *View of the Doge's Palace*. Pen and brown ink. 225 x 176 mm. Inv. 976. Ashmolean Museum.

1512. The Ashmolean collection contains some drawings for the ceiling frescoes, among them one of great importance for the Libyan Sibyl (no. 297). This same sheet has also six small sketches for the *Slaves* that were carried out in sculpture for the tomb of Julius II, two of which are today in the Louvre and four in the Accademia in Florence. The sketches of this sheet have been identified by critics, at least in part, as specifically related to the Louvre sculptures. Also from the period of the Sistine chapel frescoes the Ashmolean possesses a sketchbook of eight pages, later remounted (nos. 299–306), containing small, very detailed sketches of numerous subjects from the lunettes of the Sistine ceiling, one of the last parts of the decoration to be executed by Michelangelo. Doubt has been cast upon this sketchbook by some critics, especially Berenson, but today it is generally considered authentic, not only for the exceptional subtlety of the drawing itself but also for the numerous variations between the sketches and the finished frescoes. As Parker and others have suggested, this sketchbook was probably used by Michelangelo during the final stage of the painting of the lunettes and in these sketches he partly followed what had already been transferred from the cartoon, and partly invented – hence the variations – new compositional ideas.

In 1516 Michelangelo returned to Florence, sent by the new pope, Leo X, to complete the façade of the church of San Lorenzo. After various vicissitudes, with the nomination of the new pope, Clement VII, in 1523, Michelangelo was again feverishly at work. In this third Florentine period, from 1516 to 1534, he was employed mainly on the Medici chapel. It is clear that at first, in addition to the tombs of the two condottieri of the Medici family, Giuliano and Lorenzo, Michelangelo thought of including in the chapel also the tombs of the two popes who had commissioned the work, Leo X and Clement VII. This is proved by an eminently important drawing in the Ashmolean collection (no. 308), which shows the plans and elevations of the tombs, datable to the moment of their invention in 1525–26. Another almost contemporary sheet (no. 307) shows more detailed sketches of the tomb of Lorenzo or Giuliano. Still others, for example drawings 309 and 310, contain sketches probably for the famous subsidiary figures of the tombs, the personifications of *Night* and *Day*.

This third Florentine period ended with the completion of work on the Medici tombs and was followed, after 1535, by a third Roman period, marking Michelangelo's definitive return to Rome, where he was employed in the Vatican by the new pope, Paul III. Between 1535 and 1541 he worked on the *Last Judgement* in the Sistine chapel, a work planned earlier by Clement VII. Beginning in 1542, again for Paul III, he undertook the decoration of the Pauline chapel. The Ashmolean collection contains numerous drawings related to the *Last Judgement*, such as the drawing with an impressive figure of a man rising from the tomb (no. 330), and for the Pauline chapel also there are various drawings, including one of numerous soldiers (no. 331).

In the next decade, 1550–60, Michelangelo turned to the completion of the dome of Saint Peter's and to his final works, the Pietàs and Crucifixions. Some of his Crucifixions are related to that poetic and relatively serene period, which lasted up to 1547, when

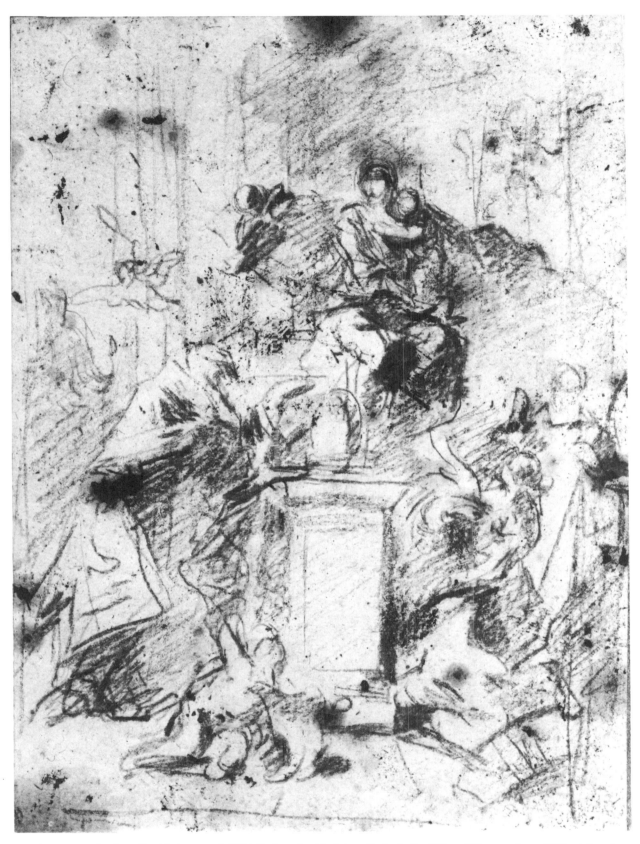

54. Gian Antonio Guardi. *Madonna and Child Enthroned with Saints*. Red chalk. 223 x 168 mm. Inv. 1007. Ashmolean
Museum.

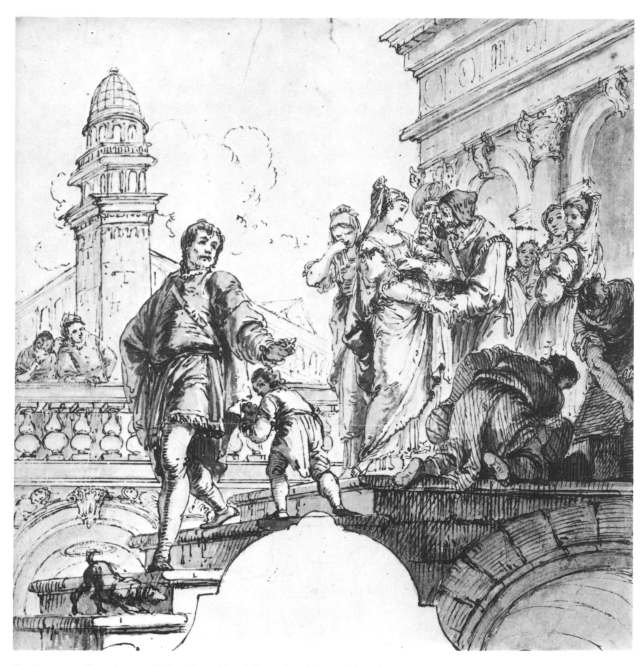

55. Francesco Fontebasso. *Design for a Mural Decoration.* Pen and black ink, with watercolour washes. 255 x 252 mm.
Inv. 996. Ashmolean Museum.

Michelangelo was deeply in love with Vittoria Colonna. Numerous drawings and a great many of his poems refer to this relationship, including also some of his drawings in the Ashmolean collection. Of the lantern of Saint Peter's, which completed the dome Michelangelo designed in several different versions, there is a very interesting drawing (no. 344) showing the design according to one of the four models Michelangelo made for the dome. It is interesting that this drawing in the Ashmolean, which shows the lantern in almost the form in which it was eventually constructed, bears an inscription addressed to the banker Francesco Bandini, in which Michelangelo seems to say that he is still not satisfied with the models presented up to now: 'mi pare che col cardinale si sia facto una figura senza capo' is the phrase written in the artist's hand at the bottom of the sheet. The Ashmolean collection includes some marvellously expressive and extremely important drawings from Michelangelo's late period. Drawing 343 of a 'Crucifixion' is one of a group of late representations of this subject, which, particularly on the basis of references to Michelangelo's poetry, are generally dated to 1554. This Oxford example is indubitably one of the most evocative of the group and bears the artist's authentic signature. Finally, we may cite the remarkably significant drawing for the *Pietà* which Michelangelo carved for the Palazzo Sanseverino-Vimercati in Rome, later Palazzo Rondanini, and which is today in the Museum of Castello Sforzesco in Milan. This drawing (no. 339) is related to the only partially begun sculpture, on which, amidst tragic difficulties, Michelangelo worked at different times in the last years of his life, and which is usually dated between 1550 and 1556.

The Raphael drawings in the Ashmolean Museum, like those of Michelangelo, come from the Lawrence collection and total one hundred and eighty-four items. One hundred and two of these are today considered works from Raphael's hand. The other eighty-two include highly interesting drawings by his followers, copies from ancient sculptures, and copies from drawings, paintings, and tapestries. In fact, the Ashmolean collection of Raphael drawings can be considered the largest and most representative in existence.

As Parker has shown, this collection covers in detail all the various periods of Raphael's activity. From his pre-Florentine period, when Raphael's art was clearly influenced by Perugino and other Umbrian painters, the collection contains items related to his works for Città di Castello: drawing 501 is for the *Banner of the Trinità* and drawing 504 for the altarpiece of *Saint Nicholas of Tolentino*. It has frequently been debated whether the Ashmolean's fascinating portrait drawing (no. 515) is a self-portrait, or a portrait of Raphael by a very close follower. Today, however, the prevalent tendency is to consider this stupendous drawing an authentic work of the young Raphael. On the other hand, because of a series of physiognomic differences which have recently been pointed out, the hypothesis of a self-portrait must almost certainly be rejected. Also from the period preceding the artist's move to Florence is the very important drawing of three studies of a female head (no. 514) used in his *Marriage of the Virgin*, completed in 1504 and today in the Brera in Milan.

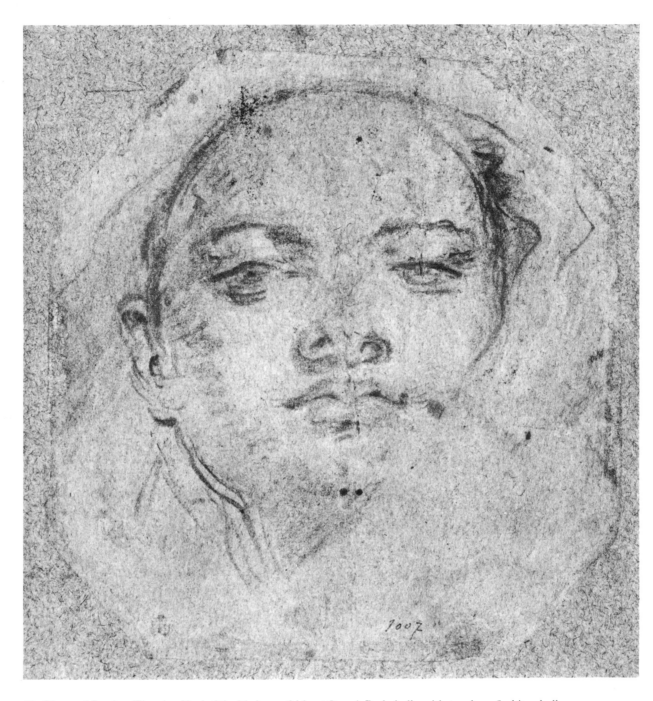

56. Giovanni Battista Tiepolo. *Head of the Madonna of Mount Carmel*. Red chalk, with touches of white chalk, on grey paper. 163 x 152 mm. Inv. 1078. Ashmolean Museum.

During the year 1504 Raphael arrived in Florence, where he stayed until 1508. The most significant and best known of his works from this period are the Madonnas. The Ashmolean collection contains drawings related to no fewer than four of the most important of these Florentine Madonnas. Drawings 516 and 517 are studies for the Madonna and Child with Saint John in the Uffizi, popularly known as the *Madonna del Cardellino* (pl. 18). Drawing number 518 contains studies for the Madonna and Child with Saint John in Vienna, known as the *Madonna of the Meadow*. Drawing 520 is an extremely interesting cartoon for the *Holy Family with the Lamb* in the Prado, from 1507. Finally, drawing 521 is a preparatory sketch for the Madonna and Child in the Louvre, called *La Belle Jardinière*. Also from this period is the so-called 'Large Florentine Sketchbook' consisting of sixteen drawings, which in the past have been doubted but are today almost unanimously considered from the master's hand. Many of these contain representations of warriors or nudes and are to be dated in the period between 1504 and 1508. In the year 1507 Raphael signed and dated the *Entombment* today in the Galleria Borghese in Rome. For this great work there exist some twenty drawings, of which four are in the Ashmolean collection (nos. 529–532).

Upon his arrival in Rome, in 1508 or very early in 1509, Raphael began work on the frescoes in the Vatican Stanze. The Stanza della Segnatura was completed during 1511. The Stanza d'Eliodoro followed immediately and was executed between 1511 and 1514. Numerous drawings of the collection relate to these two great undertakings. For the frescoes of the Stanza della Segnatura the Ashmolean contains: for the *Parnassus,* a drawing for Melpomene and Virgil (no. 541); for the *Disputa,* various drawings for the Christ in Glory and diverse heads of Apostles and other figures (nos. 542, 546, 547); for the *School of Athens,* the third fresco of this room, there are drawings of various philosophers and other personages (nos. 550, 551, 553). For the Stanza d'Eliodoro there is a cartoon for the horse and studies of figures in the *Expulsion of Heliodorus* (nos. 556, 557).

It was in all probability in about 1513 that Raphael began to prepare drawings for a *Resurrection.* But no painting of this subject is known and it is even possible that it was never begun. Nevertheless, numerous drawings exist for such a work. Drawings 558, 559 and 560 of the Ashmolean collection represent a portion of a composition for a Resurrection and studies of figures, including a recumbent soldier, all of whom could have formed part of it.

From the final years of Raphael's life, between 1514 and 1520, the Ashmolean contains numerous works. Drawing 562 is for the Phrygian Sibyl of Raphael's fresco decoration in Santa Maria della Pace in Rome, from the year 1514. For the mosaic decoration in the Chigi chapel of Santa Maria del Popolo, executed in 1516 on Raphael's design, drawing 566 is a study for God the Father in the centre of the dome. For Raphael's final work, the famous *Transfiguration* in the Vatican Gallery, a great number of preparatory drawings exist, scattered over various collections. The Ashmolean collection offers important graphic documentation of the *Transfiguration,* particularly in drawing 568, which is a study of the heads and hands of two Apostles. This sheet is actually an auxiliary cartoon, that is, a cartoon prepared, after the transfer of the general composition from the first cartoon, in order to delineate further individual details of the composition. As clearly demonstrated by

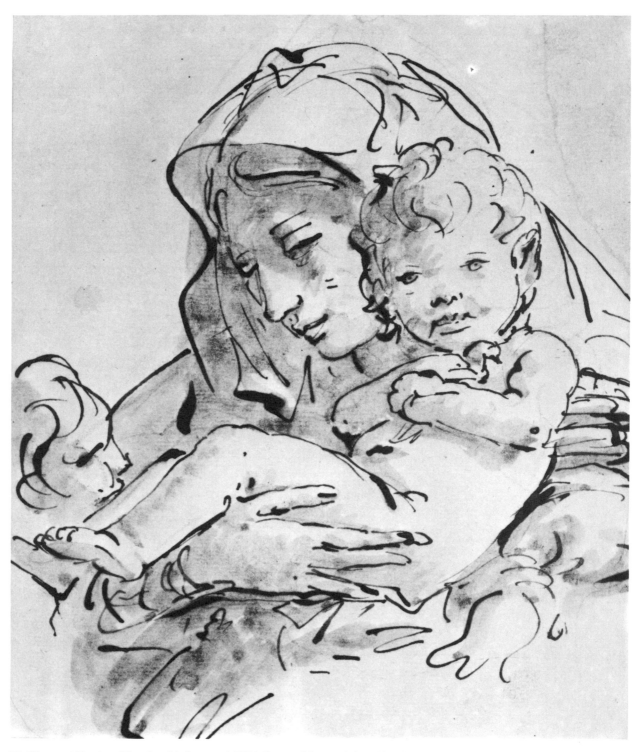

57. Giovanni Battista Tiepolo. *Madonna and Child*. Pen and brown ink, with ink wash. Ashmolean Museum.

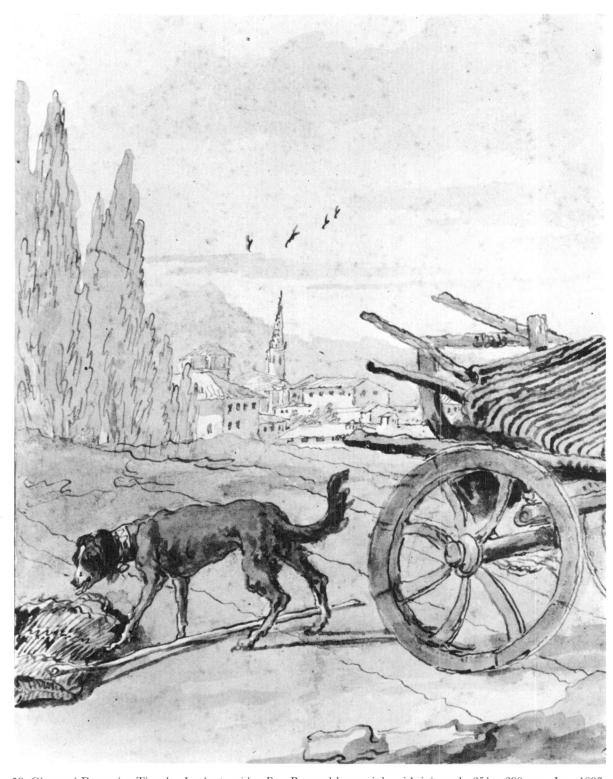

58. Giovanni Domenico Tiepolo. *Landscape wih a Dog*. Pen and brown ink, with ink wash. 351 x 290 mm. Inv. 1097. Ashmolean Museum.

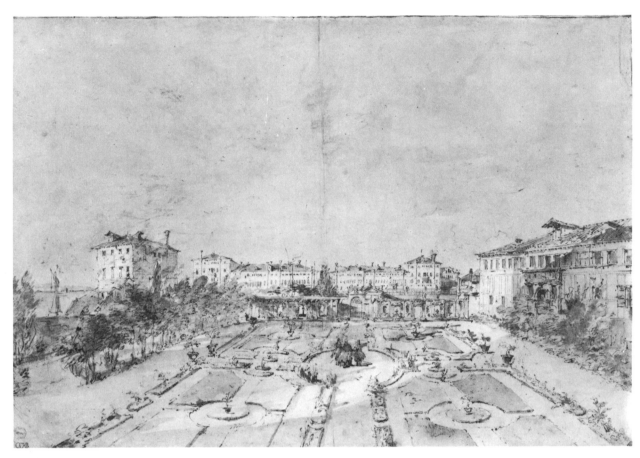

59. Francesco Guardi. *Garden of the Villa Contarini*. Pen and black ink, with ink wash. 355 x 510 mm. Inv. 1014. Ashmolean Museum.

the extremely accurate and subtle drawing of this Oxford sheet, such cartoons served to obtain greater perfection in the final painted work.

In addition to the hundred and two authentic Raphael drawings, the collection, as mentioned above, contains eighty-two sheets not from the hand of the master but nevertheless of extraordinary interest for their relation to extant or lost works by him, as well as for the information they provide concerning the graphic styles of Raphael's followers and collaborators.

After the sale of the Michelangelo and Raphael drawings Woodburn offered the subscription committee, for the modest sum of £1,500, another very important part of the Lawrence collection: the drawings by Parmigianino. Unfortunately, the offer was not accepted and the drawings finally went on sale and were dispersed. Immediately thereafter he offered another group of forty drawings, this time by the Carracci. Sad to say, these too were refused. They were bought by the Earl of Ellesmere in 1853, and some of them are today on deposit in the Leicester Art Gallery. In any case, in 1845 the Michelangelo and

78

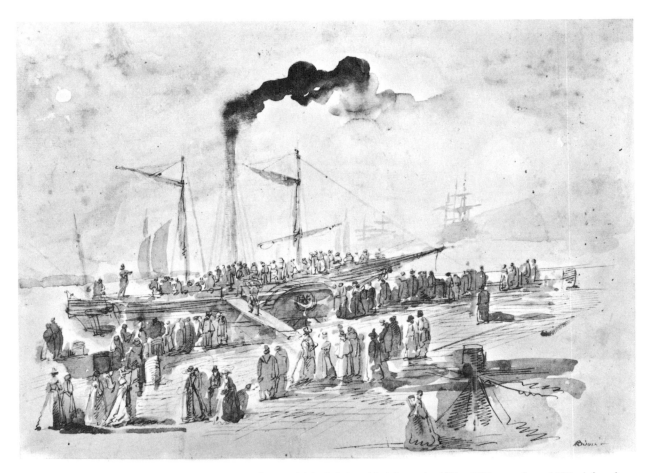

60. Giuseppe Bernardino Bison. *Harbour Scene*. Pen and black ink, with ink wash. 197 x 277 mm. Inv. 1107. Ashmolean Museum.

Raphael drawings had finally become the property of Oxford University, through the great merit and tenacity of Wellesley and the unexpected but decisive benefaction of Lord Eldon. In 1846 they were at last installed in the Ashmolean Museum.

This great victory of the supporters of the Lawrence collection very quickly had an effect at Oxford. The Oxford University Press transferred to the Ashmolean Museum the series of watercolours by Turner, De Wint, and others which were in their possession, having been used for the illustrations of the Oxford *Almanac*. A few years later the Earl of Ellesmere gave the Ashmolean some of the drawings by Lodovico, Annibale, and Agostino Carracci that he had acquired from the Lawrence collection. Following these donations, in 1855 the Museum received the already mentioned bequest of Chambers Hall, including the important items by Leonardo, Correggio, Raphael, Guardi, and Canaletto. Finally, in 1863, the drawings of the Francis Douce collection, bequeathed to the University as early as 1834, were transferred from the Bodleian Library to the Ashmolean Museum, enriching it in particular with works by the northern masters, but also with a goodly number of Italian drawings.

79

The present total of about 1100 drawings was not attained, however, until this century and, in fact, only within the last fifty years, largely through the efforts of the Keepers of the collection, in particular Sir Karl Parker. These recent acquisitions were of outstanding importance. The collection was doubled in number, and lacunae and shortages in various areas were remedied. The final result was a graphic panorama of extraordinary completeness. Parker organized numerous exhibitions of the Ashmolean collection, making it known everywhere. In addition, he published a complete catalogue. The volume covering the Italian school dates from 1956. Parker's catalogue, precise and very rich in information, is a work of great scholarship; at the same time, it displays the art of connoisseurship and testifies to the discriminating and exacting taste of its compiler. Another important exhibition of a selection of drawings was held in 1958 at the Cini Foundation in Venice (26). More recently, in 1970, seventy-five works from the Ashmolean were exhibited at the Wildenstein Gallery in New York (27). The catalogue of the latter exhibition was prepared by Denys Sutton and recounts in full the story of the Lawrence drawings and their acquisition for the Ashmolean Museum.

Notes

(1) J. Byam Shaw, *Drawings by Old Masters at Christ Church, Oxford,* Oxford 1976.

(2) Byam Shaw's above cited catalogue gives the complete history of the Christ Church collection, based on information contained in the College archives. I wish to thank him heartily for allowing me to consult his research material prior to its publication.

(3) J. Byam Shaw, *op. cit.,* 1976, p. 5.

(4) A. J. Dézailler d'Argenville, *Abrégé de la vie des plus fameux peintres,* Paris, 1745. The brief note on the collection of 'Colonel Guiche' seems to indicate that it was well known to foreign connoisseurs.

(5) J. Byam Shaw, *op. cit.,* 1976, Excursus, pt. 25–30 gives complete information on Guise's life and his university career (this latter part with the collaboration of J. F. A. Mason).

(6) F. Lugt, *Les marques de collections des dessins et d'estampes,* Amsterdam, 1921; *Supplément,* The Hague, 1956.

(7) Two drawings (nos. 33, 36) from Vasari's 'Book' have their original framings and are of Rawson-Gautier provenance. A third (no. 1221) was probably acquired from Dean Aldrich.

(8) These former Crozat drawings come from a sale of 1741 in Paris.

(9) Complete and ample information on the Ridolfi albums and family collection is given by J. Byam Shaw, *op. cit.,* 1976, p. 9 and Appendix, p. 401.

(10) On Baldinucci and his collections see: R. Bacou and J. Bean, *Dessins Florentins de la collection Baldinucci,* Paris, 1958.

(11) J. Byam Shaw, *op. cit.,* 1976, p. 12; A. E. Popham, 'Sebastiano Resta and his collections', *Old Master Drawings,* XI, June, 1936, pp. 1–15.

(12) On this unknown connoisseur, weak in spelling but strong in artistic matters, see: J. Byam Shaw, *op. cit.,* 1976, p. 15.

(13) The important figure of the librarian, Dr. Edward Smallwell, at Christ Church from 1757 to 1775, is discussed by J. Byam Shaw, *op. cit.,* 1976, p. 15 ff.

(14) Byam Shaw (*op. cit.,* 1976, p. 16) has identified the known handwriting of Zanetti on about 20 drawings. On Zanetti see: A. Bettagno, *Caricature dello Zanetti alla Fondazione Cini,* Venice, 1970; L. C. Frerichs, 'Mariette et les eaux-fortes des Tiepolo' in *Gazette des Beaux-Arts,* LXXVIII, 1971, pp. 233–252.

(15) On Cavalcaselle's visit there is a note on the back of drawing no. 1669, dated August 1856.

(16) J. C. Robinson, *A Critical Account of the Drawings of Michelangelo and Raphael in the University Galleries, Oxford,* Oxford, 1870.

(17) On this exhibition see: J. Byam Shaw, *op. cit.,* 1976, p. 2.

(18) Information on Prof. Powell's restoration work and cataloguing is given in J. Byam Shaw, *op. cit.,* 1976, p. 2, note 3.

(19) S. Colvin, *Drawings of the Old Masters in the University Galleries and in the Library of Christ Church, Oxford,* Oxford, 1903–1907.

(20) B. Berenson, *Drawings of the Florentine Painters*, 1st ed., London, 1903; O. Fischel, *Raphaels Zeichnungen, Versuch einer Kritik...*, Strasbourg, 1898; *Idem, Raphaels Zeichnungen*, Berlin, 1913–41.

(21) C. F. Bell, *Drawings by the Old Masters in the Library of Christ Church, Oxford*, Oxford, 1914.

(22) J. Byam Shaw, 'The Collection of Drawings at Christ Church, Oxford', *Master Drawings*, 1968, no. 3, pp. 235–240.

(23) J. Byam Shaw, *Old Master Drawings from Christ Church, Oxford*, Washington, 1972.

(24) K. T. Parker, *Catalogue of the Collection of Drawings of the Ashmolean Museum*, Oxford, vol. I, 1938, vol. II, 1956, containing complete information on the formation of the collection.

(25) A detailed account of the whole affair of the Michelangelo and Raphael drawings of the Lawrence collection and their acquisition for the Ashmolean is given in the exhibition catalogue by D. Sutton, *Drawings from the Ashmolean Museum, Oxford*, New York, 1970.

(26) K. T. Parker, *Disegni Veneti di Oxford*, Venice, 1958.

(27) D. Sutton, *op. cit.*, 1970.

Bibliography

BALLARIN, A., 'Introduzione a un Catalogo dei disegni di Jacopo Bassano, I', *Arte Veneta*, 1969, p. 85 ff.

BALLARIN, A., 'Considerazioni su una Mostra di disegni veronesi del Cinquecento', *Arte Veneta*, 1971, pp. 92–118.

BALLARIN, A., 'Introduzione a un Catalogo dei disegni di Jacopo Bassano, II', in *Studi di Storia dell'Arte in Onore di Antonio Morassi*, Venice, 1971, p. 148 ff.

BALLARIN, A., 'Introduzione a un Catalogo dei disegni di Jacopo Bassano, III', *Arte Veneta*, 1973, p. 91 ff.

BAUMGART, F., 'Die Jugendzeichnungen Michelangelos bis 1506', *Marburger Jahrbuch*, X, 1937, pp. 209–262.

BEAN, J. - STAMPFLE, F., *Drawings from New York Collections, II: The 17th Century*, New York 1967.

BEAN, J. - STAMPFLE, F., *Drawings from New York Collections, III: The 18th Century*, New York 1971.

BECKERATH, A. VON, 'Nochmals über einige Zeichnungen alter Meister in Oxford', *Repertorium für Kunstwissenschaft*, XXXI, 1908, pp. 108–114.

BELL, C. F., *Drawings of the Old Masters in the Library of Christ Church, Oxford*, Oxford 1914.

BELLORI, P., *Le vite de' Pittori, Scultori ed Architetti moderni*, Rome 1672.

BELTRAMI, L., *Luini, 1512–1532*, Milan 1911.

BERENSON, B., *Lorenzo Lotto. An essay in constructive art criticism*, London 1901.

BERENSON, B., *The Drawings of the Florentine Painters*, 1st ed., London 1903.

BERENSON, B., *The Drawings of the Florentine Painters*, 2nd ed., Chicago 1938.

BERENSON, B., *Italian Pictures of the Renaissance: Venetian School*, London 1957.

BERENSON, B., *I Disegni dei Pittori Fiorentini*, 3rd ed., Milan 1961.

BODMER, H., *Leonardo. Des Meisters Gemälde und Zeichnungen*, Stuttgart 1931.

BORENIUS, T., *The Painters of Vicenza*, London 1909.

BOSCHINI, M., *La carta del navegar pitoresco*, Venice 1660.

BOTTARI, S. - ROLI, R. - OTTANI CAVINA, A., *Guercino: Disegni*, Florence 1966.

BRANDI, C., *Catalogo, Mostra del Correggio*, Parma 1935.

BRIGANTI, G., *Pietro da Cortona o della pittura barocca*, Florence 1962.

BRINCKMANN, A. E., *Michelangelo: Zeichnungen*, Berlin 1925.

BRIQUET, C. M., *Les Filigranes. Dictionnaire historique des marques du papier dès leur apparition vers 1282 jusqu'en 1600*, Paris 1923.

BYAM SHAW, J., 'Notes on Drawings: Giovanni Bellini', *Old Master Drawings*, II, no. 8, Mar. 1928, pp. 50–54.

BYAM SHAW, J., 'Some Venetian Draughtsmen of the Eighteenth Century', *Old Master Drawings*, VII, no. 28, Mar. 1933, pp. 47–63.

BYAM SHAW, J., 'Notes on Drawings: Francesco Guardi', *Old Master Drawings*, IX, no. 35, Dec. 1934, pp. 50–51.

BYAM SHAW, J., 'Four Drawings by Francesco Guardi in English Public Collections', *Old Master Drawings*, XII, no. 46, Sept. 1937, pp. 18–21.

BYAM SHAW, J., *The Drawings of Francesco Guardi*, London 1951.

BYAM SHAW, J., 'The Drawings of Francesco Fontebasso', *Arte Veneta*, 1954, pp. 317–325.

BYAM SHAW, J., 'Study for the Head of the Virgin by Sebastiano del Piombo', *Master Drawings*, 1968, p. 242.

BYAM SHAW, J., *Old Master Drawings from Christ Church, Oxford*, Washington D.C., 1972.

BYAM SHAW, J., *Drawings by Old Masters at Christ Church, Oxford*, Oxford 1976.

CHENNEVIÈRES, PH. DE, 'Les dessins de maitres anciens', *Gazette des Beaux-Arts*, XIX, 1879, pp. 503–533.

COLVIN, S., *Drawings of the Old Masters in the University Galleries and in the Library of Christ Church, Oxford*, Oxford 1903–07.

CONSTABLE, W. G., *Canaletto*, Oxford 1962.

COX REARICK, J., *The Drawings of Pontormo*, Cambridge, Mass. 1964.

CROWE, J. A. - Cavalcaselle, G.B., *Raphael*, London 1882–85.

CUST, F., *Giovanni Antonio Bazzi*, London 1906.

DALLI REGOLI, G., *Lorenzo di Credi*, Vicenza 1966.

DE DOMINICI, B., *Vite dei Pittori, Scultori ed Architetti Napoletani*, Naples 1742–43.

DEGENHART, B., *Pisanello*, Turin 1945.

DEGENHART, B., 'Nach der Bellini-Ausstellung', *Zeitschrift für Kunst*, 1950, IV, 1.

DELACRE, M., *Le Dessin de Michel-Ange*, Paris 1938.

DUSSLER, L., *Sebastiano del Piombo*, Basel 1942.

DUSSLER, L., *Giovanni Bellini*, Vienna 1949.

EMILIANI, A., *Catalogo, Mostra di Federico Barocci*, Bologna 1975.

FENYÖ, J., 'I disegni veneziani del Museo di Belle Arti di Budapest', *Acta Historiae Artium*, 1959, pp. 87–113.

FIOCCO, G., *Paolo Veronese*, Bologna 1928.

FIOCCO, G., *Il Pordenone*, Padua 1943.

FIOCCO, G., 'I disegni di Giambellino', *Arte Veneta*, 1951, p. 40 ff.

FIOCCO, G., 'Francesco Vecellio', *The Connoisseur*, Nov. 1955, pp. 165–170.

FISCHEL, O., *Raphael Zeichnungen, Versuch einer Kritik der bisher veröffentlichten Blätter*, Strasbourg 1898.

FISCHEL, O., *Raphaels Zeichnungen*, Berlin 1913–41.

FISCHEL, O., *Die Zeichnungen der Umbrer*, Berlin 1917.

FISCHEL, O., 'A New Approach to Sebastiano del Piombo as a Draughtsman', *Old Master Drawings*, XIV, Sept.-Mar. 1939–40, pp. 21–33.

FISHER, J., *Seventy etched Fac-similes after Studies by Michel Angelo and Raffaelle in the University Galleries*, Oxford 1852.

FISHER, J., *Eighty-four etched Fac-similes after Studies by Michel Angelo and Raffaelle in the University Galleries*, Oxford 1862.

FORLANI, A., *Mostra di disegni di Jacopo Tintoretto e della sua scuola*, Florence 1956.

FRAENCKEL, I., *Andrea del Sarto, Gemälde und Zeichnungen*, Strasbourg 1935.

FREY, K., *Die Handzeichnungen Michelangelos*, Berlin 1911.

FRIZZONI, G., 'Disegni di Antichi Maestri', *L'Arte*, VII, 1904, pp. 93–103.

FRIZZONI, G., 'Diverse opere d'arte evocate da una nota illustrazione di disegni', *L'Arte*, XI, 1908, pp. 161–178.

GIBBONS, F., 'New Evidence for the Birth Dates of Gentile and Giovanni Bellini', *The Art Bulletin*, 1963, pp. 54–58.

GOLDSCHEIDER, L., *Michelangelo Drawings*, London 1951.

GOMBOSI, G., *Moretto da Brescia*, Basel 1943.

GRONAU, G., *Correggio. Des Meisters Gemälde*, Stuttgart and Leipzig 1907.

GRONAU, G., *Giovanni Bellini*, Stuttgart 1930.

HADELN, D. VON, Über Zeichnungen der früheren Zeit Tizians', *Jahrbuch der Preussischen Kunstsammlungen*, XXXIV, 1913, pp. 224–250.

HADELN, D. VON, *Zeichnungen des Giacomo Tintoretto*, Berlin 1922.

HADELN, D. VON, *Zeichnungen des Tizian*, Berlin 1924.

HADELN, D. VON, *Venezianische Zeichnungen des Quattrocento*, Berlin 1925.

HADELN, D. VON, *Venezianische Zeichnungen der Hochrenaissance*, Berlin 1925.

HADELN, D. VON, *Canaletto Zeichnungen*, Berlin 1926.

HADELN, D. VON, *Venezianische Zeichnungen der Spätrenaissance*, Berlin 1926.

HADELN, D. VON, *Handzeichnungen von G. B. Tiepolo*, Florence and Munich 1927.

HADELN, D. VON, *Drawings of Antonio Canal*, London 1929.

HEIKAMP, D., 'Ancora su Federico Zuccaro', *Rivista d'Arte*, 1958, p. 45 ff.

HILL, G. F., *Drawings of Pisanello*, Brussels 1929.

HIRST, M., 'A Late Work of Sebastiano del Piombo', *The Burlington Magazine*, 1965, p. 177.

JEUDWINE, W. R., 'Drawings by Pontormo', *Apollo*, 1959, p. 114 ff.

KNAPP, F., *Andrea del Sarto*, Leipzig 1907.

LONGHI, R., Review of D. von Hadeln, 'Über Zeichnungen der früheren Zeit Tizians' (*Jahrbuch der Preussischen Kunstsammlungen*), *L'Arte*, XX, 1917, p. 357.

LUGT, F., *Les marques de collection de dessins et d'estampes*, Amsterdam 1921; *Supplément*, The Hague 1956.

MAHON, D., *Il Guercino, Dipinti*, Bologna 1968.

MAHON, D., *Il Guercino, Disegni*, Bologna 1968.

MORASSI, A., *Disegni antichi della collezione Rasini in Milano*, Milan 1937.

MORASSI, A., 'A Signed Drawing by Antonio Guardi and the Problem of the Guardi Brothers', *The Burlington Magazine*, 1953, pp. 260–267.

MORASSI, A., *Disegni dei Guardi*, Venice 1975.

MORELLI, G., *Kunstkritische Studien über italienische Malerei: Die Galerie zu Berlin*, Leipzig 1893.

MOSCHINI, V., *Francesco Guardi*, Milan 1952.

MOSCHINI, V., *Canaletto*, Milan 1954.

MULLALY, T., *Disegni veronesi del '500*, Vicenza 1971.

OBERHUBER, K. - LEVENSON, J. - SHEENON, J., *Early Italian Engravings from the National Gallery of Art*, Washington D.C. 1973.

OBERHUBER, K. - WALKER, D., *Catalogue of the*

Drawings of the Scholz Collection at the Morgan Library, New York 1974.

OERTEL, R., *Neuerwerbungen. Gemäldegalerie Berlin,* Berlin 1971.

OLSEN, H., *Barocci,* Copenhagen 1962.

OTTINO DELLA CHIESA, A., *Bernardino Luini,* Novara 1956.

PALLUCCHINI, R., *I disegni dei Guardi al Museo Correr,* Venice 1943.

PALLUCCHINI, R., *Sebastiano Viniziano,* Milan 1944.

PALLUCCHINI, R., *Catalogo, Mostra di Giovanni Bellini,* Milan 1949.

PALLUCCHINI, R., *Tiziano,* Florence 1969.

PARKER, K. T., 'Notes on Drawings: Bartolomeo Montagna', *Old Master Drawings,* IX, no. 33, June 1934, p. 8.

PARKER, K. T., 'Notes on Drawings: Giovanni Battista Piranesi', *Old Master Drawings,* X, no. 38, Sept. 1935, p. 27.

PARKER, K. T., 'Notes on Drawings: Carletto Caliari', *Old Master Drawings,* XI, no. 42, Sept. 1936, pp. 27–28.

PARKER, K. T., 'Notes on Drawings: Giovanni Battista Piranesi', *Old Master Drawings,* XII, no. 48, Mar. 1938, pp. 54–55.

PARKER, K. T., *Catalogue of the Collection of Drawings in the Ashmolean Museum, Vol. I: Netherlandish, German, French and Spanish Schools,* Oxford 1938.

PARKER, K. T., 'Some Observations on Guardi and Tiepolo', *Old Master Drawings,* XIII, no. 52, Mar. 1939, pp. 58–60.

PARKER, K. T., 'Alcuni disegni veneti recentemente acquistati dal Museo Ashmolean di Oxford', *Arte Veneta,* 1947, pp. 47–48.

PARKER, K. T., 'Report of the Keeper of the Department of Fine Arts', *Ashmolean Museum - Report of the Visitors,* 1947.

PARKER, K. T., *The Drawings of Canaletto in the Collection of His Majesty the King at Windsor Castle,* London 1948.

PARKER, K. T., *Catalogue of the Collection of Drawings in the Ashmolean Museum, Vol. II: Italian Schools,* Oxford 1956.

PARKER, K. T., 'Report of the Keeper of the Department of Fine Arts', *Ashmolean Museum - Report of the Visitors,* 1956, p. 36.

PARKER, K. T., 'Report of the Keeper of the Department of Fine Arts', *Ashmolean Museum Report of the Visitors,* 1957, pp. 33–34.

PARKER, K. T., *Disegni Veneti di Oxford,* Venice 1958.

PASSAVANT, J. D., *Tour of a German Artist in England,* London 1836.

PASSAVANT, J. D., *Raphael d'Urbin et son père Giovanni Santi,* Paris 1860.

PEDRETTI, C., 'Leonardo's Allegories at Oxford Explained by Lomazzo', *The Burlington Magazine,* 1954, pp. 175–177.

PEDRETTI, C., *Studi Vinciani,* Florence 1957, pp. 54–61.

PEROTTI, A., *I pittori Campi da Cremona,* Milan n. d.

PIGNATTI, T., 'Un disegno di Antonio Guardi donato al Museo Correr', *Boilettino dei Musei Civici Veneziani,* 1957, nos. 1–2, pp. 21–32.

PIGNATTI, T., 'Disegni Veneti del Seicento', in the exhibition catalogue by P. Zampetti, *La pittura del Seicento a Venezia,* Venice 1959.

PIGNATTI, T., *Disegni Veneti del '700 del Museo Correr,* Venice 1964.

PIGNATTI, T., *I Guardi, Disegni,* Florence 1967.

PIGNATTI, T., *Bellini,* Milan 1969.

PIGNATTI, T., *Canaletto, Disegni,* Florence 1969.

PIGNATTI, T., *Giorgione,* Venice 1970.

PIGNATTI, T., *Vittore Carpaccio,* Milan 1972.

PIGNATTI, T., *Il Passaggio del Mar Rosso di Tiziano,* Venice 1973.

PIGNATTI, T., *Tiepolo, Disegni,* Florence 1974.

PIGNATTI, T., *Venetian Drawings from American Collections,* Washington D.C. 1974.

PIGNATTI, T., *Paolo Veronese, Catalogo ragionato delle pitture,* Venice 1976.

POPHAM, A. E., *Italian Drawings Exhibited at the Royal Academy,* London 1930; Oxford 1931.

POPHAM, A. E., *Catalogue of Drawings in the Collection... now in the possession of T. F. Fenwick,* London 1935.

POPHAM, A. E., *The Drawings of Leonardo da Vinci,* London 1946.

POPHAM, A. E., *The Drawings of Parmigianino,* London 1952.

POPHAM, A. E., *Correggio Drawings,* London 1957.

POPHAM, A. E., *Catalogue of the Drawings of Parmigianino,* New Haven and London, 1971.

POPHAM, A. E. - POUNCEY, P., *The Italian Drawings in the Department of Prints and Drawings in the British Museum: 14th and 15th Centuries,* London 1950.

POPHAM, A. E. - WILDE, J., *The Italian Drawings of the XV and XVI Centuries in the Collection of His Majesty the King at Windsor Castle,* London 1949.

POPHAM, A. E. - WILDE, J., *Summary Catalogue of an Exhibition of Drawings by Michelangelo,* London 1953.

POUNCEY, P., 'Two Studies of Children by Andrea del Sarto', *The Burlington Magazine,* 1953, p. 93 ff.

POUNCEY, P., Review of B. Berenson, *I disegni dei pittori fiorentini, Master Drawings,* 1964, p. 278 ff.

POUNCEY, P. - GERE, J. A., *The Italian Drawings in the Department of Prints and Drawings in the British Museum: Raphael and his Circle,* London 1962.

REARICK, R., 'I Bassano, 1568–69', *The Burlington Magazine,* 1962, p. 524 ff.

RICCI, C., 'I disegni di Oxford', *Rassegna d'Arte,* 1905, pp. 74–77.

RICCI, C., *Correggio,* Rome and London 1930.

RIDOLFI, C., *Le Meraviglie dell'Arte,* Venice 1648.

ROBINSON, J. C., *A Critical Account of the Drawings of Michelangelo and Raphael in the University Galleries, Oxford,* Oxford 1870.

ROSSI, P., *I disegni di Jacopo Tintoretto,* Florence 1975.

RULAND, C., *The Raphael Collection in the Royal Library at Windsor,* London 1876.

SACK, E., *Giambattista und Domenico Tiepolo,* Hamburg 1910.

SANUDO, M., *I Diarii di M. S. (1496–1533),* edited by R. Fulin, Venice 1879–1902.

SCHMITT, U. B., 'Francesco Bonsignori', *Münchner Jahrbuch,* 1961, p. 73 ff.

SCHOENBRUNNER, J. - MEDER, J., *Handzeichnungen alter Meister in der Albertina und anderen Sammlungen,* Vienna 1896–1908.

STIX, A. - FRÖLICH-BUME, L., *Die Zeichnungen der Venezianischen Schule,* Vienna 1926.

STRONG, S. A., *Drawings at Wilton House,* London 1900.

SUIDA MANNING, B., *Cambiaso,* Genoa 1952.

SUTTON, D., *Italian Drawings from the Ashmolean Museum,* New York 1970.

THIEME, U. - BECKER, F., *Allgemeines Lexikon der Bildenden Künstler,* Leipzig 1907–50.

THODE, H., *Michelangelo: kritische Untersuchungen über seine Werke,* Berlin 1913.

THOMAS, H., *The Drawings of Giovanni Battista Piranesi,* London 1954.

TIETZE, H. - TIETZE-CONRAT, E., 'Tizian-Studien', *Wiener Jahrbuch für Kunstgeschichte,* 1936, pp. 137–192.

TIETZE, H. - TIETZE-CONRAT, E., *The Drawings of the Venetian Painters of the 15th and 16th Centuries,* New York 1944.

TIETZE-CONRAT, E., 'Titian's Cavalli', *Old Master Drawings,* X, no. 40, Mar. 1936, pp. 54–57.

TOLNAY, C. DE, *Michelangelo. I, The Youth of Michelangelo; II, The Sistine Ceiling; III, The Medici Chapel; IV, The Tomb of Julius II,* Princeton 1943–54.

TOZZI, R., 'Disegni di Domenico Tintoretto', *Bollettino d'Arte,* 1937, pp. 19–31.

VAN MARLE, R., *The Development of the Italian Schools of Painting, Vol. XI: The Renaissance Painters of Florence in the 15th Century, the Second Generation,* The Hague 1929.

VASARI, G., *Le vite de' più eccellenti pittori, scultori ed architetti,* Florence 1568.

VENTURI, A., critical ed. of G. Vasari, *Le Vite... Gentile da Fabriano e il Pisanello,* Florence 1896.

VENTURI, A., *Storia dell'Arte Italiana, Vol. IX: La Pittura del Cinquecento,* Milan 1926.

VERTUE, G., *Notebooks of George Vertue, Walpole Society,* 1929–52.

VIVIAN, F., *Il Console Smith mercante e collezionista,* Venice 1971.

WAAGEN, G. F., *Treasures of Art in Great Britain,* London 1854.

WAGNER, H., *Raphael im Bildnis,* Munich 1969.

WATSON, F. J. B., *Canaletto,* London and New York 1949.

WETHEY, H., *Titian,* London 1969–75.

WIBIRAL, N., 'Contributi alle ricerche sul Cortonismo in Roma, i pittori della galleria di Alessandro VII nel palazzo del Quirinale', *Bollettino d'Arte,* 1960, p. 23 ff.

WILDE, J., *The Italian Drawings in the Department of Prints and Drawings in the British Museum: Michelangelo and his Studio,* London 1953.

WITTKOWER, R., 'Works by Bernini at the Royal Academy', *The Burlington Magazine,* 1951, pp. 51–56.

WITTKOWER, R., *The Drawings of the Carracci in the Collection of Her Majesty the Queen at Windsor Castle,* London 1952.

Plates

PISANELLO

Painter and medallist, Antonio Pisano, called Pisanello, was born in Pisa, son of Puccio di Giovanni da Cereta, before November 22, 1395 and died about 1455.

In the first years of the 15th century he lived in Verona with his mother. Between 1415 and 1420 he was summoned to Venice as assistant to Gentile da Fabriano in the decoration of the Sala del Gran Consiglio in the Palazzo Ducale. In 1422 he was perhaps in Florence with Gentile. In 1424 he was in Pavia; in 1424–25 in Mantua; in 1426 he worked on the *Annunciation* in the church of San Fermo in Verona; in 1431 he was in Ferrara; and in 1431–32 in Rome, where he finished Gentile's frescoes in San Giovanni in Laterano. 1438 is the date of the portrait medal of the Byzantine Emperor, John VIII Palaeologus, at that time in Italy for the Council of Ferrara. Before 1438 he worked in Verona, where he produced his masterpiece, the fresco of *Saint George* in the church of Sant'Anastasia, as well as in Ferrara, Mantua and Milan. In 1445 he was in Rimini; in 1447 in Mantua; and in 1449 in Naples. Pisanello's career was thus typical of the wandering court artist.

Stefano da Verona and, in particular, Gentile da Fabriano were the point of departure for his art, but in its fundamental characteristics Pisanello's work belongs to the courtly International Style. But in his intense observation of nature, confirmed by the many studies that have come down to us, his adherence to this style took a personal turn. Thanks to his feeling for plastic values and for the quality of surfaces, as well as to the great variety of his models, in his hands the International Style became a precursor of the Renaissance in northern Italy. As a draughtsman from nature and as a medallist Pisanello occupies a unique position in Italian art.

1 Studies of costumes and a female head

Pen and brown ink, with watercolour washes, on vellum. 183 x 240 mm.

Colls.: *Lagoy (Lugt 1710); Douce.*

Lit.: *Chennevières 1879, p. 258; Venturi 1896, p. 123; Colvin 1903–07, II, pl. 27; Hill 1929, p. 24; Degenhart 1945, pp. 12, 23, 76, no. 78; Parker 1956, no. 41; Parker 1958, no. 1.*

Ashmolean Museum.

The elaborate costumes are similar to those of Pisanello's frescoes in Verona and Mantua, but the subject of this drawing is unknown. On the cloak of the gentleman at the right is an unidentified coat-of-arms with a flax-hackle and a climbing tree with grafting slips. The figure with the long train has even been considered that of a lady.

A pen drawing on the *verso* is part of a group of studies by Pisanello after the antique. It represents two bacchantes, perhaps derived from a sarcophagus relief and similar to a figure in the volume of copies after ancient works by Dal Pozzo in the British Museum (fol. 58).

ANDREA VERROCCHIO

The sculptor and painter Andrea di Michele di Cione, called Verrocchio, was born in Florence in 1435 and died in Venice in 1488.

Like most 15th-century Florentine artists Verrocchio began his career as an apprentice goldsmith. This youthful activity was later to prove very important for the development of certain distinctive refinements of his sculpture technique. The effect of light in the work of Desiderio da Settignano was also important for his development, and it is supposed that Verrocchio collaborated with him on the *Funerary Monument of Carlo Marsuppini* in the Florentine church of Santa Croce. Verrocchio was to create a style based on a grand and forceful plasticity but always marked by a great sensitivity to the vibrant effects of light. Of the artist's activity as sculptor there remain numerous examples, all of great quality and representative of that process of modernization to which Renaissance formulas were submitted in Florence in the second half of the 15th century. In Florence, we may cite his bronze *David*, the *Lady with a Bunch of Flowers*, and the *Madonna and Child*, all in the Bargello, the *Tomb of Piero and Giovanni de' Medici* in the Old Sacristy of San Lorenzo, and the *Incredulity of Saint Thomas* at Orsanmichele, and finally, in Venice, his splendid *Equestrian Monument to Bartolomeo Colleoni* in the Campo di San Zanipolo. Examples of his painting, however, are today very rare. His only securely documented panel is the *Baptism of Christ* from the Florentine church of San Salvi, now in the Uffizi. With its tense line and vigorous contrasted chiaroscuro, this work, in which Verrocchio had as collaborator the young Leonardo, reconfirms the essentially sculptural quality of his artistic expression.

*

2 Head of a young woman

Black chalk, heightened with white; retouchings in pen and black ink. 408 x 327 mm.

Coll.: *Guise.*

Lit.: *Colvin 1903–07, III, pl. 1; Bell 1914, p. 92 A. 5; Van Marle 1929, p. 534; Popham 1931, no. 51; Berenson 1938, no. 2782 A; Byam Shaw 1972, no. 84; Byam Shaw 1976, no. 15.*

Christ Church.

As Byam Shaw has noted, this sheet brings to mind the Verrocchio drawings Vasari described in his collection: 'some female heads with an air of beauty and elaborately styled hair'. The few traces of retouching in pen are of later date.

The head can be related to the painting of the *Madonna and Child in a Landscape* in Berlin and attributed to Verrocchio without hesitation. It is, in fact, one of the master's most beautiful drawings.

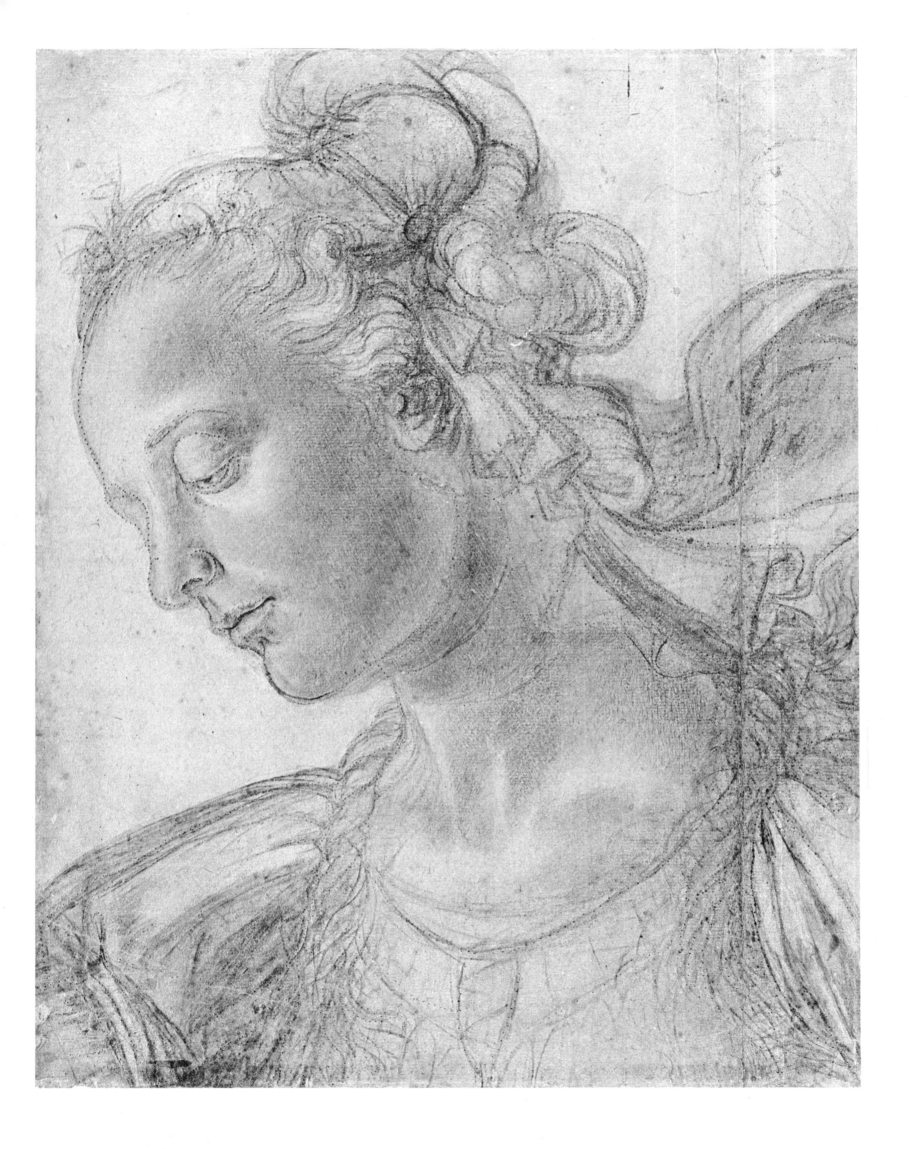

FILIPPINO LIPPI

Filippino Lippi, one of the most bizarre and fascinating artistic personalities of the late 15th and early 16th centuries, was born in Prato in 1457 and died in Florence in 1504.

After an apprenticeship with his father, the famous Filippo Lippi (with whom he collaborated, among other things, on the frescoes in the apse of the cathedral of Spoleto), in 1472 he was working in the shop of Sandro Botticelli, where he had the opportunity of completing his stylistic education in the purest tradition of Florentine design. Filippino received his first important commission in 1484 when he was called to complete the decoration of the Brancacci chapel in the church of the Carmine, left unfinished at Masaccio's death. Shortly thereafter, in 1486, not yet thirty, he produced the very beautiful *Apparition of the Virgin to Saint Bernard* in the Florentine church of the Badia. Between 1489 and 1493 he was in Rome, where he painted the frescoes of *Episodes from the Life of Saint Thomas* in the Caraffa chapel in Santa Maria sopra Minerva. This Roman stay led to a deepening of his classical culture, which in turn contributed greatly to the maturing of his style. The results of this are best seen in the new grandeur and capricious decorative imagination that distinguish the frescoes of *Scenes of the Lives of Saints Philip and John* in the Strozzi chapel in Santa Maria Novella in Florence. Filippino was effectively defined by Giorgio Vasari as a 'painter of the most beautiful talent and most enchanting invention... and very new and bizarre in his ornament, who was the first to show modern men a new way of diversifying dress and to decoratively embellish his figures with succinct ancient costumes'.

3 Studies of nude and draped figures

Silverpoint, heightened with white, on paper primed blue. 565 x 450 mm.

Coll.: *Vasari; Guise.*

Lit.: *Passavant 1836, II, p. 139; Bell 1914, p. 63; Berenson 1938, nos. 853 A, 1355 B; Byam Shaw 1972, no. 39 verso; Byam Shaw 1976, no. 33 verso.*

Christ Church.

These drawings made up an entire page of Vasari's 'Book of Drawings' and are still in the characteristic framings Vasari himself designed. Attributed to Filippino ever since Vasari's ownership, they represent studies of nudes and dressed figures drawn on two levels, on both *recto* and *verso*. On the *verso*, reproduced here, Byam Shaw has observed that the figure at the lower left is probably a portrait of Botticelli, similar to that which appears in Filippino's *Adoration of the Magi* in the Uffizi. The strong influence of Botticelli apparent in this drawing would seem to place it at the time Filippino was working in Botticelli's shop, in 1472–73.

LORENZO DI CREDI

The painter and perhaps also sculptor, Lorenzo Barducci, called di Credi after the name of his uncle, was born in Florence about 1459 and died there in 1537.

As early as 1480 he was working in Verrocchio's shop along with Leonardo and Perugino. From these early years come di Credi's *Madonna and Child with Saints* in the Pistoia cathedral, a work ordered from Verrocchio's studio. One of the principal paintings of his later period is the *Adoration of the Shepherds* now in the Uffizi. His style is based on the important lessons learned and the inspirations derived from his years in Verrocchio's studio, not only from his master but also from his fellow pupils, Perugino and Leonardo. All these influences he assimilated and combined with a Flemish-inspired taste for detailed, realistic representation. He remained faithful all his life to an ideal of elegant gracefulness and his painting is remarkable above all for the splendid quality of his craftsmanship and the preciseness of his execution, praised by Vasari.

4 David with the head of Goliath

Silverpoint, heightened with white, on primed paper. 280 x 126 mm.

Colls.: *Padre Resta; Lord Somers; Guise.*

Lit.: *Passavant 1836, II, p. 138; Berenson 1903, no. 995; Colvin 1903–07, I, pl. 13; Bell 1914, p. 41, B. 11; Dalli Regoli 1966, p. 109, no. 23, fig. 35; Byam Shaw 1972, no. 23; Byam Shaw 1976, no. 29.*

Christ Church.

This figure clearly derives from the famous *Davids* of Donatello and Verrocchio, particularly the latter's bronze in the Bargello of about 1475. The date indicated by Byam Shaw for the drawings is, in fact, very close to that of the sculpture and even the graphic style reflects Verrocchio.

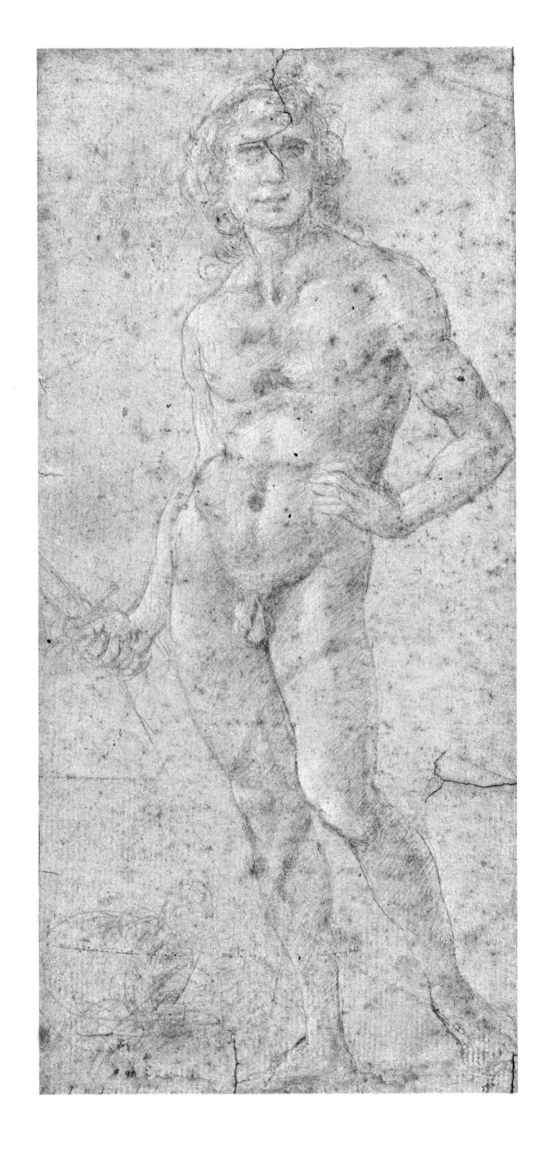

PERUGINO

Pietro Vannucci, called Perugino, was born in Città della Pieve in 1445 and died in Fontignano (Perugia) in 1524. He was receptive to the art of Piero della Francesca and, in Florence, was perhaps a pupil of Verrocchio.

Among his earliest works are the *Scenes from the Life of Saint Bernardino* (1473) in the gallery in Perugia. In 1479 he was called to Rome to fresco the apse of Old Saint Peter's (later destroyed). Shortly thereafter, together with Botticelli, Ghirlandaio, and Cosimo Rosselli, he worked in the Sistine chapel, where he left his masterpiece, the *Consignment of the Keys to Saint Peter* (1481). In this important work Perugino harmoniously combined the strongly plastic figures in the foreground, derived from Verrocchio, with the broad and well defined spatial structure characteristic of Piero della Francesca.

The artist produced his most significant works between 1488 and the very end of the century: the *Annunciation* in Santa Maria Nuova in Fano, the *Virgin Appearing to Saint Bernard* in Munich, and above all the *Apollo and Marsyas* in the Louvre, in which he established a perfect accord between figures and landscape. The compositional scheme of the *Apollo and Marsyas*, from which architecture as a perspective means is completely excluded, is found again in his *Lamentation over the Dead Christ* of 1495, painted for the nuns of Santa Chiara in Florence and now in Palazzo Pitti. Here, the broad and open landscape is deprived of any dynamic function; it exists as a tranquil expanse that accompanies the slowly turning plastic forms of the foreground figures. This pleasing style was shortly to be compromised by sentiment become sentimentality in the *Assumption of the Virgin* in the Uffizi and the frescoes of the Collegio del Cambio in Perugia, finished in 1500. In this same year, the seventeen-year-old Raphael began his career in Perugino's workshop.

5 Studies for Tobias and the Angel

Silverpoint, heightened with white, on paper primed very pale-yellow. 238 x 183 mm.

Colls.: *Wicar; Lawrence (Lugt 2445); Woodburn.*

Lit.: *Fisher 1852, p. 17; Robinson 1870, no. 16; Morelli 1893, p. 312; Fischel 1917, p. 122; Popham 1930, no. 107; Parker 1956, no. 27.*

Ashmolean Museum.

The sheet is a study for the right hand panel of Perugino's polyptych of about 1496, commissioned by Ludovico il Moro for the Certosa of Pavia and now in the National Gallery in London. Once attributed to Raphael, the drawing came to the Ashmolean as such from the Lawrence collection. It was recognized as a work of Perugino by Morelli and Fischel, and the attribution was confirmed by Popham, who exhibited the sheet at Burlington House in 1930. At Windsor there is another drawing for the same polyptych, related to the panel with the Archangel Michael, but in this case the paper is primed blue.

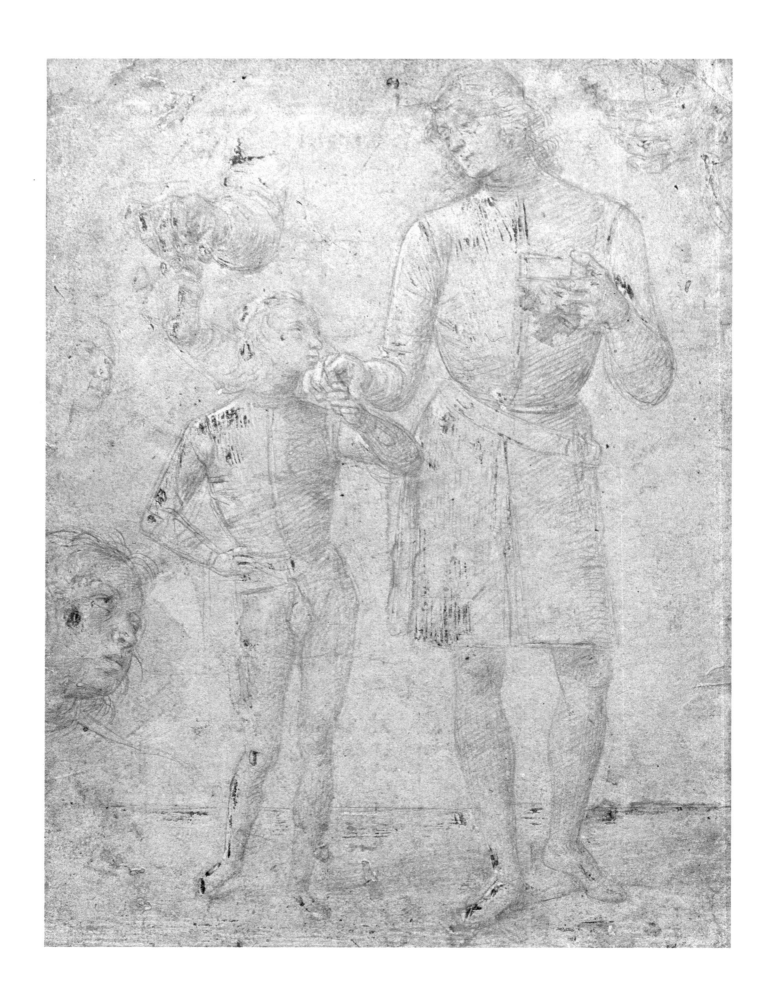

FRANCIA

The painter and goldsmith Francesco Raibolini, called Francia, was born in Bologna about 1450 and died there on January 5, 1517.

He began his career as a goldsmith and, according to Vasari, as an engraver of seals. On December 10, 1482 he enrolled in the guild of the goldsmiths, but as early as 1479 he had been mentioned as a gold-worker. In 1483, when he was about thirty years old, he was qualified as *massaro* of the guild, or senior member. In 1503 he was inscribed in the guild of the Quattro Arti. Nothing of his activity as goldsmith remains, however, and in 1486 he was already referred to as a painter. His first securely datable painting comes from the year 1492. Francia was in great measure influenced by Lorenzo Costa but also by Ercole de' Roberti, and he was obviously attracted by Umbrian painting. Indeed, in his limpid, harmonious compositions, placid figures, and delicate light that softly models his forms and endows his colour with a luminous intensity, Francia's art has an affinity with that of Perugino. He was undoubtedly the most significant Bolognese painter of the late 15th and early 16th centuries.

6 Three figures in a landscape

Brush and brown ink, heightened with white, on light-brown paper. 224 x 367 mm.

Coll.: *M. Marignane (Lugt 1872)*.

Lit.: Ashmolean Museum Report *1940, p. 17, pl. VIII; Parker 1956, no. 10*.

Ashmolean Museum.

There are other drawings by Francia in a similar style in the Albertina, Louvre, and Morgan Library. All show the same fusion of influences from Umbrian art and the style of Lorenzo Costa.

The subject of this sheet has never been explained, but Parker reports that J. D. Beazley identified the female figure in the centre as the 'silent' Roman goddess Angerona, referred to by Macrobius (*Saturnalia*, III, IX, 4).

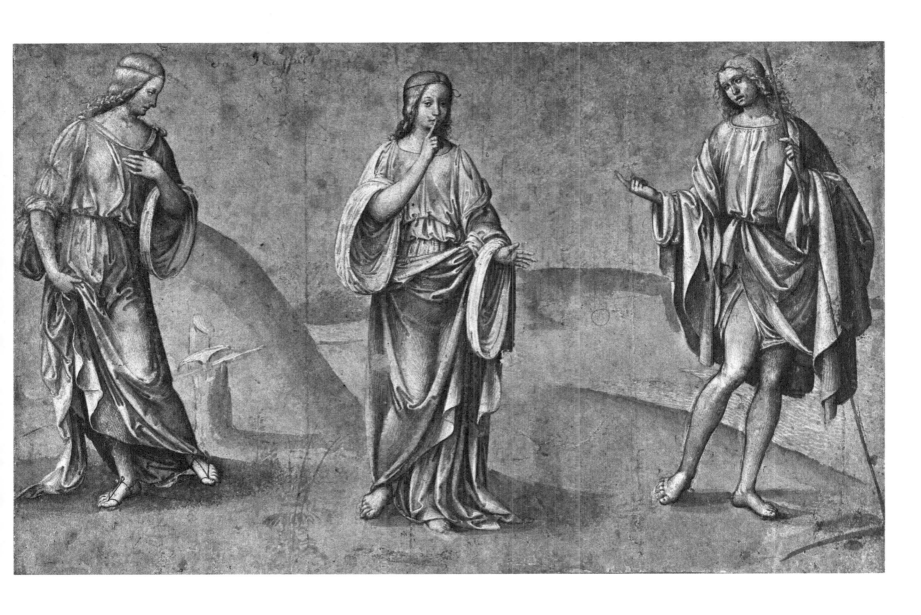

LORENZO COSTA

The painter Lorenzo Costa was born in Ferrara in 1459 or 1460 and died in Mantua on March 5, 1535. He seems to have settled in Bologna towards the year 1483, making brief trips to Ferrara, in 1499, and to Rome, in 1503. In the spring of 1507 he became court painter to the Gonzaga family of Mantua, succeeding Andrea Mantegna, some of whose unfinished works he completed. Vasari mentions a period of study in Florence, but Costa's early works clearly evidence Ferrarese influence, principally of Ercole de' Roberti but also of Tura. In his early years Lorenzo was also attracted by Venetian art, but his later works bespeak the inspiration of Umbrian painting, revealed above all in his lovely landscape representations. The attraction to Umbrian art was also typical of the Bolognese painter Francesco Francia, with whom Costa had much in common. Around 1500 Costa achieved a classicizing compositional equilibrium, but of a delicacy that remained committed to Quattrocento taste. His late works are indeed more animated and more painterly in the use of colour and light, but are still far from the style of the High Renaissance masters.

7 The Supper in the house of Simon

Pen and brown ink, with some ink wash. 296 x 453 mm.

Coll.: *Guise.*

Lit.: *Colvin 1903–07, II, pl. 23; Ricci 1905, p. 77; Bell 1914, p. 40, I. 4; Byam Shaw 1972, no. 22; Byam Shaw 1976, no. 861.*

Christ Church.

This large sheet was described by Colvin as the most beautiful surviving example of Costa's drawing. It reveals the artist's composite formation from Emilian and Tuscan art. Byam Shaw dates it after 1500, in the period following Costa's work in the church of San Giovanni in Monte in Bologna.

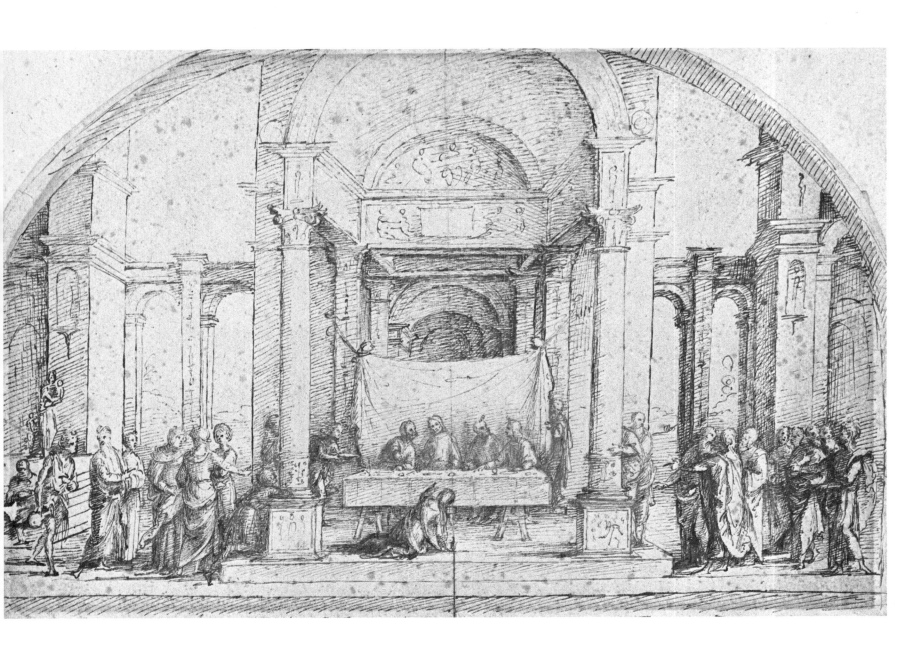

Giovanni Bellini, son of Jacopo and brother of Gentile, was born in Venice about 1430 and died there, as Sanudo noted in his *Diarii*, on November 29, 1516.

As early as 1459 Giovanni had his own workshop in Venice, but occasionally still collaborated with his father and brother. After a first training under his father, whose works frequently evidence an attraction for the Renaissance, Giovanni was drawn to the art of Antonio Vivarini and subsequently to that of Andrea Mantegna, who in 1453 had married Giovanni's sister. From 1460 until the time he painted his *Coronation of the Virgin* in Pesaro about 1470, Giovanni was much influenced by Mantegna, but in his interpretation of Mantegna's plastic form colour was always dominant. As indicated by Pallucchini, the *Pietà* in the Brera is the high point of this particular phase of Giovanni's development. The trip to the Marches to paint the altarpiece of Pesaro, during which he als ·isited Ferrara, Rimini, and Urbino, was fundamental for the substantial change in Bellini's style. Through the example of Piero della Francesca he was led to conceive a perspective system 'in which light regulates the relationships between form and colour'. Also important was the arrival in Venice in 1475 of Antonello da Messina, under whose influence Giovanni's pictorial technique became softer and more fused. His painting gradually became more lyrical and deeper in its religious expression. This is the moment of the *Resurrection* in Berlin and the *Madonna and Saints* in the Uffizi. By the time of the triptych in the Frari in Venice, dated 1488, Bellini had fully achieved his atmospheric, *sfumato* colour.

In 1479, he was charged with the execution of some large canvases for the Sala del Maggior Consiglio of the Palazzo Ducale, a commission that occupied him (with the help of numerous collaborators) until after 1493. With these works, destroyed by a fire in the palace in 1577, he assumed the role of official painter of the Venetian Republic.

Receptive to the trends of the new times, at the very beginning of the 16th century his painting became progressively more luminous, his colours gradated in soft and fluid tones, as in the *Baptism* in Santa Corona in Vicenza (1502) and the *Madonna and Saints* in San Zaccaria in Venice (1505). In the works of his last years, such as the altarpiece of 1513 in the church of San Crisostomo, Bellini's colour became warm and richly shadowed, demonstrating his assimilation, principally from Giorgione, of the new naturalism of High Renaissance painting.

8 Portrait of Gentile Bellini (?)

Black chalk, with some wash, on greenish-grey paper. 391 x 280 mm.

Coll.: *Guise.*

Lit.: *Berenson 1901, p. 92; Colvin 1903–07, II, pl. 32; Bell 1914, p. 93, H. 9; Byam Shaw 1928, p. 54; Popham 1930, no. 177; Tietze-Tietze-Conrat 1944, no. A. 318; Schmitt 1961, p. 139, no. 105; Gibbons 1963, p. 56; Byam Shaw 1972, no. 5; Byam Shaw 1976, no. 702.*

Christ Church.

Both the identification of the sitter and the attribution of this stupendous drawing have been disputed. Modern critics, however, are almost unanimously of the opinion (advanced by Colvin and recently sustained by Gibbons) that the sitter is Gentile Bellini, brother of the more famous Giovanni, here portrayed at the age of sixty or seventy. The similarity with the many known portraits of Gentile (in the series of canvases of the *Miracle of the Holy Cross* in the Accademia in Venice and in medallions) confirms such an identification, accepted also by Byam Shaw.

Concerning the attribution, earlier scholars suggested minor Venetian artists: Colvin and Berenson ascribed it to Alvise Vivarini and Popham to Bonsignori. The problem later became the choice between Giovanni Bellini, first proposed by Byam Shaw, and Mantegna, sustained by the Tietzes. In agreement with Schmitt and Gibbons, I too consider the attribution to Giovanni Bellini the more probable and would date this sheet, along with the Colleoni portrait in Washington and that of Doge Loredan in London, to the end of the 15th or the beginning of the 16th century. In my opinion only Giovanni Bellini was capable of creating an image which has all the severity of Mantegna's line, but is at the same time live in the trembling, pictorial quality of its surfaces.

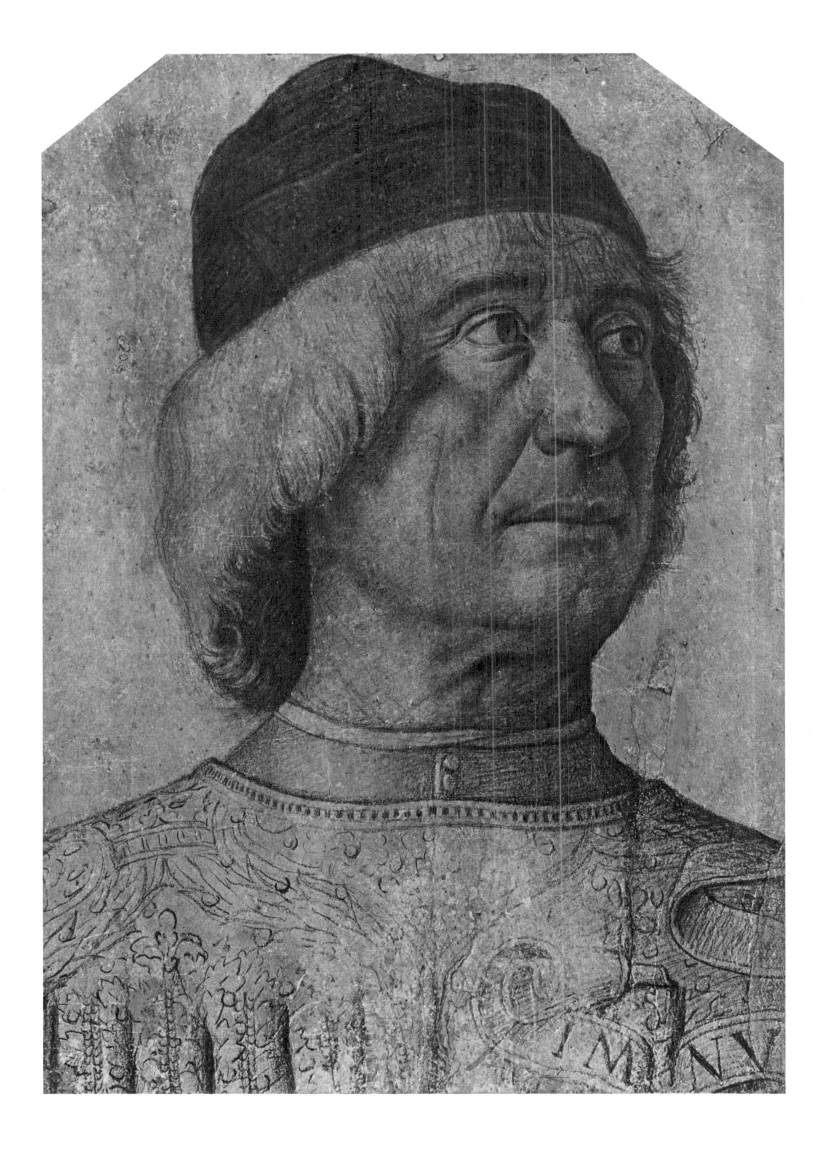

9 The Christ Child

Pen and brush with brown ink, heightened with white, on grey-blue paper. 206 x 285 mm.

Colls.: *J. Richardson, Jun. (Lugt 2170); Dalhousie; Mrs. Broun Lindsay.*

Lit.: *Byam Shaw,* Vasari Society, *XVI, 1935, pl. 3; Tietze-Tietze-Conrat 1944, no. 316; Dussler 1949, p. 83, pl. 11; Fiocco 1949, p. 54; Pallucchini 1949, p. 222; Degenhart 1950, p. 27; Parker 1956, no. 2; Parker 1958, no. 2.*

Ashmolean Museum.

This debated drawing has generally been related to the *Madonna and Child* in the Fogg Museum in Cambridge, Massachusetts, attributed to Bellini by Gronau (1930, p. 57). The figure of the Christ Child with the detail of the legs does correspond almost exactly to the painting, but Gronau's attribution has often been doubted and the painting considered a work produced with the intervention of Bellini's shop (Pignatti 1969, no. 118). Byam Shaw was the first to question the attribution of the drawing and was followed in this by Fiocco and Degenhart, who suggested Carpaccio or an artist of Carpaccio's circle, and by Roberto Longhi (oral communication), who preferred to ascribe the sheet to Alvise Vivarini. Parker (1956) cited the opinion of Goldscheider, who considered it a work of Martino da Udine from about the same time as his altarpiece of *Saint Ursula* in the Brera, dated 1507.

However, in my opinion this drawing is best compared with the graphic work of Cima. Certainly it is very close in style to Carpaccio, but, like Cima's drawings in the British Museum and the Koenigs collection in Haarlem, it is sharper and drier in its outlines and highlighting, the volumes heightened in white taking on an almost porcelain-like quality.

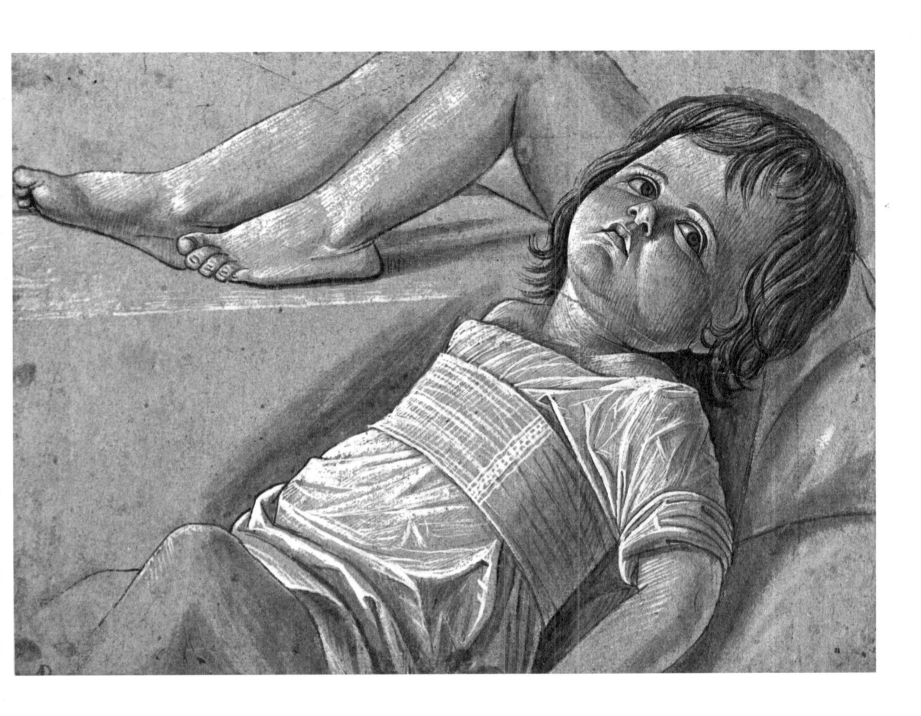

BARTOLOMEO MONTAGNA

Bartolomeo Cincani, called Bartolomeo Montagna, was born in Orzinuovi (Brescia) probably about 1450 and died in Vicenza on October 11, 1523.

An outstanding personality in the school of Vicenza, Bartolomeo's pictorial formation took place in Venice. In 1474 he was in Vicenza, where he returned in 1482. He was active also in Verona, Padua, and other localities in the region of Venice. The basic element of Montagna's art was the tradition of Mantegna, mediated by the work of Bartolomeo Vivarini and Giovanni Bellini. He developed the metallic angularity characteristic of Bartolomeo Vivarini, modifying it in terms of a softer treatment of light derived from Bellini. Montagna's best works are characterized by a robust monumentality and luminous colour.

10 Head of the Madonna

Black chalk, heightened with white chalk. 290 x 199 mm.

Colls.: *Padre Resta (?) ; Lord Somers (?) ; Guise.*

Lit.: *Colvin 1903–07, II, pl. 31; Borenius 1909, p. 110; Bell 1914, p. 69, H. 27; Parker 1958, no. 10; Byam Shaw 1976, no. 709.*

Christ Church.

In the past this drawing was compared with the Mantegna-like altarpiece in the Brera, painted by Montagna in 1499. Ricci (1905) and Popham (1949), however, noted that the Royal collection at Windsor contained a drawing similar in all respects, except for the neckline of the tunic, and demoted the Christ Church sheet to a derivation from the Windsor drawing. Byam Shaw, noting many other differences between the two sheets, instead considers the Christ Church 'Madonna' independent of that at Windsor and relates it to other works by Montagna of about 1500, such as the Madonnas of his altarpieces in Berlin and the church of Santa Maria in Vanzo in Padua. For the refined delicacy of the execution, which has a far greater *sfumato* effect than the Windsor example, I too consider this an authentic work by Montagna, perhaps from a slightly later period, around 1510.

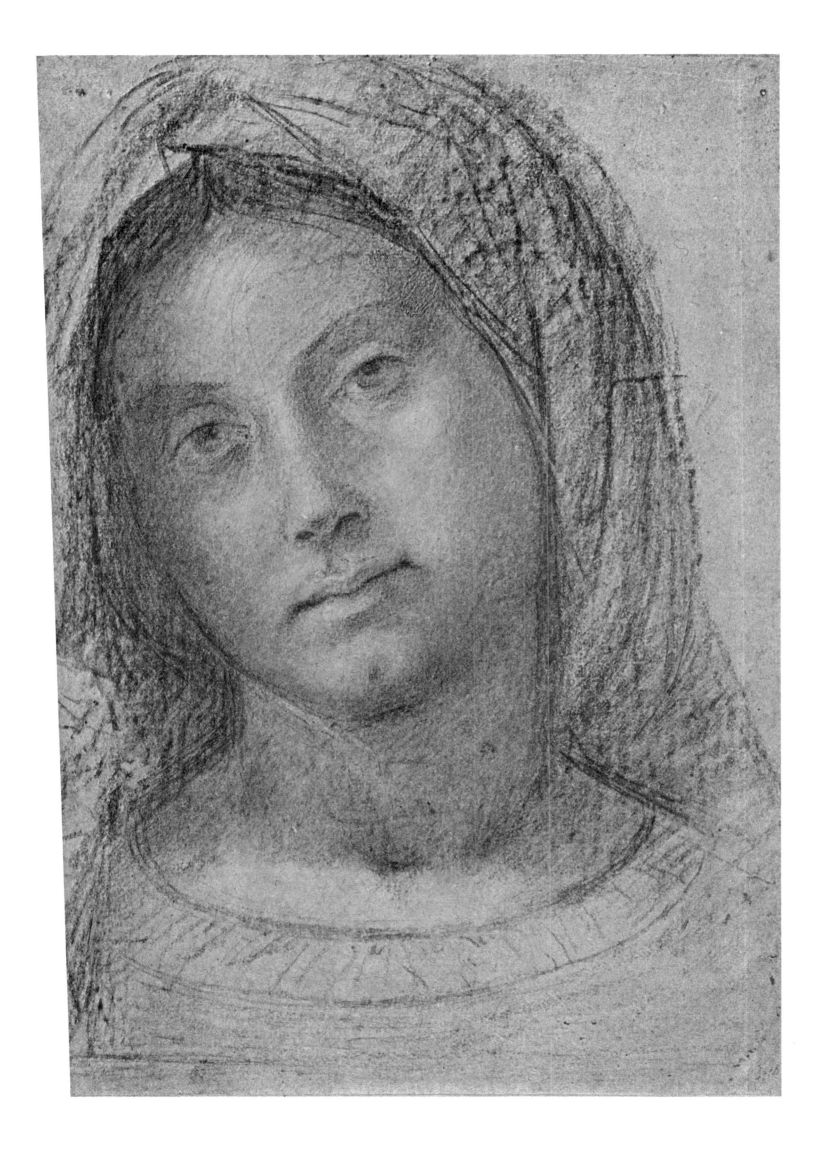

VITTORE CARPACCIO

The painter Vittore Carpaccio was probably born in Venice (he often added the qualification 'venetus' next to his signature) about 1465 and died there in 1526.

It has been supposed, without any real proof, that in the course of probable youthful journeys he could even have visited the Orient. However that may be, the inspiration fundamental to his stylistic formation came from Giovanni Bellini and from Antonello da Messina who had been in Venice between 1475 and 1476, leaving behind some of his major masterpieces. Only from these masters could Carpaccio possibly have acquired that extraordinary synthesis of light, space, and colour that, along with an outstanding narrative talent, is common to all his best pictorial production. This includes: the scene of the *Miracle of the Rialto Bridge,* now in the Accademia in Venice, with which in 1494 he participated in the decoration directed by Gentile Bellini for the Scuola di San Giovanni Evangelista; the nine canvases of the *Legend of Saint Ursula,* all now in the Accademia in Venice; and those he painted between 1502 and 1507 for the Scuola di San Giorgio degli Schiavoni. Carpaccio's fame rests on these works, which are of exceptional quality, but from the second decade of the 16th century his painting, unfortunately, reveals a progressive stylistic decline and an exhausted imagination.

11 Bust of a young man

Black chalk, brush and brown ink, heightened with white, on blue paper. 265 x 187 mm.

Colls.: *Padre Resta; Lord Somers; Guise.*

Lit.: *Byam Shaw 1972, no. 12; Pignatti 1972, p. 25; Byam Shaw 1976, no. 710.*

Christ Church.

This drawing is generally considered a preparatory study for one of the personages in the scenes of the Ambassadors of Carpaccio's *Legend of Saint Ursula* cycle, although it has no precise resemblance with any given figure. The sheet, in any case, is to be dated in the last five years of the 15th century, when in his drawings Carpaccio often adopted the technique of white highlights hatched in with the brush on dark papers. This procedure, earlier typical of Alvise Vivarini, seems in just this period to have been favoured by Dürer for his 'finished' drawings, but from this one need not deduce a dependence of one artist on the other. In the case of Carpaccio this graphic technique tends to suggest the glowing colour that he was progressively to develop in terms of tonal effects and which characterizes the evolution of his style in the early years of the 16th century.

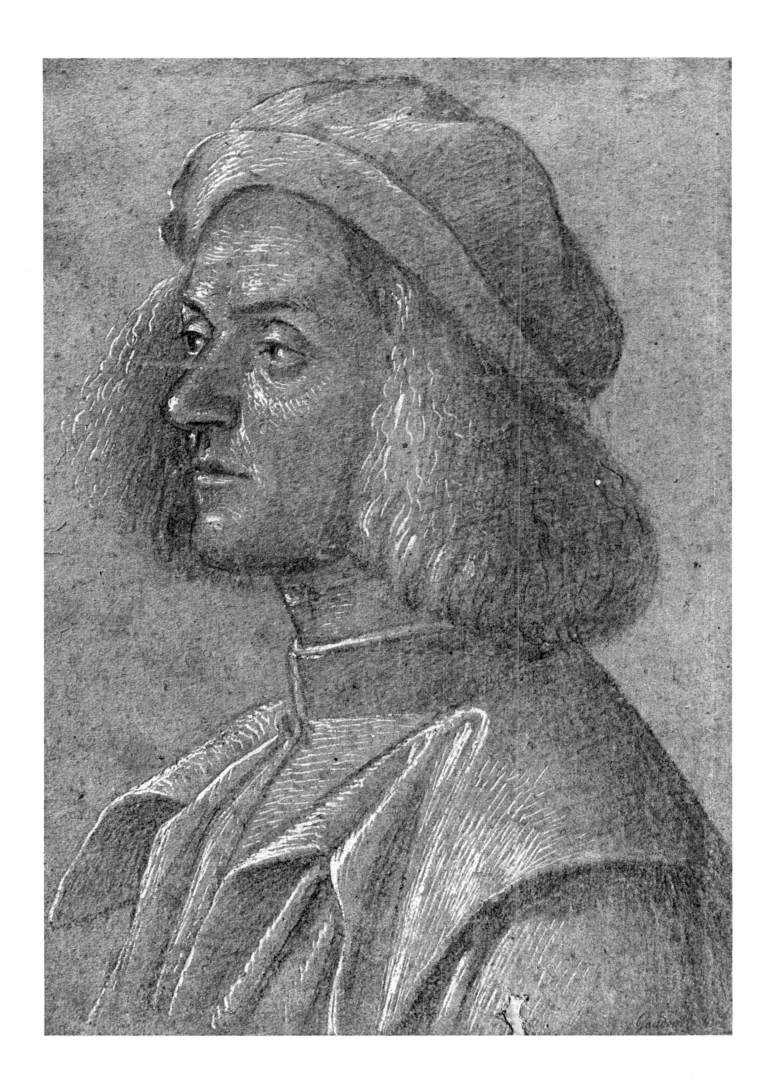

LEONARDO DA VINCI

Painter, sculptor, engineer, architect, and scientist, Leonardo was born in Vinci on April 15, 1452, son of Ser Piero da Vinci and a peasant girl named Caterina. He died in Amboise on May 2, 1519.

In 1469 he entered Verrocchio's workshop and was still there when in 1472 he joined the Compagnia di San Luca. In 1481 Leonardo was commissioned by the monks of San Donato a Scopeto to paint the altarpiece of the *Adoration of the Magi* now in the Uffizi, left unfinished when he entered the service of Ludovico Sforza in Milan. There, between 1495 and 1497, he worked on the *Last Supper* in the refectory of the convent of Santa Maria delle Grazie. When in 1499 the French troops occupied the city Leonardo returned to Florence, passing through Mantua and Venice. In Florence, in 1501, he exhibited the cartoon of *Saint Anne with the Virgin and Child*. The following year he spent eight months in the service of Cesare Borgia. In October of 1503 he was commissioned to paint the fresco of the *Battle of Anghiari* in the Palazzo Vecchio, which was never completed. In June of 1506 Leonardo returned to Milan, frequently travelling back and forth between this city and Florence. It was in these years that he painted the *Mona Lisa*. Between the end of 1516 and the beginning of 1517, invited by Francis I, he left for France.

In the multiplicity of his activities and interests Leonardo, the artist-scientist, was the quintessence of the Renaissance ideal of the universal genius. Relentless in his search for knowledge, Leonardo's investigations were penetrating and examined phenomena in their cause and effect. He was fascinated above all by the laws of movement, by the change and development of life, and by human and animal expression. Through the analytical study of such problems he arrived at archetypal forms and essential relationships which impart a mysterious, magical power to his few remaining paintings and his very numerous drawings and writings. Through his insight into natural laws he recreated nature in the light of an ideal universe. For this reason his works had a radiant force and served as a stimulus not only in those centres where he was active, but in the whole of Italy, as well as in the Low Countries and France. There was hardly a great painter of the time, from Michelangelo to Raphael, Giorgione, Correggio, Dürer, and Quentin Metsys, and perhaps even Hieronymus Bosch, who did not at one time or other feel Leonardo's influence.

12 Girl with a unicorn

Pen and brown ink. 95 x 75 mm.

Colls.: *Lawrence (Lugt 2445); Woodburn; Chambers Hall (Lugt 551).*

Lit.: *Berenson 1938, no. 1057; Popham 1930, no. 64; Parker 1956, no. 15.*

Ashmolean Museum.

The representation of a girl with a unicorn is generally understood as an allegory of chastity. The same subject appears in a drawing in the British Museum, on the *recto* of which is a study for Leonardo's *Madonna del Gatto* (*Vasari Society*, I, 1905–06, pl. 1, 2). Certainly a very youthful work, Parker dated this sheet about 1478. In the thin, incisive line the influence of the traditions of Botticelli and Verrocchio is still evident.

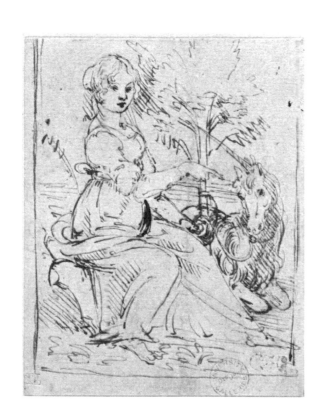

LEONARDO DA VINCI

13 Two allegories of envy

Pen and brown ink, traces of red chalk. 210 x 289 mm.

Coll.: *Guise.*

Lit.: *Berenson 1903, no. 1051; Colvin 1903–07, I, pls. 18, 19; Bodmer 1931, pp. 158–159;* Commissione Vinciana, *III, pls. 99, 100; Popham 1946, nos. 107, 108; Pedretti 1954, pp. 175–177; Pedretti 1957, pp. 54–61; Byam Shaw 1972, no. 34* recto*; Byam Shaw 1976, no. 17 recto.*

Christ Church.

Pedretti discovered this to be precisely the sheet of allegories described and interpreted by Lomazzo in his *Trattato dell'arte de la pittura* (Milan 1584, pp. 449–451), and thus Lomazzo must have had the drawing before his eyes at the time. At the centre, this complicated allegory shows Envy, with a mask, riding a figure of death. At the right of the sheet, the two bodies that rise from the same pair of legs represent the duplicity of Virtue and Envy that are born together. According to Pedretti the drawing is to be dated 1485–87.

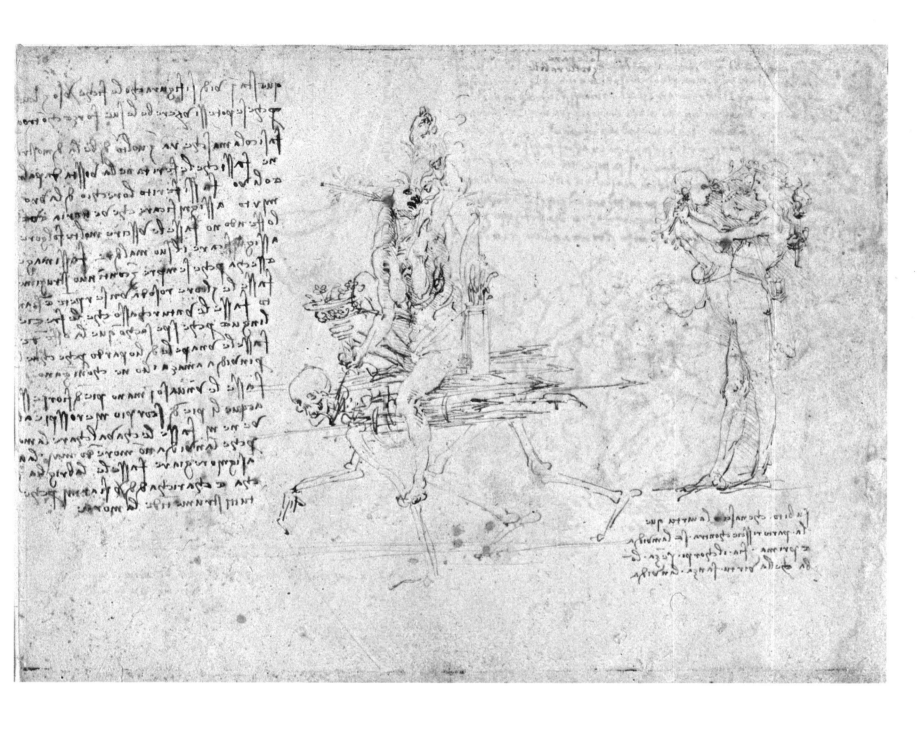

BERNARDINO LUINI

The painter Bernardino Luini was probably born in Milan in about 1490 and died in 1532. His first documented works come from the early years of the 16th century. Motifs derived from Borgognone, Bramante, and even Vincenzo Foppa can be detected in his painting, along with the far more important Leonardesque influence. In fact, Luini was for long considered a pupil of Leonardo. Ottino della Chiesa has hypothesized a trip to Rome in about 1508, but Luini's works show little trace of such an experience. Bernardino's inventive capacity was relatively limited but he was strongly endowed with an ability for the treatment of surfaces. The typically Lombard aspects of his style are the very ample distribution of figures and draperies within the light, colour, and space, the tendency to simplicity, a gracefulness of both expression and composition, the latter balanced and never dramatic, and a sensibility to the beauty of surfaces, which, however, are immediately dematerialized by the light. Like Fra Bartolomeo in Florence, in Milan Luini was the major representative of the classical phase of early 16th-century art.

14 Saint Matthew and the Angel

Brush and brown ink, heightened with white, on greyish paper. 166 x 222 mm.

Coll.: *K. T. Parker.*

Lit.: *Parker 1956, no. 286.*

Ashmolean Museum.

The drawing was probably part of a series of the four Evangelists, but no paintings of these subjects by Luini are known. In any case, there seems to be no doubt about the attribution made by Parker, who noted the similarity of the representation with Luini's fresco of *Elijah and the Angel*, formerly in the convent of Santa Maria delle Vetere in Milan and now in the Brera, dated between 1516 and 1521 (Beltrami 1911, p. 80).

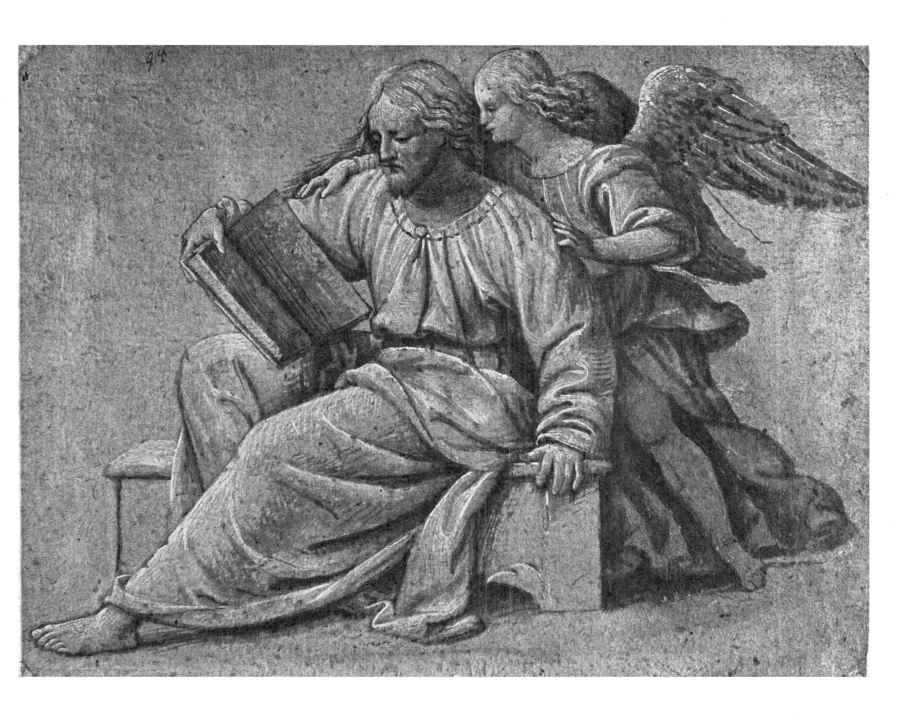

SODOMA

Giovanni Antonio Bazzi, better known as Sodoma, was born in Vercelli in 1477 and died in Siena in 1549. In his native town, between 1490 and 1497, he was a pupil in the shop of Martino Spanzotti. In 1500 he arrived in Siena accompanied by a certain fame, to judge from the numerous and important commissions with which he was very soon entrusted in his new residence. In paintings such as the frescoes of 1503 in the church of Sant'Anna in Camprena, the banners with the *Crucifixion* in Montalcino and in the Pinacoteca Nazionale in Siena, and above all in the frescoes of the cloister of the monastery of Monte Oliveto Maggiore, begun towards 1505, he showed himself capable of grafting onto the Leonardesque foundation of his early Lombard training the suggestions he could derive from the Sienese works of Baldassare Peruzzi or Pinturicchio.

In Rome, where he was for a first time in 1508 and again in 1512, he worked on the ceiling of the Stanza della Segnatura of the Vatican Palace, and for Agostino Chigi he painted the fresco of the *Marriage of Alexander and Roxane* in the Villa Farnesina. In this latter work a classicizing vein of Raphaelesque origin is transcribed in a softly feminine and pleasing decorative idiom. These characteristics were to be progressively accentuated in the paintings produced after his return to Siena, such as the frescoes in the church of San Bernardino of about 1518, the banner with *Saint Sebastian* painted in 1525 and now in the Galleria Pitti in Florence, the frescoes of the *Life of Saint Catherine* carried out between 1526 and 1528 in the church of San Domenico, and those of the Sala del Mappamondo in the Palazzo Pubblico executed in 1529. In these works, not least because of the apparent pressure of so many commissions, Sodoma's style degenerated into empty schemes of a mawkish pedantry.

15 Bust of a young man

Black chalk and wash, heightened with white. 404 x 288 mm.

Colls.: *Vasari (?); Benedetto Luti (?) William Kent (?); Guise.*

Lit.: *Passavant 1836, II, p. 133; Robinson 1870, p. 319; Colvin 1903–07, I, pl. 26; Frizzoni 1904, p. 98; Ricci 1905, p. 775; Cust 1906, p. 114; Bell 1914, p. 85, B. 23; Popham 1931, no. 243; Wagner 1969, pp. 45–47; Byam Shaw 1972, no. 69; Byam Shaw 1976, no. 313.*

Christ Church.

Perhaps the greatest interest of this drawing lies in the possibility that the sitter is Raphael. This identification made by Frizzoni in 1904 was at first contested, but has recently been taken up again by Wagner, who believes it a portrait made in Siena in about 1504 when Raphael was twenty-one. There is indeed an obvious resemblance to the portrait in the British Museum, which Pouncey and Gere (1962, no. 1 *verso*) regard as a self-portrait. Byam Shaw, however, considers this identification uncertain, also because of the retouchings which have modified the expression around the mouth of Sodoma's sitter.

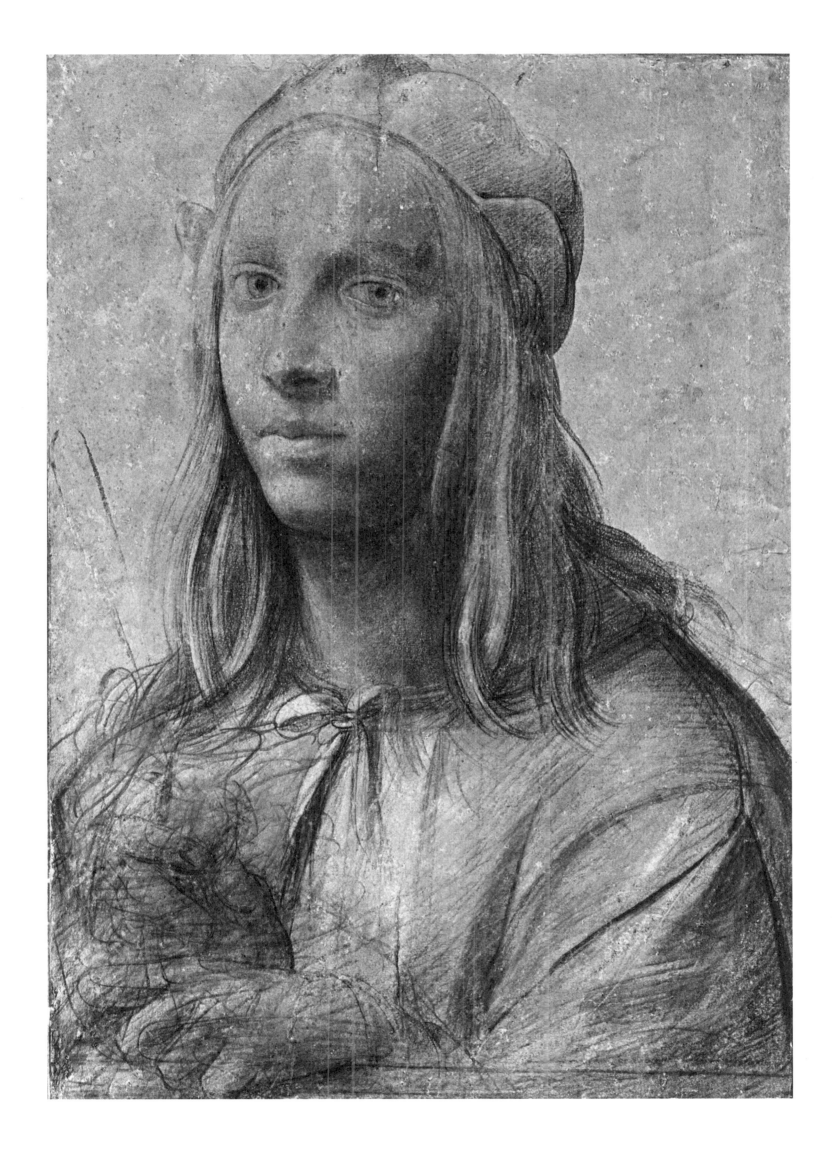

RAPHAEL

Painter and architect, Raffaello Sanzio was born in Urbino on March 28, 1483 and died in Rome on April 6, 1520.

As a very young boy he studied with his father, the painter Giovanni Santi, who died in 1494, and later in Perugia with Perugino, producing his first independent works in the years around 1500. Towards 1503 the young artist seems to have executed some designs and cartoons for Pinturicchio's frescoes in the Piccolomini Library of the Siena cathedral. In 1504 Raphael went to Florence, where he had the opportunity of studying the works of Leonardo and Michelangelo, as well as those of Fra Bartolomeo and the 15th-century Florentine masters. Late in 1508 he was called to Rome by Julius II, and in the service of this pope and his successor, Leo X, he was active at the papal court as both painter and architect. Among the principal works of his Roman years were the frescoes of the Stanze and Logge of the Vatican, the cartoons for the tapestries of the Sistine chapel, and altarpieces such as the *Sistine Madonna* in Dresden, the *Saint Cecilia* in Bologna, and the *Transfiguration* in the Vatican gallery. He also had numerous commissions from great private patrons. First among these was the rich banker Agostino Chigi, for whom Raphael frescoed a chapel in Santa Maria della Pace, painted the famous *Galatea* and the *Loggia of Psyche* in his new villa on the Tiber, later known as the Farnesina, and also built and designed the decoration for his family chapel in Santa Maria del Popolo. In the last years of his short life Raphael was much occupied with architectural projects and archaeological investigations. He succeeded Bramante in the direction of the building works of Saint Peter's and designed the summer residence, now known as Villa Madama, of Cardinal Giulio de' Medici, Leo X's nephew and future Pope Clement VII. From his very earliest activity Raphael demonstrated an innate sense for harmonious composition and limpid spatial organization. With untiring energy he analysed each new artistic trend, continually enriching and rendering monumental the figurative ideal inherited from Perugino. Through the constant practice of drawing from life and from works of classical antiquity, Raphael achieved an ever greater expressive ability, creating human images imbued with distinct and individual personalities, that yet conformed to a perfect classical canon of proportion, movement, and expression.

16 Studies of two guards

Silverpoint, heightened with white, on paper primed pale-grey. 320 x 220 mm.

Colls.: *Alva; Lawrence (Lugt 2445); Woodburn.*

Lit.: *Passavant 1860, II, p. 501, no. 479; Fisher 1862, no. 3; Robinson 1870, no. 12; Ruland 1876, p. 39; Fischel 1898, no. 394 A; Parker 1956, no. 505.*

Ashmolean Museum.

This sheet belongs to the group of Raphael's earliest drawings, prior to 1504. The two soldiers have evidently been studied for a representation of the Resurrection: one is sleeping and the other rises up with a gesture of wonder. The technique, typical of Raphael's pre-Florentine drawings, is still clearly Umbrian in the extreme refinement of the outlines and the enamel-like reflections of the highlights.

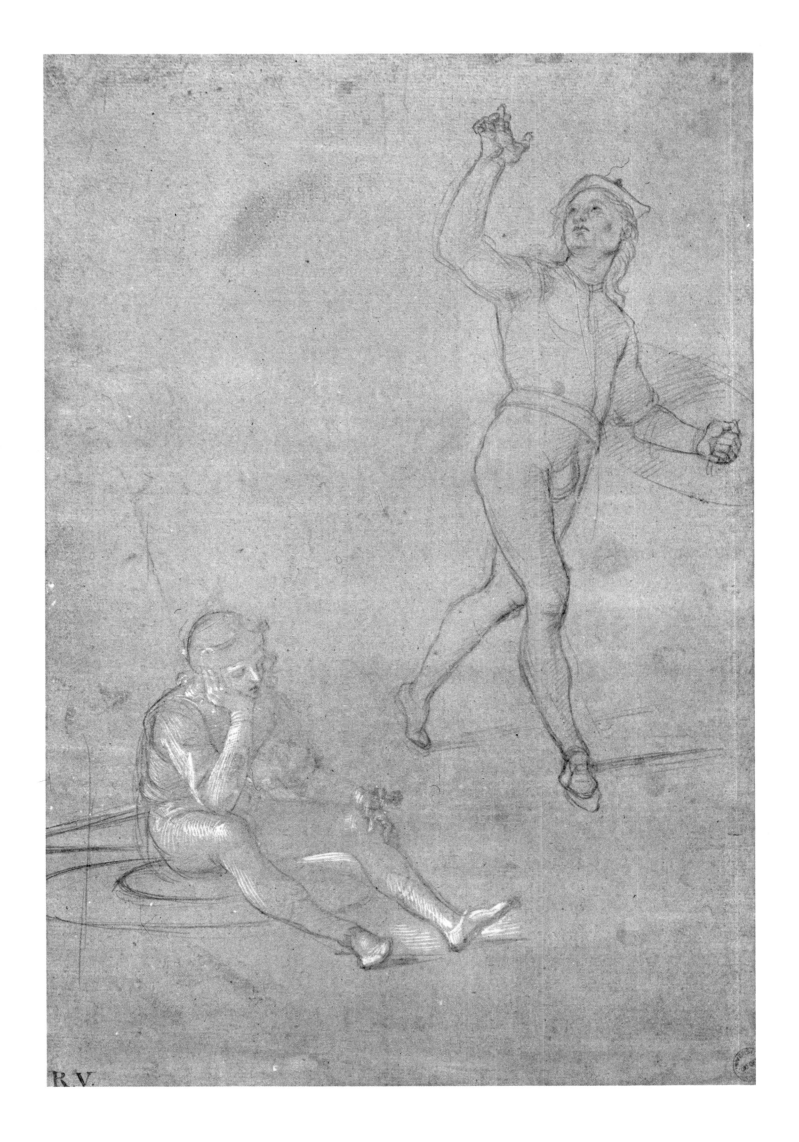

17 Seven putti at play

Pen and brown ink. 145 x 214 mm.

Colls.: *Lanière (Lugt 2886); J. Richardson, Sen. (Lugt 2184); Guise.*

Lit.: *Passavant 1836, II, p. 131; Passavant 1860, II, p. 514, no. 561; Robinson 1870, pl. 2; Ruland 1876, p. 141; Crowe-Cavalcaselle 1882–85, II, p. 547; Fischel 1898, no. 491; Bell 1914, p. 78, D. 2; Fischel 1913–41, II, p. 125, no. 102; Parker 1956, p. 275; Byam Shaw 1972, no. 60; Byam Shaw 1976, no. 362.*

Christ Church.

This youthful drawing has been dated by Byam Shaw to 1507–08. The children playing at judge and prisoner recall a Raphael drawing in the Ashmolean Museum (Parker 1956, no. 528). The great freshness of the line and the very immediate, lifelike treatment of the subject seem to discredit Fischel's suggestion that Raphael was here inspired, rather than by nature, by the frieze of Donatello's pulpit in San Lorenzo in Florence.

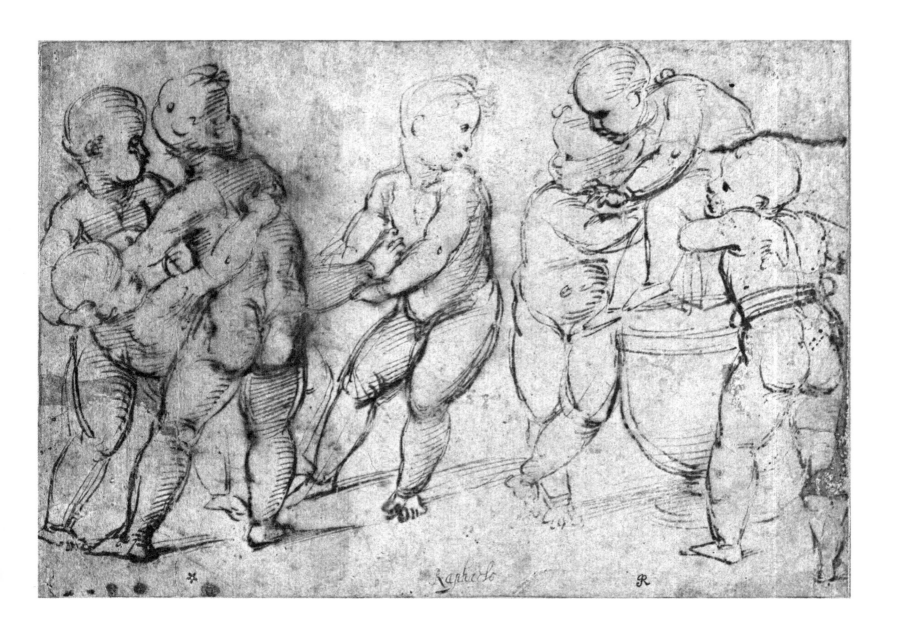

18 Two studies for a Madonna and Child with Saint John

Pen and brown ink. 248 x 204 mm.

Colls.: *Viti-Antaldi (Lugt 2245); Josi; Lawrence (Lugt 2445); Woodburn.*

Lit.: *Fisher 1852, no. 11; Passavant 1860, II, p. 501, no. 483; Robinson 1870, no. 47; Ruland 1876, p. 59; Colvin 1903-07, II|1, pl. 12: Fischel 1913–41, III, p. 138, no. 112; Parker 1956, no. 516.*

Ashmolean Museum.

Ruland was the first to observe the relationship of this drawing with the *Madonna del Cardellino* in the Uffizi. This is somewhat more evident in the smaller study, especially in the pose of the Child and the motif of the Madonna with the book. The sheet is in any case a preparatory drawing, as demonstrated by the representation of the figures nude, to be covered later with draperies. The same procedure is seen in other Raphael drawings in the collection: no. 518 for the *Madonna of the Meadow* in Vienna and no. 502 related to the *Diotallevi Madonna.*

On the *verso* is a sketch of an architectural niche with a barrel vault and circular window.

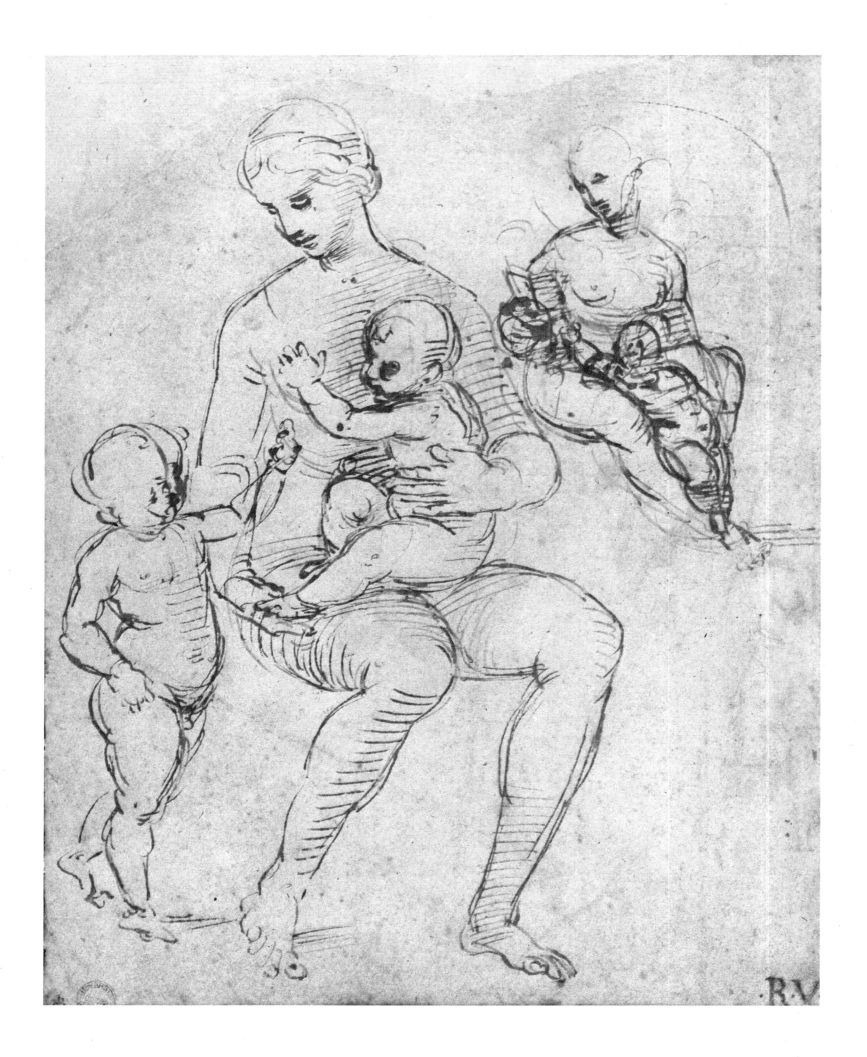

·R·V

19 Madonna and Child

Silverpoint, heightened with white, on paper primed grey. 161 x 128 mm.

Colls.: *Lagoy (Lugt 1710); Lawrence (Lugt 2445); Woodburn.*

Lit.: *Passavant 1860, II, p. 502, no. 489; Fisher 1862, no. 23; Robinson 1870, no. 79; Ruland 1876, p. 97; Fischel 1898, no. 441; Fischel 1913–41, VIII, p. 384, no. 376; Parker 1956, no. 561.*

Ashmolean Museum.

The sheet belongs to a group of late drawings executed in Rome after 1514. Although not precisely related to any particular painting, Fischel compared it to the figures at the lower left in the fresco of the *Mass of Bolsena.* It is not certain that the white highlighting was not retouched at some later time, nor has it been proven that the sheet comes from one of the two books of sketches on primed paper from Raphael's late Roman period.

Parker observed that Reynolds probably made use of this drawing in his portrait of *Countess Spencer and her Son* in the Huntington collection. Reynolds, however, changed the composition and inscribed it in a triangle, raising one of the heads and adding a dog at the lower right.

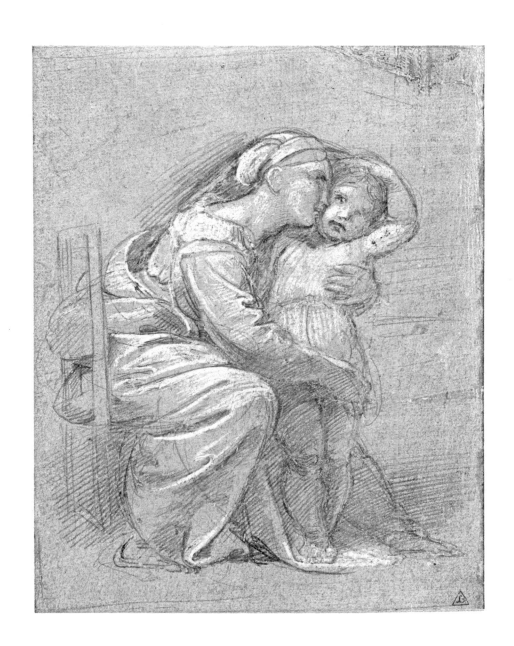

MICHELANGELO

Sculptor, painter, and architect, Michelangelo Buonarroti was born in Caprese near San Sepolcro on March 6, 1475 and died in Rome on February 18, 1564.

In 1488, Michelangelo was apprenticed for a term of three years to Domenico and Davide Ghirlandaio in Florence. But he very soon left them to study from the antique sculptures collected in the Medici garden at San Marco, guided by the sculptor Bertoldo. At the end of 1494 he was for a while in Bologna. In 1496 he went to Rome for the first time and there sculpted his *Bacchus* and the famous *Pietà*. In the spring of 1501 he returned to Florence, where in March of 1504 he completed his *David*. Towards the end of the same year he began the cartoon for the *Battle of Cascina*.

In the spring of 1505 Julius II summoned him to Rome and entrusted him with the commission for his tomb. In 1508 Michelangelo began the fresco decoration of the Sistine chapel, finished on October 31, 1512. After having worked at length on the tomb project, in 1516 he returned to Florence. Here he was entrusted with the design for the façade of San Lorenzo. In 1520, he began work on the Medici tombs and, in 1524, on the design of the Laurentian Library.

Again in Rome, in November 1536 he began work on the fresco of the *Last Judgement* in the Sistine chapel, completed October 31, 1541. In August of 1542 he began the frescoes in the Pauline chapel of the Vatican, finished in 1550. In 1545 work was concluded on the tomb of Julius II. Michelangelo's architectural activity in Rome began in 1546. He designed the Piazza del Campidoglio and its buildings, and after Antonio da Sangallo the Younger's death, became architect of Saint Peter's and also completed Palazzo Farnese. In his final years he designed the Porta Pia, as well as unexecuted projects for San Giovanni dei Fiorentini, and worked on the Rondanini *Pietà*.

Attracted by the beauty of this world Michelangelo was at the same time overwhelmed by the immensity of transcendental nature, in which he felt above all its tremendous, awe-inspiring aspects. He was first and foremost a sculptor: his painting and drawing are dominated by the overruling interest in movements and expressions of the human figure, conceived as though extracted and liberated from the sculptural block that had enclosed it; as architect he conceived wall surfaces and architectural members as plastically configured masses.

20 Female head

Red chalk. 205 x 165 mm.

Colls.: *Casa Buonarroti; Wicar; Lawrence (Lugt 2445); Woodburn.*

Lit.: *Fisher 1862, no. 13; Robinson 1870, no. 10; Colvin 1903–07, I/2, pl. 33; Frey 1911, no. 172 B; Brinckmann 1925, no. 30; Berenson 1938, no. 1552; Tolnay 1943–54, II, p. 209; Goldscheider 1951, no. 65; Popham-Wilde 1953, no. 34; Parker, 1956, no. 315.*

Ashmolean Museum.

In the past this drawing was generally dated in the period of the Sistine chapel (1508–12) and related, even if not specifically, to that work. Beginning with Berenson, however, scholars have tended to a later dating. Goldscheider and Wilde consider it an independent drawing made as a gift for some *amateur* and relate it to the group executed for Gherardo Perini about 1522. Parker finds this conjecture acceptable stylistically, but on the other hand, while relating the sheet to the Perini group, Goldscheider dates it as late as 1528–30 and Wilde as early as 1516. Certainly to be rejected is Tolnay's opinion that the drawing is an imitation of Michelangelo by Bachiacca, who surely never achieved such outstanding quality.

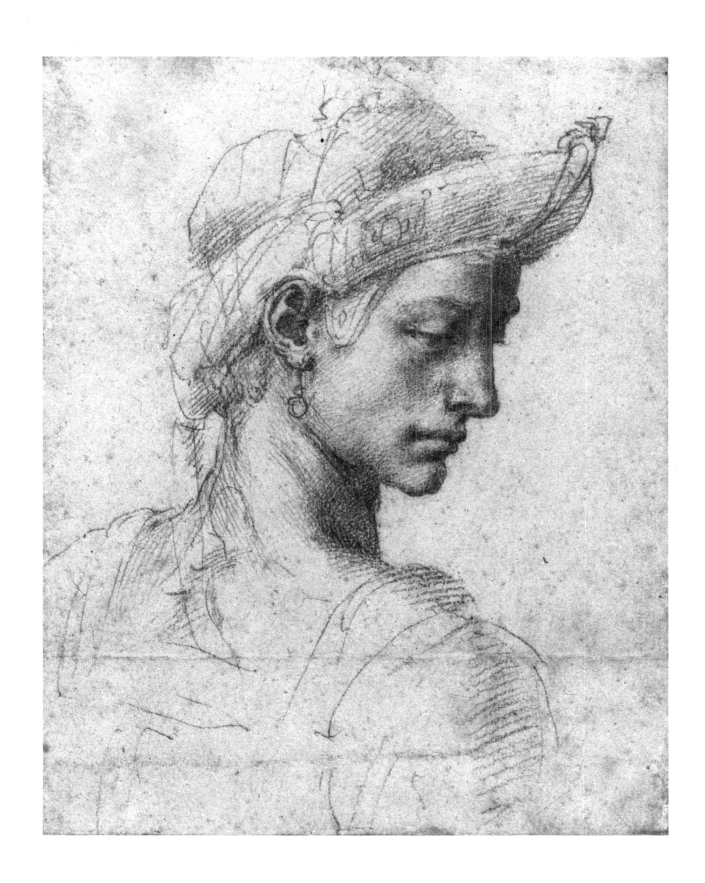

21 The Adoration of the brazen serpent

Red chalk. 244 x 335 mm.

Colls.: *Casa Buonarroti; Wicar; Lawrence (Lugt 2445); Woodburn.*

Lit.: *Robinson 1870, no. 29; Colvin 1903–07, I/2, no. 35; Frey 1911, no. 51; Brinckmann 1925, no. 45; Tolnay 1943–54, III, no. 107; Goldscheider 1951, no. 91; Popham-Wilde 1953, no. 98; Parker 1956, no. 318.*

Ashmolean Museum.

The two groups of figures, in which Michelangelo creates a stupendous dynamic effect of impressive plasticity with the simple medium of red chalk, refer to the Biblical episode of the invasion of serpents. The upper group shows the desperate struggle against the serpents; the lower, the crowd thronging to behold the miraculous brazen serpent. For a long time these two designs were naturally related to the fresco of the Brazen Serpent in the Sistine chapel (Robinson and Berenson). Frey was the first to reject this relationship, principally on the basis of the graphic style, which he considered to conform with that of the 1530s. Goldscheider too dated this sheet in the 1530s, contemporary with the drawings executed for Tommaso Cavalieri. Popham and Wilde preferred the somewhat earlier date of 1528. Parker also cited the theory of A. E. Popp (*Die Medici-Kapelle Michelangelos*, Munich 1922, p. 158 ff.), who related these two designs to the frescoes that were to have been painted in the lunettes above the tombs in the Medici chapel: one representing the plague of the serpents, the other, the stricken cured by the miraculous brazen serpent. Parker, however, was not persuaded by this theory, which was supported by Brinckmann and Tolnay.

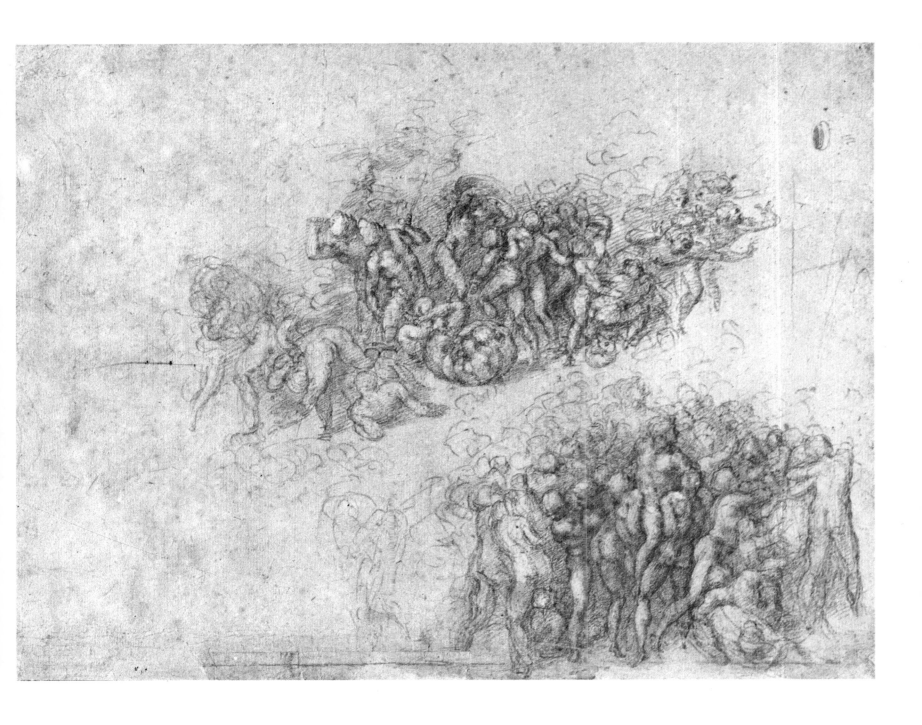

22 The Deposition of the dead Christ

Red chalk, on buff paper. 375 x 280 mm.

Colls.: *Vivant-Denon (Lugt 779); Lawrence (Lugt 2445); Woodburn.*

Lit.: *Fisher 1862, no. 9; Robinson 1870, no. 37; Colvin 1903–07, I/2, pl. 38; Frey 1911, no. 150; Brinckmann 1925, no. 76; Berenson 1938, no. 2491; Goldscheider 1951, no. 88; Popham-Wilde 1953, no. 95; Parker 1956, no. 342.*

Ashmolean Museum.

The attribution of this drawing to Michelangelo is now almost unanimously accepted. Berenson, however, preferred to ascribe the sheet to Sebastiano del Piombo. This was actually an old idea of Wickhoff's (*Jahrbuch der Preussischen Kunstsammlungen* 1899, p. 202) that had been followed by Colvin and Frey. But recent scholars of Sebastiano's graphic art, L. Dussler and R. Pallucchini, do not accept the attribution.

Parker has no doubt that the sheet is by the hand of Michelangelo and relates it to two other drawings of Pietàs in the Albertina in Vienna (no. 135) and the Louvre. It is certainly a work of the master's late period, in the 1550s, and is undoubtedly related to his various Pietàs, from that of the Florence cathedral on.

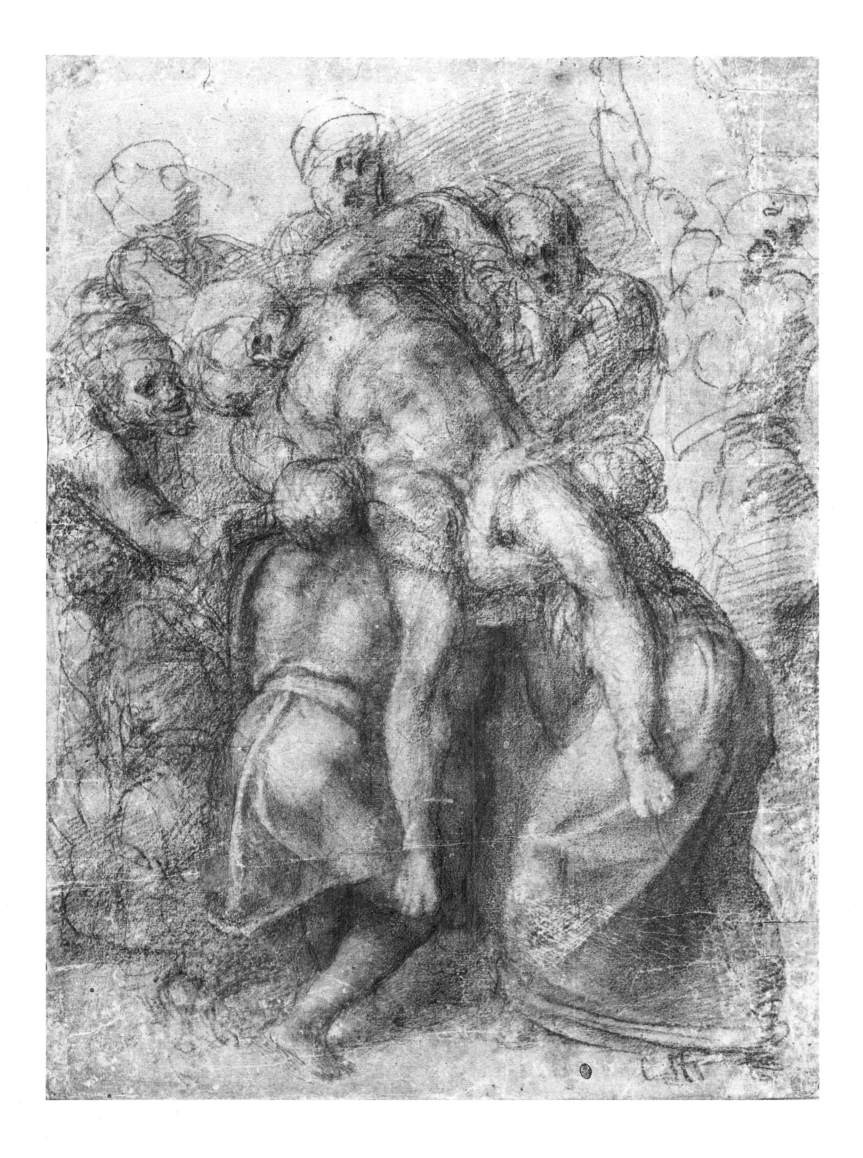

FRA BARTOLOMEO

Bartolomeo di Paolo del Fattorino, called Baccio della Porta, was born in Florence probably prior to February 18, 1472 and died on October 6, 1517 in the Dominican monastery of San Marco in Florence or in Pian del Mugnone.

Between 1484 and 1490 he worked in Cosimo Rosselli's shop and there met Piero di Cosimo, as well as Mariotti Albertinelli, with whom he was often to collaborate. In 1496, deeply moved by Savonarola's preaching, he burned his paintings and abandoned the profession of painter. In 1500 he entered the monastery of San Domenico in Prato. Four years later the prior of the monastery of San Marco in Florence, Sante Pagnini, persuaded him to resume painting and in 1505 Fra Bartolomeo became head of the painting workshop of San Marco. Between April and June of 1508 he was in Venice and in 1514 made a trip to Rome. Fra Bartolomeo re-elaborated the various tendencies of late 15th-century Florentine art, combining them with new ideas acquired from Leonardo, and developed an artistic expression based on careful and stable compositions and a vision of nature softened by certain idealizing stylizations. From an art of extreme delicacy he gradually developed a language of great monumentality and rhetorical impressiveness, in which his visits to Venice and Rome certainly played a notable part.

23 Saint Antoninus distributing Alms

Pen and brown ink, with grey wash. 122 x 142 mm.

Lit.: Sotheby Sale, *November 19, 1952, lot 8; Colnaghi,* Old Master Drawings, *1953, no. 2, pl. V; Parker 1956, no. 104.*

Ashmolean Museum.

On the *verso* are studies for the niche behind the saint's throne and an inscription in the artist's hand, difficult to decipher: *tene istud up prob... | si euenire potest.*

Here on the *recto*, the Almsgiving of Saint Antoninus, Archbishop of Florence, is sketched by Fra Bartolomeo in his mature style, probably in the second decade of the 16th century. This subject was to be taken up again in Venice by Lorenzo Lotto in his altarpiece of 1542 for the church of Santi Giovanni e Paolo. Fra Bartolomeo's drawing was almost certainly related to a work destined for Rome, since a drawing of similar style, representing Saint Antoninus standing with a dove above his head and flanked by angels (subject identified by Byam Shaw), is to be found in the collection of the Farnesina in Rome (Berenson 1938, no. 506). Parker observed that the attribution is further confirmed by the fact that an inscription in the same hand appears on the *verso* of a Fra Bartolomeo drawing in the Uffizi (Berenson 1938, no. 286).

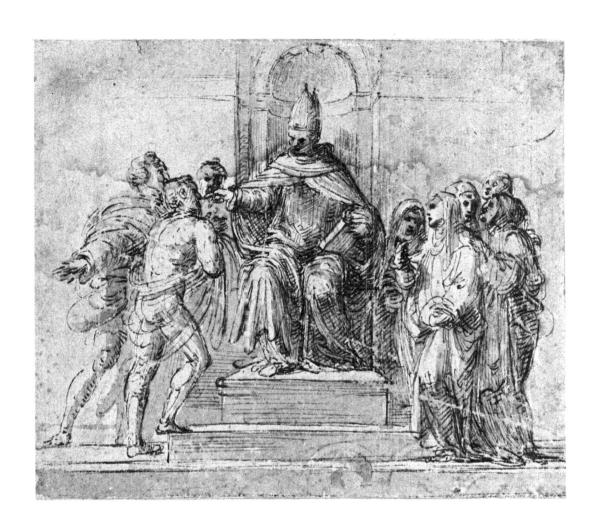

ANDREA DEL SARTO

The painter Andrea Lanfranchi, called del Sarto after his father's trade of tailor, was born in Florence on July 16, 1486 and died in Florence of the plague on September 28, 1530.

According to Vasari he served a first apprenticeship with a goldsmith and later entered Piero di Cosimo's workshop. In 1506 he opened his own shop together with Franciabigio and in about 1511 he shared a studio with Jacopo Sansovino. Between May 25, 1518 and October 17, 1519 Andrea was court painter to Francis I at Fontainebleau. In about 1520 he was probably in Rome, whence in 1523 he fled from the plague to San Piero a Luco in the Mugello, remaining there for a year. After Fra Bartolomeo, Andrea was the major artistic personality in Florence during the first three decades of the 16th century. He very quickly developed a refined and monumental style, animated by the striking penetration of his emotive expressions and marked by the eloquent simplicity and solemnity of his compositions. His artistic language indeed remained faithful to the Florentine tradition of a rhythmical articulation of solidly composed and structured forms.

Andrea del Sarto was extremely important for the subsequent development of Florentine painting, not only through his pupils Rosso and Pontormo, but above all for the influence his works exercised on artists of the late 16th and early 17th centuries. Virtuoso of both painting and drawing, especially in the latter field he manifests his extraordinary ability in the translation of space and light into geometric elements of form.

24 Head of Saint Elizabeth

Red chalk. 250 x 186 mm.

Colls.: *Wicar; Lawrence (Lugt 2445); Woodburn.*

Lit.: *Fisher 1862, no. 24; Robinson 1870, no. 130; Ruland 1876, p. 77; Crowe-Cavalcaselle 1882–85, II, p. 473; Fischel 1898, no. 333; Knapp 1907, p. 135; Fraenckel 1935, pp. 85, 181, 232; Parker 1956, no. 692.*

Ashmolean Museum.

At one time considered within the realm of Raphael's drawings, this sheet was attributed to Andrea del Sarto by Crowe and Cavalcaselle. The attribution was confirmed by Knapp and again by Fraenckel, who identified the head as that of the Saint Elizabeth in del Sarto's *Madonna and Child with Saint Elizabeth and Saint John* in the Palazzo Pitti, painted in 1528–29. Similar studies for the Christ Child and Saint John are in the Albertina and the Louvre (Pouncey 1953, p. 97).

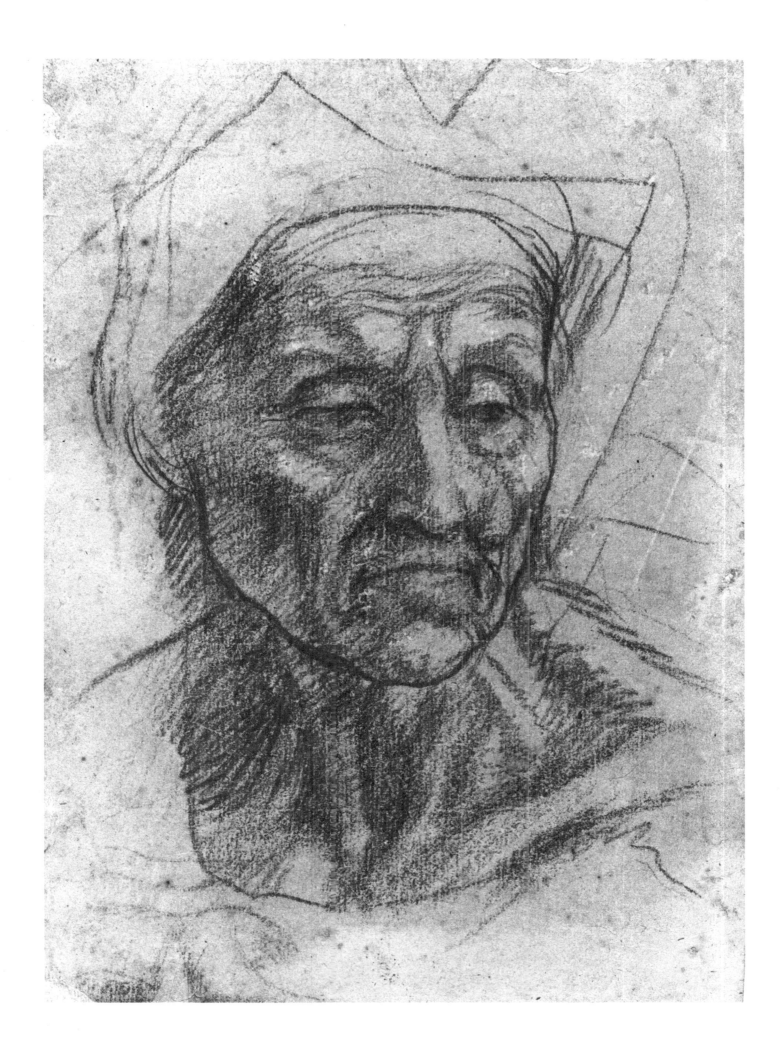

PONTORMO

Jacopo Carucci, called Pontormo after the small village near Empoli where he was born in 1494, died in Florence in 1557.

Pontormo is undoubtedly one of the most disquieting artistic personalities of the entire 16th century, and the principal and most complete interpreter of the first generation of Mannerism. He translated into an exemplary style, born of genius together with the strictest application, the profound psychological perturbations and existential drama of a morbidly sensitive spirit, thus becoming the spokesman of the complex and multiform crisis that agitated the world in which he lived.

After passing a brief time in the workshops of Leonardo, Piero di Cosimo, and Mariotto Albertinelli, from 1512 to 1514 he worked alongside Andrea del Sarto. In 1518 he produced his first great masterpiece, the *Madonna and Child and Saints* commissioned by Francesco Pucci for the Florentine church of San Michele Visdomini. The principal subsequent phases of his extraordinary activity are represented by the following works: the frescoes painted in 1520–21 in the Medici villa at Poggio a Caiano; those just a bit later in the large cloister of the Certosa of Galluzzo; the hallucinating *Deposition* of 1525–28 in the Florentine church of Santa Felicità; the *Visitation* in the Collegiata of Carmignano; and finally, the frescoes, which occupied him until his death, in the choir of the church of San Lorenzo in Florence, unfortunately no longer existing but attested by a stupendous series of drawings.

Truly great exponent of the most authentic tradition of Florentine design, Pontormo fused in a refined and obsessively intellectualized style a host of extremely diverse conceptions extracted from his surrounding artistic culture. These included the subtle psychological effect of Leonardo's *sfumato*, inspirations derived from Piero di Cosimo's bizarre eccentricities, as well as from Andrea del Sarto's eloquent academicism, Michelangelo's great examples that exercised an almost magnetic attraction upon him, and the intellectualized formalism of northern European prints, especially those of Dürer.

25 The Deposition of the dead Christ

Black chalk, heightened with white; squared in red chalk. 443 x 276 mm.

Colls.: *J. Richardson (Lugt 2184); Guise.*

Lit.: *Jeudwine 1959, p. 144; Berenson 1961, I, p. 461; Cox Rearick 1964, no. 272, pl. 254; Pouncey 1964, p. 290; Byam Shaw 1972, no. 58; Byam Shaw 1976, no. 119.*

Christ Church.

Strangely enough attention has been drawn to this important Pontormo sheet only recently, by Jeudwine, who recognized it as the preparatory drawing for the artist's altarpiece in the Capponi chapel of Santa Felicità in Florence, painted between 1525 and 1528. For the same work there exist many drawings of details in the Uffizi and the British Museum (Cox Rearick 1964).

In the upper part the drawing has been perforated for copying, but the rest is in excellent condition.

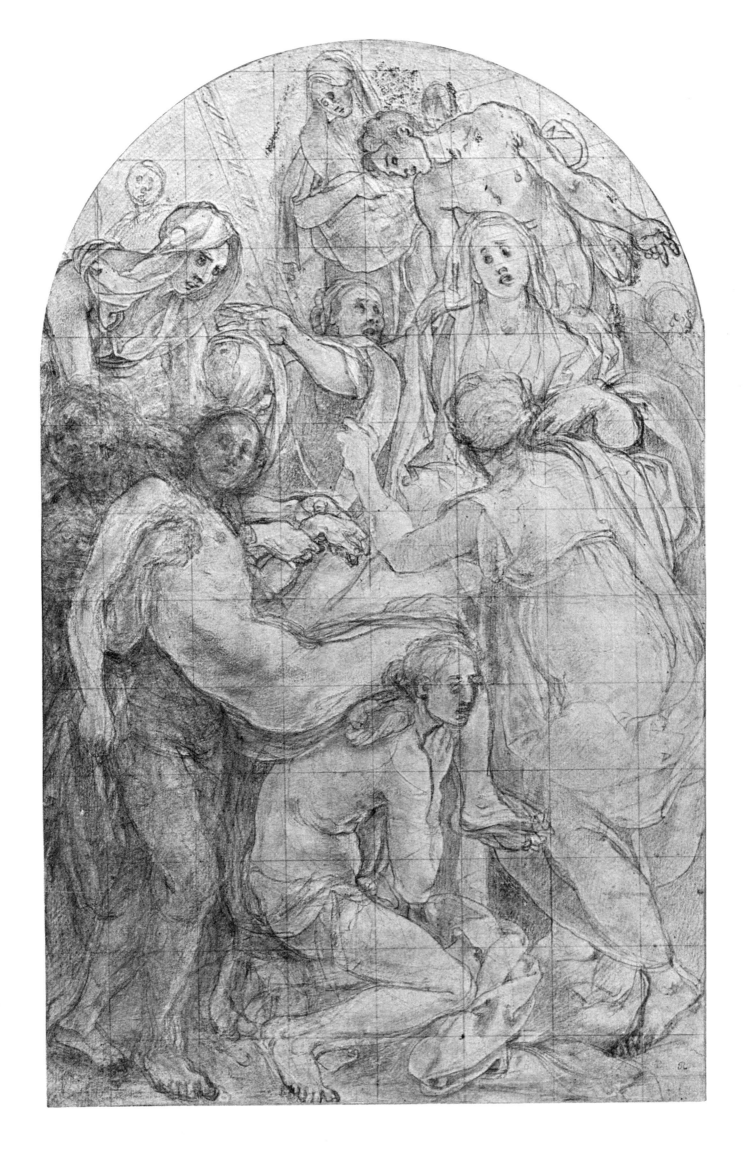

ROSSO FIORENTINO

Giovan Battista di Jacopo, called Rosso, was born in Florence in 1495 and died at Fontainebleau in 1540. Like Pontormo he developed in almost total independence of any school or workshop, preferring to form his style autonomously, even if it did not exclude those influences that from time to time proved particularly consonant with his own personality. In first place among these were the studies he made after Michelangelo's cartoon of 1504 for the *Battle of Cascina,* one of the fundamental texts for the whole first generation of Mannerists, which according to Vasari Rosso copied attentively. Equally important for his development were Albecht Dürer's prints, which circulated in great numbers in Florence in the first decade of the 16th century and stimulated Rosso's eccentric spirit with their exaggerated formalism so unusual in Italy. All these elements, together with a certain influence from Bandinelli's graphic style, were constants of Rosso's stylistic expression and present even in his youthful masterpieces, such as the *Descent from the Cross* in the Galleria Comunale of Volterra (1521), the *Madonna and Child with Saints* painted for the Dei family and now in the Galleria Pitti (1522), or the *Marriage of the Virgin* in the Florentine church of San Lorenzo (1523).

In 1523 Rosso was in Rome, where he worked for Clement VII and whence he fled four years later during the sack of the city by the troops of Charles V. This flight began a period of peregrinations through Italy, in the course of which he produced the *Deposition* in the church of San Lorenzo in Borgo San Sepolcro and the *Transfiguration* in the cathedral of Città di Castello (1528). This period ended when Rosso was summoned to France as official artist at the court of Francis I. Here he spent the last years of his life in intense activity, creating among other things the extraordinary *Pietà* now in the Louvre. But most importantly, in this position he became, along with Primaticcio, the principal representative of the school of Fontainebleau, which was one of the fundamental components of international Mannerism.

26 Decorative panel

Pen and brown ink, with grey wash, heightened with white, on paper primed brown. 425 x 536 mm.

Colls.: *P. Lely (Lugt 2092) ; Guise.*

Lit.: *Bell 1914, p. 83; Byam Shaw 1972, no. 64; Byam Shaw 1976, no. 125.*

Christ Church.

The armorial bearings of Cardinal Jean de Lorraine inserted in the design suggest that the drawing belongs to Rosso's final period, passed in France up to his death in 1540. The Cardinal's arms, however, here appear in the form assumed after 1547 and thus must have been corrected after the artist's death. The subject is the illustration of a fragment of Petrarch's *Rime,* which describes a vision of a beast with a human face pursued by two dogs. Rosso probably intended this for a mural decoration with stuccoes, like those in the Gallery of Francis I at Fontainebleau (1536–40).

Byam Shaw has noted that Cardinal Lorraine's family was related to the de Guise Cardinals, perhaps considered distant ancestors of John Guise, the former owner of the drawing.

Standomi un giorno solo a la senestra
mà come vidi ch'era tanto honesta,
d'uno vel di morte, non so come, presta
una pena si aspra, che ne mai
un fermo. Non so come si prende una
cassiana, dov'ha ventre un velo ti bella
che Ven et l'altro guasto
de la vita offrì subentrato al core,
che'l pensa ognor immortal al pianto
era chiusa, in vita poi
movea vada de la vista, condur morte
se mi fu sempre sua dolce sorte.

BRONZINO

Agnolo di Cosimo Tori, called Bronzino, was born in Florence on November 7, 1503 and died there in 1572. Bronzino entered the pictorial scene when the phenomenon of Mannerism was already an accomplished fact, completely accepted by local taste and culture. After a brief time spent in Raffaellino del Garbo's workshop, which had no really important effect on his formation, Bronzino acquired his education from the example of Pontormo and precisely in the moment the latter was involved with the frescoes of the Certosa of Galluzzo and his work for the Florentine church of Santa Felicità. Nevertheless, Bronzino did not experience that profound existential and psychological crisis of his master, who all his life was a solitary figure. Instead, very early Bronzino entered the mundane world of the Medici court, becoming one of its most esteemed artists. In 1529 he was summoned by the Medici to collaborate on the decorations erected in Florence for the marriage of Duke Cosimo to Eleanor of Toledo. His part in this enterprise must have been so admired that he was immediately thereafter entrusted with another commission of great prestige: the pictorial decoration of Eleanor's private chapel in the Palazzo Vecchio, a work in which Bronzino left one of the best examples of his refined and cerebral style. Also for the Medici he created a series of extraordinary portraits, among which are the famous *Portrait of Eleanor of Toledo with Her Son Don Giovanni*, executed about 1550 and now in the Uffizi, as well as various cartoons for a series of tapestries destined for the Sala del Dugento in Palazzo Vecchio. From this moment on, however, Bronzino was caught up in the moralistic spirit of the Counter Reformation, the effects of which are most noticeable in his religious paintings. Consequently his style lost that tone of profane elegance that had been one of the outstanding features of his art, and assumed instead a suffocating over-elaboration, which lowered the quality of his pictorial production.

27　Nude woman

Black chalk, heightened with white, on paper primed buff. A piece 35 mm. in height was added to the head at a later date. 353 x 167 mm.

Coll.: *Gigoux (Lugt 1164)*.

Lit.: *Parker 1957, pp. 33–34; Sutton 1970, p. 14.*

Ashmolean Museum.

Ascribed to Luini in the old collection, the attribution was later changed to Sodoma and the drawing was exhibited as such at the Wildenstein exhibition in 1970. In the catalogue of that exhibition Sutton considered it a variation by Sodoma of a Leonardesque Leda. Recently, however, Byam Shaw (oral communication) has suggested a new attribution to the young Bronzino, which seems more convincing than the preceding ones.

BACCIO BANDINELLI

The sculptor Baccio Bandinelli was born in Florence in 1488 and died there in 1560. He was at first a student of his father, Michelagnolo di Viviano, a successful goldsmith, and later of the sculptor Giovanfrancesco Rustici. It was in Rustici's shop, industriously copying from Michelangelo's cartoon for the *Battle of Cascina*, that he acquired his notable skill as a draughtsman, which also determined the cultivated academicism of his sculptural style. His draughtsmanship shares certain characteristics with that of Rosso.

An artist much appreciated in the Medici circle, he received numerous commissions from various members of this family, both in Florence and Rome. He worked in the papal city at different times. At first for Pope Leo X, who in about 1525 ordered from him, among other things, a copy of the ancient group of the *Laocoön* that was to have been sent as a gift to Francis I of France. Subsequently, Pope Clement VII entrusted to him the major part of the work on the funerary monuments destined for Leo X and himself in the church of Santa Maria sopra Minerva. In addition, Bandinelli received other important commissions in the Republic of Genoa and in Bologna. In this latter city he entered into contact with the Emperor Charles V, to whom he offered a bronze relief of the *Deposition*, and who bestowed upon him the honour of Knight of the Order of Saint James.

Among the artist's more famous works produced in Florence are to be cited: the group of *Hercules and Cacus* (1534) in the Piazza della Signoria; the *Monument to Giovanni delle Bande Nere*, commissioned by Duke Cosimo for the church of San Lorenzo and in the last century set up in the square in front of the church, the eighty-eight marble reliefs with figures of Prophets and Apostles that decorated the octagonal railing of the choir of the cathedral, now in part in the Museo dell'Opera del Duomo; and finally, again for the cathedral, the gigantic sculptural complex that was to have formed the high altar and which is now dismembered and divided between the church and cloister of Santa Croce and the Bargello Museum.

28 Woman reading by a lamp

Red chalk. 253 x 215 mm.

Coll.: *Mrs. J. Franklin-Kohn.*

Lit.: *Parker 1956, no. 79.*

Ashmolean Museum.

This drawing, ascribed to Annibale Carracci when it was acquired in 1954, was attributed by Parker to Bandinelli's youthful period, for its closeness to two other drawings in the Ashmolean collection (nos. 77, 78), perhaps representing the same female model. Parker also cited an engraving by Enea Vico after Bandinelli, representing the latter instructing his pupils in drawing, in which the effect of artificial light is rendered in the same way. Another similar print after Bandinelli, by Agostino Veneziano, dated 1531, offers still further confirmation of the attribution of this evocative drawing.

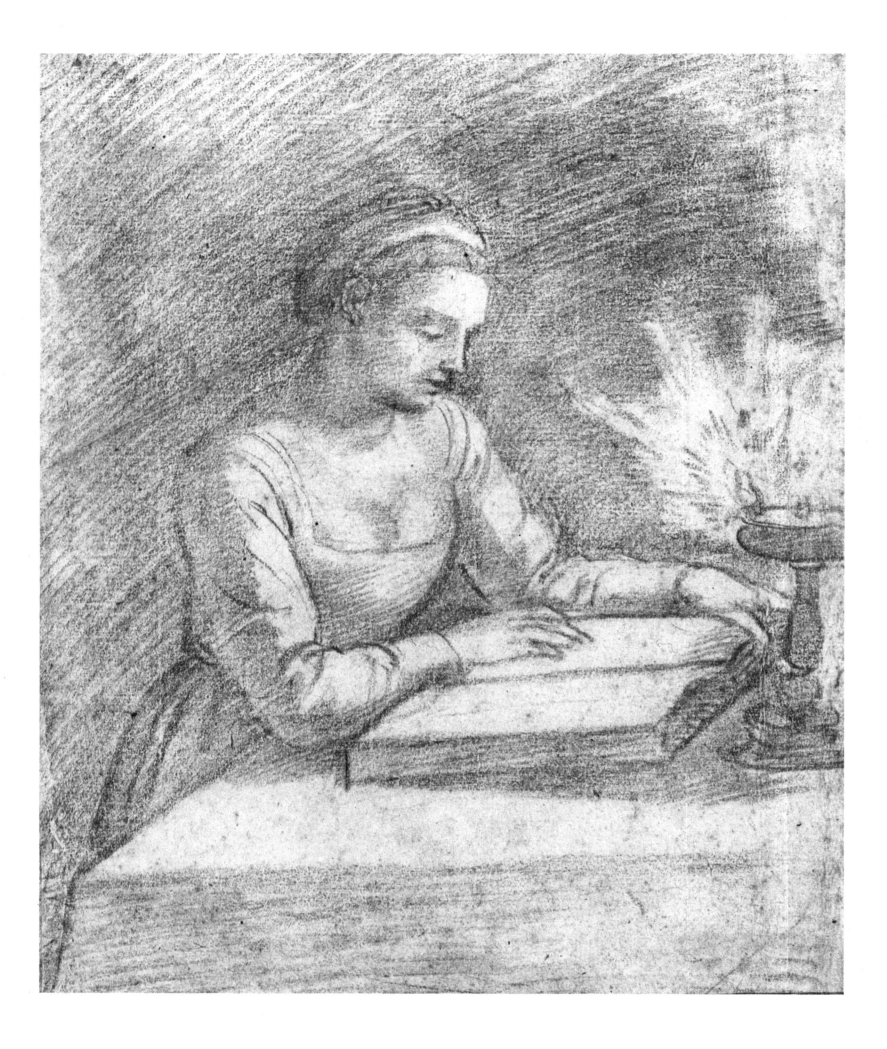

CORREGGIO

Antonio Allegri was born in the Emilian town of Correggio, from which he derives his name, in 1489 and died there in 1534.

He acquired his first artistic education in Mantua from the examples of Mantegna, Lorenzo Costa, and Dosso Dossi. These were the masters who provided the cultural bases for Correggio's paintings such as the *Madonna and Child* in the Kunsthistorisches Museum in Vienna, the *Madonna and Child with Angels* in the Uffizi (1512), the *Nativity* in the Brera in Milan (1513–14), and the *Madonna of Saint Francis* in Dresden (1514–15). Later, his style developed further through new influences. Most important among these was Leonardo's handling of light, reflected in Correggio's works such as the *Campori Madonna* in the Este gallery in Modena, the *Madonna and Child with the Young Saint John* in the Prado in Madrid, and the so-called *Zingarella* in the gallery of Capodimonte in Naples. This Leonardesque influence marked his works until at least 1518. At this time, in the fresco decoration of the Abbess' room in the convent of San Paolo in Parma, Correggio demonstrated his sensitivity to the classicism of Raphael's Roman works. In the successive phases of his intense activity, with incredible ease and results of the highest quality, Correggio applied himself to the most diverse types of pictorial undertakings: the grand fresco decorations carried out in Parma, in the domes of the church of San Giovanni Evangelista (1520–23) and the cathedral (1526–30), that were to influence Baroque painters; the many large altarpieces of a subtle religious piety (the *Madonna of Saint Sebastian* and the *Adoration of the Shepherds*, known as *La Notte*, in Dresden, the *Madonna of Saint Jerome* and the *Holy Family* in the Galleria Nazionale in Parma, and last in order of time, the *Madonna of Saint George*, also in Dresden); and finally, the series of paintings of the *Loves of Jupiter*, imbued with overt sensuality, executed by the artist in his late period, probably for Federico Gonzaga.

29 Study for a wall decoration

Red chalk. 198 x 167 mm.

Colls.: *P. Lely (Lugt 2092); J. Richardson (Lugt 2183); Spencer (Lugt 1531); Chambers Hall (Lugt 551).*

Lit.: *Colvin 1903–07, II/2, pls. 24, 25; Gronau 1907, pls. 99, 100; Venturi 1926, pls. 132, 133; Ricci 1930, p. 214; Brandi 1935, p. 134; Parker 1956, no. 203.*

Ashmolean Museum.

The design on the *recto*, reproduced here, shows figures flanking a round window set within a columned structure; on the *verso*, a similar design with the addition of sphinxes.

Gronau was the first to recognize this sheet as a preparatory sketch for the decoration of the dome of the Parma cathedral, for which no other compositional drawings are known. Although the dome fresco is dated between 1522 and 1530, the dates of the contract and the final payments, work actually began only in 1526 and was still not finished at Correggio's death in 1534. Thus the drawing was made at some time during these nine years.

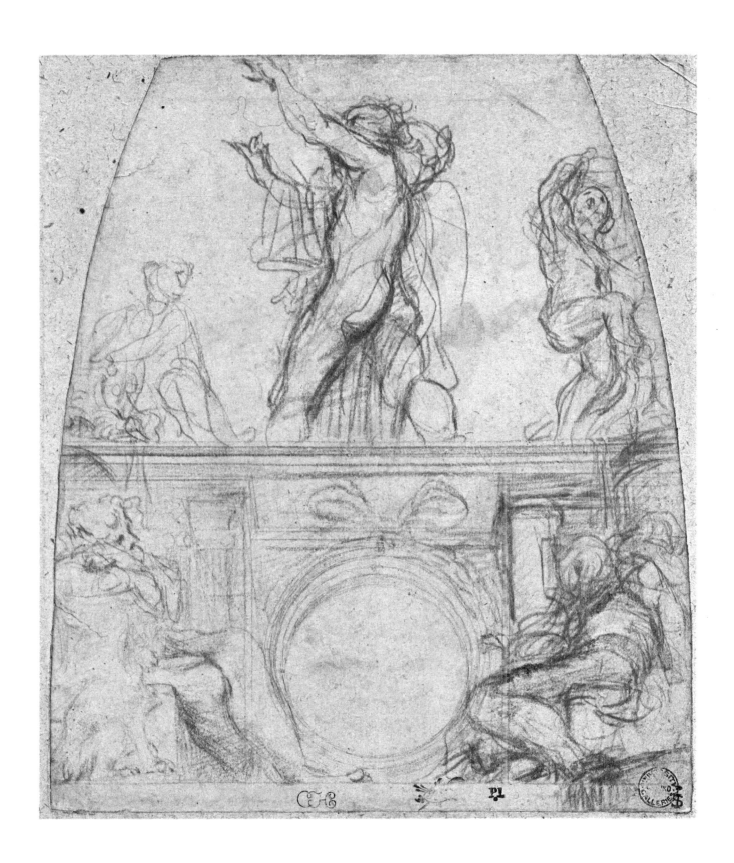

PARMIGIANINO

The painter and etcher Francesco Maria Mazzola, called Parmigianino, was born in Parma on January 11, 1503 and died at Casalmaggiore in 1540.

We do not know who his teachers were but Correggio's and Anselmi's influence are evident in his youthful works. In 1521 he created his first important painting, the altarpiece in Viadana, whither he had fled just before the arrival of the French troops. Not long after this he received the commission for the frescoes in San Giovanni Evangelista in Parma, in which church Correggio was working at the time. Late in 1523 Parmigianino went to Rome and remained there until the sack of the city in 1527, which surprised him while at work on the large altarpiece of the *Vision of Saint Jerome*, now in the National Gallery in London. After a sojourn in Bologna, in 1531 he returned to Parma. Completely taken up by his interest in alchemy (possibly aroused by chemical experiments made in connexion with his etchings) he neglected his work in the church of the Steccata in Parma; in order to avoid a lawsuit, in 1539 he fled to Casalmaggiore, where he died in neglect.

Parmigianino's contemporaries admired the grace and yielding delicacy of his refined creations. His art was a harmonious blending of the North Italian taste for fantastic images and emotive expressivity with the traditional formal clarity of the Tuscan and Roman schools, absorbed during his years in Rome. Draughtsman *par excellence*, Parmigianino had a love of sweeping, flowing lines that evoke life and movement, as well as for precise clarity of graphic notation. The predilection for linear precision is eminently demonstrated in his etchings, while the chiaroscuro prints executed on his designs fully reveal his acute sensibility to the distribution of light and shade. Foremost exponent of Mannerism in Emilia, Parmigianino's imaginative compositions and strikingly elegant figures not only made a great impression on his contemporaries, above all in northern Italy and also in France and Holland, but they became the supreme model of refinement and grace for courtly artists of many successive generations.

30 Drapery study

Black chalk, heightened with white chalk. 232 x 161 mm.

Coll.: *E. Joseph-Rignault (Lugt 2218).*

Lit.: Drouot Sale, *February 13, 1939, lot 16 (Correggio); Popham 1952, p. 31; Parker 1956, no. 442.*

Ashmolean Museum.

This drawing of a partially draped female figure shows on the *verso* a study of a nude baby resting on his mother's breast. The study on the *verso* is similar to a drawing of the 'Madonna and Child' in the École des Beaux-Arts in Paris, as well as to that of a 'Christ Child' in the Musée Condé in Chantilly. Popham related this latter drawing to Parmigianino's painting of the *Vision of Saint Jerome* in the National Gallery in London, attributing also this Oxford sheet to the artist.

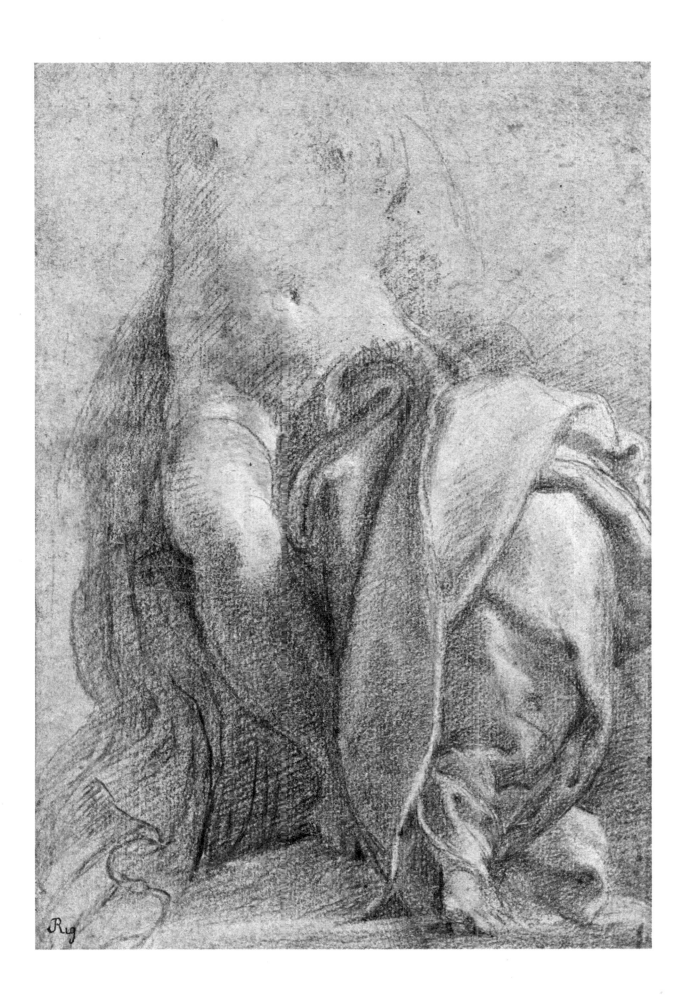

31 Decorative panel

Pen and brush with brown ink and watercolour washes, heightened with white. 102 x 43 mm.

Colls.: *Lanière (Lugt 2886); P. Lely (Lugt 2092); Guise.*

Lit.: *Bell 1914, p. 71, M. 19, A, B, C; Popham 1971, I, pp. 22–25, nos. 347–349, pl. 325; Byam Shaw 1972, nos. 51 a, 51 b; Byam Shaw 1976, no. 1085.*

Christ Church.

This drawing of Saint John the Evangelist is one of a large number of similar sheets which have been identified by Popham as designs for the soffits of the arches in Santa Maria della Steccata in Parma. Parmigianino began his decoration of this church in 1531, but it was still not finished in 1539 when he fled to Casalmaggiore. The thin, elegant figure brings to mind the artist's etchings, which contributed so much to the diffusion of the Mannerist style in northern Italy and elsewhere in Europe.

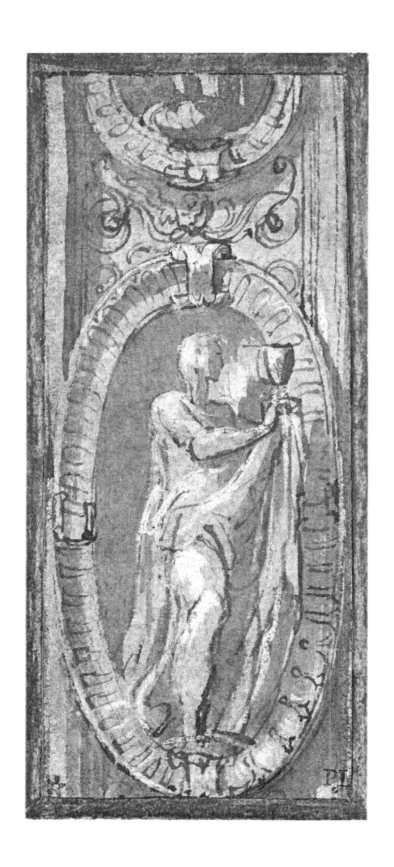

BERNARDINO CAMPI

The painter Bernardino Campi, son of the goldsmith Pietro and perhaps a cousin of the other artists named Campi, was born in Cremona in 1522 and died in Reggio Emilia in 1591.

He was in the workshop of Giulio Campi and had an interest in the Mannerist art of Mantua, where it seems he spent some time. But in his painting, rather than pursuing the Roman monumentality of Giulio Romano's Mantuan works, he sought a delicate, detailed and intimate grace. He is, in fact, distinguishable from the other Campi by his great refinement, which he carefully cultivated and which brought him many pupils, among them Sofonisba Anguissola. He was also aware of the Mannerist art of the northerners who worked in Rome. Bernardino was very active in Cremona and there in 1570 frescoed the *Paradise* in the dome of the church of San Sigismondo. As early as 1550 he worked in Milan, whither he was summoned by Isabella di Capua, wife of the governor of the city, Ferrante I Gonzaga. In 1565 he painted the altarpiece of the *Transfiguration* for one of the right hand altars of the Milanese church of San Fedele, replaced a few years ago with a ceramic altarpiece by Lucio Fontana. In the same year he produced the *Holy Family* in Sant' Antonio Abate in Milan. In 1568 he painted the altarpiece for the altar of the sacristy of the Milanese church of San Marco. He also left works in various localities of the Po valley: in Lodi, Pizzighettone, Piacenza, Parma, and Reggio Emilia, where he worked in San Prospero.

32 Jupiter

Black chalk, heightened with white chalk, on bluish-grey paper; squared. 202 x 157 mm.

Coll.: *Unknown (Lugt 3000).*

Lit.: *Parker 1956, no. 137; Parker 1958, no. 37.*

Ashmolean Museum.

Originally attributed to Parmigianino, Parker authoritatively reattributed this drawing to Bernardino Campi. According to Parker it is a sketch for a wall decoration, possibly the frescoes with stories of Minerva that were once in Casa Trivulzio at Formigara, near Cremona, painted by Bernardino in 1541.

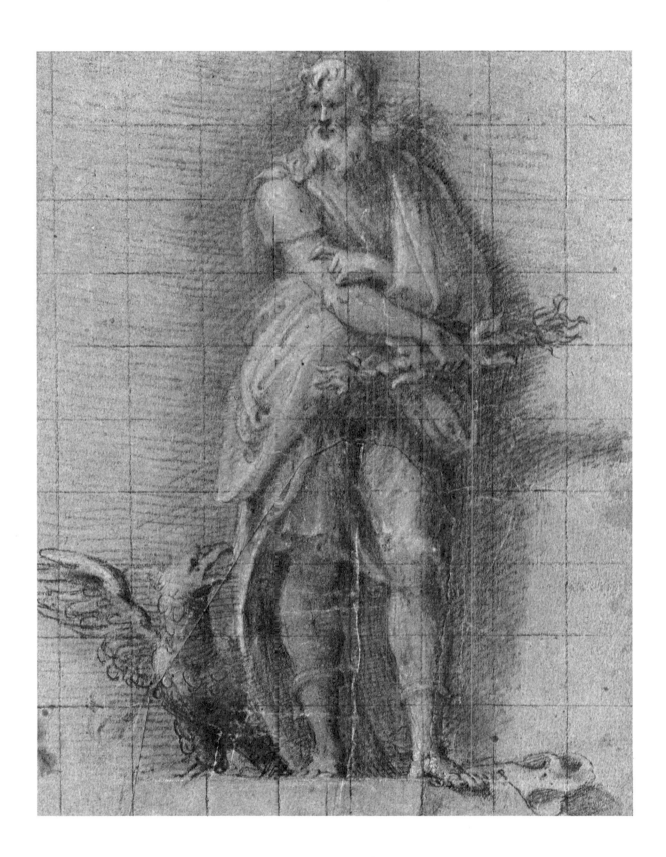

GIORGIONE

Giorgio Barbarelli, called Giorgione, the first innovating genius of Venetian 16th-century painting, was born in Castelfranco Veneto in 1477 and died in Venice, of the plague, in 1510.

He began his career when Bellini was already old and Titian was just arriving from his native Cadore to his artistic apprenticeship in Venice. The companions of Giorgione's brief life were Dürer, Sebastiano del Piombo, Lotto, and Palma Vecchio. His surviving works are very few easel paintings (not more than thirty), while the many frescoes in Venetian palaces referred to by the sources have just about totally disappeared. Moreover, the surviving paintings are almost all intended for a particular type of patron. Public commissions, so common in Venice at the time, are completely lacking. Instead, the greater part of his existing works were painted for a limited circle of intellectuals, among whom the painter spent his life. Portraits are numerous, including one in Berlin, the so-called *Laura* in Vienna, the Goldmann portrait in the National Gallery in Washington, and the Terris portrait in San Diego, dated 1510. The subjects of his paintings are often allegorical and difficult to interpret, but probably have a philosophical or magical significance understood by the select cultural group for which they were intended: *The Storm* in the Accademia in Venice (today interpreted as the magic harmony of the forces of nature), the *Three Philosophers* in Vienna, and the so-called *Tramonto*, or *Sunset*, in London. The only important religious work is his famous altarpiece in Castelfranco.

Giorgione at first formed his style on Bellini, as seen in his early *Christ Bearing the Cross* in the Gardner Museum in Boston. Very soon, however, he turned for inspiration to the nature realism of Dürer's landscapes and the psychological penetration of Flemish portraits, already well known at this time in Venice. Subsequently, Giorgione progressively developed colour as an atmospheric medium. Overturning traditional early Renaissance conceptions, he made colour independent of design and created tonalities and *sfumato* effects new in their strongly pictorial value.

Giorgione's known drawings are exceedingly few: the 'Shepherd' in Rotterdam (where the image is created by means of a patient hatching that dissolves the forms in atmospheric effects); the 'Head of an Old Man' in Zurich (where the contours are softly fused in keeping with the style of his final works); the drawing at Christ Church reproduced here (which with the usual delicacy adopts a hatching that seems already Titianesque). The 'Venus' in Darmstadt, on the other hand, appears too close to Titian to be considered securely by Giorgione.

33 Seated old man with a book

Red chalk. 151 x 112 mm.

Coll.: *Guise.*

Lit.: *Bell 1914, p. 56, W. 3; Pignatti 1970, p. 106, no. 20, pl. 98; Byam Shaw 1972, no. 28; Byam Shaw 1976, no. 715.*

Christ Church.

This refined and subtle drawing was overlooked by scholars until very recently. Byam Shaw drew attention to it and in 1970 I published it as Giorgione. My attribution is based on the iconographic resemblance to figures such as Giorgione's *Philosophers* in the painting in Vienna (this figure too could be a philosopher, if not a Saint Luke), as well as on the stylistic similarity to drawings such as the Head of an Old Man' in a private collection in Zurich, or the 'Shepherd' in Rotterdam, which shows the same minute hatching. The mood of thoughtful melancholy, so strikingly conveyed by the artful isolation of the figure that it becomes an expressive image complete in itself, seems to me an unmistakable sign of Giorgione's authorship. In Byam Shaw's exhibition catalogue of 1972, however, the drawing appeared as 'Giorgione (?)' and the author expressed doubts about the attribution, while recognizing its 'Giorgionesque' quality. In his catalogue of 1976 Byam Shaw assigns it to a 'Follower of Giorgione', indicating its affinity with Romanino, whose 'Adoration of the Christ Child' in Leningrad and other drawings attributed to him in the Christ Church collection show stylistic similarities to this sheet.

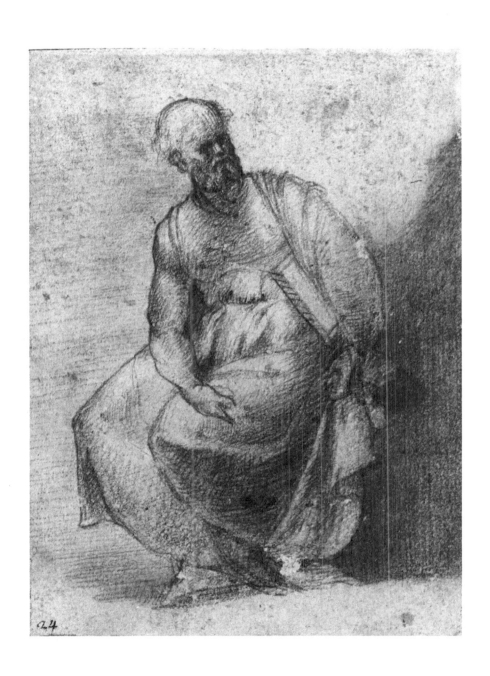

GEROLAMO ROMANINO

Gerolamo Romanino was born in Brescia about 1484–87 and died there after 1559. His earliest works and development stem from Venetian art and a sojourn in Padua in 1513, during which he painted the large altarpiece of the *Madonna and Saints* today in the museum of the city. In this work the influence of Giorgione and Titian is very evident. A stay in Cremona put him in contact with Emilian Mannerism, with particular consequences for his artistic language, which took on new, sophisticated and expressive qualities. Following this Romanino worked principally in the area of Brescia, where he has left the greater part of his paintings.

Extremely interesting is the artist's graphic production. At first his drawing was related to the work of northern draughtsmen, particularly Dürer. Later he tended to a *sfumato* manner close to Giorgione and Titian. Finally Romanino developed a graphic style of linear vivacity and marked Mannerist accent, nourished by Correggesque influence and Parmigianino's fluid line.

34 The judgement of Paris

Black chalk, heightened with white chalk, on bluish-grey paper. 275 x 240 mm.

Lit.: *Parker 1956, no. 671; Parker 1958, no. 27.*

Ashmolean Museum.

The subject is obviously a Judgement of Paris, with Venus holding the apple at the left and Minerva and Juno at the right. Parker noted the Giorgionesque quality of the style and implicitly dated the drawing in the beginning of the second decade of the 16th century. Although such a date seems acceptable, it should be borne in mind that Romanino, so often varying his style, took up this Giorgionesque manner again in later drawings, such as the sheet in the Scholz collection or that of the Gardner Museum.

The inscription *orbeto* at the bottom of the sheet would seem to be a completely unfounded attribution to the Veronese painter Alessandro Turchi, called Orbetto.

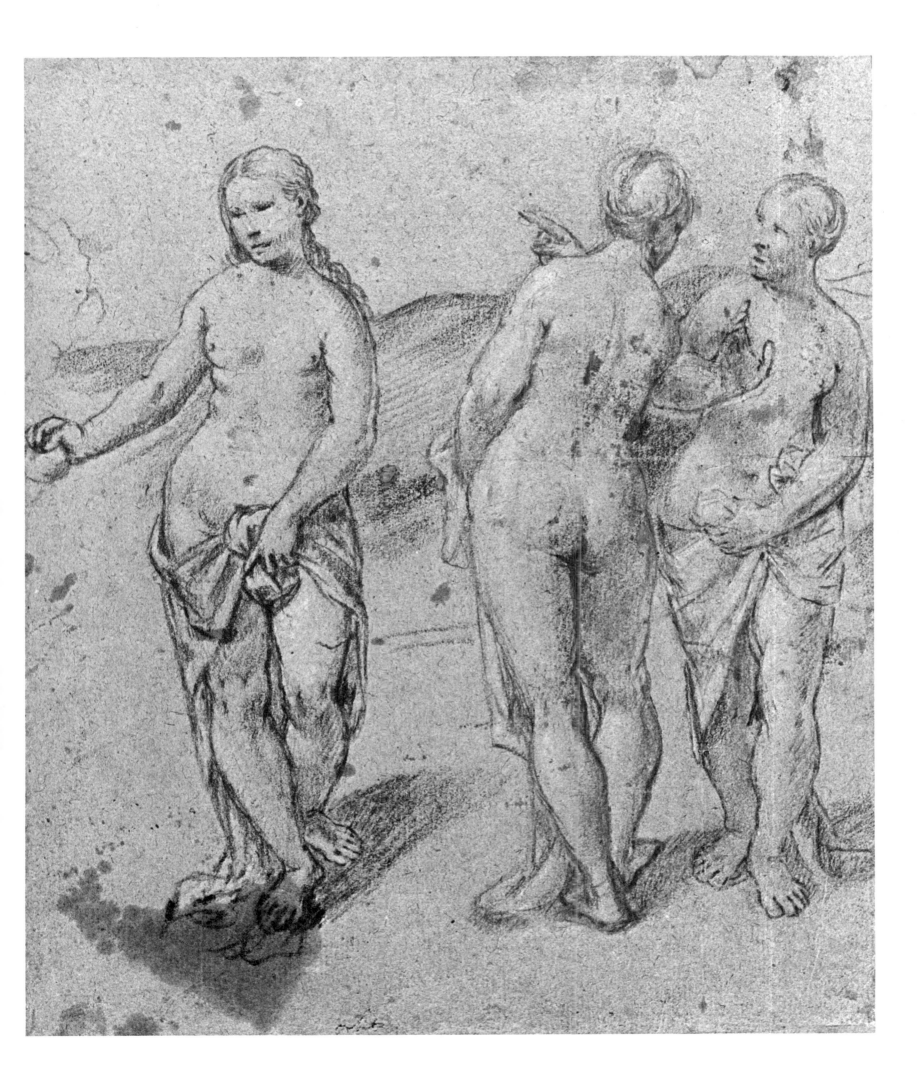

TITIAN

Tiziano Vecellio was born in Pieve di Cadore about 1490 and died in Venice on August 27, 1576. At the age of nine he went to Venice, where he studied with the Zuccato family and later with Gentile and Giovanni Bellini, and finally with Giorgione. In 1511 he painted the frescoes in the Scuola del Santo in Padua, but all his subsequent activity was as a painter of panels and canvases. With his *Assumption of the Virgin*, painted for the Venetian church of the Frari in about 1518, Titian won renown, becoming the foremost painter of Venice, a position he held for the rest of his life. In 1533 he was named count palatine by the Emperor Charles V and in 1547 went to Augsburg to paint the Emperor's portrait. Charles's successor to the Spanish throne, Philip II, became Titian's most important patron. In 1545–46 he was in Rome, where he painted the portrait of Pope Paul III. From Venice he sent paintings to every part of Europe. In his late works he developed a Mannerist expression, immersed in a nocturnal melancholy.

Titian is still considered the master of colour *par excellence*. To his sense for the structuring of form by means of large areas of colour, by which he quickly distinguished himself from his master Giorgione, Titian added monumentality and solemnity and an intense and dramatic expressivity. But his art is also eminently characterized by the sensual beauty that impetuously vibrates upon the surfaces of the figures and objects he painted. The influence of Titian's painting and the artistic principles that governed it have endured uninterruptedly and can be traced through all subsequent European art.

35 Madonna and Child enthroned

Red chalk; pen and brown ink. 265 x 185 mm.

Colls.: *P. Lely (Lugt 2092); Guise.*

Lit.: *Colvin 1903–07, II, pl. 39; Beckerath 1908, p. 112; Frizzoni 1908, p. 174; Hadeln 1913, p. 244; Bell 1914, pp. 89, 91, H. 28; Longhi 1917, p. 357; Hadeln 1924, pl. 40; Tietze-Tietze-Conrat 1944, no. 2019; Fiocco 1955, p. 166, fig. 5; Parker 1958, no. 21; Byam Shaw 1972, no. 73; Byam Shaw 1976, no. 718.*

Christ Church.

In its essential lines the drawing corresponds to the altarpiece formerly in the church of the Santa Croce in Belluno and now in Berlin, a work of Francesco Vecellio, Titian's brother. Hadeln, on the basis of this correspondence, attributed also the drawing to Francesco, considering it a preparatory study. In 1917, however, Longhi rejected Hadeln's opinion, observing the iconographic and stylistic differences of the drawing, far superior in quality to the painting. In addition, Byam Shaw has noted the existence, in the Kupferstichkabinett in Berlin, of a drawing for the second angel of the altarpiece, who sounds a tambourine. The inferior quality of this Berlin drawing, in comparison to that of Christ Church, supports the attribution of the latter to Titian, on which the majority of scholars agree, with the exception of the Tietzes and Fiocco.

Longhi's supposition that the Christ Church drawing, executed by Titian, could have served as a *modello* for his less talented brother's altarpiece, still seems quite plausible, despite the doubts recently expressed by Byam Shaw. It is true that we have no other red chalk drawings by Titian from the period around 1510. On the other hand, if we think of works such as the small *Madonna and Child with Saints* in Madrid, or the so-called *Gipsy Madonna* in Vienna, it is possible to accept such a graphic style in this period, which is not contradicted by known examples. The original drawing reveals a much less soft and *sfumato* quality than would appear from the reproductions of it in the Tietzes' publication and more recently elsewhere. Indeed, certain hatchings in the shadows are not really different from those always accepted as authentic in Titian's pen drawings of this same period.

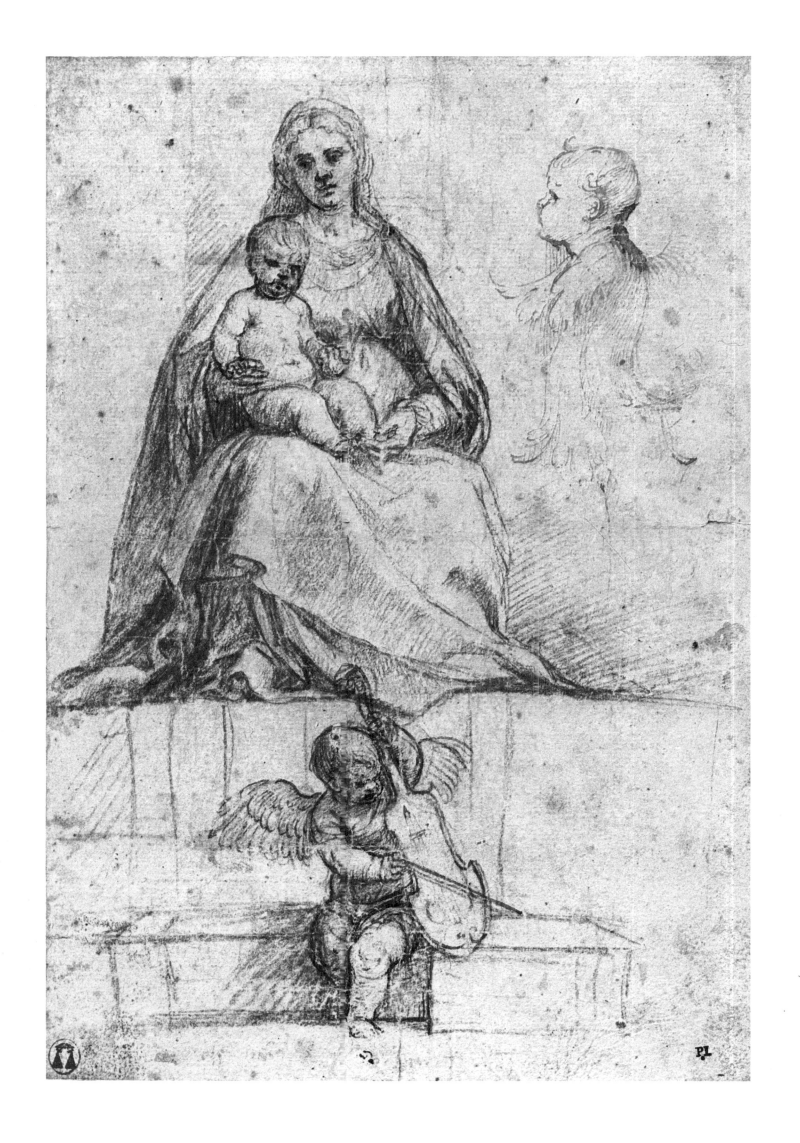

36 Falling horse and rider

Black chalk, on grey paper; squared in red chalk. 274 x 262 mm.

Colls.: *Lanière (Lugt 2886); J. Richardson, Sen. (Lugt 2184); B. West (Lugt 419). Lawrence (Lugt 2445); Esdaile (Lugt 2617); Wellesley; Josiah Gilbert.*

Lit.: *Colvin 1903–07, II/2, pl. 40; Hadeln 1926, pl. 26; Tietze-Conrat 1936, pp. 54–57, pl. 53; Tietze-Tietze-Conrat 1944, no. 1949; Parker 1956, no. 718; Parker 1958, no. 20; Pallucchini 1969, p. 173; Pignatti 1973, pl. 19; Wethey 1975, p. 230.*

Ashmolean Museum.

In the past this sheet was considered one of the preparatory drawings for the destroyed painting once in the Palazzo Ducale, originally intended as a Battle of Spoleto but renamed *Battle of Cadore* in 1538. However, according to Tietze-Conrat (1936) it is a *modello* by Titian for a battle canvas executed by his son Orazio, in 1562–64, for the Sala del Maggiore Consiglio in the Palazzo Ducale. This opinion was reaffirmed by the Tietzes in 1944 and finally by Pallucchini and myself. In fact, to my mind, the only one of the various drawings representing battle subjects with horsemen and soldiers which has a certain correspondence with the copies of Titian's destroyed painting of the *Battle of Cadore* is that in the Uffizi. Even the drawing in Munich and that in the Török collection seem related to other paintings, or to the woodcut of the *Crossing of the Red Sea*. In any case, this falling pose of horse and rider, rendered with the plastic line of Titian's mature years, is a stupendous example of the master's graphic power.

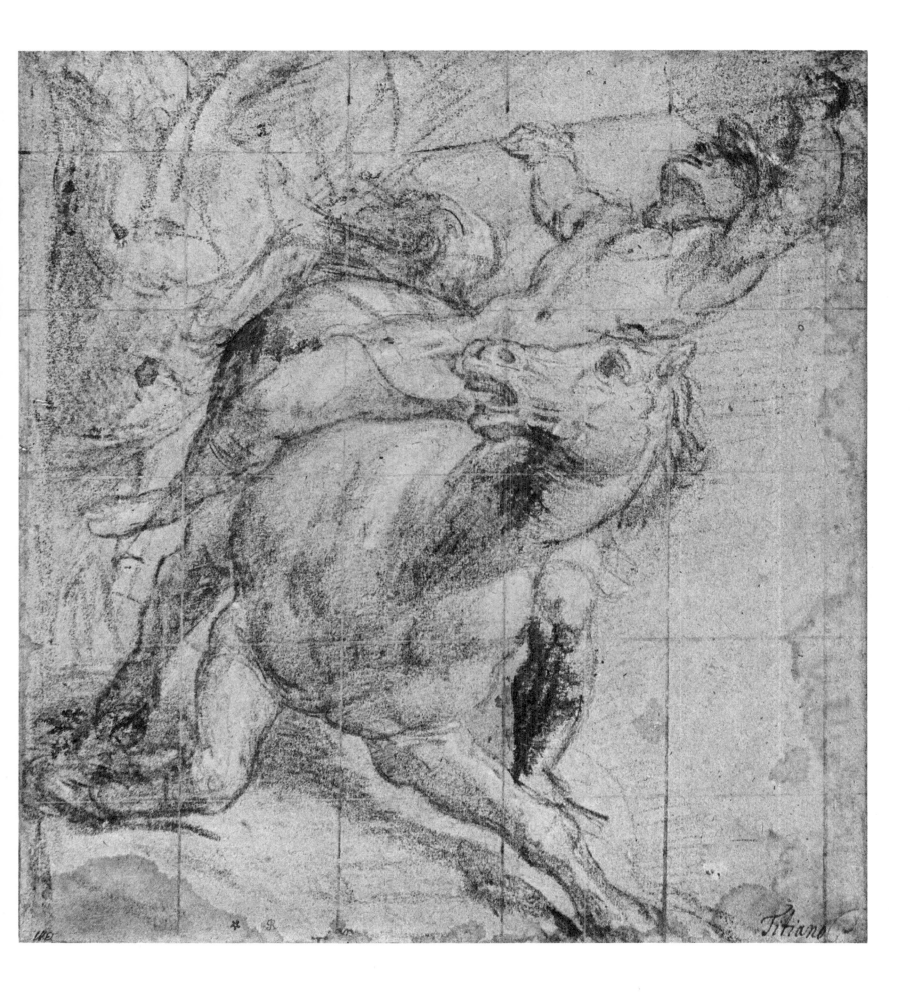

Titiano

DOMENICO CAMPAGNOLA

Painter, engraver, and woodcut artist, Domenico Campagnola, the adopted son of Giulio Campagnola, was born of a German father in 1500 and died in Padua on December 10, 1564.

Domenico was for a certain period in Titian's workshop. We actually know little of his activity as painter, which he carried on principally in Padua. His activity as engraver, in which he manifested a personal style very close to that of his drawings, was limited to the years 1517–18, the same period to which belong his woodcuts. His woodcuts and drawings of landscapes, in which Campagnola transformed Titian's style into a linear, calligraphic language of more immediate legibility, had a remarkable importance for landscape painting in the whole of Europe and even artists such as Bruegel drew inspiration from them.

37 Study of four heads

Pen and greyish-brown ink. 205 x 148 mm.

Lit.: *Tietze-Tietze-Conrat 1944, no. 523; Parker 1956, no. 134; Parker 1958, no. 12.*

Ashmolean Museum.

Parker very rightly assigned this sheet to Campagnola's youthful period, when his graphic style was forming under the influence of Titian's early works and within an orbit of artistic expression indebted to Dürer's example. The attribution is also confirmed by Oberhuber's recent studies, which present a number of similar drawings, at times even attributed to Titian. In fact, the work more directly comparable to this evocative group of heads is Titian's fresco decoration in the Scuola del Santo in Padua, finished in 1511, on which Campagnola himself later collaborated.

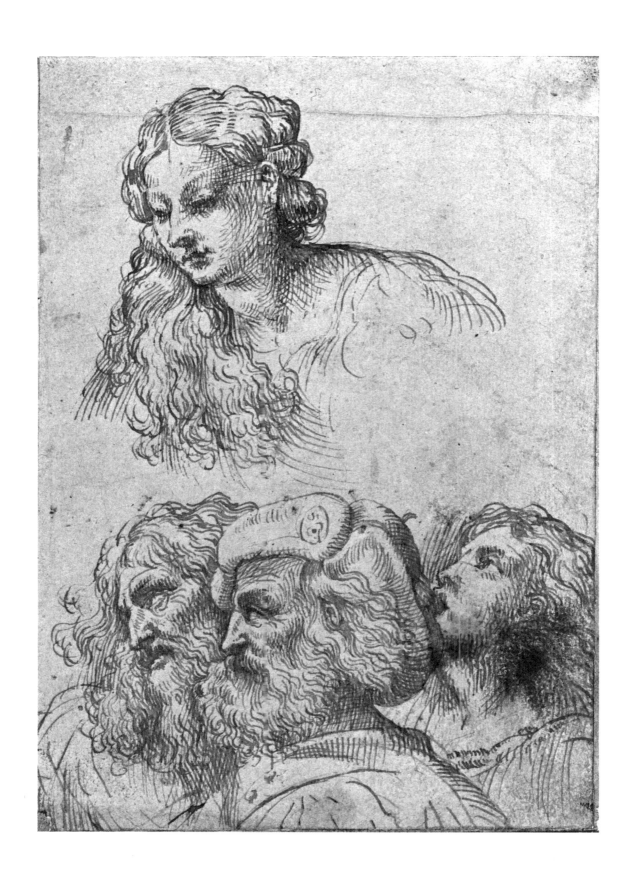

PORDENONE

The painter Giovanni Antonio de' Sacchi, called Pordenone after the town where he was born about 1483–84, died in Ferrara in 1539. His father, Angelo de Lodesanis, came originally from the region of Brescia, where Pordenone was repeatedly active. He also worked in the cathedral of Cremona, in 1520–21, and in the church of Santa Maria di Campagna in Piacenza, in 1529–31.

His first paintings reveal the influence of Gianfrancesco da Tolmezzo and Bartolomeo Montagna. A bit later Pordenone came to know the work of the young Titian. Around 1516 he made a trip to central Italy, going at least as far as Alviano in the Tiber valley and thus entering into contact with Roman art. In his last years he frequently worked in competition with Titian, even in the Palazzo Ducale, where he decorated the Sala dello Scrutinio (later unfortunately burned). This is perhaps the source of the legend that Titian got rid of his dangerous rival by having him poisoned. Although this story is certainly false, we can well imagine that Titian was impressed with Pordenone, who had gone beyond him in the trend towards central Italian Mannerism. Pordenone developed a dramatic and tumultuous expression that had its roots, more than in Titian's art of the second decade of the 16th century, in the works of Correggio and Giulio Romano studied during his travels. His style, characterized by emphatic gestures, grand flowing draperies, and a host of personal inventions, exercised considerable influence on Venetian painters of the mid 16th century.

38 Composition with a Sibyl and Prophets

Pen and brown ink, with grey wash, on greenish-grey paper; lightly squared in black chalk. 400 x 274 mm.

Colls.: *Unknown (Lugt 2961-2); Pembroke; C. R. Rudolf (Lugt, Supplèment, 2811 b).*

Lit.: *Strong 1900, IV, pl. 40; Parker 1956, no. 490; Parker 1958, no. 28.*

Ashmolean Museum.

On the *verso* is an old inscription: *Di mano propria del Pordenone C.* The drawing is evidently a preparatory sketch for one of the compartments of the dome of the Madonna di Campagna in Piacenza, which Pordenone frescoed between 1529 and 1531. There are similar drawings for the same work in the Uffizi and at Windsor. As Parker noted, the group of little angels appears again in Pordenone's frescoes in the church of San Rocco in Venice.

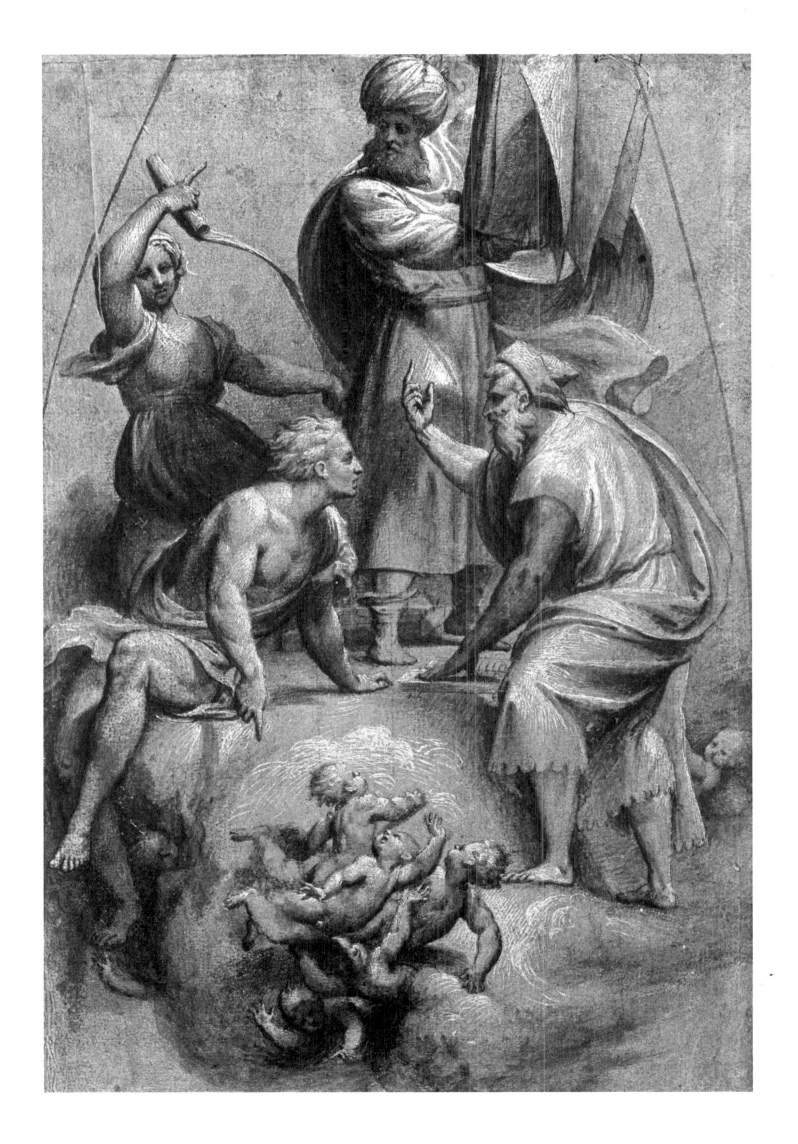

SEBASTIANO DEL PIOMBO

Sebastiano Luciani, called Sebastiano del Piombo, was born in Venice in 1485, but remained there only until 1511, when he moved to Rome, where he died in 1547.

At first Sebastiano was a follower of Giorgione and works such as his *Judgement of Solomon* in the Bankes collection at Kingston Lacy, or his altarpiece in the Venetian church of San Crisostomo, clearly imitate the master's style. Later, in Rome, where he painted the frescoes of Ovid's *Metamorphoses* in the Villa Farnesina, he became a follower of Michelangelo and Raphael. Sebastiano was particularly successful in his portraits, which he endowed with a penetrating psychological intensity. As a draughtsman, works from his Venetian period are almost unknown and attributions made to him of Giorgionesque sheets are now being rejected. Even from his later period the drawings that can reasonably be ascribed to him are very few, among them the Oxford drawing reproduced here.

39 Study for the head of a Madonna

Black chalk, heightened with white, on faded blue paper. 92 x 84 mm.

Colls.: *Padre Resta; Lord Somers; Guise.*

Lit.: *Byam Shaw 1968, p. 242; Byam Shaw 1972, no. 67; Byam Shaw 1976, no. 78.*

Christ Church.

This small but very subtle drawing seems to have been used in the preparation of the head of the Madonna in Sebastiano's Holy Family, known as *Madonna del Velo*, in the Galleria Nazionale at Capodimonte in Naples. Byam Shaw, evidently giving weight to the Raphaelesque traits of this sheet, now tends to date it towards 1530, while previously he had considered it much later. Suggesting a later date is the fact that a very similar drawing in the Louvre, published by Hirst (1965), is related to Sebastiano's late *Visitation* in the collection of the Duke of Northumberland.

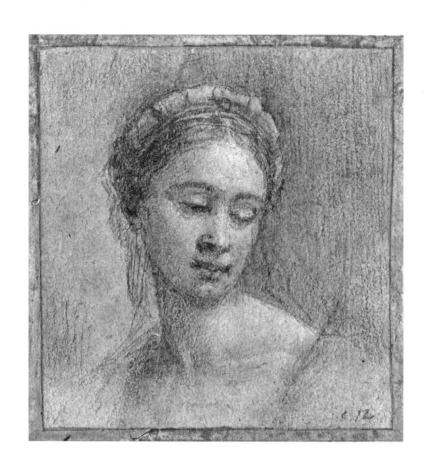

MORETTO

Alessandro Bonvicino, called Moretto, was born in Brescia in 1498 and died there in about 1554. He developed alongside Romanino, but the profoundly dramatic and melancholic accent of his art is very different from the impetuous inventive verve of his fellow Brescian artist. Restrained and realistic, Moretto's painting can best be compared with that of Savoldo and Moroni. He at first collaborated with Romanino in San Giovanni Evangelista in Brescia. Principally his production consists of altarpieces for the Brescian churches. His mature style is distinguished by a controlled and frigid colour, of a silvery intonation, that also appears in the rare drawings that can be attributed to him, recognizable above all for their chiaroscuro modelling.

40 The Virgin adoring the Christ Child

Pen and brush with brown ink, over black chalk, heightened with white; squared in charcoal. 261 x 278 mm.

Coll.: *Evans.*

Lit.: *Parker*, Ashmolean Museum Report, *1956, pp. 54–55; Parker 1958, no. 17.*

Ashmolean Museum.

Parker relates this drawing to Moretto's predella in the sacristy of Santi Nazaro e Celso in Brescia (Gombosi 1943, pl. 39). The rather widely spaced squaring would suggest that it served to transfer the image on more or less the same scale, rather than for an enlargement, and the dimensions of the drawing are, in fact, about those of the predella. One of the very few graphic works attributed to Moretto, this sheet demonstrates the forceful plasticity of his chiaroscuro.

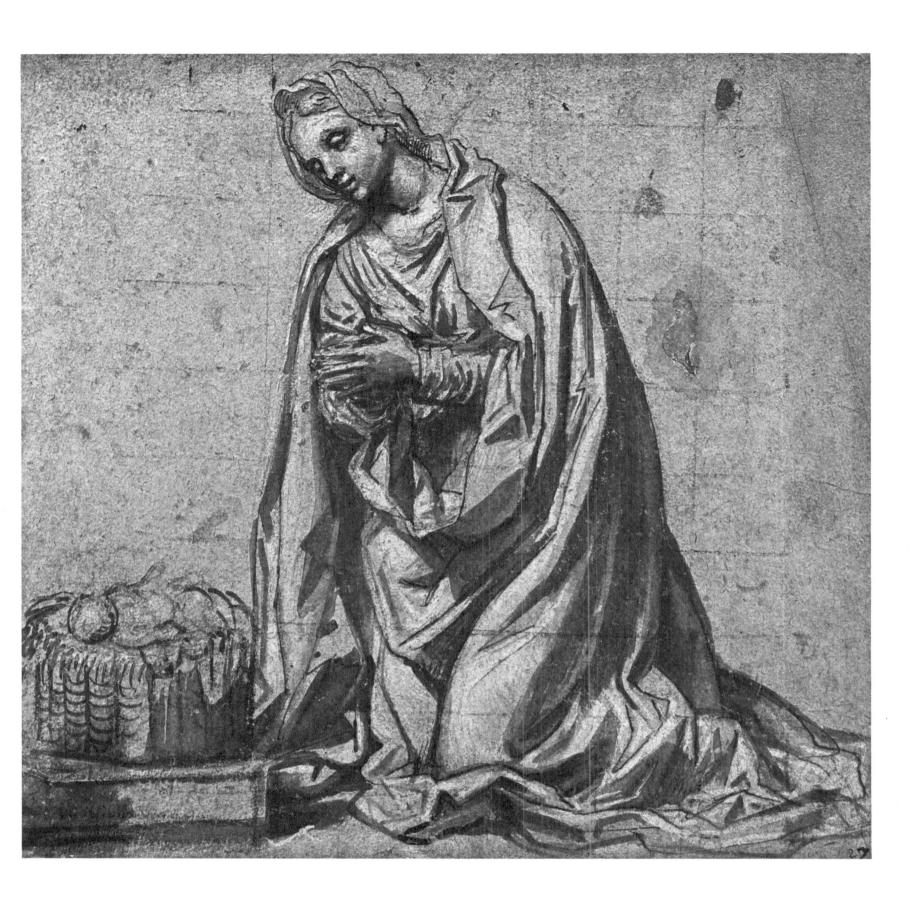

JACOPO TINTORETTO

Jacopo Robusti, called Tintoretto, was born in Venice in 1518 and died there in May 1594. We do not really know who his masters were, but Titian, Bonifacio de' Pitati, Schiavone, and Paris Bordone have all been suggested. Raffaello Borghini's statement that Tintoretto derived his drawing from Michelangelo and his colour from Titian is a literary commonplace, even if his drawings after Michelangelo's sculptures demonstrate Tintoretto's strong interest in this master's work. Actually, as Pallucchini has shown, Tintoretto's formation took place under the influence of Tuscan and Roman art and the work of Parmigianino. All these elements reflect the particular artistic situation of Venice in the 1540s, which also formed the style of the early works of Giuseppe Porta, Jacopo Bassano, and Schiavone.

Tintoretto was the foremost painter of vast compositions in Venice in the second half of the 16th century. His style is characterized by the dynamic tension and grandiose spatial conceptions of his compositions, the expressive intensity of the poses and movements of his figures, and his vigorous, essential modelling of plastic forms. These qualities make him the counterpart of the great fresco painters of Rome and Tuscany in the Venetian idiom of oil on canvas. A painter of dramatic actions and states of mind, Tintoretto is one of the major masters of the Cinquecento. On a level with his paintings of religious, historical, and mythological subjects are his fine portraits.

41 Head of Giuliano de' Medici

Charcoal, heightened with white chalk, on light-blue paper. 357 x 238 mm.

Coll.: *Guise.*

Lit.: *Colvin 1903–07, II, pl. 42; Bell 1914, p. 87, L. 4; Hadeln 1922, p. 27, pl. 9; Popham 1931, no. 279; Morassi 1937, pl. XXIX; Tietze-Tietze-Conrat 1944, no. 1731; Byam Shaw 1972, no. 72; Rossi 1975, p. 50; Byam Shaw 1976, no. 758.*

Christ Church.

Three drawings of the Christ Church collection are copies of motifs from Michelangelo's Medici tombs, drawn from statuettes reproducing the sculptures or from plaster casts of them. This sheet clearly copies the head of Giuliano de' Medici. Another graphic version copying the same model, and attributed to Marietta Tintoretto, appears on the *verso* of a drawing in the Rasini collection in Milan, on the *recto* of which is a classical head and a contemporary inscription with the name of Tintoretto's daughter. Morassi believed that the Christ Church drawing also could be attributed to Marietta, but comparison of the two makes clear the inadmissibility of this hypothesis. As Byam Shaw and Rossi have conclusively shown, this sheet is from the hand of Jacopo. Still another version of this same Michelangelo head appears on a drawing in the Uffizi, but does not have the quality of the Oxford sheet.

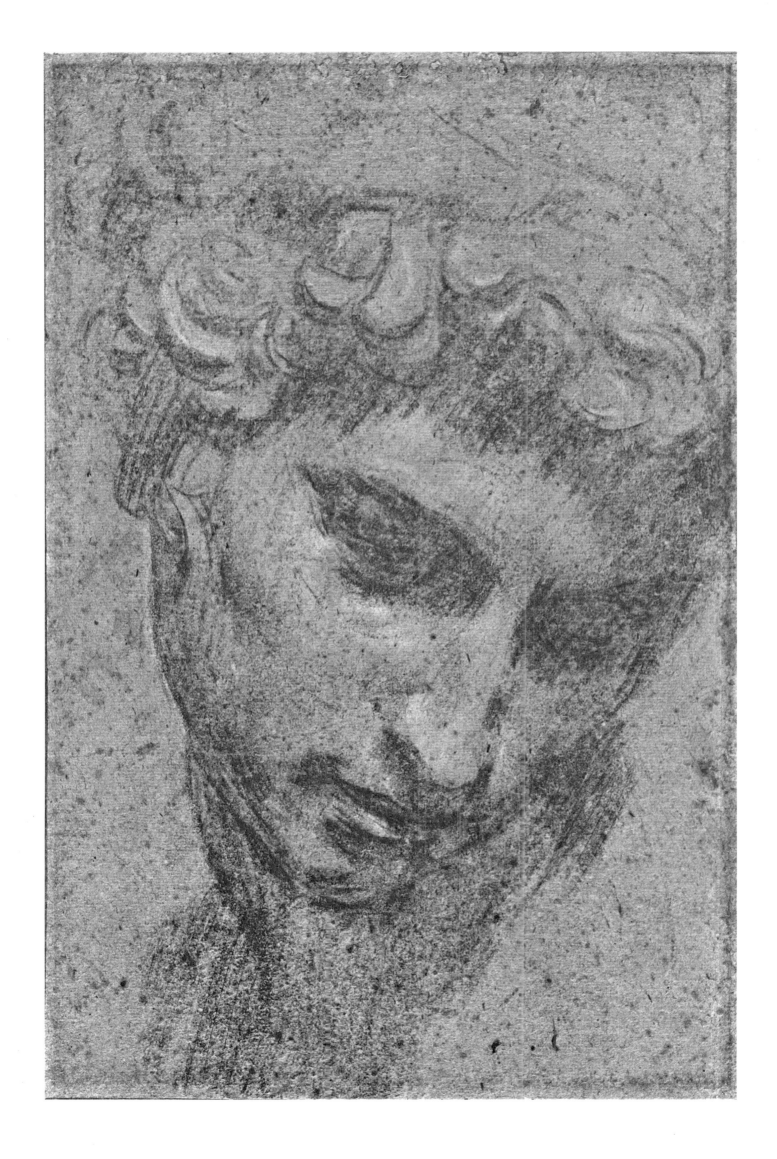

JACOPO TINTORETTO

42 Male nude in violent motion

Black chalk; traces of squaring with the stylus. 348 x 251 mm.

Colls.: *Reynolds (Lugt 2364); B. Fürst.*

Lit.: *Parker 1956, no. 716; Parker 1958, no. 53; Rossi 1975, p. 49.*

Ashmolean Museum.

This is one of the most characteristic of Tintoretto's drawings of nudes in action and perhaps served for a battle scene or a Resurrection. The sheet was considered a late work by Parker, who also noted the use of white paper, quite unusual for Tintoretto. Rossi too considers this a late drawing and compares it to similar examples in Leningrad and Rotterdam.

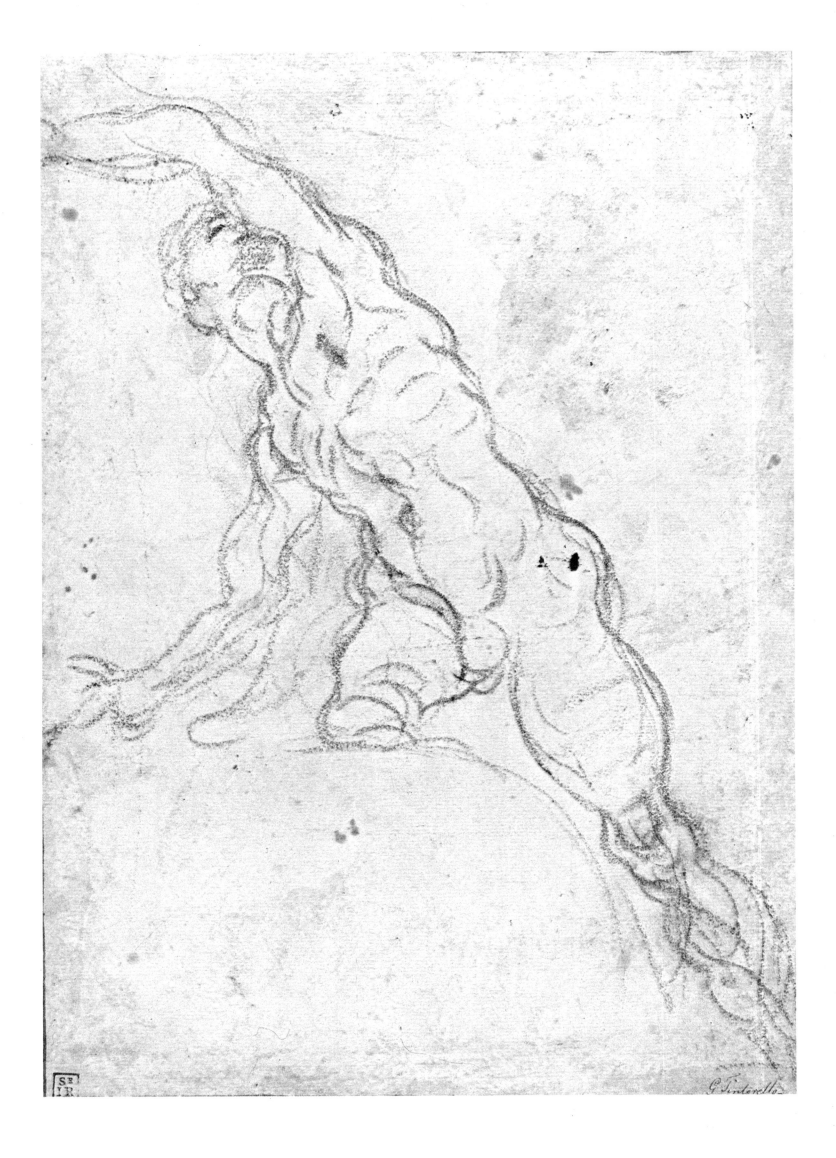

DOMENICO TINTORETTO

Son of the famous Jacopo, Domenico Tintoretto was born in Venice in about 1560 and died there in 1635.

Domenico's own artistic personality was at first inevitably suffocated by the practice of his father's workshop and only after Jacopo's death, in 1594, could he develop independently. It was Ridolfi, in his *Meraviglie dell'Arte* of 1648, who first drew attention to the originality of Domenico's art, singling out the artist's ample imagination and culture, which produced compositions rich in allegorical significance and of a refined, academic execution. While today such an evaluation of Domenico's pictorial work is debatable, it fits very well his graphic production. This includes at least two hundred sheets, almost half of which are in the stupendous sketchbook in the British Museum. Many of these drawings, for their reflection of Baroque literary themes, as well as for the loose linear style of their brushwork, are remarkably evocative, and among the very best of Venetian graphic production of the early 17th century.

43 The Martyrdom of Saint Stephen with the Ascension

Brush drawing in oil, on blue paper; squared. 345 x 187 mm.

Colls.: *J. Richardson; Guise.*

Lit.: *Bell 1914, p. 87, L. 12; Hadeln 1922, pl. 72; Tozzi 1937, p. 24; Tietze-Tietze-Conrat 1944, no. 1536; Byam Shaw 1972, no. 71; Byam Shaw 1976, no. 778.*

Christ Church.

The drawing corresponds to the altarpiece in San Giorgio Maggiore in Venice, which was commissioned from Jacopo Tintoretto in 1593, and it offers new proof that the execution of that canvas was due to the son and not to the father, who, moreover, at this time was nearing the end of his life. There is no doubt whatsoever that this strongly chiaroscuro style created with luminous contrasts is that of Domenico. It is, in fact, characteristic of all his brush sketches, including those in the Uffizi and the British Museum.

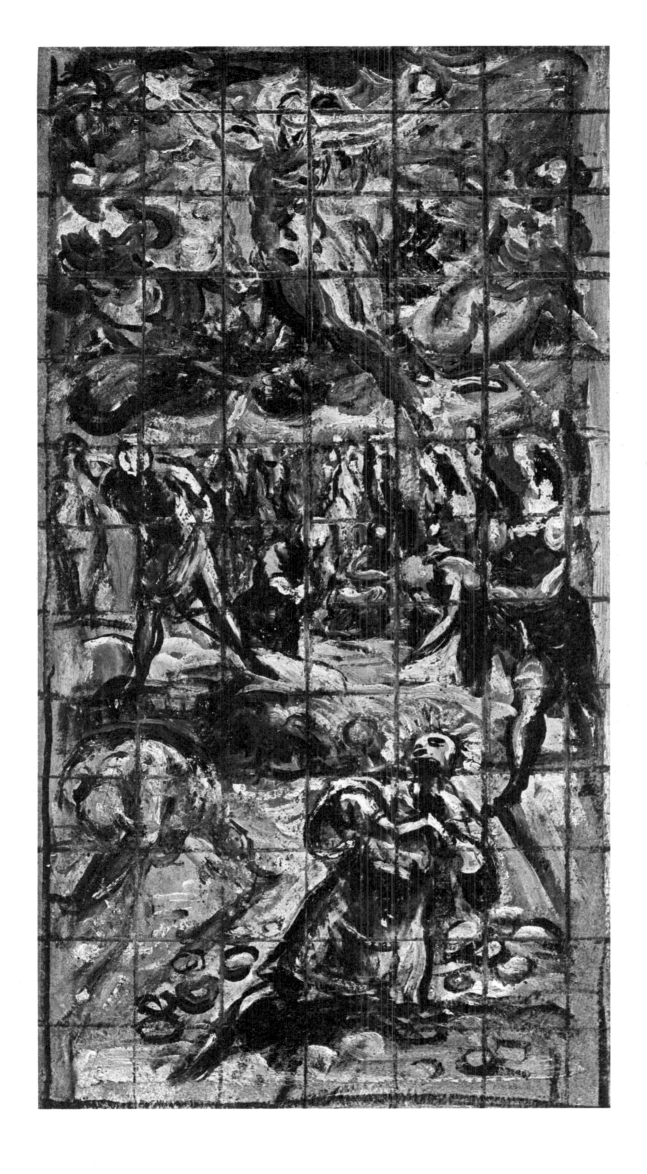

JACOPO BASSANO

The painter Jacopo da Ponte takes the name Bassano from the place where he was born about 1515 and where he died on February 13, 1592.

He probably received his first artistic training from his father, Francesco. As early as about 1530, however, the boy went to Venice, where he studied with Bonifacio de' Pitati, but was also influenced by Titian. On January 15, 1535 he received his licence from the Venetian Senate. In 1535–36 he executed paintings for the audience hall of the Palazzo Pretorio in Bassano. In his native town, in 1541, in honour of his artistic merit he was exonerated from payment of taxes. In 1544 he became Counsellor and Magistrate of Bassano. In 1586 he assisted his son Francesco in the execution of paintings for the Palazzo Ducale in Venice, but we know that already in 1581 the artist had felt himself to be old and no longer capable of much work.

A painter of great originality, in his early years in Venice he was receptive to the very latest artistic trends coming from Parma, Florence, and Rome. After this youthful Mannerist phase Jacopo developed a style of monumental composition and exceptionally vigorous colour, which gained in luminosity through his strongly contrasted chiaroscuro and in substance by means of his dense but fluid application of paint. A strong realistic vein emerges in his figures, representations of animals, and genre paintings. He maintained an extremely active workshop, staffed chiefly by his sons, Francesco, Leandro, and Girolamo, who repeated their father's inventions, developing them further well into the 17th century.

44 Diana

Black chalk, heightened with white chalk, on blue paper. 508 x 379 mm.

Coll.: *P. Lely (Lugt 2092); Guise.*

Lit.: *Ballarin 1969, p. 107, fig. 121; Byam Shaw 1972, no. 4; Byam Shaw 1976, no. 751.*

Christ Church.

Among the many drawings at Christ Church attributable to Jacopo Bassano, this one is of great quality and without doubt an authentic work of the master. According to Byam Shaw this could be a study for a Diana who appears among the clouds in a representation of the Sacrifice of Iphigenia. The large dimensions of the sheet and the quality of its rapid and essential graphic notation, that is nevertheless rich in pictorial effects, once again pose the problem recently debated by Rearick and Ballarin, i.e., whether such a drawing was executed as a 'memory piece', or record, by a member of the master's shop after one of his finished works, or as a cartoon prepared by the master himself for the execution of one of his own works. In the present case the objective elements tend to weigh in favour of the latter hypothesis.

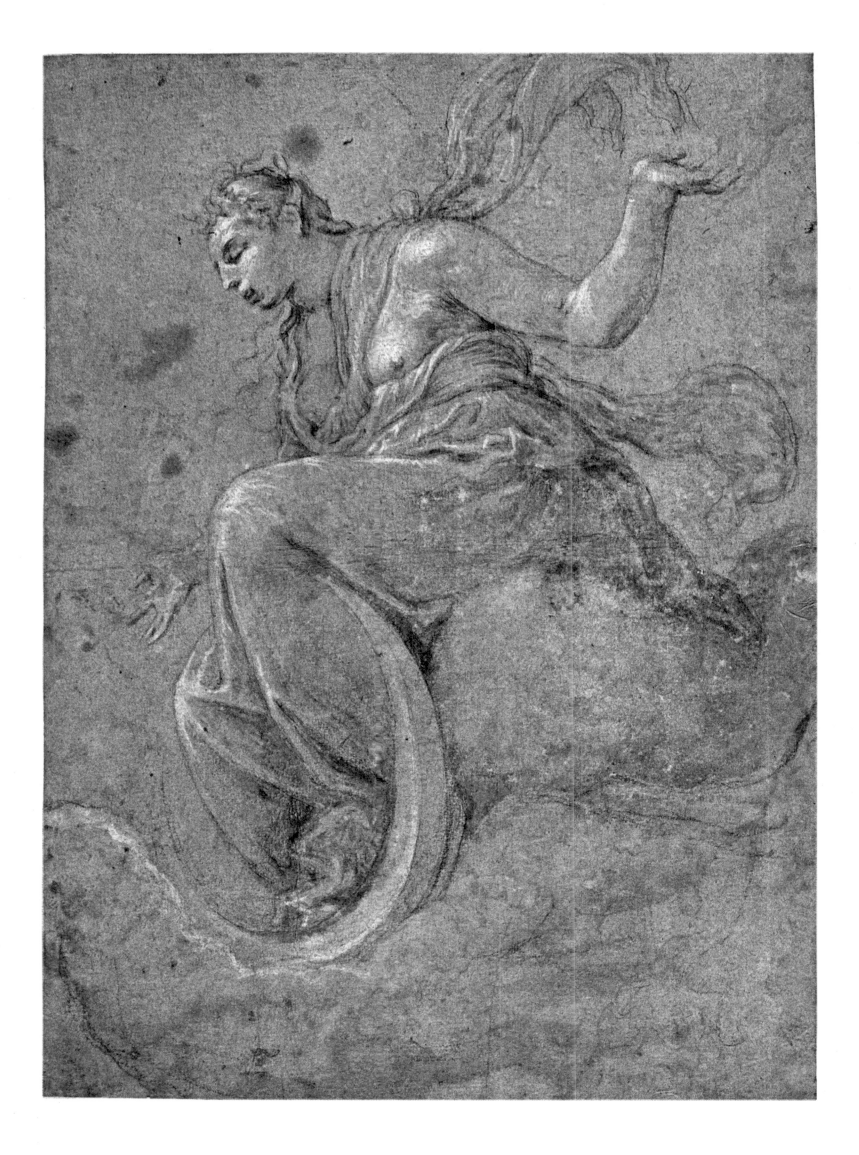

PAOLO VERONESE

Paolo Caliari, called Veronese, was born in Verona in 1528 and died in Venice on April 19, 1588. He was the pupil of Antonio Badile. His earliest known works date from 1548 and his frescoes in the Villa Soranzo were executed in 1551. A few years later, perhaps already in 1553, Veronese settled in Venice, where he worked in the Palazzo Ducale and the church of San Sebastiano. In the years 1556–57 he was judged to be the best among the painters working on the decoration of Sansovino's Libreria and from that time on he was listed among the major Venetian painters. We have an indirect reference to a trip to Rome made at the end of the 1550s. This was also the period of Veronese's masterpiece, the frescoes of the Villa Maser (1559–61).

In addition to the luminous colour of his teacher Badile, Veronese took an interest in the various Mannerist currents then reaching Venice from Rome, Florence, and Parma. He must have studied the works of Giulio Romano, Parmigianino, Niccolò dell'Abate, Francesco Salviati, Giuseppe Porta, and others. But in comparison to Zelotti, for example, who experienced analogous influences, for Veronese the contact with Venetian art and above all Titian was of far greater importance. His extraordinary capacity of observation, his sense of light and the changing effects of colour in his landscapes and upon precious fabrics, the subtlety of his colours themselves, his grace, lightness, and richness of invention, as well as his restrained but penetrating emotive expression place him far above any of the other grand Venetian decorators.

No one was capable of responding better than Veronese to the attractions of a secular and allegorical decorative art abounding in mythological representations. The splendour of his painted fabrics and his grand festive settings endowed even his religious paintings with those worldly overtones that in 1573 brought him before the Inquisition. In many ways Paolo Veronese was one of the most significant precursors of 18th-century art. His very numerous drawings, in various techniques, are almost always related to the execution of his canvases, and served as precious models in the hands of his successors.

45 The Coronation of the Virgin

Pen and brush with brown ink. 305 x 210 mm.

Colls.: *P. Lely (Lugt 2092) ; Guise.*

Lit.: *Bell 1914, p. 92, K. 18; Hadeln 1926, p. 31, pls. 38, 39; Fiocco 1928, p. 210; Tietze-Tietze-Conrat 1944, no. 2128; Parker 1958, no. 41; Mullaly 1971, no. 64; Byam Shaw 1972, no. 82; Byam Shaw 1976, no. 793; Pignatti 1976, p. 680.*

Christ Church.

Both *recto* and *verso* are drawn with the same subject of the Coronation. The numerous inscriptions in the master's hand indicate the names of the saints. On the *verso* there is also a sketch of an Annunciation.

The drawing is related to the altarpiece ordered from Veronese for the church of the Ognissanti in Venice, in about 1586, and today in the Accademia. As often in Veronese's late works, so too in this painting there was a certain amount of collaboration on the part of his brother, Benedetto, and perhaps also of his son, Carletto Caliari. Paolo's drawing is rarely pictorial, rather it tends to a functional definition of the composition and figure types, as in this example, which is among the most notable of his vast production.

CARLETTO CALIARI

Son of the great Paolo Veronese, Carletto Caliari was born in Venice in 1570 and died there very young in 1596. Only his earliest activity took place under the aegis of his father, who died in 1588. After this Carletto continued in the shop of the 'Haeredes Paoli', together with his uncle Benedetto and his brother Gabriele. We know from Ridolfi that from an early age Carletto worked not only in his father's shop, but also in that of Jacopo Bassano. Consequently his hand has often been identified in parts of his father's very late works where the influence of Bassano is evident, particularly in certain types of heads. Recently, an analogous process of identification has been applied to Carletto's graphic works and his hand has been recognized in drawings of heads in coloured chalks (coming in large part from a Marignane album), previously ascribed to members of the Bassano family, especially to Leandro.

46 Portrait of a man

Various coloured chalks, on blue paper. 272 x 187 mm.

Colls.: *Sagredo (?); M. Marignane; H. Marignane (Lugt, Supplément 1343 a).*

Lit.: *Tietze-Tietze-Conrat 1944, no. 234; Parker 1956, no. 112; Parker 1958, no. 46.*

Ashmolean Museum.

This sheet, purchased in 1954, is part of a group of portrait drawings in coloured chalks coming from the Marignane collection and bearing characteristic indications in pen on the *versi*, in this case: *463 lapis*. It has been supposed that the Marignane album came from the Sagredo collection in Venice.

Traditionally the group has been ascribed to Leandro Bassano. But as early as 1936 Parker attributed one of the portraits ôf this group to Carletto Caliari, on the basis of comparison with a sheet in the Fenwick collection, now in the British Museum, which portrays Paolo Paruta, and which as Popham noted (Popham 1935, p. 39, pl. XXVI) bears the old inscription: *Carleto*. The Tietzes, however, ascribed these drawings to Leandro Bassano, and even Parker, in his exhibition catalogue of 1958, reverted to this attribution. But after the discussion of the problem by Rearick, Ballarin, and Oberhuber, I too have accepted the attribution of these drawings to Carletto Caliari and exhibited a previously unpublished one in the exhibition in Washington in 1974 (Pignatti 1974, no. 25).

PALMA GIOVANE

The painter and etcher Jacopo Negretti, called Palma Giovane or Palma the Younger, was born in Venice in 1544 and died there in 1628. His earliest training was with his father, Antonio Palma, nephew of Palma Vecchio. While copying Titian paintings he was discovered by Duke Guidobaldo of Urbino and sent to complete his studies in Pesaro and Urbino and, finally, in Rome. Here he stayed for eight years 'drawing the most precious statues of Rome. He drew especially after the cartoons of Michelangelo and the paintings of Polidoro, whose manner pleased him very much, because, as he said, it was similar to the Venetian style...' (Ridolfi). In 1568 he returned to Venice, where he was decisively influenced by Tintoretto, whom along with Titian he admired very much, and by Veronese. He was also attracted by the Bassanos, particularly for their realism and chiaroscuro, elements that likewise interested him in Tintoretto.

After the death of the older masters Palma was so overwhelmed by commissions that the quality of his painting suffered. But even then, without betraying his own artistic origins, he was capable of achieving a realistic animation and figurative expression compatible with the nascent Baroque, the way to which was prepared in Venice by the Roman painter Domenico Fetti and the German Jan Lys. Thus historically Palma Giovane's position may be compared to that of Lodovico Carracci.

Palma was an excellent and tireless draughtsman, as witnessed by the sheets in the Graphische Sammlung in Munich (over four hundred), in the Uffizi, and in Bergamo, followed by those in the Albertina (about forty). His graphic talent, admired even by his contemporaries, is seen also in his etchings, especially those of the *De Excellentia et Nobilitate Delineationis*, published in 1611 by Jacopo Franco, which reveal a distinctly Baroque temperament. Fenyö has demonstrated the influence of Parmigianino's works on Palma's graphic style, which is aptly described by the lines of Boschini's *Carta del Navegar pitoresco*: 'E in tal modo padron de la pitura, che in quattro colpi el fava una figura' (He was such a master of painting that in four strokes he made a figure).

47 Studies for a Bathsheba

Pen and brown ink, with ink wash. 343 x 220 mm.

Coll.: *Lawrence (Lugt 2445)*.

Lit.: *Parker 1956, no. 428; Parker 1958, no. 64.*

Ashmolean Museum.

One of Palma's typical sheets of studies in which the same motif, in this case a figure of Bathsheba, is repeated in different poses. On the *verso*, which shows some heads and a Holy Family, is the inscription: *G. P. No. 112*. Parker noted that this manner of numbering is characteristic of other drawings (Fenwick collection, British Museum) evidently coming from the same source.

48 Self-portrait (?)

Red chalk. 176 x 157 mm.

Colls.: *Sagredo; J. Richardson, Jun. (Lugt 2170).*

Lit.: *Parker 1956, no. 425; Parker 1958, no. 65.*

Ashmolean Museum.

An inscription in English on the *verso* states: *The head of Old Palma by his Nephew Giac. Palma. Out of the Sagredo Collection sold at Langford's 1764.* The sitter's 17th-century costume quite obviously excludes his identification as Palma Vecchio. Parker feels the drawing could be a self-portrait, which seems a very plausible hypothesis when this sheet is compared with the self-portrait in the Brera and the bust of the artist by the sculptor Alessandro Vittoria. Parker notes that an inscription on a drawing by Palma Giovane in the Rudolf collection speaks of the same Langford sale, at which, it states, nearly three hundred Palma sheets were sold. The use of red chalk, a technique rarely adopted by Palma, and the essential line that so forcefully expresses the psychological state of the sitter, make this drawing one of the most exceptional graphic products of this prolific artist.

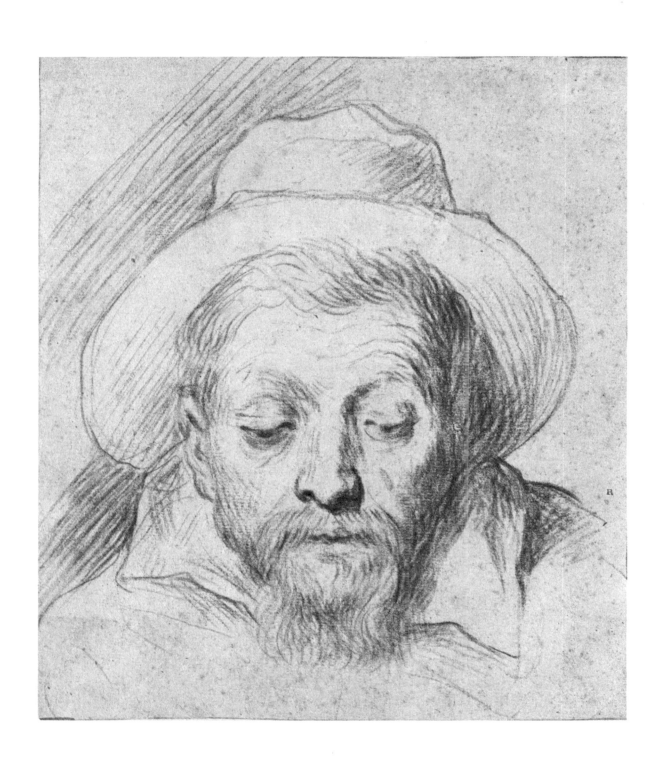

LUCA CAMBIASO

Luca Cambiaso, called Luchetto, was the son of the painter Giovanni Cambiaso, his first teacher. Luca was born in Moneglia (Genoa) in 1527 and died in Madrid in 1585.

Receptive to the art of the great masters of northern Italy, he collaborated with his father on fresco decorations and developed a personal style based on the combination of Venetian colour with Lombard chiaroscuro. Luca Cambiaso may well be considered the creator of Genoese mural painting, distinguished by architectural characteristics all its own, which was to continue to develop schemes analogous to his down into the 17th century. In 1583 Cambiaso, together with his son Orazio and Lazzaro Tavarone, went to Spain to paint in the Escorial. These last works, however, reveal a certain decadence. His drawings, characterized by a rapid, broken stroke, are amazing for their technical virtuosity, the fruit of continual practice. Indeed it is known that he devoted himself to drawing for many hours every night. Cambiaso's graphic style transforms the last echo of post-Raphaelesque Mannerism into a dynamic, agitated effect of broken lines that clearly presages the Baroque.

49 The Nativity

Pen and brown ink, with ink wash. 340 x 233 mm.

Colls.: *Vallardi (Lugt 1223); Warwick; Sir Bruce Ingram.*

Lit.: *Suida Manning 1952, p. 202; Parker 1956, no. 131.*

Ashmolean Museum.

This evocative drawing of an interior, with strong contrasts of light and shade typical of Cambiaso's nocturnal scenes, has been related by Suida Manning to the canvas of the Lercari chapel in San Lorenzo in Genoa. According to Parker it also resembles Cambiaso's *Nativity* of the Pinacoteca Nazionale in Bologna.

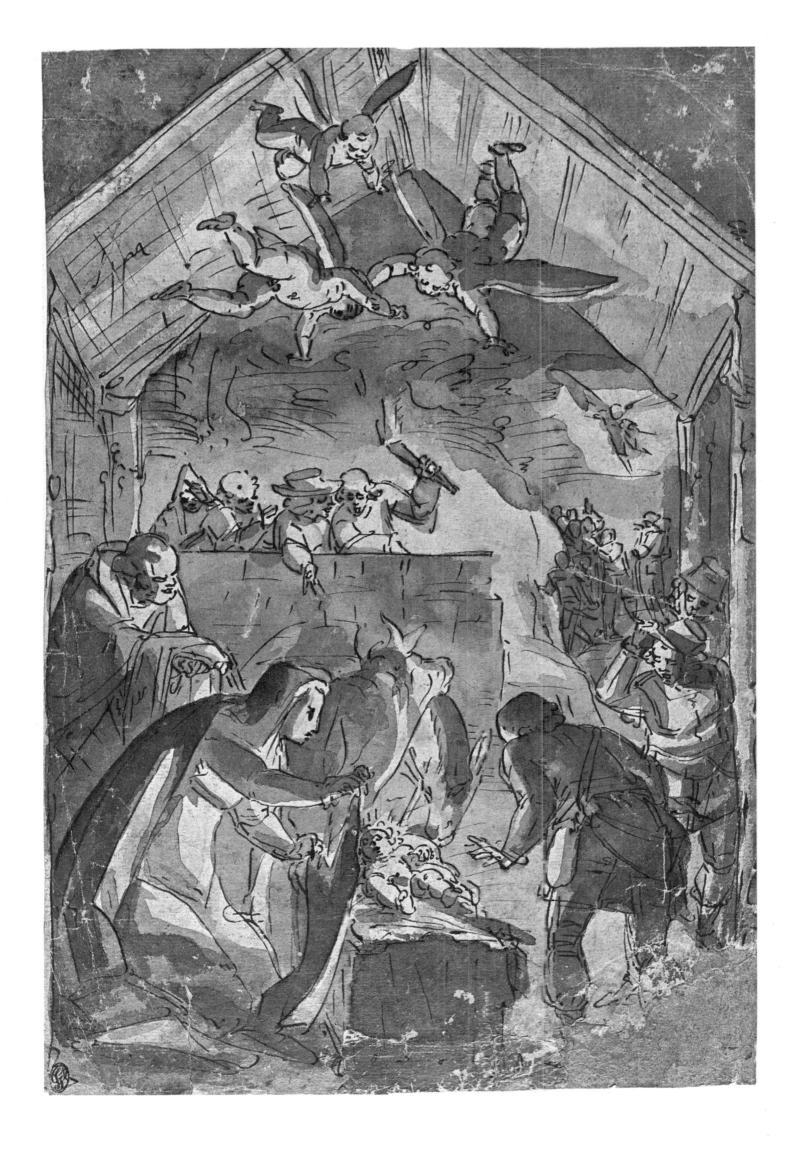

FRANCESCO SALVIATI

Francesco Salviati was born in Florence in 1510 and died in Rome in 1563. The outstanding quality of his painting makes him certainly the most important figure in that group of artists (which included Giorgio Vasari and Daniele da Volterra) which for a good part of the 16th century continued the vein of pronounced intellectualism of the first generation of mannerism, by that time, however, divested of its hauntingly visionary and dramatic component.

Educated in Andrea del Sarto's studio, in 1531, in the company of Giorgio Vasari, with whom he had been friendly for several years, Salviati went to Rome. Here he very quickly and intelligently absorbed stylistic elements from the Raphaelesque current of Giulio Romano, Perin del Vaga, and Polidoro da Caravaggio, as well as from Michelangelo in the Sistine chapel, and from the refined Mannerism of Parmigianino's Roman works. To these experiences were subsequently added others made in the course of trips to Bologna, Parma, Venice, and France. On this varied and ample cultural foundation Salviati developed a style in which the tones of a palette rich in precious gradations and vibrations were fused with a refined and eminently accomplished drawing and a great, painstakingly applied compositional skill. Of this important and complex artistic personality the following works are the most characteristic: the *Visitation* frescoed in 1538 in the oratory of San Giovanni Decollato in Rome, the well known painting in the Uffizi of the *Allegory of Charity*, and, in addition to a splendid series of portraits, the fresco cycles he left in Rome in the Cancelleria, the Farnese and Sacchetti palaces, and in the Chigi chapel of Santa Maria del Popolo.

50 Design for a ewer

Pen and brown ink, with grey wash, heightened with white, on buff paper. 411 x 276 mm.

Colls.: *Gelozzi (Lugt 545); Hampden; Douce (?).*

Lit.: *Parker 1956, no. 683.*

Ashmolean Museum.

Salviati's graphic production includes many stupendous designs for metal work. The body of this vessel is decorated in relief with a chimera and the mouth has the form of an animal head. Two nude females sit on the neck and a third, standing on the shoulder and leaning against the rim, serves as a handle. The under side of the vessel has a markedly classical decoration of garlands and bucranes. Parker notes a similar design in the Print Room in Budapest.

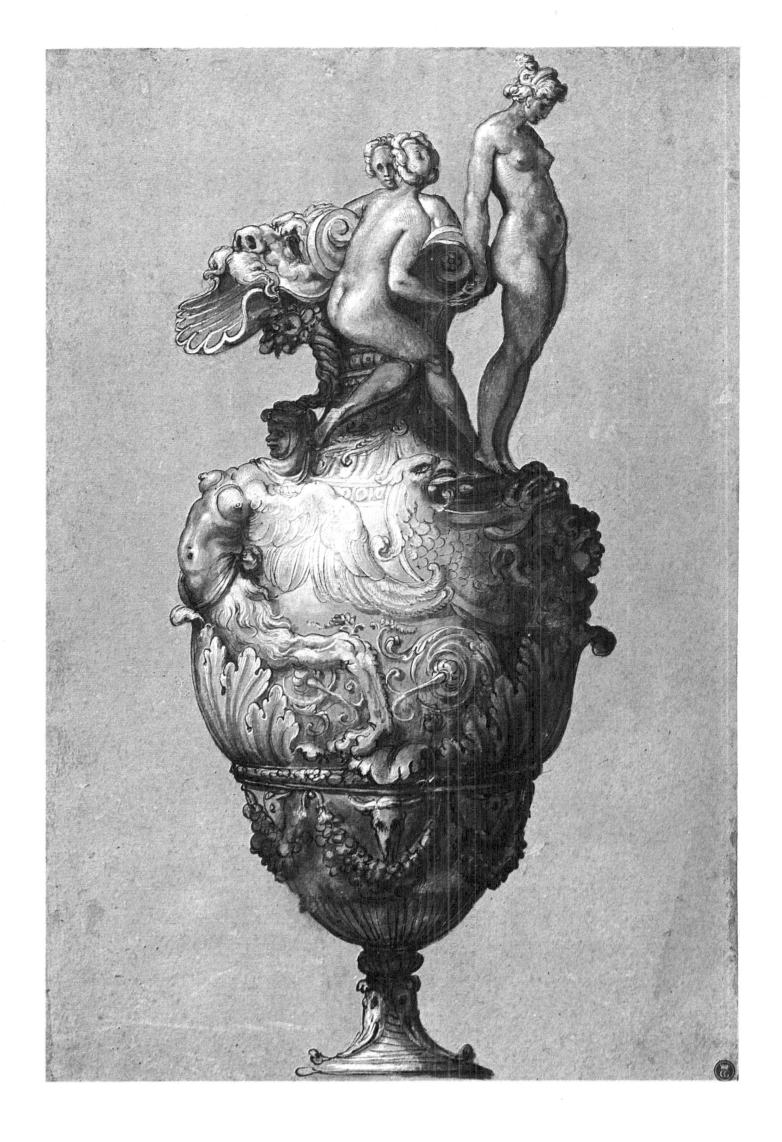

TADDEO ZUCCARI

The painter Taddeo Zuccari, brother of Federico, was born in Sant'Angelo in Vado near Urbino in 1529. Early in life he moved to Rome, where he died in 1566.

Taddeo's painting represents a very particular moment of Mannerist expression: it partakes not only of the style of the Roman school, but also of the tense and vibrant sensibility of the Flemish Mannerists. This latter interest is manifest in Taddeo's choice of highly sensual subjects, treated with an accentuation of the graphic design and startling effects of colour, at times of a marked acidity. His drawings are of exceptional quality and in them, with great inventive liberty, he translates his hallucinating world in terms of tense and vibrant forms.

51 Group of figures

Pen and brush with brown ink, heightened with white, on light-buff paper. 272 x 198 mm.

Colls.: *P. Lely (Lugt 2092); J. Richardson, Sen. (Lugt 2183); B. West (Lugt 419); Lawrence (Lugt 2445); Woodburn.*

Lit.: *Parker 1956, no. 766.*

Ashmolean Museum.

The subject to which this group might relate is unknown. The figures, however, would seem to have been drawn from life, probably using as a model a group of common people leaning against a wall with a small boy playing the pipes. Earlier ascribed to Niccolò dell'Abate and Franco, Parker advanced this attribution with some reservation, but the subtly Mannerist line that recalls Parmigianino makes Taddeo's authorship seem quite probable.

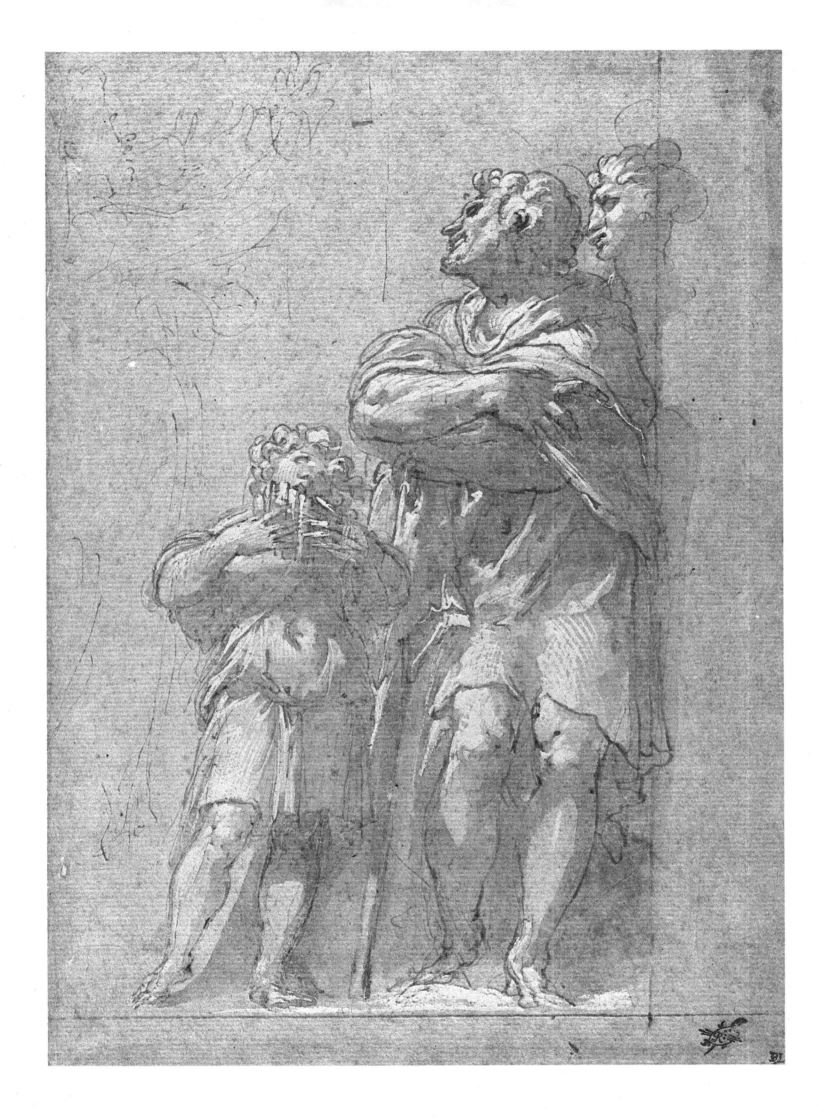

FEDERICO BAROCCI

Painter and etcher, Federico Barocci was born about 1535 in Urbino, where he died on September 30, 1612. He first studied with his father Ambrogio and then with Battista Franco. In 1556 and again in 1560 Barocci was in Rome, where he worked in the Vatican with his compatriots, Taddeo and Federico Zuccari. His stylistic formation was determined by the influence of Venetian art transmitted to him through his teacher Franco, and still more importantly by Correggio's works, from which he derived his ecstatic expression of sentiment, highly original formal conception, and vivacious effects of light. Barocci's fundamental predilection for the irrational, visionary, and immaterial made his art a stimulus for the ascetically unreal and exaggeratedly elegant style of late Mannerist painters, such as Vanni and Salimbeni, and even Bellange in France. On the other hand, his expression of certain emotional attitudes and sentiments, his particular gamut of colours, and the fulness of his forms were a major factor in the revival of the arts that took place around 1600 through the work of the Carracci and others. In central Italy Barocci was the most important precursor of Baroque religious art.

52 Head of a man

Black and coloured pastel chalks, on blue-grey paper. 296 x 220 mm.

Coll.: *Shirley.*

Lit.: *Parker 1956, no. 95; Olsen 1962, p. 192; Sutton 1970, no. 33; Emiliani 1975, no. 252.*

Ashmolean Museum.

This sheet was identified by Parker as a probable preparatory drawing for one of the heads in the left background of Barocci's *Presentation of The Virgin* in the Chiesa Nuova in Rome, begun in 1593 and finished in 1603. In excellent condition, this beautiful drawing is one of Barocci's many sheets of coloured heads, which are so indicative of the artist's subtle and enquiring temperament.

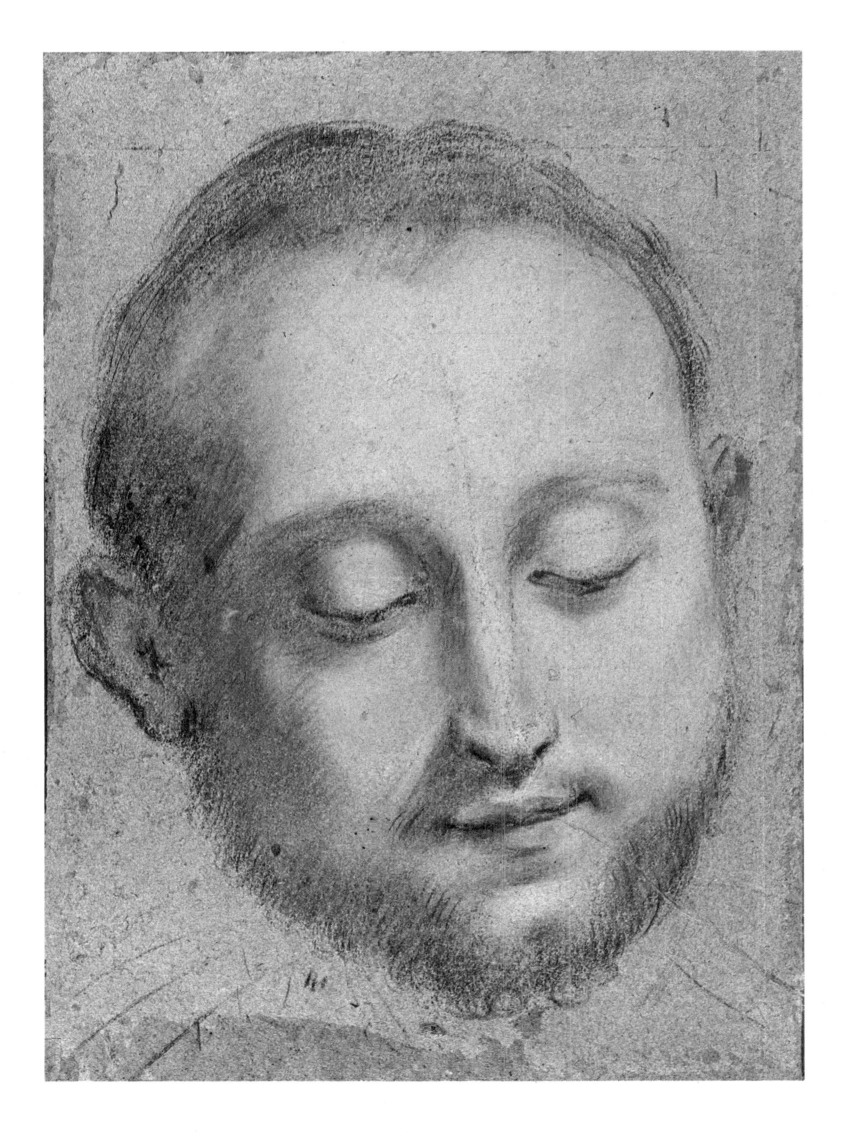

FEDERICO ZUCCARI

Painter, architect, and theorist, Federico Zuccari was born in Sant'Angelo in Vado, near Urbino, in about 1540–41 and died in Ancona on October 20, 1609.

In 1550 his parents sent him to Rome to study painting in the studio of his brother Taddeo. Until the latter's death in 1566 Federico's activity, with a few notable exceptions, was limited to that of collaborator or executor. From 1564 to 1565 he was in Venice, where he was greatly impressed by the art of Paolo Veronese. In 1565 he moved to Florence. In 1574 he travelled in France, the Low Countries, and England. He was again in Florence between 1575 and 1579 and subsequently moved to Rome. Still other travels followed, in particular in Spain, where he worked in The Escorial (1588–89). In Rome in 1593 he refounded the Accademia di San Luca, of which he became *principe* in 1598.

Federico's style derives from that of his brother Taddeo, for whom, in addition to the artistic currents of Rome at the time, the art of Correggio had a decisive importance. Taddeo Zuccari was, in fact, one of the major figures among those who attempted a break with the decorative rigidity of masters such as Vasari and Salviati, and sought to create a livelier style of greater plasticity, richer colour, and more articulated spatial structure. Of a more intellectual temperament, Federico lacked Taddeo's vitality. He combined a tendency to schematic abstraction in figures and compositions with facility in figurative invention, and was thus perfectly at ease in fresco decoration on a vast scale. His major work—and the most debated—is the decoration of the dome of the Florence cathedral, begun by Vasari and continued by Federico in a very different vein. In comparison to Vasari Federico's style is more realistic and his figures have a greater compactness, but he lacked the sense of monumentality indispensable to such an undertaking. As a theorist he was the principal spokesman for those who saw the spiritual origin of art and all human creation in *disegno*. Among Federico's graphic works, particularly fascinating are his studies from life, personal recordings drawn without academic preoccupations.

53 The Triumph of the Arts

Pen and brown ink, with ink wash; squared in red chalk.
378 x 276 mm.

Coll.: *Guise.*

Lit.: *Bell 1914, p. 93, F. 26; Heikamp 1958, pp. 45–50; Byam Shaw 1972, no. 86; Byam Shaw 1976, no. 544.*

Christ Church.

Every year in Rome, on October 18, the feast day of Saint Luke, members of the Accademia di San Luca exhibited their work in the square in front of the Pantheon. On this occasion in 1581 Federico Zuccari, then *preside* of the academy, exhibited a cartoon. Of this cartoon there exist three sketches, of which the one reproduced here is the best. According to Byam Shaw (in consultation with John Gere) the subject is the allegory of the *Porta Virtutis*, that is, Art triumphing over Ignorance and Calumny. The evident satire of the cartoon was taken badly at the court of Pope Gregory XIII, and Zuccari and his assistant, Passignano, were tried and exiled. The painter defended himself maintaining that in the Ignorance and Calumny he did not wish to refer to the Romans, but to the Florentines who had not appreciated his work in the dome of their cathedral. The cartoon was in any case destroyed. The other two sketches are in the Scholz collection in New York (now in the Morgan Library) and the Staedelsches Kunstinstitut in Frankfurt.

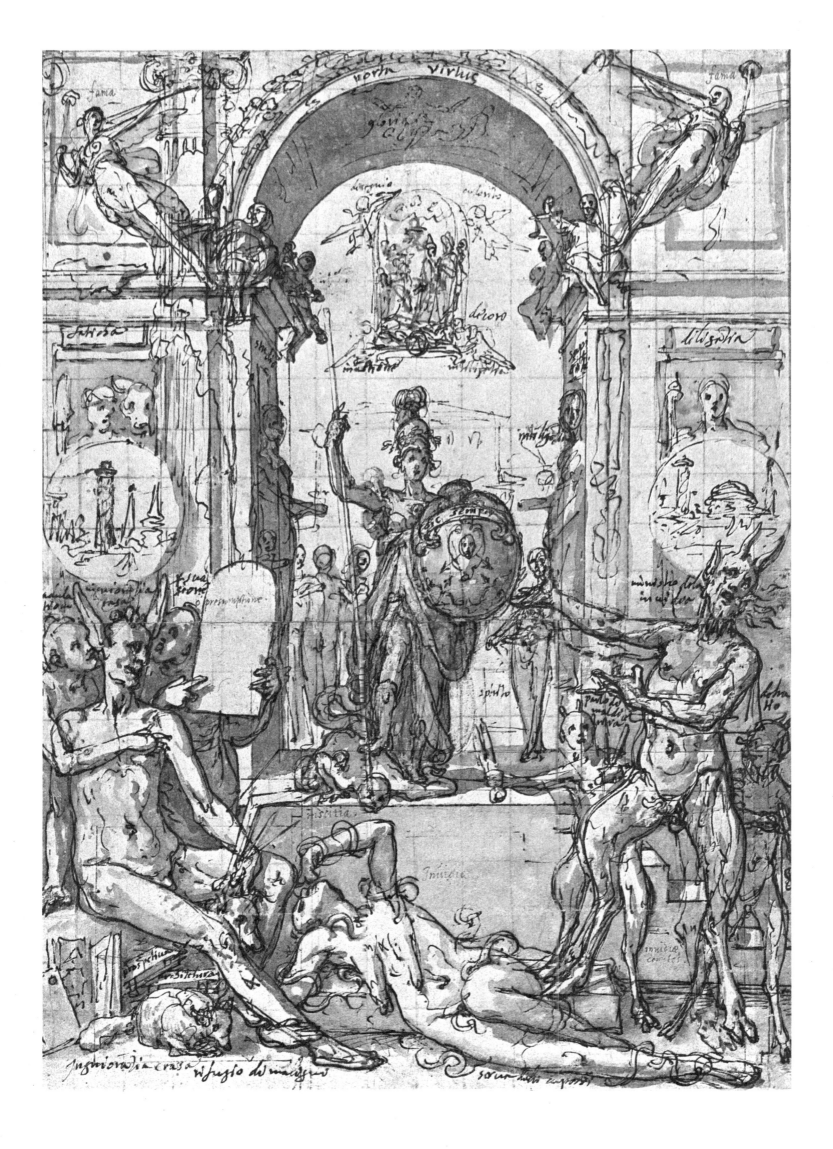

ANDREA BOSCOLI

The painter Andrea Boscoli was born in Florence about 1560 and died there in 1607. The extremely varied sources of his art indicate a remarkable breadth of interests and a multiplicity of influences: Santi di Tito, with whom he studied, Pontormo, Rosso Fiorentino, Andrea del Sarto, Federico Barocci, and the Zuccari, and in addition Polidoro da Caravaggio and Perin del Vaga, whose works he had the chance of studying during a youthful trip to Rome. In 1584 Boscoli entered the Florentine Accademia del Disegno and from that time on the young painter pursued an intense activity that also involved frequent journeys. In 1587 he painted the fresco of the *Martyrdom of Saint Bartholomew* in the small cloister of San Pier Maggiore in Florence. In 1589 he collaborated on the decoration erected for the wedding of Ferdinando de' Medici with Christine of Lorraine and on those for the triumphal entry into Siena of Ascanio Piccolomini. In the same period he executed the *Marriage at Cana* in the Uffizi and the *Saint Francis* in the Museo Nazionale in Pisa. Shortly thereafter followed the *Annunciation* in the church of the Carmine in Pisa, the *Miracle of Saint Nicholas* in San Lorenzo alle Rose near Florence, and the *Visitation* in the Florentine church of Sant'Ambrogio. From 1600 to 1606 the artist was in the Marches, where he painted the two altarpieces in the monastery of San Luca in Fabriano, the *Madonna and Saints* in the cathedral of Macerata, and other works in Fermo, Sant'Elpidio a Mare, and San Ginesio. In 1606 Boscoli was again active in Florence, where he executed the *Saint Sebastian* in the Uffizi.

54 Landscape with a deer hunt

Pen and brush with brown ink and watercolour washes. 182 x 138 mm.

Colls.: *Guillaume Hubert (Lugt, Supplément, 1160); Guise.*

Lit.: *Bell 1914, p. 57, CC. 11; Byam Shaw 1972, no. 7; Byam Shaw 1976, no. 233.*

Christ Church.

The drawing represents a frame crowned by a broken pediment and within the pediment a putto who holds up the portrait of a gentleman. The frame seems to be conceived as a stage front, through which one sees a vast landscape with an animated deer hunt. Byam Shaw reports the opinion of Popham, who compared this peculiar drawing to the scenery with the same subject painted by Federico Zuccari, in 1565, for a performance in the Palazzo Vecchio on the occasion of the marriage of Francesco de' Medici to Joanna of Austria. Boscoli would thus have produced a variant of Zuccari's scenery, the drawing for which is in the Uffizi.

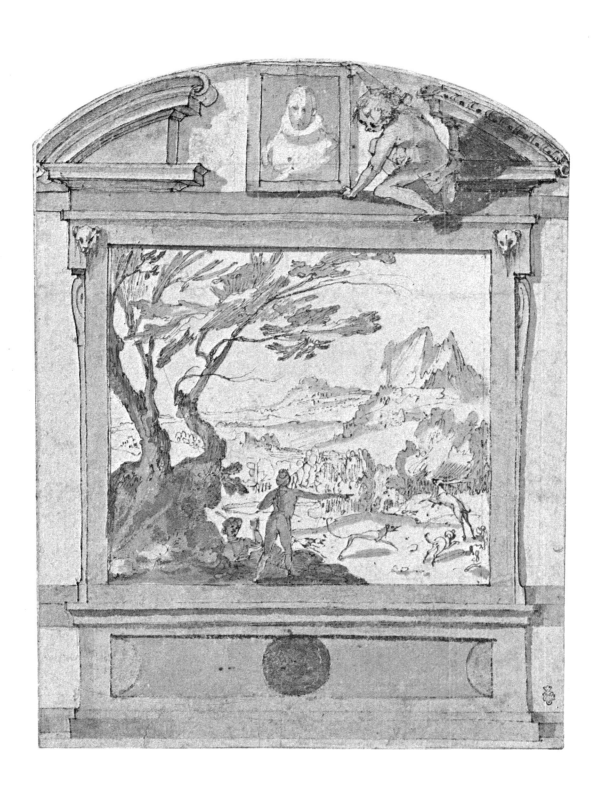

LODOVICO CARRACCI

Lodovico Carracci was born in Bologna in 1555 and died there in 1619. Along with his slightly younger cousins, Agostino and Annibale, he was the initiator of a pictorial current that for the whole of the 17th century constituted the most valid alternative to the Baroque trend. He was also the principal protagonist of the artistic reawakening of the Bolognese school.

In the period between 1570 and 1580 Lodovico studied in the school of the late Mannerist Prospero Fontana. But already in this early period he showed a great breadth of artistic interests, which formed the strict method and stylistic awareness that characterize his whole production. Although he was very receptive to the austere and intimate religiosity of certain Counter-Reformation painters (and not only the Bolognese Cesi, but also the Florentines, Santi di Tito, Procetti, Cigoli, and Passignano), and to the naturalistic simplicity of the Campi family of Cremona, he was still able to appreciate the preciosity of colour of such artists as Camillo Procaccini, and even Correggio and Parmigianino, and, stimulated by a trip to Rome in 1602, even made sporadic concessions to Annibale's noble classicism. In his abundant pictorial and graphic production, this complex of experiences and contacts was translated in terms of a sincere and pathetic religiosity and an almost affectionate approach to nature. These are characteristics met with in all his works, of which we here cite a selection of the more important: the *Conversion of Saint Paul* (*ca.* 1587) and the *Bargellini Madonna* (1588), two altarpieces in the Pinacoteca in Bologna; the frescoes of the Magnani-Salem and Sampieri palaces in Bologna, both carried out together with his cousins, respectively in 1588–91 and 1593–94; the altarpiece of the Museo Civico in Cento (1591); The *Martyrdom of Saint Angelus* in the Pinacoteca in Bologna (*ca.* 1598–99); and finally, the works executed between 1606 and 1609 for the cathedral of Piacenza, including the frescoes of the choir and vault, and the two large canvases today in the Galleria Nazionale in Parma.

55 Ecce Homo

Pen and brown ink, with ink wash, over traces of red chalk. 335 x 370 mm.

Coll.: *Guise.*

Lit.: *Byam Shaw 1972, no. 16; Byam Shaw 1976, no. 915.*

Christ Church.

The drawing is little known as it was not included in the first cataloguing of the collection by Bell. Recently it has been published by Byam Shaw as one of the final studies for the fresco of the *Ecce Homo*, painted by Lodovico about 1595, in the portico of Palazzo Ercolani in Via Galliera in Bologna, and later transferred to the Oratory of San Filippo Neri, now incorporated in the church of the Madonna di Galliera. Another drawing of the Christ Church collection shows a different version, with Pilate on the right, but is to be attributed to Lodovico's assistant, Francesco Brizio. A sketch for the same work from Lodovico's hand is in the Adair collection in New York.

The composition is still in the artist's youthful style and reflects certain inventions of Correggio seen by Lodovico in the Parma cathedral.

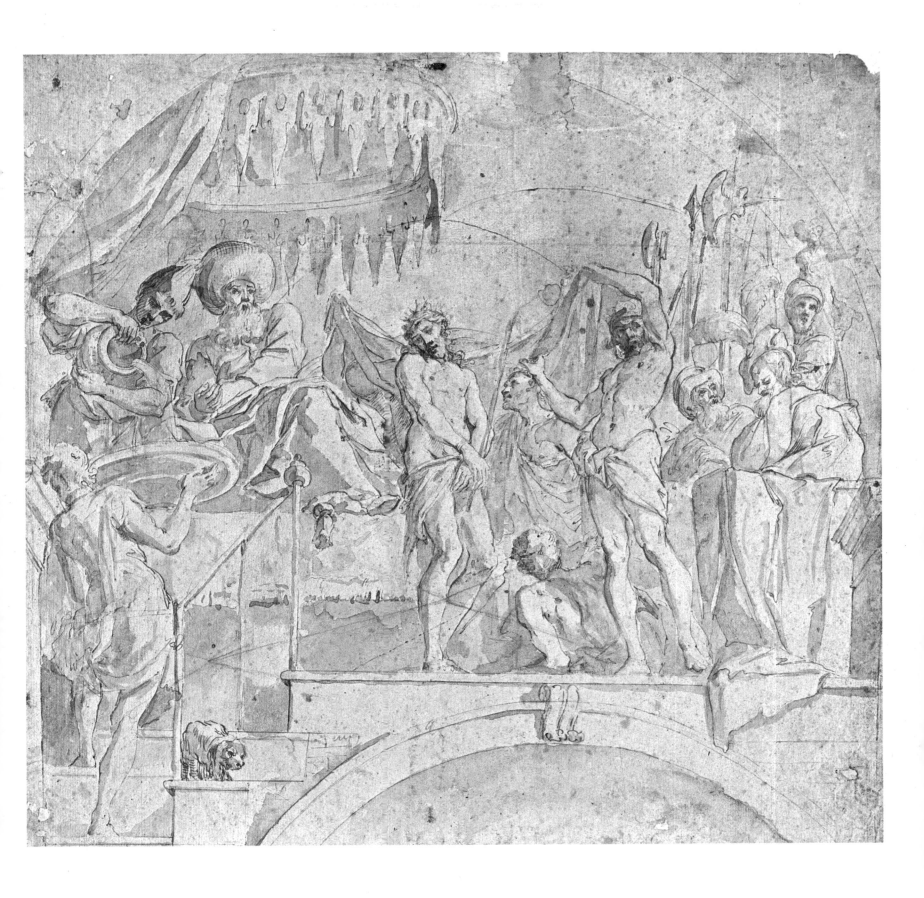

ANNIBALE CARRACCI

Annibale Carracci was born in Bologna in 1560 and died in Rome in 1609. Together with his brother Agostino, he studied with their cousin Lodovico. Jointly, in 1585–86, they founded the famous Accademia degli Incamminati, which in deliberate opposition to late Mannerist practice proclaimed the study of nature free of preconceived ideas and rules. In Parma and Venice Annibale studied the works of Correggio, Parmigianino, Niccolò dell'Abate, Titian, Tintoretto, and the Bassano family. In 1595 Cardinal Odoardo Farnese summoned him to Rome and there, between 1595 and 1604, he created his masterpiece, the fresco decoration of the Galleria of Palazzo Farnese, in which between 1597 and 1600 Agostino also participated.

Annibale's repertory spans the gamut from realistic genre scenes, of which he produced many in his early years in Bologna, to the ideal figure, developed in Rome through his devotion to the art of antiquity, Raphael, and Michelangelo. This ideal aspect of his art—later to be defined academic—was soon recognized as the opposing trend to the realism of Caravaggio and his followers. Nevertheless, as master of true-to-life portraits and idealized, heroic landscapes Annibale was an innovator.

In the title of his *Arti per Via* it is stated that many of Annibale's drawings were created in his 'hours of relaxation'. Mariette owned one of the most important collections of his drawings, including sheets coming from Crozat and the painter Pierre Mignard, and originally deriving from Annibale's own close friends, Angeloni and Agucchi. When Annibale died, his students, according to Bellori, followed his bier 'kissing in death the hand that had given spirit and life to darkness'. These words can be applied literally as well as metaphorically even to Annibale's drawings, which in their pictorial breadth and freedom were related to the Venetian tradition and found their real successor in the graphic work of Guercino.

56 Male nude

Red chalk. 368 x 252 mm.

Coll.: *Guise.*

Lit.: *Byam Shaw 1976, no. 936.*

Christ Church.

One of the drawings that escaped Bell's first cataloguing of the collection and thus little known, but of notable interest and quality. According to Byam Shaw it is drawn from life and can be related to the fresco of *Ulysses and the Sirens* in the Camerino of Palazzo Farnese, from about 1595. It is possible that other drawings by Annibale at Windsor make use of the same young model (Wittkower 1952, nos. 615, 616).

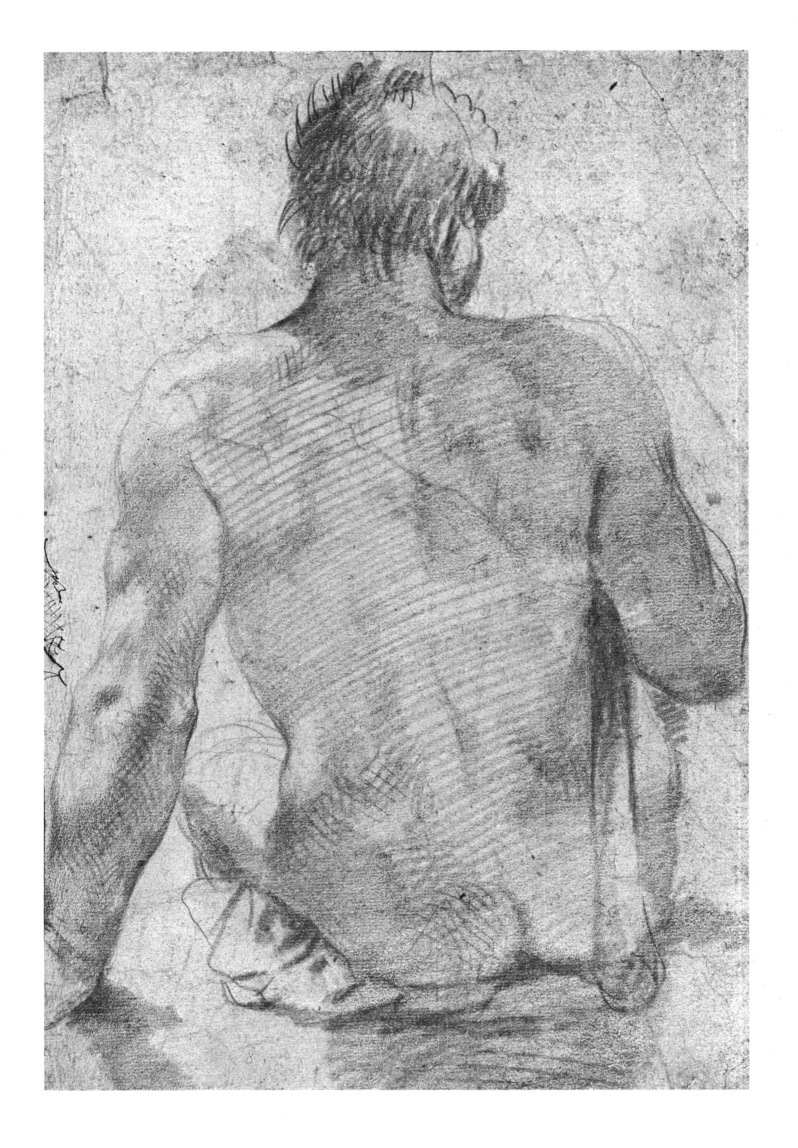

AGOSTINO CARRACCI

Nephew of Lodovico and brother of Annibale, Agostino Carracci was born in Bologna in 1557 and died in Parma in 1602.

In 1582 and again in 1588–89 Agostino visited Venice. From that experience he drew the elements for a formal expression that in Rome, especially through the work of the more gifted Annibale, was to produce extraordinarily original results. In the Galleria Farnese Agostino, in fact collaborated with his brother, albeit in a lesser capacity. Here he revealed a classicizing disposition, seen in his greater emphasis on line and in his colour, which tends to chiaroscuro gradations. This was also in keeping with his notable propensity to the graphic arts, witnessed by his engravings and drawings. Friction with Annibale led Agostino to leave Rome, subsequently entering the service of Ranuccio Farnese in Parma, where he decorated a room in the Palazzo del Giardino with elegant mythological frescoes.

57 Anchises and Venus

Pen and brown ink, with ink wash, over red chalk. 370 x 255 mm.

Coll.: *Guise.*

Lit.: *Bell 1914, p. 34, O. 6; Byam Shaw 1972, no. 14; Byam Shaw 1976, no. 930.*

Christ Church.

This is yet another almost unknown Carracci work to which Byam Shaw has drawn attention and which he considers of great interest. The male figure (Anchises?) undressing an only partially seen female figure (Venus?) brings to mind the fresco of *Venus and Anchises* in the Galleria of Palazzo Farnese, painted in about 1600 and up to now attributed to Annibale. The indisputable attribution of this sheet to Agostino Carracci has made it possible for Byam Shaw to observe that even the fresco of *Venus and Anchises,* in comparison to Annibale's nearby panel of *Bacchus and Ariadne,* has that cold tonality, tending to grey in the flesh tones, which is seen in other frescoes of the ceiling traditionally attributed to Agostino, such as the *Cephalus and Aurora* and the *Glaucus and Scylla.*

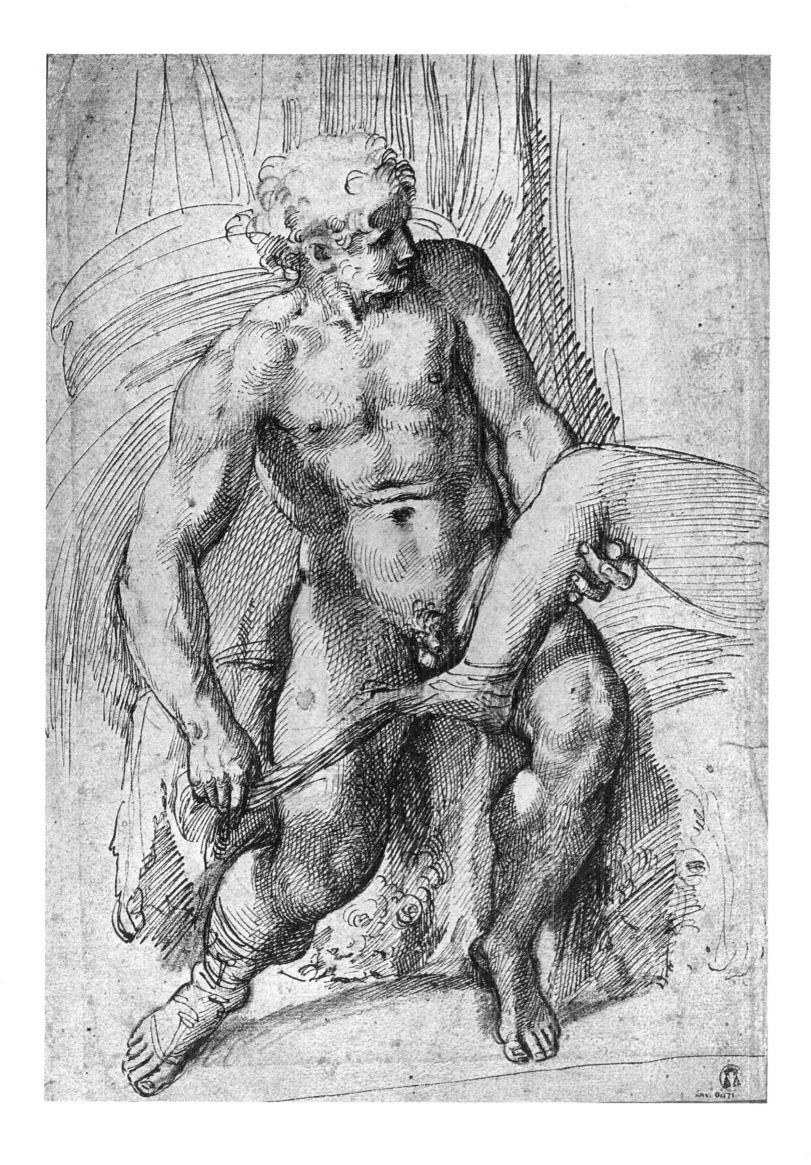

GUIDO RENI

The son of a musician, Guido Reni was born in Bologna in 1575 and died there in 1642. Along with Domenichino and Albani he received his first artistic instruction from the Fleming Dionys Calvert, who directed his students first of all to Dürer and in second place to Raphael. About 1595, attracted by the Carraccis' Academy and their liberal approach to the study of antiquity and nature, Reni became a student of Lodovico. In the first years of the new century he went to Rome and joined the circle around Annibale, studying also the work of Caravaggio. But above all, and even more strongly than the Carracci and their other followers, Reni felt the fascination of Raphael. He was also attracted by the works of Andrea del Sarto and Correggio. Raphael's art was particularly consonant with Reni's own idealism, so clearly expressed in the words of a letter, written much later, to Monsignor Massani concerning his *Archangel Michael* for the Roman church of Santa Maria della Concezione: 'I would like to have had the brush of an angel and the forms of Paradise to create the Archangel and see him in Heaven' (Bellori). From 1602 to 1605 Reni was again in Bologna. Between 1607 and 1614, except for a brief stay in Bologna in 1611–12, he worked in Rome for Paul V and Cardinal Scipione Borghese. After finishing his famous ceiling fresco of *Aurora* in the casino of Cardinal Borghese's palace on the Quirinal, he returned for good to his native city.

Guido Reni became the ideal of all artists seeking classical harmony, in his own century and later, not only in Italy but also abroad, and especially in France, where he was particularly important for such artists as Vouet, La Hire, and Le Sueur. With his innate concept of beauty Reni inspired theories of art from Bellori to Winckelmann, and succeeded in combining classical harmony and clarity of form with the pictorial accomplishments and feeling for nature proper to his own time.

58 Head of an old man

Black and red chalk, on blue-grey paper. 250 x 184 mm.

Lit.: *Parker 1956, no. 931.*

Ashmolean Museum.

According to Otto Kurz, whose opinion is recorded by Parker, this penetrating study of a head, evidently sketched from life, was used by Reni for one of the Apostles in his *Assumption of the Virgin*, painted in 1617, for the church of Sant' Ambrogio in Genoa.

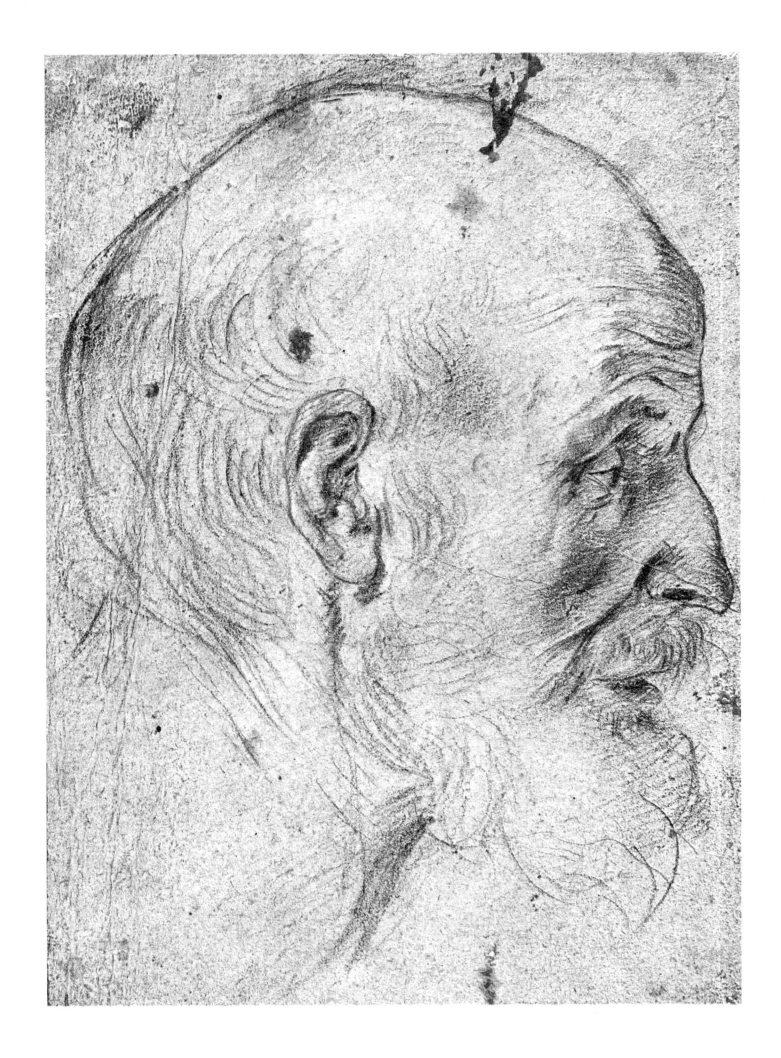

GUERCINO

Francesco Barbieri, called Guercino, was born in Cento in 1591 and died in Bologna in 1666. Largely self-taught, his artistic formation was influenced by the Carracci, especially Lodovico, but he was never actually his pupil. In 1607 he worked in Cento as assistant to the local painter Benedetto Gennari and later was active in Ferrara, Bologna, and Mantua. In 1618 he visited Venice, where he met Palma Giovane. Summoned to Rome in 1621 by the Bolognese Pope, Gregory XV Ludovisi, he there painted his famous fresco of *Aurora* in the Ludovisi villa on the Pincio. Late in 1623 he returned to Cento, where he worked, with a few interruptions (in 1626 he was in Piacenza), until 1642. In the same year, after Guido Reni's death, Guercino moved to Bologna, where for the rest of his life he carried on an intense activity.

Among the artists of the Bolognese school Guercino was the most affected by the Caravaggesque manner, which he lightened, however, especially in his late works, which reflect the competition with Reni's painting. Like the Carracci a versatile artist, Guercino also cultivated landscape and genre painting. His drawing style is directly related to that of the Carracci, particularly Lodovico, but also Annibale. As a draughtsman he has always been loved and sought after by collectors, especially in England, where the major collections of his graphic works are to be found.

59 The mystic marriage of Saint Catherine

Pen and brown ink, with ink wash, over black chalk. 256 x 203 mm.

Lit.: *Parker 1956, no. 856; Bottari-Roli-Ottani Cavina 1966, pl. XXII; Mahon*, Disegni, *1968, no. 53.*

Ashmolean Museum.

This beautiful drawing has been identified as a preliminary sketch for the painting of the same subject, formerly in the Denis Mahon collection and now in Berlin, which Guercino executed for Cavalier Piombino of Cento in 1620 (Mahon, *Dipinti*, 1968, no. 40; Oertel 1971, no. 1). A youthful work, just preceding the artist's departure for Rome in the spring of 1621, Guercino here interprets his subject with direct and intimate realism, in terms of robust forms and a rich chiaroscuro.

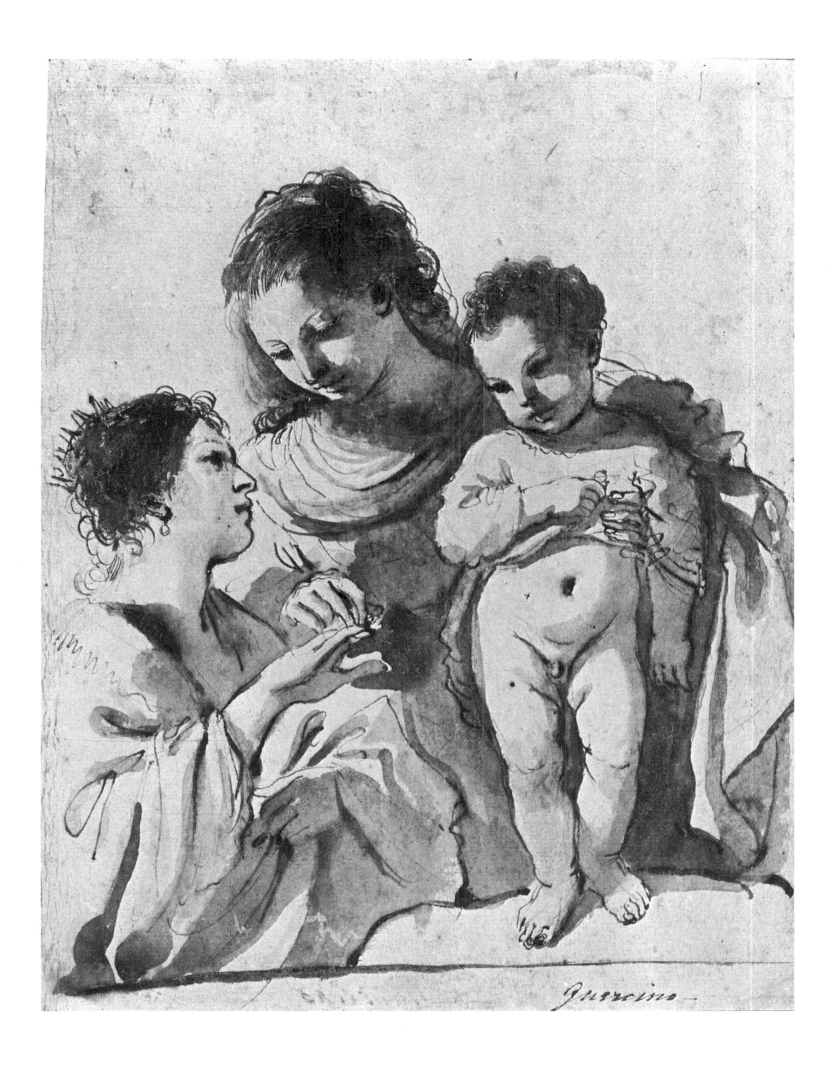

Guercino

60 Two women conversing

Red chalk, partially stumped. 279 x 384 mm.

Colls.: *Philippe Mercier; J. Richardson, Sen. (Lugt 2184); Blomberg; Wm. A. Worsley; Reitlinger (Lugt, Supplément, 2274 a).*

Lit.: *Parker 1956, no. 864; Sutton 1970, no. 52; Mahon, Disegni, 1968, no. 223.*

Ashmolean Museum.

On the back of the drawing is an inscription in the hand of Jonathan Richardson, Senior: *Given me by Mr. Mercier, 1724.* The drawing thus came from the noted French engraver and genre painter, Philippe Mercier, who worked a great deal in London after 1716.

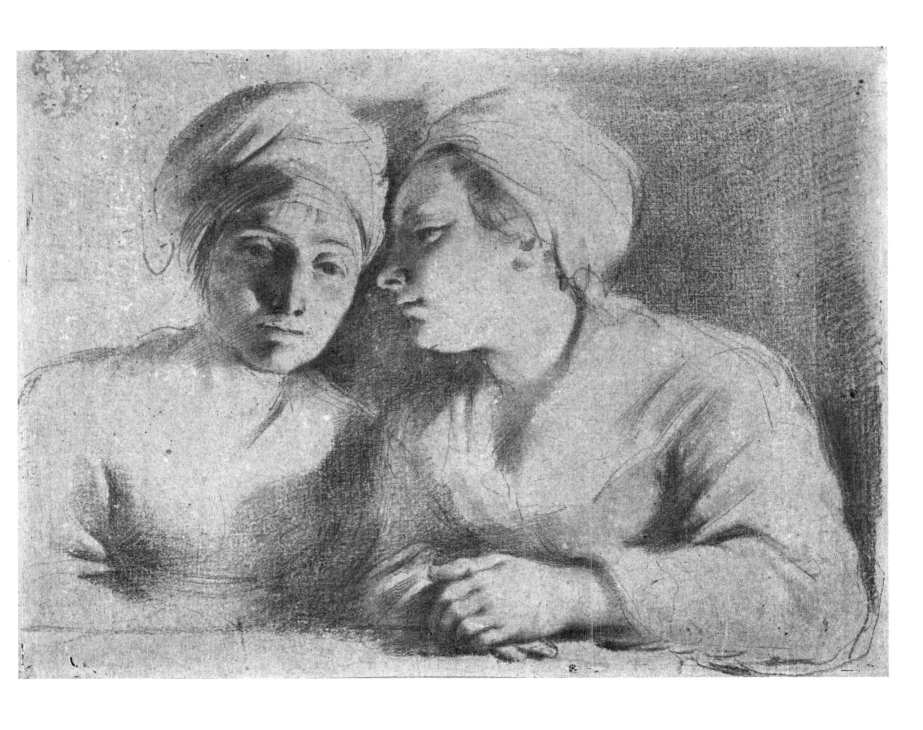

OTTAVIO LEONI

Ottavio Leoni was born in Rome in 1578 and died there in 1630. A modest, eclectic painter of sacred canvases for Roman churches, Leoni made a specialty of portrait drawings or engravings of famous persons of his time. Examples of these works are very numerous (Biblioteca Marucelliana, Florence) and often bear precise biographical information and dates. Prince Borghese made a collection of about four hundred of Leoni's portraits, which later went to France and was sold in 1747 at the death of the last owner, D'Aubigny.

61 Portrait of Princess Peretti

Black chalk, heightened with white chalk, on grey paper. 193 x 155 mm.

Coll.: *Lempereur (Lugt 1714).*

Lit.: *Colnaghi*, Old Master Drawings, *1948, no. 10; Parker 1956, no. 879.*

Ashmolean Museum.

The sitter, a Roman noblewoman in the following of Sixtus V, is identified by the inscriptions: *S. Ana Maria 1611*, in the artist's hand, and *Princip.ᵃ Peretti*, added in pen. A typical work of this prolific portraitist, it was probably part of the collection of over four hundred such drawings once belonging to Prince Borghese, which were examined by Mariette at the time of their sale in Paris in 1747.

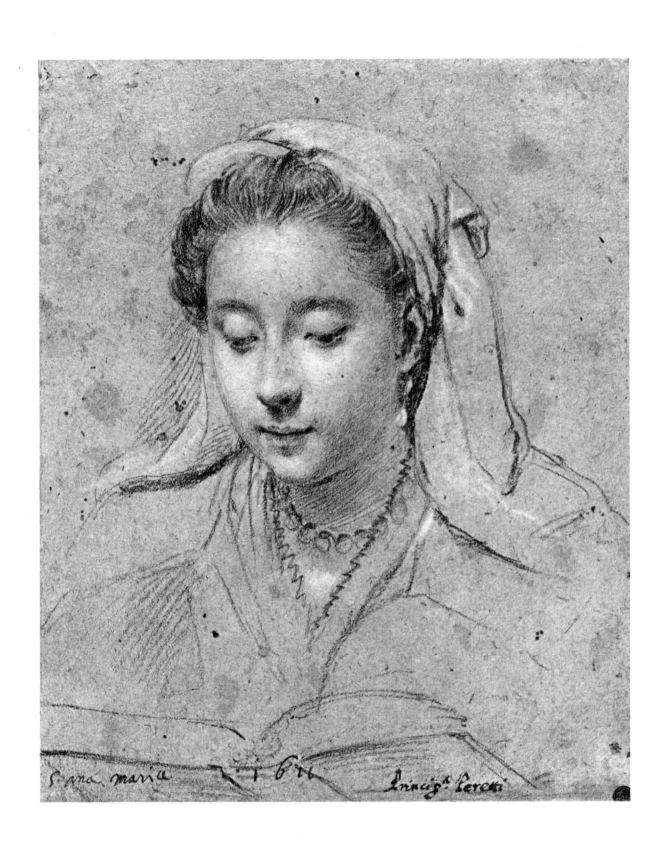

Sana maria 1616 Princig.ª Peretti

DOMENICO FETTI

The painter Domenico Fetti was born in Rome in 1589 and died in Venice in 1624. He was educated in the post-Caravaggesque circle of Borgianni and his particularly painterly tendency was nourished on a warm, rich colour of Flemish stamp. In 1614 he moved to Mantua and there had the opportunity of studying directly works by Rubens. This experience influenced him greatly, as can be seen in his works painted for the churches and Ducal Palace of Mantua. In 1622 he moved to Venice, where he was the first of those masters who revived Venetian painting in the 17th century. The rarity of his drawings makes identification of his graphic work difficult, but those that have nevertheless been attributed to him are sketches of a fluent, structural line, in the manner of the *Parables* he painted in his late years.

62 Portrait of Catherine de' Medici

Red and black chalk. 322 x 241 mm.

Col.: *Guise.*

Lit.: *Bell 1914, p. 44, No. 17 A; Pignatti 1959, no. 25; Byam Shaw 1972, no. 27; Byam Shaw 1976, no. 851.*

Christ Church.

A contemporary inscription on the *verso* identifies the sitter as the Duchess de' Medici, wife of Ferdinand I of Mantua, and indicates Domenico Fetti as the artist. Fetti was in Mantua up to 1622 and this date seems to correspond with the age of the Duchess, who would then have been about thirty. The attribution to Fetti, indicated in the certainly old inscription, is further confirmed by the distinctly Rubens-like style of the portrait. Indeed, there is no reason whatsoever to doubt this attribution, especially as Fetti was very active as a portraitist at the Ducal court: an inventory of 1627 lists no less than twenty-three portraits by his hand.

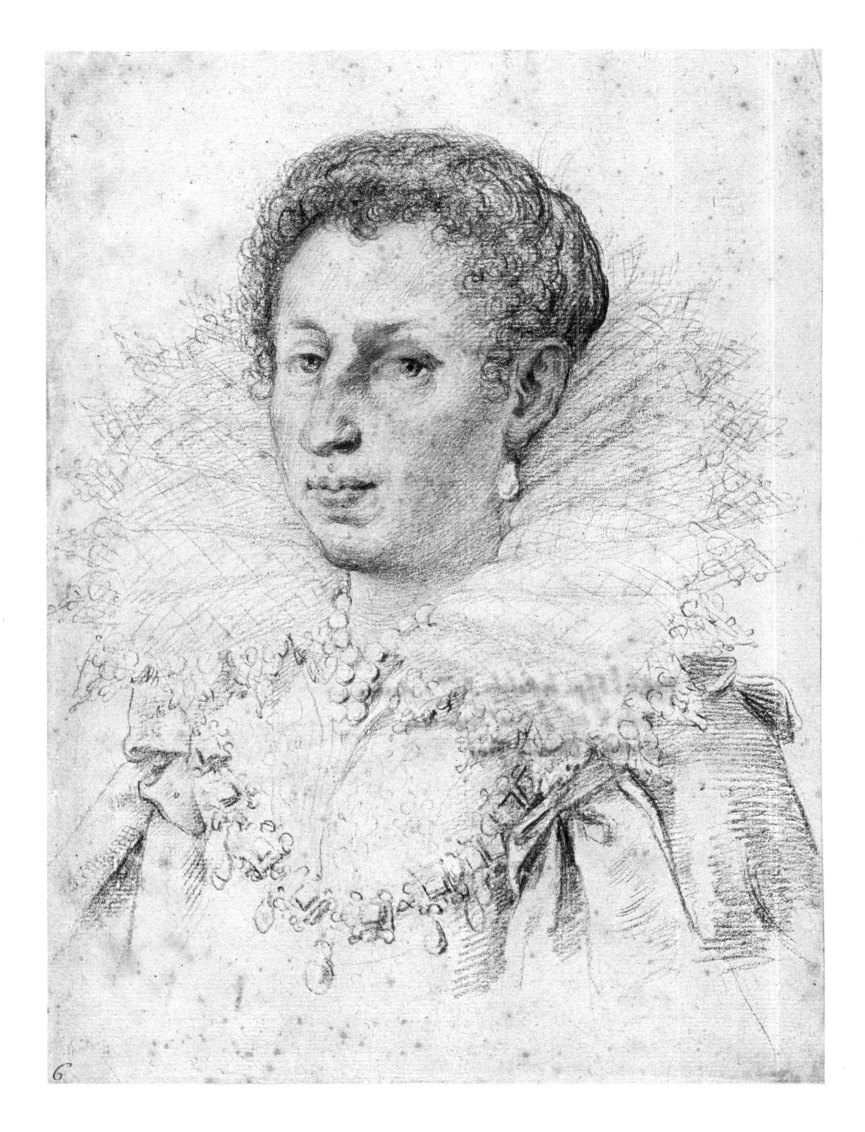

6

GIAN LORENZO BERNINI

The sculptor and architect Gian Lorenzo Bernini, son of the Florentine sculptor Pietro Bernini, was born in Naples in 1598 and died in Rome in 1680.

In 1605 his father moved to Rome, where the young Gian Lorenzo's earliest artistic experiences were based principally on the examples of Michelangelo's powerful monumentality, Annibale Carracci's classicizing paganism, and the vivacious pictorialism of the sculptor Camillo Mariani. Very quickly divorcing himself from the late Mannerist climate of his father's workshop, Bernini formulated a completely original style. On the one hand, his absolutely new art was destined to revolutionize Italian sculpture and architecture, opening the way to the grand Baroque era. On the other, it also lent itself particularly well to the expression of that function which the great patrons, first and foremost the papacy, attributed to the figurative arts: a reconfirmation in the eyes of the world of the prestige of institutions and the validity of the social order. It is within this context that one finds not only the historical justification for the overwhelming scenographic architecture and the amazing sculptural undertakings with which Bernini literally changed the face of Rome, but also the reason for the enormous success this new and grandiose language encountered.

This success is certainly demonstrated by the incredible number of commissions the artist received in the course of his career. Among these we may record: the youthful sculptures executed for Cardinal Scipione Borghese, including among others the *David* and the *Apollo and Daphne* (1623–24) in the Borghese Gallery; the many works he almost continually provided for the basilica of Saint Peter's, including the *Baldacchino* (1624–33), the statue of *Saint Longinus* (1629–38), the square of Saint Peter's with its colonnade (1656–65), the *Cathedra Petri* (1657–66), and the funerary monuments of Urban VIII (*ca.* 1642–44) and Alexander VII (1672–78); the construction of such buildings as the Palazzo Barberini or the church of Sant'Andrea al Quirinale (1658); the innumerable statues, among them the *Saint Bibiana* in the church of this saint (1626), the *Truth* in the Borghese Gallery (1646–52), the *Daniel* and *Habakkuk* in Santa Maria del Popolo (1656–61), the beautiful *Angels* in Sant'Andrea delle Fratte (1667–69), and the *Blessed Ludovica Albertoni* in San Francesco a Ripa (1675–76). Finally, he created a gallery of portraits in which the principal figures of his time are represented with an aura of great splendour and rhythms of a monumental plasticity.

63 Self-portrait

Red and white chalk, on light-brown paper. 299 x 208 mm.

Lit.: *Wittkower 1951, p. 55, pl. 18; Parker 1956, no. 793.*

Ashmolean Museum.

The Ashmolean owns three Bernini self-portraits (nos. 792–794), identified by Wittkower on the basis of their resemblance to the noted drawing in the Farnesina collection in Rome, where the sitter is identified by an old inscription. The Farnesina drawing, however, is considered by Wittkower and Parker to be a copy of the Ashmolean sheet no. 792. According to Parker, both the age of the sitter and the stylistic affinity with the sculpted *Bust of Costanza Buonarelli*, of 1635, offer a date for this beautiful drawing.

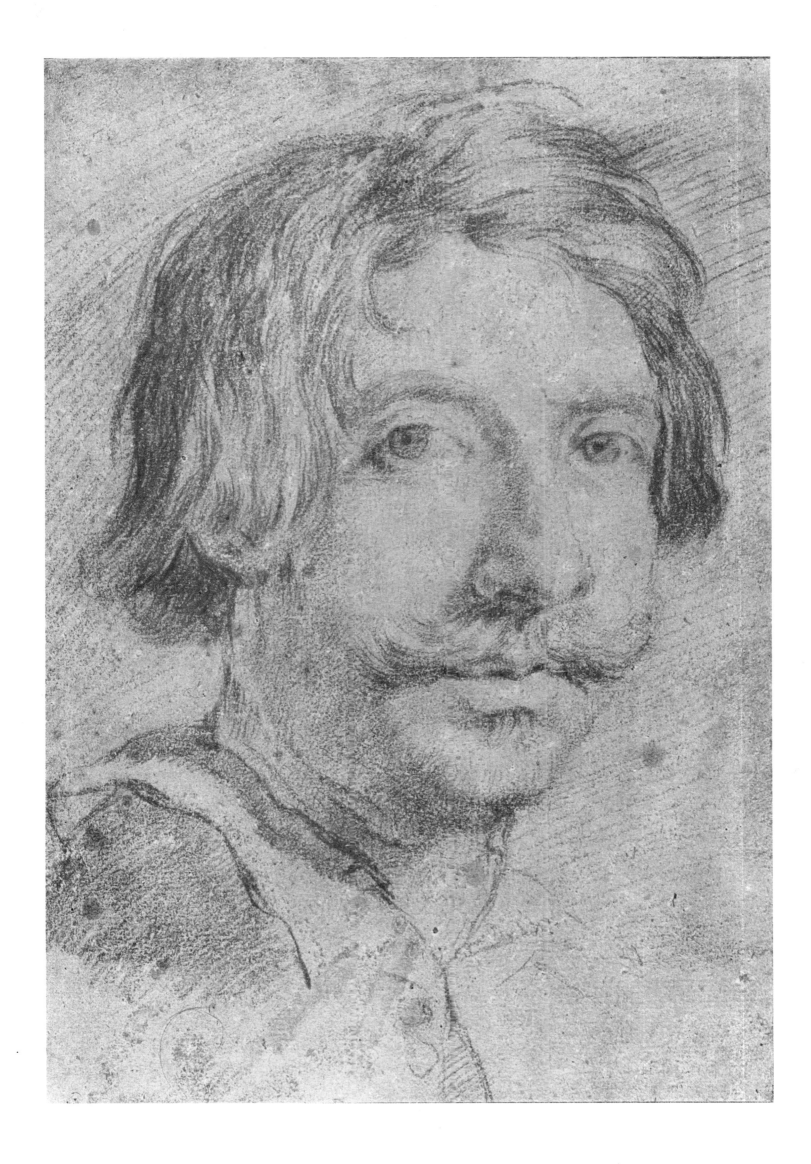

PIETRO DA CORTONA

The painter and architect, Pietro Berrettini, descended from a family of long established builders and masons, was born in the Tuscan town of Cortona, from which he derives his name, in 1596 and died in Rome in 1669.

He was the pupil of the Florentine painter Andrea Commodi, who was working in Cortona. After a brief sojourn in Florence he joined Commodi in Rome in 1612–13. When Commodi left the city Pietro went to the workshop of Baccio Carpi. In Rome the young artist studied the works of Raphael, Michelangelo, the Carracci, and Caravaggio, and also Borgianni and Rubens. Through his first patron, the Marchese Sacchetti, and the poet Marino Marini he gained entrance to the circle of Pope Urban VIII, under whose patronage he became one of the leading painters and architects of Rome. Active in Rome and also in Florence, where in 1637, 1640–42, and 1644–48 he executed the fresco decoration of various rooms in Palazzo Pitti, Pietro da Cortona along with Bernini, made a fundamental contribution to the creation of Roman High Baroque art. Together with Poussin, Mola, and his own pupil Testa, he frequented the circle of Cassiano dal Pozzo. He was *principe* of the Accademia di San Luca from 1634 to 1638, the years that witnessed the dispute with the Dutch Schildersbent and the theoretical debate with Andrea Sacchi and the exponents of the classical trend.

In addition to the architectural works he left in the city, his celebrated ceiling in Palazzo Barberini (1633–39) and the decoration of the Chiesa Nuova (1648–65) mark the apogee of Baroque fresco decoration. From the very beginning Pietro pioneered a grand and monumental manner of painting, in terms of large patches of rich colour applied with an audacious pictorial looseness and freedom, which influenced not only his many students but some of the most outstanding of later Baroque decorators, such as Baciccio and Luca Giordano. His graphic style had an analogous development, progressively deviating from the Florentine tradition of *disegno*. In fact, it is only in the dense play of lines of some of his pen and ink drawings, a technique he used as a parallel to his studies in chalk or brush, that one can find a distant echo of the Tuscan manner.

64 Design for a wall decoration

Pen and brown ink, with ink wash. 320 x 274 mm.

Colls.: *Padre Resta; Lord Somers; Guise.*

Lit.: *Bell 1914, p. 40, D.D. 7; Wibiral 1960, p. 140; Briganti 1962, p. 310; Byam Shaw 1972, no. 21; Byam Shaw 1976, no. 614.*

Christ Church.

An inscription in the hand of Padre Resta identifies this sketch with the fresco decoration of the Galleria of Alexander VII in the Quirinal palace in Rome, executed in 1656–57. This design, consisting of a doorway decorated above with a beautiful tondo flanked by putti and containing a landscape fresco, is, however, related to a portion of the painted decoration of the gallery that no longer exists. Wibiral attributed the drawing to Grimaldi, but Byam Shaw feels that the vibrant warmth and luminosity of this sheet can leave no doubt whatsoever concerning its attribution to Pietro da Cortona.

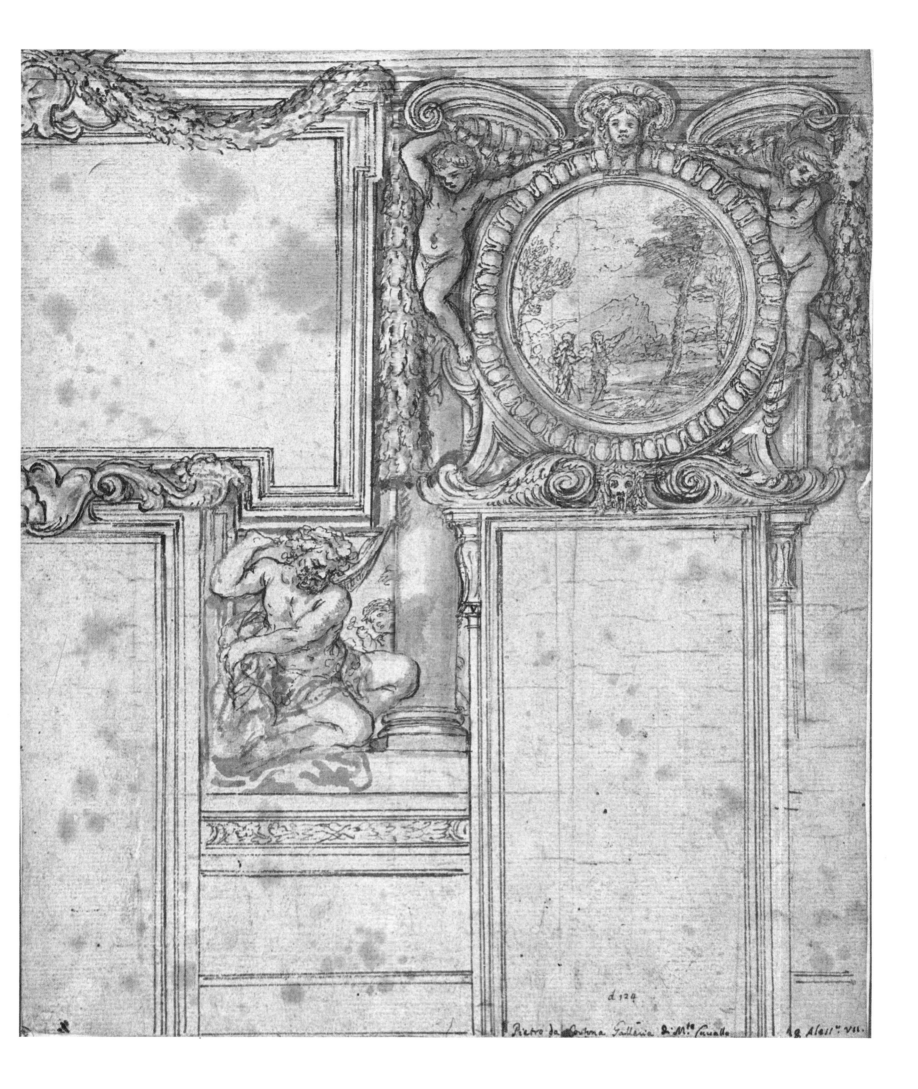

d.124

Pietro da Cortona Galleria di Mte Cavallo Ag Aless.° VII.

BACICCIO

Giovanni Battista Gaulli, called Baciccio, was born in Genoa in 1639 and died in Rome in 1709. He completed his education in Genoa and in 1657, after the plague and the loss of his entire family, he moved to Rome. There his encounter with Bernini determined the course of his career. Encouraged and protected by the great master, Gaulli not only submitted definitively to his influence, but with ever-growing sensibility and precision became the pictorial interpreter of Bernini's mature and late sculptural works, to the extent that his drawings can be confused with those of Bernini. Notable also is his affinity with Pietro da Cortona, whom Baciccio, however, surpassed in the dynamic movement and luminous, sensual colour of his painting, qualities typical of his Genoese origin. He became one of the most important painters of Rome in the Baroque period, in both fresco and oil, including even portraiture, and represented the opposite pole to that of Maratta and the classicizing camp in general. During a stay in Parma in 1669 Baciccio's art was enriched by the study of Correggio and his ebullient illusionism. The largest and most important collection of his drawings is in the Kunstmuseum in Düsseldorf.

65 Recumbent figure of a nude child

Red chalk, heightened with touches of white chalk. 195 x 254 mm.

Coll.: *Christopher Turnor.*

Lit.: *Parker 1956, no. 850.*

Ashmolean Museum.

According to Parker this sheet, acquired in 1944, is the preparatory drawing for the figure of a dead child in the lower left corner of Baciccio's *Madonna of Saint Roch,* painted about 1660 for the church of San Rocco in Rome. Baciccio's graphic style, which was later to vaporize in quivering tangles, here in this early period is robust and fluent, following the inspiration of Bernini.

PIER FRANCESCO MOLA

Son of the architect Giovanni Battista Mola, the painter Pier Francesco was born in Coldrerio, near Como, in 1612, and died in Rome in 1666.

In 1616 his father moved to Rome and there Pier Francesco studied first with Prospero Orsi and then with the Cavalier d'Arpino. Decisive for the completion of his pictorial education was a period in Bologna, where he was in contact with Francesco Albani and Guercino, followed by a long study in Venice. In Rome Mola frequented Cortona, Poussin, and Pietro Testa, the friend whom in 1637 in Lucca he portrayed in a drawing now in Montpellier, and with whom he shared the predilection for landscape. In 1641 Mola was in Coldrerio. Subsequently, for the rest of his life he worked in Rome, where in 1662–63 he was *principe* of the Accademia di San Luca. As a draughtsman he was most significantly influenced by Guercino, carrying his atmospheric style to the extreme of Baroque expressivity. Like Guercino and the Carracci Mola also drew caricatures. It was in his drawing that Mola differed radically from his friend Testa, who as a good Tuscan remained faithful to true *disegno* and the expressive force of line.

66 Arcadian landscape with figures

Pen and brush with brown ink, on blue paper. 260 x 399 mm.

Colls.: *Bourgignon de Fabregoules; Giraud; Flury Hérard (Lugt 1015).*

Lit.: *Parker 1956, no. 910.*

Ashmolean Museum.

This sheet, signed by the artist at the lower left, is one of Mola's typical landscape drawings, in which he fuses Carraccesque and Venetian inspirations with a strong chiaroscuro derived from Guercino. The subject of this sketch has been interpreted by Parker as Jacob and Rachel at the Well.

F. H. N°58 36

BERNARDO CAVALLINO

The painter Bernardo Cavallino was born in Naples in 1616 and died there in 1654. Formed in Naples in the period of transition from the tenebrous Caravaggesque style to the more luminous colouring of Ribera and Massimo Stanzione, Cavallino progressively developed a vivacious pictorial handling in a lightened and vibrant gamut of colours. His paintings, which are in a refined and personal style, are often distinguished by a soft and feminine elegance. Among his very rare drawings is one now in the Morgan Library, similar in style to the Oxford drawing reproduced here.

67 Saint Sebastian

Red chalk, with touches of black chalk. 399 x 252 mm.

Lit.: *Parker 1956, no. 816; Bean-Stampfle 1967, no. 109.*

Ashmolean Museum.

The drawings that can be attributed to Cavallino are exceedingly rare. Parker ascribed this sheet to the artist on stylistic grounds, but the inscription at the lower left, *Bernardo Cavallino*, is a good confirmation of the attribution. In the Scholz collection in New York (now in the Morgan Library) there is, in fact, a study for an 'Immaculate Conception' with the attribution, *Bernardo Cavallino,* written in the same hand as the inscription on the Oxford sheet. Bean and Stampfle specifically compare the Scholz drawing with this sheet for the similarity of the facial types and graphic notation. The soft, *sfumato* quality of the drawing, moreover, is very much in keeping with Cavallino's manner of painting.

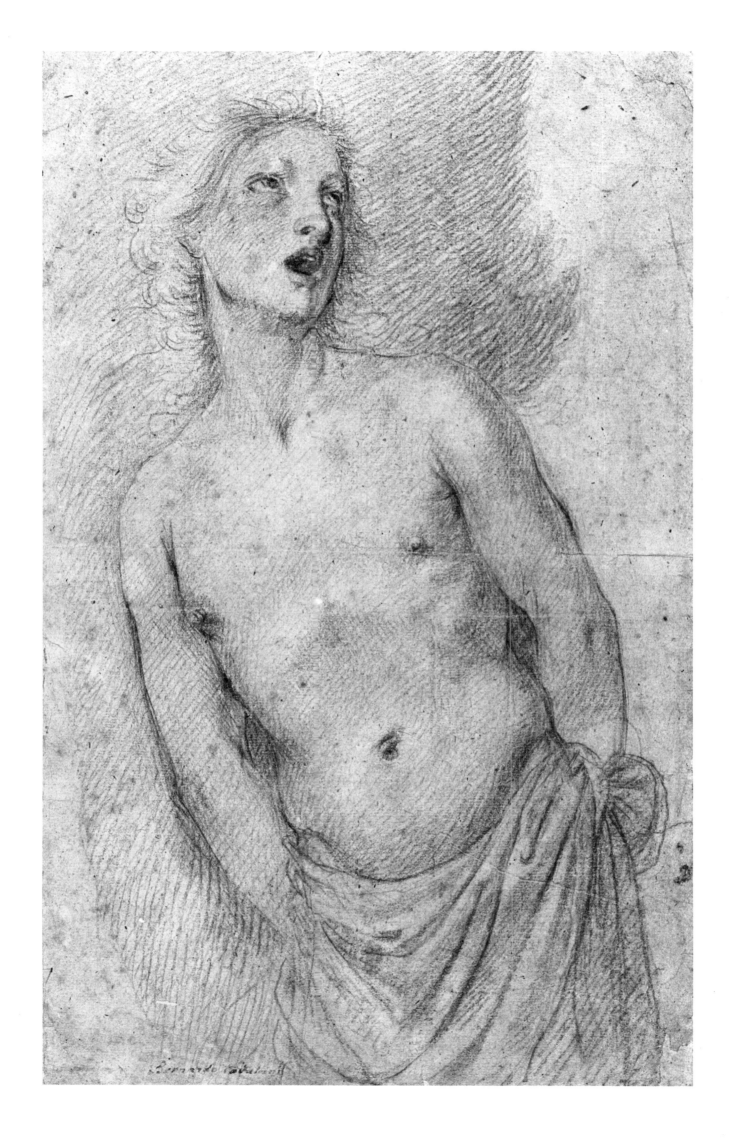

MATTIA PRETI

Mattia Preti, known also as the Cavalier Calabrese, was born in Taverna in Calabria in 1613 and died in La Valletta in Malta in 1699.

He arrived in Rome in 1630 and completed his artistic education under the influence of Ribera, Guercino, Lanfranco, and Pietro da Cortona, under whose direction he worked on the colossal frescoes in the apse of Sant'Andrea della Valle. Between 1653 and 1656 he worked in Modena (frescoes in the church of San Biagio), Bologna (where he met Guercino), Venice, and Genoa. Between 1656 and 1661 Preti was in Naples and Rome (1660). In Rome in 1641 he had become a member of the Order of the Knights of Malta and in 1661 he went to La Valetta where, except for a brief visit to his native town of Taverna, he remained for the rest of his life.

After Ribera, Mattia Preti was one of the most interesting and original followers of the Caravaggesque current. To Caravaggesque realism he added the new, lively warmth and richness of Baroque pictorialism. The development of his sense and handling of colour certainly owed much to his study of the Venetians and other artists active in Venice, in the first place Veronese, but also the Bassano family, as well as Jan Lys and Domenico Fetti. In turn, the young Luca Giordano was to owe much to the work of Preti. As a draughtsman Mattia Preti was one of the foremost talents of the Neapolitan school, in red or black chalk as well as pen and brush. But he was above all a painter of spontaneous movement, pictorial abbreviations, and chiaroscuro, as well as plastic effects, which was one of the aspects of his style to interest Luca Giordano and others. De Dominici, who had known the old master, described his way of working, which was also characteristic of other artists of similar temperament: After the Cavaliere had formed the idea of his subject in his mind, he sketched it roughly in different ways. The one that pleased him most he set down in a drawing, and according to the drawing the figures from life.... Then he drew it in a simple chiaroscuro technique of broad hatched strokes...'.

68 Caritas Romana

Red chalk. 290 x 220 mm.

Coll.: *Christopher Turnor.*

Lit.: *Parker 1956, no. 926.*

Ashmolean Museum.

This drawing, acquired in 1944, was formerly ascribed to Guercino. Parker very rightly reattributed it to Mattia Preti, typical of whom is the rapid, abbreviated style of drawing, which nevertheless creates solidly constructed forms. A painting by Preti of the same subject was formerly in the Cecconi collection in Florence (*L'Arte* 1913, p. 442).

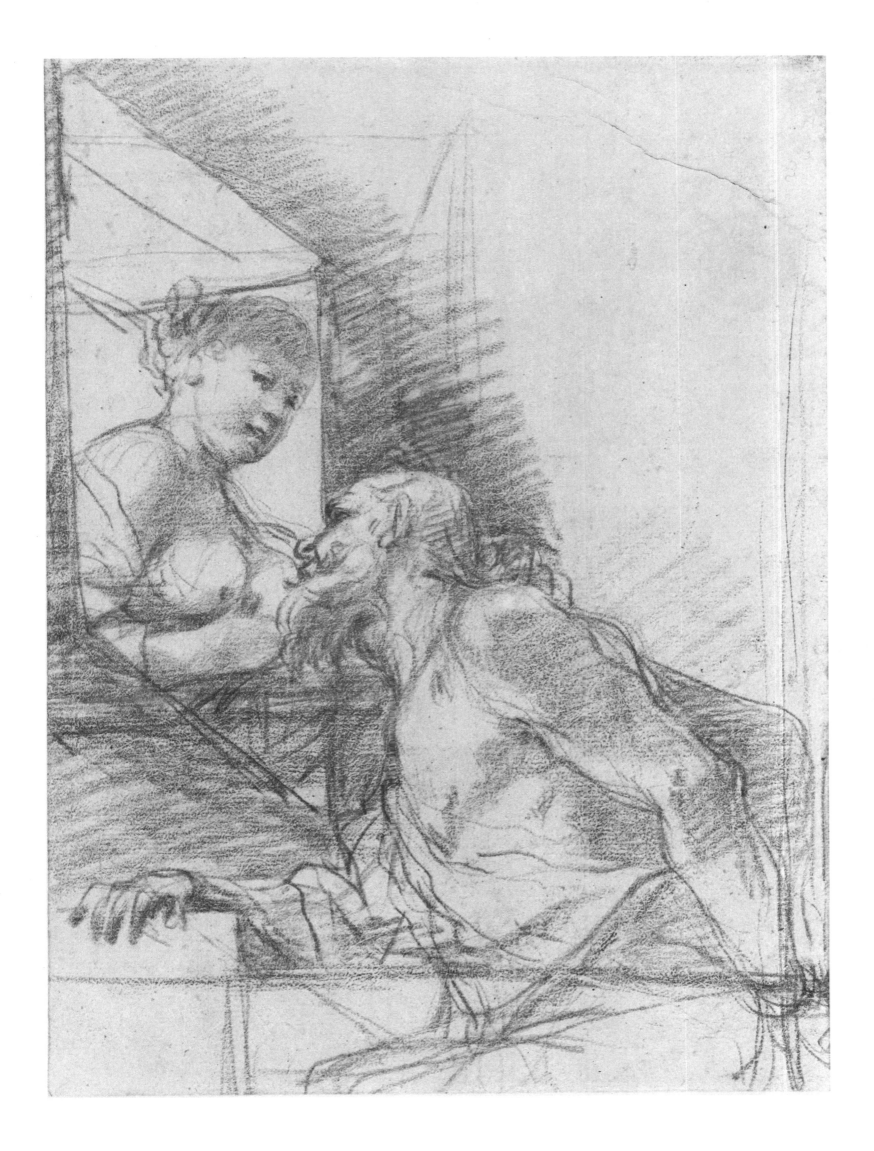

GIOVANNI BATTISTA PIAZZETTA

The painter Giovanni Battista Piazzetta was born in Venice in 1683 and died there in 1754. After a first training under his father, the sculptor Giacomo Piazzetta, he completed his studies in painting in the workshop of Antonio Molinari. In the first years of the 18th century he went to Bologna to study with Giuseppe Maria Crespi and assimilated this master's strong and richly coloured light. In Bologna he also studied the works of the Carracci and of Guercino, whose chiaroscuro was very congenial to him. In 1711 he returned to Venice and remained there definitively. In 1750 he became president of the Accademia dei Pittori.

While his career was outwardly uneventful, Piazzetta's artistic life was all the richer in interior expression. His biographer, Albrizzi, described him as 'a lover of solitude and thus a bit melancholic', and, as did d'Argenville, lamented the slowness with which he worked. This is the reason for the scarcity of Piazzetta's paintings. His predilection for chiaroscuro, which he shared with his masters in Venice and with late Seicento painting in general, as well as his search for a personal expression animated by realistic accents, made Piazzetta the antipode of Sebastiano Ricci. Unlike Ricci he never painted in fresco but only in oil on canvas, even in the case of a large ceiling composition such as the *Glory of Saint Dominic* in the Venetian church of Santi Giovanni e Paolo (*ca.* 1725).

In his drawings he preferred the media of charcoal and chalks, which create highly pictorial effects of chiaroscuro and a sensual plasticity. His heads drawn from life and those of the Apostles were already famous in his lifetime, and were in large part reproduced in individual prints by Pitteri and Cattini, and collected under the title *Icones ad vivum expressae* (1763). Piazzetta made many drawings to be used by etchers, the best among whom was Marco Pitteri. These were often for the illustration of books, among them Tasso's *Gerusalemme Liberata*, Milton's *Paradise Lost,* and the works of Bossuet. Piazzetta's influence on the young Tiepolo was great, but his example was also important for Austrian, Bohemian, and Tirolese artists, among whom we may mention Paul Troger.

69 Head of a young man

Black and white chalk, on faded brownish paper. 315 x 299 mm.

Lit.: *Parker 1956, no. 1034; Parker 1958, no. 81.*

Ashmolean Museum.

A typical drawing of Piazzetta's mature period, destined for sale to an *amateur*. The subjects of these 'finished' drawings vary from figures of saints (later etched by Pitteri and Cattini) to those of peasants, often with fruit or flowers, which according to Bean and Stampfle (1971, no. 42) were perhaps intended as representations of the five senses. This sheet shows a young shepherd and is attributed to Piazzetta's hand above all for the freshness of its drawing. The copies by his followers, such as Angeli, Maggiotto, or Cappella, all lack, in varying degree, the warm luminosity of the originals.

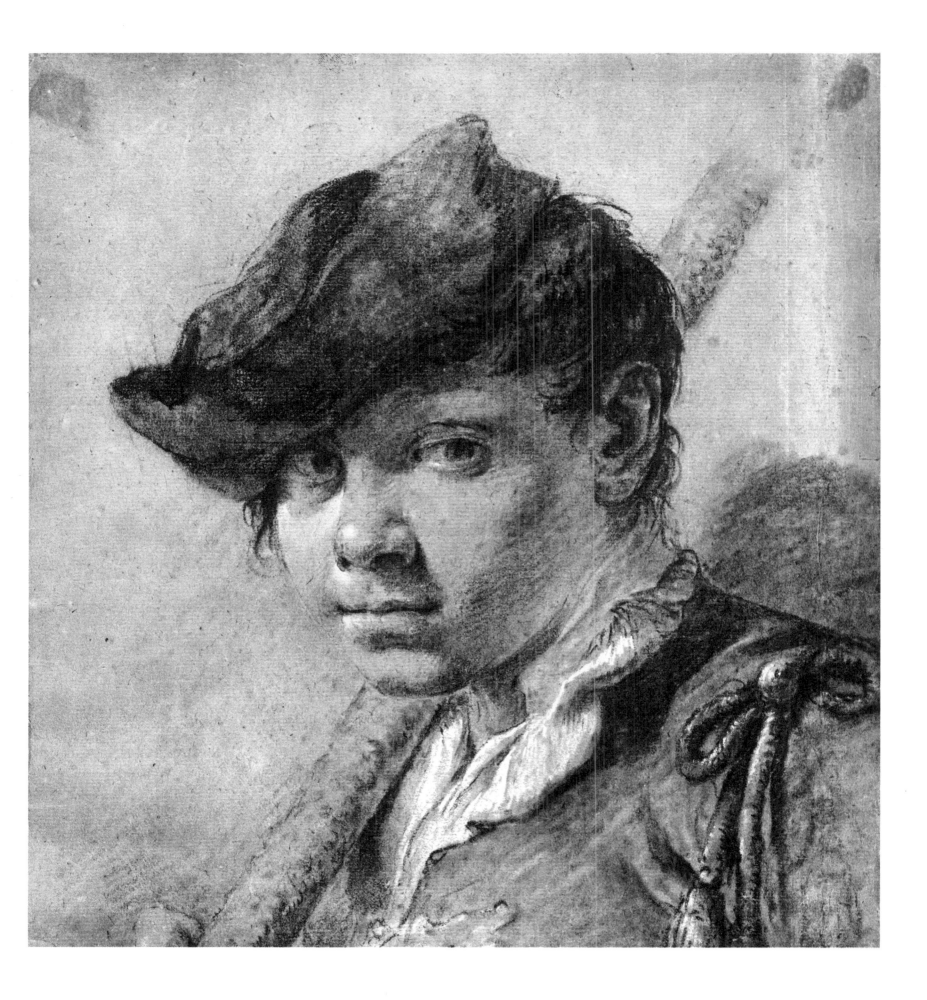

MARCO RICCI

Painter and etcher, Marco Ricci was born in Belluno in 1676 and died in Venice in 1730. He was the nephew and pupil of Sebastiano Ricci, with whom he collaborated in the painting of landscapes in Florence in 1706–07 and on numerous occasions thereafter. He probably went to Rome and also to Milan, where an encounter with Magnasco was of particular importance. From 1708 to 1710 he worked in England as a scenographer together with Pellegrini, and again from 1712 to 1716 with Sebastiano Ricci. On his return trip to Venice, passing through Flanders and the Low Countries, he visited Paris. Marco Ricci renewed Venetian landscape painting just as Sebastiano Ricci had renewed Venetian history painting. Essential to Marco's art was the example of Titian, with whom he had in common the direct visual experience of the landscape of the region of Cadore. Also important was the influence of the works of Salvator Rosa, Dughet, and Pieter Mulier (Tempesta), and Luca Carlevaris' Venetian-Roman topographical views and paintings of ruins. In his romantic landscapes Marco Ricci was the precursor of Piranesi.

Ricci began to etch in 1723, but more numerous are the etchings made by others after his designs. Giuseppe Zais was his pupil and direct follower, and Zuccarelli, Canaletto, and Guardi all felt his influence. The greater part of his drawings, about three hundred, are at Windsor. Like the Windsor collection of Sebastiano's drawings they came from Joseph Smith, the English Consul in Venice.

70 Landscape with a tower and buildings by a stream

Pen and brown ink, with ink wash. 228 x 328 mm.

Coll.: *Benno Geiger.*

Lit.: Sotheby Sale, *8 December 1920, nos. 259–272; Parker 1956, no. 1057.*

Ashmolean Museum.

This drawing is one of twenty-one sheets in the Ashmolean, included in an album belonging to Dr. Geiger which was broken up and sold in lots by Sotheby in 1920. In its entirety the album contained eighty-eight leaves, with one hundred and forty-one drawings of various periods, and was entitled 'MARCI RICCI BELLUNENSIS PICTORIS EXIMII SCHEDAE'. Some of the drawings were acquired by the British Museum. It is doubtful if this is the same album as that with a similar title, once in the Cernazai and Dal Zotto collections, to which Vivian alludes in his recent work on Consul Smith (Vivian 1971, p. 25).

In my opinion, Marco's drawings of the type reproduced here, in which, despite their eminently pictorial quality, the pen stroke is incisive and essentially linear, belong to his late period, close in date to his etchings.

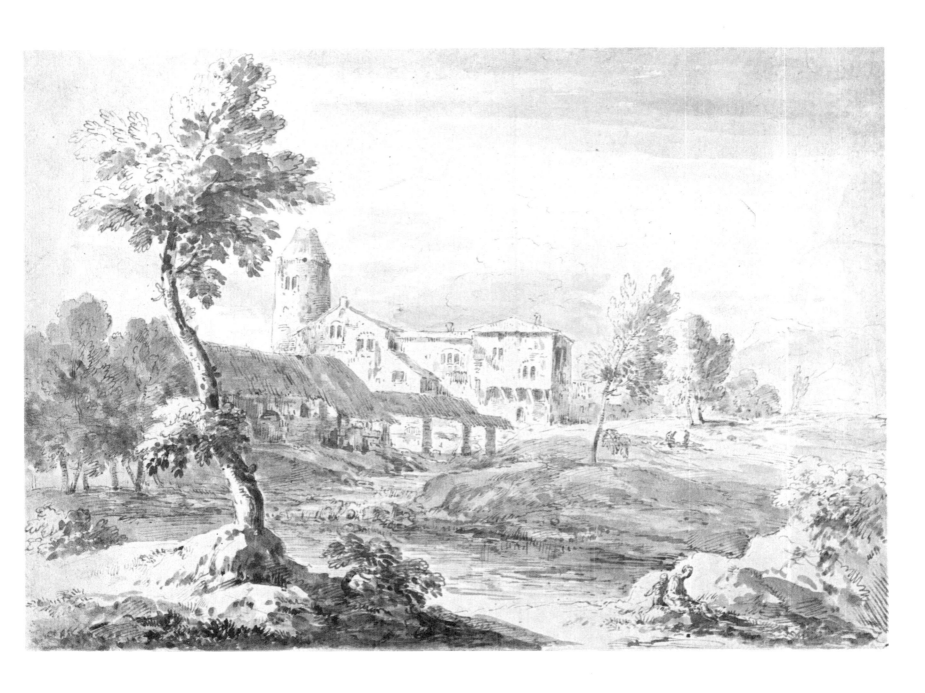

GIOVANNI BATTISTA PIRANESI

Born in Mogliano Veneto in 1720 and died in Rome in 1778, Piranesi was one of the protagonists of the complex cultural phenomenon to which we give the name Neoclassicism. But although the major part of his works were dedicated to the illustration of those monuments of antiquity exalted by the theorists of this classical expression, Piranesi cannot be defined completely a Neoclassicist. He was actually a transitional figure, with all the contradictions of one who participates equally in two contrasting worlds. In him were already to be seen the Romantic taste for archaeological fragments, calculated recompositions of heterogeneous elements, and the picturesque play of delicate lights upon light-toned surfaces, all of them important elements in the transition to the new vision of the late 18th century.

In architecture, as demonstrated by his church of the Priory of the Knights of Malta in Rome, he favoured a highly picturesque style. The same conceptions and sentiments also animate his graphic work, which constituted his principal activity. In the *Opere di architettura,* published in Rome in 1750, he collected all his earlier plates, including the *Carceri* and the *Capricci.* In 1756 he etched the *Antichità romane,* and in 1760 the second edition of the *Carceri.* To be cited finally are the *Vedute di Roma,* published between 1747 and 1778.

Piranesi's preparation as an etcher must have begun in his early youth, when he surely studied the etchings of Ricci and Tiepolo, from whom he derived a luminosity that is typically Venetian. In his prints he expressed his overriding love of ancient Rome, which he even polemically opposed to the Greek ideal of the German theorists. His grand, emotive vision of ruins, rendered still more evocative by the widened perspective, the almost necromantic atmosphere of his underground chambers populated with phantomatic figures, and the extraordinary construction of a lost world that still lives in memory create Piranesi's vast visual poem.

In many ways Piranesi may be compared with Francesco Guardi. These two artists seem to express the final lament of the two great civilizations of Rome and Venice, the former barely rediscovered, the latter already consigned to memory.

71 Woman carrying a baby

Pen and brush with brown ink. 174 x 100 mm.

Coll.: *Villiers David.*

Lit.: *Parker 1938, p. 55, pl. 57; Parker 1956, no. 1037.*

Ashmolean Museum.

Attributed to Gian Domenico Tiepolo by an old inscription, Parker reattributed this sheet to Piranesi, dating it about 1743, that is, in the period of the artist's return to Venice from Rome. In making this attribution Parker expressed some slight doubt, but in my opinion Piranesi's authorship is indisputable. Many similar drawings, in which the artist studied the characteristic small figures that populate his etchings, are to be found in the Morgan Library, the Seilern collection in London, the Rasini collection in Milan, the Louvre, Munich, Berlin, and Budapest. Parker's dating of this sketch indeed accords with the drawing style, which still recalls Ricci and Marieschi and is thus indicative of Piranesi's youthful period, before his definitive return to Rome in 1745.

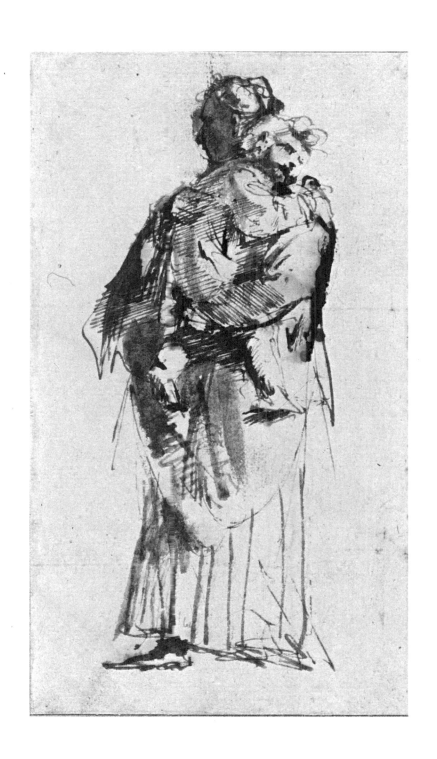

72 Architectural fantasy

Pen and brush with brown ink, over red chalk. 365 x 505 mm.

Coll.: *Earl of Abingdon.*

Lit.: *Parker 1935, p. 27, pl. 27; Thomas 1954, pl. 37; Parker 1956, no. 1039.*

Ashmolean Museum.

The inscription *Piranesi* on the second riser of the central staircase is probably the artist's actual signature. The drawing belongs to Piranesi's full maturity and represents one of his typical buildings in Roman style, with grand staircases and a profusion of columns and arches. Although it does not correspond to any known etching it reflects the spirit of his *Antichità Romane*, published after 1756.

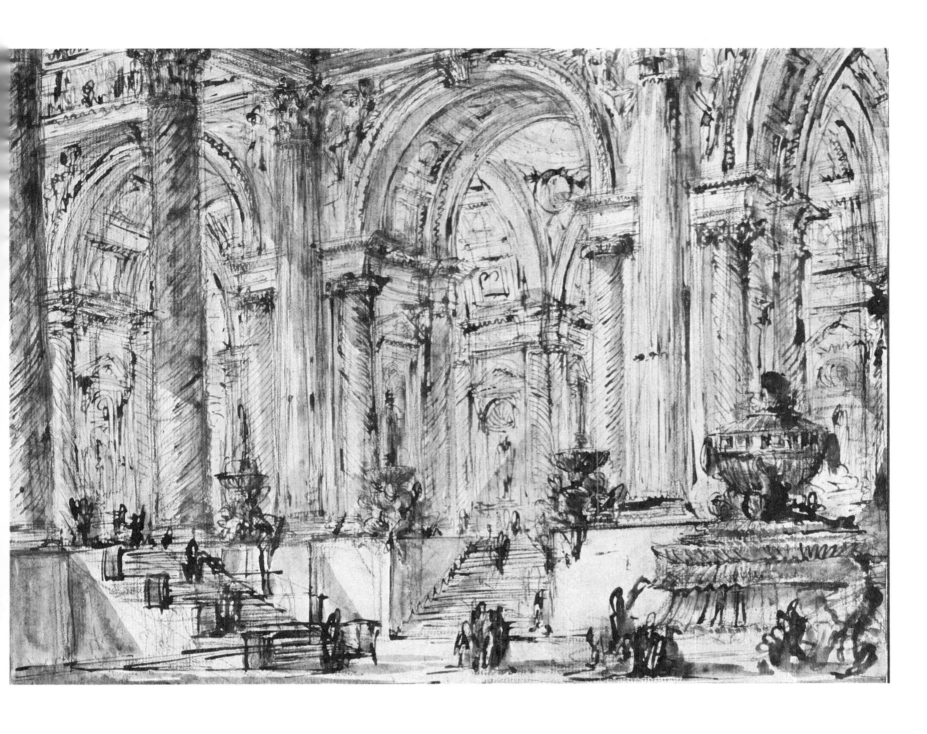

GIAN ANTONIO GUARDI

Giovanni Antonio Guardi, son of the painter Domenico and Maria Pichler, was baptized on May 27, 1699 in Vienna, and died on January 22, 1760 in Venice.

His father Domenico Guardi, originally from Mastellina in the Val di Sole, had studied painting in Vienna and perhaps before 1702 moved to Venice. This move was to be of fundamental importance for the artistic careers of his two sons, destined to play very important roles in the history of Venetian paintings.

When his father died in 1716, Gian Antonio found himself at the head of a workshop. But his art was revealed only in about 1730 by a series of copies in the tradition of Ricci and Pellegrini. Guardi's style tends to dematerialize plastic forms, reducing them to ephemeral apparitions. His hand is clearly recognized in the zigzag and serpentine brushstrokes that enliven the drapery surfaces, creating loose, evanescent, incorporeal images.

The reconstruction of the artistic personality of Gian Antonio Guardi is still not completely certain. It is now, however, possible to group around his few certain paintings and some absolutely secure drawings a complex of work that reveals a figure of prime importance, developed upon the formal experiments of grand decorative painting.

After the signed *Death of Joseph* in Berlin, between 1735 and 1738 Gian Antonio painted the lunettes in the church in Vigo d'Anaunia near Trent. From about 1746 is his *Madonna* in Belvedere near Grado, followed in 1750 by his altarpiece in Pasiano. His altarpiece in Cerete Basso of about 1745 is a technical masterpiece, in which the effect of his vivacious brushwork envelops the forms in a glittering, luminous atmosphere. Following these works he provided decorative paintings with *Aurora* for Palazzo Suppiej (now in the Cini collection) and others with *Diana* for Palazzo Barbarigo (now in the Museum of Cà Rezzonico). Finally, between 1750 and 1760, in the Venetian church of Sant' Angelo Raffaele, he decorated the choir loft with *Stories of Tobias*. This work constitutes the ultimate and most felicitous moment of Rococo decorative painting, which here, in a rapture of sensuality, disintegrates and dissolves the dancing forms in a crackling luminosity.

73 A Venetian admiral received by the sultan

Pen and brush with light-brown ink. 495 x 752 mm.

Coll.: *Oppenheim.*

Lit.: *Byam Shaw 1951, p. 58; Parker 1956, no. 1006; Parker 1958, no. 109; Pignatti 1967, p. 20.*

Ashmolean Museum.

This is one of the earliest and most famous drawings from the hand of Gian Antonio Guardi, history painter and older brother of Francesco. Inscribed *Ant.º Guardi* in a contemporary hand, on both *recto* and *verso*, it is a key drawing for the identification of this artist's airy, fluent style, so completely Rococo in its expression. The Ashmolean Museum owns other sheets by Gian Antonio, including a 'Triumph of Aurora' (Pignatti 1967, pl. LXII) and a 'Madonna and Child Enthroned with Saints', reproduced here in figure 54, which is the *bozzetto* for his altarpiece of 1745 at Cerete Basso.

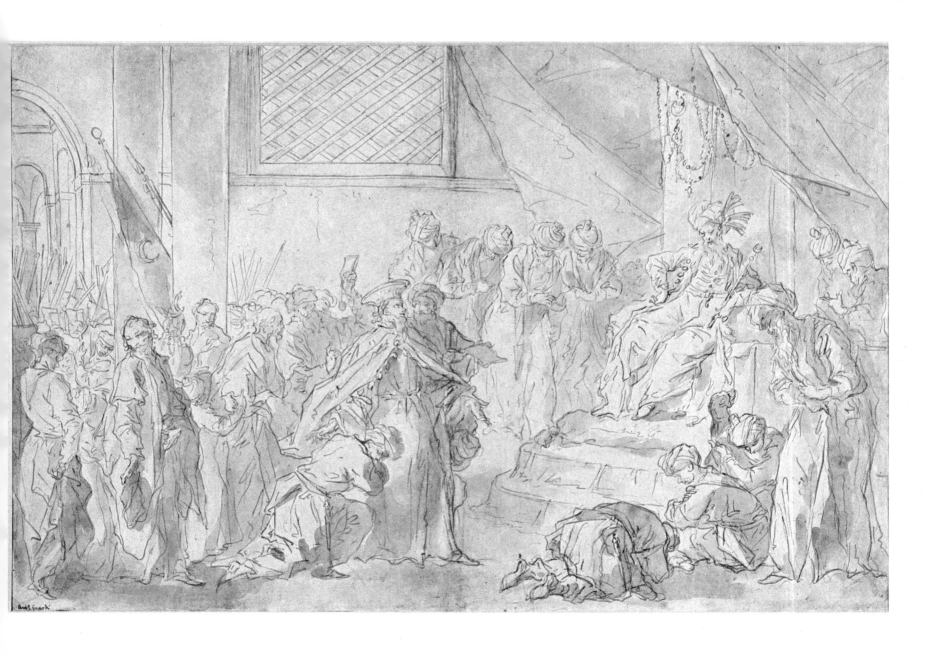

GIOVANNI BATTISTA TIEPOLO

Tiepolo was born in Venice in 1696 and died in Madrid in 1770. A pupil of Gregorio Lazzarini, in his earliest years Tiepolo was influenced by the chiaroscuro realism of Piazzetta and Bencovich, which was to reappear at times even in his mature works. But he soon turned to the light-filled manner of Sebastiano Ricci and Pellegrini, which was more congenial to his sunny temperament. While developing Ricci's fantasy and pleasant ease of manner in bolder terms he also submitted to the fascination of Veronese's decorative richness and sumptuous solemnity.

In 1719 he married Cecilia, sister of the painters Gian Antonio and Francesco Guardi. Enormously active, Tiepolo has left frescoes in Venice, Udine (1726), Milan (1731 and again later), Bergamo, Vicenza, and other Venetian cities. Between 1750 and 1753 he was in Würzburg, where he executed the frescoes in the Residenz. In 1762 Charles III summoned him to Madrid, and there the aged painter continued to create canvases and frescoes for the rooms of the Royal Palace.

Tiepolo's highly versatile production reaches its acme in his frescoes, unsurpassed for their expressive vigour, radiant luminosity, and fantasy of interpretation. Brilliant and tireless inventor and narrator, he is often to be seen at his best in the numerous existing oil sketches for his larger works. A fantastic and grotesque vein is manifest in his etchings, the *Capricci* and the *Scherzi*, where his manner comes close to that of Castiglione.

A very great number of Tiepolo's drawings have survived, often preserved in groups that correspond to the artist's original albums: in the Victoria and Albert Museum in London, the Heinemann collection, Morgan Library, and Metropolitan Museum in New York, Princeton University, the museums of Triest, Stuttgart and Würzburg, and the Correr Museum in Venice. They constitute the greatest monument of 18th-century graphic art and an inexhaustible source for the study of the artist.

74 The Holy Family

Pen and brown ink, with ink wash. 315 x 228 mm.

Colls.: *Convent of the Somaschi (Santa Maria della Salute, Venice); Cicognara; Canova; F. Pesaro; E. Cheney; d'Hendecourt; M. Oliver.*

Lit.: *Hadeln 1927, II, pl. 110; Parker 1956, no. 1077.*

Ashmolean Museum.

This is a typical drawing from the so-called Savile album, which was broken up and sold by this London gallery in 1928. The Savile album was one of the volumes of drawings that Tiepolo left in deposit in the convent of the Somaschi in Venice when he went to Spain. Passing through various Venetian collections, these volumes finally came into the hands of the Englishman Cheney and were dispersed when he sold them in 1885. The sheet reproduced here, generally dated 1755–60, is one of Tiepolo's most evocative drawings, stupendous in the dazzling effect of light produced by the paper, barely touched by the rapid strokes of the master's pen (Pignatti, *Tiepolo*, 1974, pl. LIX).

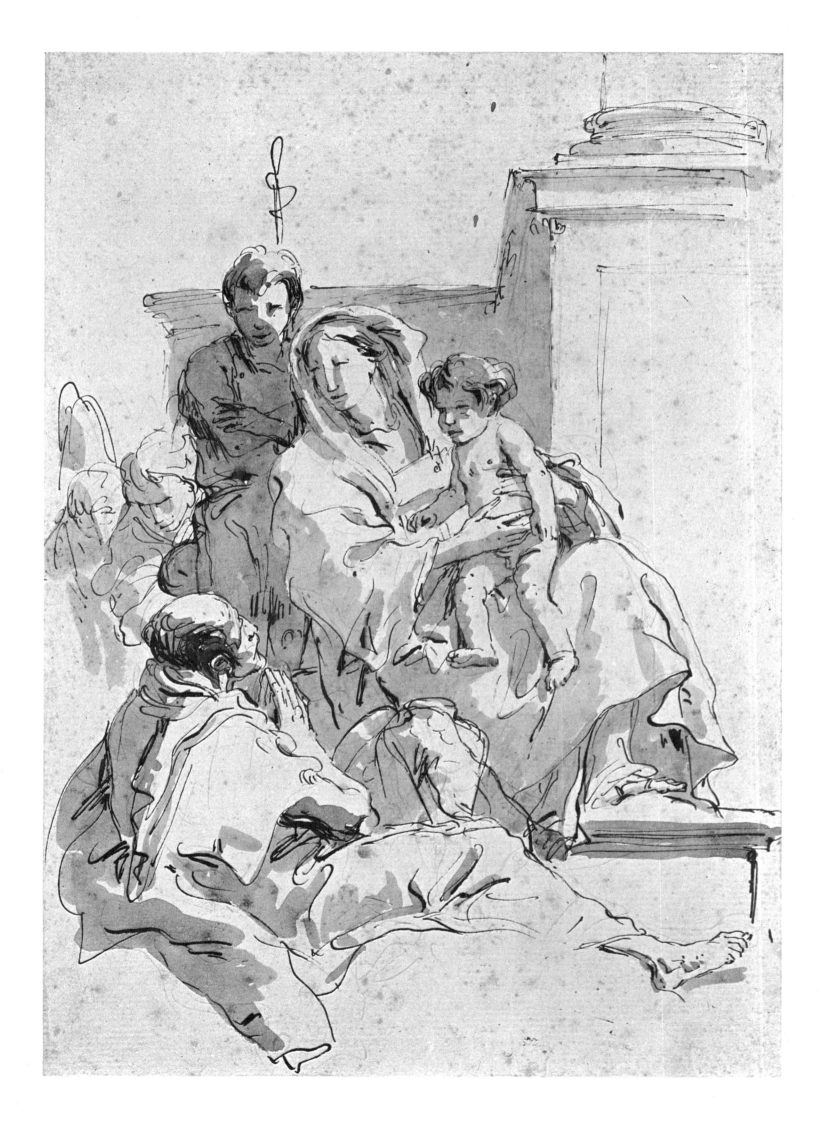

GIOVANNI DOMENICO TIEPOLO

Giovanni Domenico Tiepolo, son and pupil of the great Giovanni Battista and older brother of Lorenzo, was born in Venice in 1727 and died there in 1804. He went with his father and brother to Würzburg in 1750–53 and to Madrid in 1762.

His collaboration in the formidable activity of the Tiepolo workshop was above all on frescoes, where his own work corresponds so closely with that of the master that it is hard to distinguish. After his father's death in Madrid, he returned to Venice, where he remained, except for a brief interval in Genoa in 1783–85. Giandomenico found a personal style and expression in the painting of popular genre scenes, animals, bucolic-mythological subjects, and landscapes, as can be seen, for example, in his frescoes of 1757 in the guest house of the Villa Valmarana in Vicenza. He showed particular originality in his drawings and his etchings (*Via Crucis,* 1748; *Flight into Egypt,* 1753).

His vast production of prints and drawings is inspired entirely by themes of a basically realistic content, regardless of the actual subjects, which include everything from Biblical stories to satyrs and animals, as well as Punchinello scenes, a genre especially congenial to him. In these works he used ideas gathered from Callot, Rembrandt, Magnasco, and Marco Ricci, but so completely assimilated that they appear to be the fruit of his own intuition.

In the scenes of popular life in the Villa Valmarana and in the frescoes from the small Villa of Zianigo, now in Cà Rezzonico, Giandomenico shows himself the contemporary of the bitter and bizarre satire of Parini and Hogarth, and at times even a precursor of Goya.

75 Young woman with a macaw

Red chalk, heightened with touches of white chalk, on grey-blue paper. 326 x 259 mm.

Colls.: *Suermondt; Pauline of Saxe-Weimar.*

Lit.: *Sack 1910, p. 270; Parker 1956, no. 1082; Parker 1958, no. 94.*

Ashmolean Museum.

Parker observed that an 18th-century etching by G. D. Tessari reproduces the drawing in reverse with the inscription: *Gio. Batta. Tiepolo Inv. et Pinx.* On the basis of this Parker at first attributed the drawing to Giovanni Battista, but in 1958 he left the attribution uncertain between father and son. In my opinion there is no doubt that the graphic style is that of Giovanni Domenico. Evidently the print reproduces a lost painting by the father, which, as very often happened, had been copied in a drawing by Giandomenico, as a record or to serve for a later print. Byam Shaw (cited in Parker 1958) believes the drawing could relate to a lost painting by Giambattista of the type of a head, very similar to the drawing, in a private collection in the United States. Comparison with the many sheets in Stuttgart drawn from the Würzburg frescoes suggests a date in the early 1750s for this drawing.

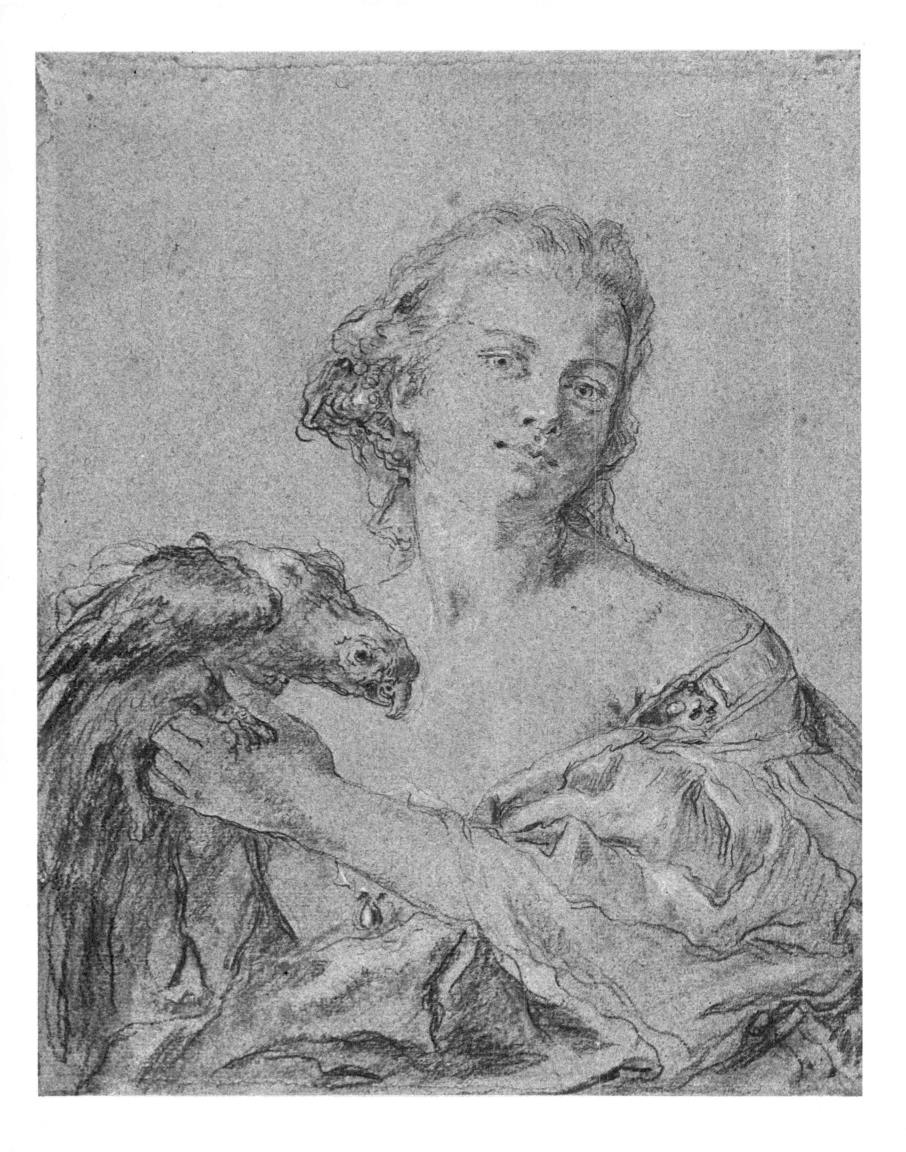

FRANCESCO ZUCCARELLI

Zuccarelli was born in Pitigliano (Grosseto) in 1702 and died in Florence in 1778. In Rome he became the disciple of Paolo Anesi, painter of Arcadian landscapes, and of Pietro Nelli, one of Morandi's pupils, who instructed him chiefly in figure painting. In about 1732 he established himself in Venice and followed in the footsteps of Marco Ricci, who had recently died. Ricci's patron, the English Consul Joseph Smith, became Zuccarelli's patron and introduced him in England, where he resided from 1752 to 1762 and again from 1765 to 1771, achieving success and exercising a notable influence. In Venice Zuccarelli had known Richard Wilson and Sir Joshua Reynolds, encounters that proved mutually fruitful artistically. In England Zuccarelli was one of the founders of the Royal Academy and in Venice, in 1772, he was elected president of the Venetian Academy. As was the current practice, Zuccarelli often painted the figures that animate the architectural and topographical views of other artists, such as Visentini and Bellotto. The paintings and drawings of Zuccarelli's later period frequently reveal a relationship with the works of Claude Lorraine.

Count Tassi of Bergamo, for whom Zuccarelli worked at various times between 1747 and 1752, characterized his art in the following manner: '...countrysides with such very charming figures, they not only surpass the modern painters but compete with the most famous of the past, there being no one until now capable of combining, with so much naturalness of colour, the beauty and gentle harmony of the countryside with more gracefully posed figures'.

76 Landscape with women bathing

Gouache drawing. 402 x 566 mm.

Coll.: *Viscount Eccles.*

Lit.: Royal Academy Exhibition, *1954–55, no. 594; Colnaghi,* Baskett Catalogue, *1963, no. 9;* Royal Academy Exhibition, *1968–69, no. 516;* Ashmolean Museum Report, *1972–73, p. 32.*

Ashmolean Museum.

Of this beautiful coloured drawing there exists a pendant in the Victoria and Albert Museum (F. A. 610). Zuccarelli's very peculiar, fragmentary brush-stroke, which almost seeks to create the tonal effects of an impasto, is so highly pictorial that very often, as in this case, his drawings are more paintings than simple graphic works.

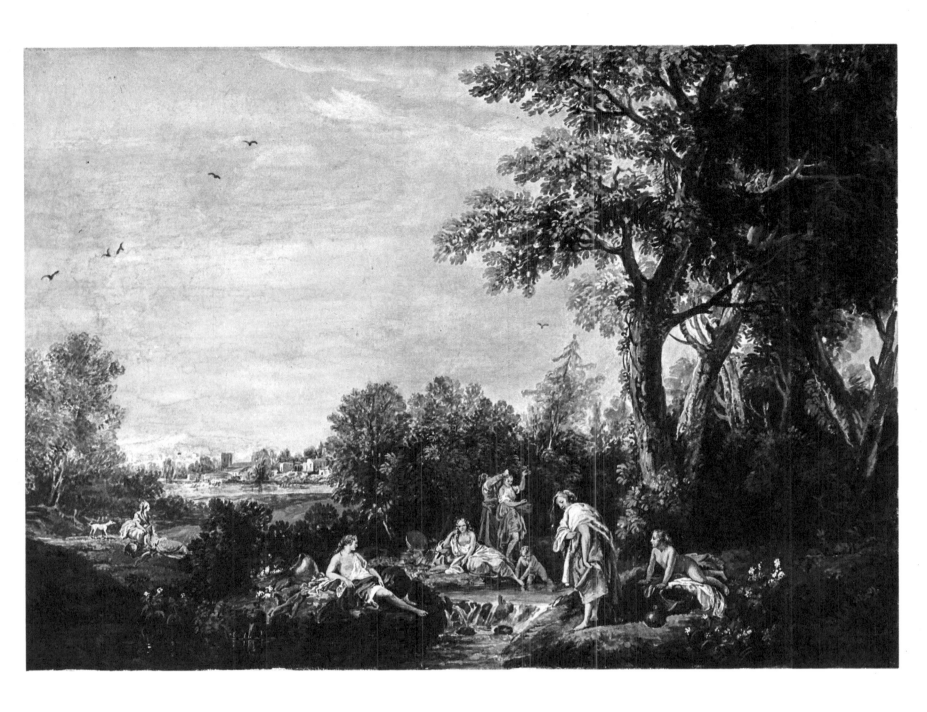

CANALETTO

The painter and etcher, Antonio Canal, called Canaletto, was born in Venice in 1697 and died there in 1768.

Prepared by his knowledge of Carlevaris' topographical views and his own earliest artistic experience, together with his father, as a scenographer, during a stay in Rome in about 1719–20 Canaletto began drawing from nature. It was thus that his style developed in terms of a new technique for the representation of reality, in which drawings tirelessly verified by nature itself played a very important part. In this way he also created a completely new type of colour that accorded with the systematic topography of his perspective views. Canaletto's paintings naturally had enormous success among Anglo-Saxons, for whom he painted large series of views, from the thirty-eight for Consul Smith and the twenty-six for the Duke of Bedford (1725–35), to those for the Duke of Buckingham and Lord Carlisle. Subsequently Canaletto made several trips to England, where he stayed between 1746 and 1755. When he returned to Venice he was imitated by contemporary painters, from among whom emerged the highly original figure of Francesco Guardi.

In 1744 Canaletto published his collection of thirty etchings, entitled *Vedute: altre prese dai luoghi altre ideate*. These prints, exceptional in their luminosity, are images of those immensely pleasant places along the Brenta populated with villas, and other places in Venice. Together with those of Tiepolo, published in about this same period, they constitute one of the most important monuments of Italian 18th-century etching.

The patient study of perspective and light, the 'reason' that always governed Canaletto's language, never smothered his authentic artistic expression, which has left us the most vivid image of the Venetian cityscape.

77 The Rialto bridge

Pen and brown ink. 141 x 202 mm.

Coll.: *Chambers Hall (Lugt 551).*

Lit.: *Hadeln 1926, p. 310; Parker 1956, no. 975; Parker 1958, no. 82; Pignatti 1969, pl. 1.*

Ashmolean Museum.

This is perhaps the earliest Canaletto drawing to survive, since it corresponds to the painting, today in Montreal, ordered in 1725 by Stefano Conti of Lucca. The annotation, *sole*, at the lower right, is a direct reference to a point in the painting where a ray of sun enlivens the water of the Grand Canal. With a few stenographic strokes Canaletto here conveys the architectural details and the luminosity of the setting, offering an unequalled example of his graphic style.

Veduta del ponte di rialto infazo levbone

Sole

78 An island in the lagoon

Pen and brown ink, brush and grey wash. 200 x 279 mm.

Coll.: *O. Gutekunst.*

Lit.: *Hadeln 1929, p. 14; Parker 1956, no. 980; Parker 1958, no. 85.*

Ashmolean Museum.

This drawing corresponds in reverse to Berardi's print which bears the inscription: *Quanto più bello appare | presso alla terra il mare.* Parker notes a painting by Canaletto with the same composition formerly in the Lovelace collection and now in the Clarke collection (Constable 1962, no. 367). Other drawn versions of this same composition are to be found at Windsor and in the Wadsworth Atheneum in Hartford, and there also exist various copies. Stylistically it is difficult to accept the date 1742 generally assigned to Berardi's print. A date at least ten years later would agree far better with the curling, wiggling line, which had become typical of Canaletto during his English period.

FRANCESCO GUARDI

Francesco Guardi was born in Venice in 1712 and died there in 1793. He began as the pupil and assistant of his brother Gian Antonio, a history painter, who directed the paternal workshop after the premature death of their father, Domenico, in 1716. Francesco's earliest production included history subjects and altarpieces, but the view of Venice was to become his marvellous, exclusive reign.

Guardi took as his models Marco Ricci and Canaletto, both of whose works he at first copied more or less freely, as well as Marieschi, from whom he derived his summary brushstroke. Magnasco, too, must have considerably impressed and influenced Guardi, who in his figure painting and drawing comes near to Magnasco's fantastic realism and capricious transfigurations. Finally, Guardi's figures, rendered in terms of linear abbreviations that are at the same time realistically expressive, would seem to relate to Callot, whose fantastic world often borders his own. It is the strong sense of reality that differentiates Francesco's work from that of his brother. Francesco's art is born directly from the atmosphere of the lagoon city of Venice and its artistic tradition of intense pictorialism, which reached its conclusion precisely in him. From his hand we have also some views of the Venetian mainland: in 1778 and 1782, during two trips through the Valsugana to the town of Mastellina, where his family originated, he made some splendid drawings of the mountain landscape. The largest collection of Guardi drawings is that totalling about three hundred in the Correr Museum in Venice. Other important collections are in the British Museum and the Metropolitan Museum in New York.

79 View across the garden of the Villa Loredan

Pen and brush with brown ink. 375 x 705 mm.

Coll.: *K.T. Parker.*

Lit.: *Byam Shaw 1937, p. 21, pl. 22; Byam Shaw 1951, p. 65; Parker 1956, no. 1016; Parker 1958, no. 114.*

Ashmolean Museum.

This drawing was recognized by Byam Shaw as a view from a rear window of the Villa Loredan at Paese, near Treviso. The villa no longer exists, but the identification was made on the basis of comparison with other known drawings of the villa, which was reproduced also in a canvas formerly in the Rothermere collection and now in a private collection in London. The drawings are in the Fodor collection in Amsterdam, the Murray Danforth collection in Providence, Rhode Island, the Metropolitan Museum in New York, and the Ashmolean Museum itself (no. 1015, with an inscription by the English Consul in Venice, John Strange, datable to about 1778). This sheet is one of the rare large-size drawings from life from the artist's mature period, and particularly striking for its vibrant, fractured luminosity, which the thinly applied washes endow with iridescent effects.

FRANCESCO GUARDI

80 The Rialto bridge

Pen and brush with brown ink, over traces of red chalk. 224 x 177 mm.

Coll.: *Chambers Hall (Lugt 551).*

Lit.: *Byam Shaw 1951; p. 65; Parker 1956, no. 1013; Parker 1958, no. 118.*

Ashmolean Museum.

This is certainly a very late drawing by Francesco, since the *verso* shows a 'Venetian Capriccio' by his son Giacomo, whose activity began only in the 1780s. For the airy, atmospheric line that dissolves in romantic evocations, this sheet may be compared with a very beautiful drawing in the Correr Museum in Venice, with a view from the Fondamenta of Palazzo Manin-Dolfin (Pignatti 1964, no. 92).

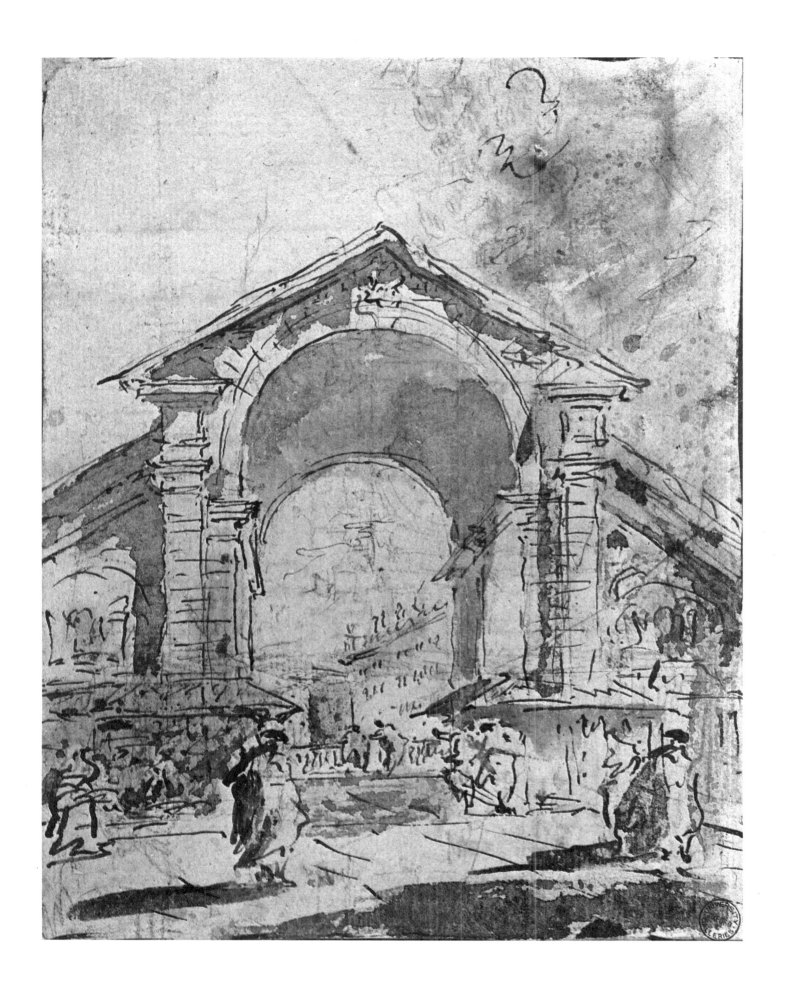

Black and white illustrations

The inventory numbers of the Ashmolean Museum and Christ Church drawings are those of the catalogues of the respective collections by Parker (1956) and Byam Shaw (1976).

I. Christ Church, Tom Tower viewed from the Great Quadrangle.

II. General John Guise, founder of the Christ Church collection.

III. Ashmolean Museum.

IV. Sir Thomas Lawrence, collector of the Michelangelo and Raphael drawings now in the Ashmolean Museum.

V. The Rev. Dr. Henry Wellesley, promoter of the public subscription for the purchase of the Michelangelo and Raphael drawings for the Ashmolean Museum.

VI. Samuel Woodburn, Lawrence's principal dealer, who also disposed of the artist's collection after his death.

1. Filippino Lippi. *Man in a Heavy Drapery*. Silverpoint, heightened with white, on paper primed blue. 209 x 127. Inv. 32. Christ Church.

2. Perugino. *Joseph of Arimathaea*. Black chalk. 270 x 250. Inv. 8. Christ Church.

3. Leonardo da Vinci. *Grotesque Bust*. Black chalk. 382 x 275. Inv. 19. Christ Church.

4. Follower of Giorgione. *A Pair of Lovers in a Landscape*. Pen and grey ink, on paper primed light-red. 188 x 322. Inv. 717. Christ Church.

5. Gerolamo Romanino. *The Holy Family*. Red chalk. 170 x 160. Inv. 736. Christ Church.

6. Boccaccio Boccaccino. *Christ in Majesty*. Brush and brown ink, heightened with white, on primed paper. 234 x 179. Inv. 5. Ashmolean Museum.

7. Bartolomeo Montagna. *Constantine*. Brush and blue watercolour, heightened with white, on blue paper. 264 x 141. Inv. 25. Ashmolean Museum.

8. Gerolamo Santacroce. *Two Saints*. Pen and black ink, brush and grey wash, heightened with white, on paper primed dull-green. 270 x 200. Inv. 712. Christ Church.

9. Raphael. *Four Warriors*. Pen and brown ink. 271 x 216. Inv. 523. Ashmolean Museum.

10. Perin del Vaga. *Young Lady Playing the Virginals*. Pen and brown ink, with ink wash. 255 x 201. Inv. 64. Ashmolean Museum.

11. Michelangelo. *The Good Thief*. Black chalk. 162 x 101. Inv. 63. Christ Church.

12. Michelangelo. *Studies of a Horse and Sketch of a Battle*. Pen and brown ink. 427 x 283. Inv. 293r. Ashmolean Museum.

13. Michelangelo. *Madonna and Child and Saint Anne*. Pen and brown ink. 257 x 175. Inv. 291r. Ashmolean Museum.

14. Rosso Fiorentino. *Saint John the Baptist Preaching*. Red chalk. 263 x 152. Inv. 124. Christ Church.

15. Cristofano Allori. *The Crossing of the Red Sea*. Black chalk, brush and brown ink, heightened with white chalk, on paper primed greyish-blue. 312 x 250. Inv. 133. Christ Church.

16. Giorgio Vasari. *Design for a Cameo of Duke Cosimo I de' Medici*. Pen and brown ink, with ink wash. 283 x 210. Inv. 161. Christ Church.

17. Lodovico Cigoli. *Two Celestial Virtues*. Black and red chalk, heightened with white chalk, on blue paper. 390 x 265. Inv. 256. Christ Church.

18. Jacopo da Empoli. *Study of a Standing Young Man*. Red chalk. 411 x 225. Inv. 240. Christ Church.

19. Jacopo Ligozzi. *Dante*. Pen and brush with brown ink, heightened with white, on paper primed brown. 201 x 275. Inv. 215. Christ Church.

20. Taddeo Zuccari. *Alexander and Bucephalus*. Pen and grey ink, with ink wash. 376 x 429. Inv. 532. Christ Church.

21. Giulio Campi. *The Obsequies of Saint Agatha*. Pen and black ink. 346 x 244. Inv. 140. Ashmolean Museum.

22. Domenico Campagnola. *Landscape*. Pen and brown ink. 243 x 388. Inv. 723. Christ Church.

23. Paris Bordone. *Study of a Seated Boy*. Black chalk, heightened with white chalk, on blue-grey paper. 190 x 242. Inv. 120. Ashmolean Museum.

24. Andrea Schiavone. *The Presentation in the Temple*. Brush and grey ink, heightened with white, on paper primed mauve. 184 x 276. Inv. 695. Ashmolean Museum.

25. Battista Franco. *The Holy Family*. Pen and black ink. 222 x 120. Inv. 233. Ashmolean Museum.

26. Domenico Tintoretto. *Doge Marino Grimani in Adoration before the Virgin*. Pen and brown ink, with ink wash, heightened with white, on bluish paper. 164 x 409. Inv. 710. Ashmolean Museum.

27. Jacopo Bassano. *Figure of a Gondolier*. Black and red chalk, heightened with white chalk, on brown paper. 415 x 273. Inv. 110. Ashmolean Museum.

28. Andrea Vicentino. *Apollo and Marsyas*. Pen and brown ink, with ink wash. 160 x 234. Inv. 746. Ashmolean Museum.

29. Palma Giovane. *Venetian Lady*. Pen and brown ink, with ink wash. 237 x 150. Ashmolean Museum.

30. Palma Giovane. *Study for an Assumption of the Virgin*. Black chalk, with touches of white chalk, on bluish-grey paper. 326 x 227. Inv. 424. Ashmolean Museum.

31. Luca Cambiaso. *Madonna and Child with Saint John*. Pen and brown ink. 338 x 287. Inv. 1221. Christ Church.

32. Domenichino. *The Finding of Moses*. Pen and brown ink. 205 x 182. Inv. 839. Ashmolean Museum.

33. Annibale Carracci. *Pastoral Landscape*. Pen and brown ink. 244 x 183. Inv. 165. Ashmolean Museum.

34. Agostino Carracci. *Portrait of a Lady*. Black and red chalk, with touches of white chalk. 272 x 228. Inv. 144. Ashmolean Museum.

35. Giovanni Lanfranco. *Head of a Young Man*. Black and white chalk, on buff paper. 274 x 234. Inv. 597. Christ Church.

36. Guido Reni. *Head of Saint Proculus*. Black, red, and white chalk. 338 x 260. Inv. 966. Christ Church.

37. Domenichino. *Putto*. Black chalk. 770 x 447. Inv. 983. Christ Church.

38. Lodovico Carracci. *The Birth of Saint John the Baptist*.

39. Giovanni Francesco Grimaldi. *Landscape with Artist Sketching*. Pen and black ink. 289 x 215. Inv. 851. Ashmolean Museum.

40. Guercino. *Two Women Fighting*. Pen and brown ink, with ink wash. 238 x 277. Inv. 868, Ashmolean Museum.

41. Guercino. *Swooning Woman*. Pen and brown ink. 188 x 156. Inv. 997. Christ Church.

42. Bartolomeo Schedoni. *Madonna and Child with Saints*. Black and white chalk, on greyish paper. 182 x 182. Inv. 697. Ashmolean Museum.

43. Simone Cantarini. *Madonna and Child*. Red chalk. 272 x 210. Inv. 1016. Christ Church.

44. Giovanni de Vecchi. *Design for an Apse Decoration*. Pen and brown ink, with ink and watercolour washes. 387 x 490. Inv. 558. Christ Church.

45. Pietro da Cortona. *The Triumph of Ceres*. Pen and black ink, with grey wash. 351 x 228. Inv. 846. Ashmolean Museum.

46. Stefano della Bella. *The Flight into Egypt*. Pen and brown ink, with grey wash. 190 x 238. Inv. 788. Ashmolean Museum.

47. Pier Francesco Mola. *Monks on a Balcony*. Pen and brown ink, with ink wash. 98 x 264. Inv. 911. Ashmolean Museum.

48. Francesco Maffei. *Design for an Oval Ceiling Decoration with Saints*. Brush with dark-brown and reddish wash, heightened with white, on greyish paper. 295 x 444. Inv. 896. Ashmolean Museum.

49. Pietro Liberi. *The Holy Family with Saint Cecilia*. Pen and black ink. 182 x 141. Inv. 894. Ashmolean Museum.

50. Alessandro Magnasco. *Studies of Washerwomen at Work*. Brush and brown wash, heightened with white, on buff paper. 168 x 278. Inv. 1025. Ashmolean Museum.

51. Gian Paolo Pannini. *Roman Capriccio*. Pen and brown ink, with grey and light-brown wash. 432 x 298. Inv. 1031. Ashmolean Museum.

52. Pier Leone Ghezzi. *A Gentleman and his Two Servants*. Pen and black ink. 298 x 261. Inv. 1003. Ashmolean Museum.

53. Canaletto. *View of the Doge's Palace*. Pen and brown ink. 225 x 176. Inv. 976. Ashmolean Museum.

54. Gian Antonio Guardi. *Madonna and Child Enthroned with Saints*. Red chalk. 223 x 168. Inv. 1007. Ashmolean Museum.

55. Francesco Fontebasso. *Design for a Mural Decoration*. Pen and black ink, with watercolour washes. 255 x 252. Inv. 996. Ashmolean Museum.

56. Giovanni Battista Tiepolo. *Head of the Madonna of Mount Carmel*. Red chalk, with touches of white chalk, on grey paper. 163 x 152. Inv. 1078. Ashmolean Museum.

57. Giovanni Battista Tiepolo. *Madonna and Child*. Pen and brown ink, with ink wash. Ashmolean Museum.

58. Giovanni Domenico Tiepolo. *Landscape with a Dog*. Pen and brown ink, with ink wash. 351 x 290. Inv. 1097. Ashmolean Museum.

59. Francesco Guardi. *Garden of the Villa Contarini*. Pen and black ink, with ink wash. 355 x 510. Inv. 1014. Ashmolean Museum.

60. Giuseppe Bernardino Bison. *Harbour Scene*. Pen and black ink, with ink wash. 197 x 277. Inv. 1107. Ashmolean Museum.

Colour plates

1. Pisanello. *Studies of Costumes and a Female Head*. Pen and brown ink, with watercolour washes, on vellum. 183 x 240. Inv. 41. Ashmolean Museum.

2. Verrocchio. *Head of a Young Woman*. Black chalk, heightened with white. 408 x 327. Inv. 15. Christ Church.

3. Filippino Lippi. *Studies of Nude and Draped Figures*. Silverpoint, heightened with white, on paper primed blue. 565 x 450. Inv. 33*v*. Christ Church.

4. Lorenzo di Credi. *David with the Head of Goliath*. Silverpoint, heightened with white, on primed paper. 280 x 126. Inv. 29. Christ Church.

5. Perugino. *Studies for Tobias and the Angel*. Silverpoint, heightened with white, on paper primed pale-yellow. 238 x 183. Inv. 27. Ashmolean Museum.

6. Francia. *Three Figures in a Landscape*. Brush and brown ink, heightened with white, on light-brown paper. 224 x 367. Inv. 10. Ashmolean Museum.

7. Lorenzo Costa. *The Supper in the House of Simon*. Pen and brown ink. 296 x 453. Inv. 861. Christ Church.

8. Giovanni Bellini. *Portrait of Gentile Bellini (?)*. Black chalk, with some wash, on greenish-grey paper. 391 x 280. Inv. 702. Christ Church.

9. Giovanni Bellini *(attr. to)*. *The Christ Child*. Pen and brush with brown ink, heightened with white, on grey-blue paper. 206 x 285. Inv. 2. Ashmolean Museum.

10. Bartolomeo Montagna. *Head of the Madonna*. Black chalk, heightened with white chalk. 290 x 199. Inv. 709. Christ Church.

11. Vittore Carpaccio. *Bust of a Young Man*. Black chalk, brush and brown ink, heightened with white, on blue paper. 265 x 187. Inv. 710. Christ Church.

12. Leonardo da Vinci. *Girl with a Unicorn*. Pen and brown ink. 95 x 75. Inv. 15. Ashmolean Museum.

13. Leonardo da Vinci. *Two Allegories of Envy*. Pen and brown ink. 210 x 289. Inv. 17*r*. Christ Church.

14. Bernardino Luini. *Saint Matthew and the Angel*. Brush and brown ink, heightened with white, on greyish paper. 166 x 222. Inv. 286. Ashmolean Museum.

15. Sodoma. *Bust of a Young Man*. Black chalk and wash, heightened with white. 404 x 288. Inv. 313. Christ Church.

16. Raphael. *Studies of Two Guards*. Silverpoint, heightened with white, on paper primed pale-grey. 320 x 220. Inv. 505. Ashmolean Museum.

17. Raphael. *Seven Putti at Play*. Pen and brown ink. 145 x 214. Inv. 362. Christ Church.

18. Raphael. *Two Studies for a Madonna and Child with Saint John*. Pen and brown ink. 248 x 204. Inv. 516. Ashmolean Museum.

19. Raphael. *Madonna and Child*. Silverpoint, heightened with white, on paper primed grey. 161 x 128. Inv. 561. Ashmolean Museum.

20. Michelangelo. *Female Head*. Red chalk. 205 x 165. Inv. 315. Ashmolean Museum.

21. Michelangelo. *The Adoration of the Brazen Serpent*. Red chalk. 244 x 335. Inv. 318. Ashmolean Museum.

22. Michelangelo. *The Deposition of the Dead Christ*. Red chalk, on buff paper. 375 x 280. Inv. 342. Ashmolean Museum.

23. Fra Bartolomeo. *Saint Antoninus Distributing Alms*. Pen and brown ink, with grey wash. 122 x 142. Inv. 104. Ashmolean Museum.

24. Andrea del Sarto. *Head of Saint Elizabeth*. Red chalk. 250 x 186. Inv. 692. Ashmolean Museum.

25. Pontormo. *The Deposition*. Black chalk, heightened with white. 443 x 276. Inv. 119. Christ Church.

26. Rosso Fiorentino. *Decorative Panel*. Pen and brown ink, with grey wash, heightened with white, on paper primed brown. 425 x 536. Inv. 125. Christ Church.

27. Bronzino. *Nude Woman*. Black chalk, heightened with white, on paper primed buff. 353 x 167. Ashmolean Museum.

28. Baccio Bandinelli. *Woman Reading by a Lamp*. Red chalk. 253 x 215. Inv. 79. Ashmolean Museum.

29. Correggio. *Study for a Wall Decoration*. Red chalk. 198 x 167. Inv. 203. Ashmolean Museum.

30. Parmigianino. *Drapery Study*. Black chalk, heightened with white chalk. 232 x 161. Inv. 442. Ashmolean Museum.

31. Parmigianino. *Decorative Panel*. Pen and brush with brown ink and watercolour washes, heightened with white. 102 x 43. Inv. 1085. Christ Church.

32. Bernardino Campi. *Jupiter*. Black chalk, heightened with white chalk, on bluish-grey paper. 202 x 157. Inv. 137. Ashmolean Museum.

33. Giorgione. *Seated Old Man with a Book*. Red chalk. 151 x 112. Inv. 715. Christ Church.

34. Gerolamo Romanino. *The Judgement of Paris*. Black chalk, heightened with white chalk, on bluish-grey paper. 275 x 240. Inv. 671. Ashmolean Museum.

35. Titian. *Madonna and Child Enthroned*. Red chalk, 265 x 185. Inv. 713. Christ Church.

36. Titian. *Falling Horse and Rider*. Black chalk, on grey paper. 274 x 262. Inv. 718. Ashmolean Museum.

37. Domenico Campagnola. *Study of Four Heads*. Pen and greyish-brown ink. 205 x 148. Inv. 134. Ashmolean Museum.

38. Pordenone. *Composition with a Sibyl and Prophets*. Pen and brown ink, with grey wash, on greenish-grey paper. 400 x 274. Inv. 490. Ashmolean Museum.

39. Sebastiano del Piombo. *Study for the Head of a Madonna*. Black chalk, heightened with white, on faded blue paper. 92 x 84. Inv. 78. Christ Church.

40. Moretto. *The Virgin Adoring the Christ Child*. Pen and brush with brown ink, heightened with white. 261 x 278. Ashmolean Museum.

41. Jacopo Tintoretto. *Head of Giuliano de' Medici*. Charcoal, heightened with white chalk, on light-blue paper. 357 x 238. Inv. 758. Christ Church.

42. Jacopo Tintoretto. *Male Nude in Violent Motion*. Black chalk. 348 x 251. Inv. 716. Ashmolean Museum.

43. Domenico Tintoretto. *The Martyrdom of Saint Stephen with the Ascension*. Brush drawing in oil, on blue paper. 345 x 187. Inv. 778. Christ Church.

44. Jacopo Bassano. *Diana*. Black chalk, heightened with white chalk, on blue paper. 508 x 379. Inv. 751. Christ Church.

45. Paolo Veronese. *The Coronation of the Virgin*. Pen and brush with brown ink. 305 x 210. Inv. 793. Christ Church.

46. Carletto Caliari. *Portrait of a Man*. Various coloured chalks, on blue paper. 272 x 187. Inv. 112. Ashmolean Museum.

47. Palma Giovane. *Studies for a Bathsheba* Pen and brown ink, with ink wash. 343 x 220. Inv. 428. Ashmolean Museum.

48. Palma Giovane. *Self-portrait (?)*. Red chalk. 176 x 157. Inv. 425. Ashmolean Museum.

49. Luca Cambiaso. *The Nativity*. Pen and brown ink, with ink wash. 340 x 233. Inv. 131. Ashmolean Museum.

50. Francesco Salviati. *Design for a Ewer*. Pen and brown ink, with grey wash, heightened with white, on buff paper. 411 x 276. Inv. 683. Ashmolean Museum.

51. Taddeo Zuccari. *Group of Figures*. Pen and brush with brown ink, heightened with white, on light-buff paper. 272 x 198. Inv. 766. Ashmolean Museum.

52. Federico Barocci. *Head of a Man*. Black and coloured pastel chalks, on blue-grey paper. 296 x 220. Inv. 95. Ashmolean Museum.

53. Federico Zuccari. *The Triumph of the Arts*. Pen and brown ink, with ink wash. 378 x 276. Inv. 544. Christ Church.

54. Andrea Boscoli. *Landscape with a Deer Hunt*. Pen and brush with brown ink and watercolour washes. 182 x 138. Inv. 233. Christ Church.

55. Lodovico Carracci. *Ecce Homo*. Pen and brown ink, with ink wash. 335 x 370. Inv. 915. Christ Church.

56. Annibale Carracci. *Male Nude*. Red chalk. 368 x 252. Inv. 936. Christ Church.

57. Agostino Carracci. *Anchises and Venus*. Pen and brown ink, with ink wash. 370 x 255. Inv. 930. Christ Church.

58. Guido Reni. *Head of an Old Man*. Black and red chalk, on blue-grey paper. 250 x 184. Inv. 931. Ashmolean Museum.

59. Guercino. *The Mystic Marriage of Saint Catherine*. Pen and brown ink, with ink wash. 256 x 203. Inv. 856. Ashmolean Museum.

60. Guercino. *Two Women Conversing*. Red chalk. 279 x 384. Inv. 864. Ashmolean Museum.

61. Ottavio Leoni. *Portrait of Princess Peretti*. Black chalk, heightened with white chalk, on grey paper. 193 x 155. Inv. 879. Ashmolean Museum.

62. Domenico Fetti. *Portrait of Catherine de' Medici*. Red and black chalk. 322 x 241. Inv. 851. Christ Church.

63. Gian Lorenzo Bernini. *Self-portrait*. Red and white chalk, on light-brown paper. 299 x 208. Inv. 793. Ashmolean Museum.

64. Pietro da Cortona. *Design for a Wall Decoration*. Pen and brown ink, with ink wash. 320 x 274. Inv. 614. Christ Church.

65. Baciccio. *Recumbent Figure of a Nude Child*. Red chalk. 195 x 254. Inv. 850. Ashmolean Museum.

66. Pier Francesco Mola. *Arcadian Landscape with Figures*. Pen and brush with brown ink, on blue paper. 260 x 399. Inv. 910. Ashmolean Museum.

67. Bernardo Cavallino. *Saint Sebastian*. Red chalk. 399 x 252. Inv. 816. Ashmolean Museum.

68. Mattia Preti. *Caritas Romana*. Red chalk. 290 x 220. Inv. 926. Ashmolean Museum.

69. Giovanni Battista Piazzetta. *Head of a Young Man*. Black and white chalk, on brownish paper. 315 x 299. Inv. 1034. Ashmolean Museum.

70. Marco Ricci. *Landscape with a Tower and Buildings by a Stream*. Pen and brown ink, with ink wash. 228 x 328. Inv. 1057. Ashmolean Museum.

71. Giovanni Battista Piranesi. *Woman Carrying a Baby*. Pen and brush with brown ink. 174 x 100. Inv. 1037. Ashmolean Museum.

72. Giovanni Battista Piranesi. *Architectural Fantasy*. Pen and brush with brown ink. 365 x 505. Inv. 1039. Ashmolean Museum.

73. Gian Antonio Guardi. *A Venetian Admiral Received by the Sultan*. Pen and brush with light-brown ink. 495 x 752. Inv. 1006. Ashmolean Museum.

74. Giovanni Battista Tiepolo. *The Holy Family*. Pen and brown ink, with ink wash. 315 x 228. Inv. 1077. Ashmolean Museum.

75. Giovanni Domenico Tiepolo. *Young Woman with a Macaw*. Red chalk, on grey-blue paper. 326 x 259. Inv. 1082. Ashmolean Museum.

76. Francesco Zuccarelli. *Landscape with Women Bathing*. Gouache drawing. 402 x 566. Ashmolean Museum.

77. Canaletto. *The Rialto Bridge*. Pen and brown ink. 141 x 202. Inv. 975. Ashmolean Museum.

78. Canaletto. *An Island in the Lagoon*. Pen and brown ink, brush and grey wash. 200 x 279. Inv. 980. Ashmolean Museum.

79. Francesco Guardi. *View across the Garden of the Villa Loredan*. Pen and brush with brown ink. 375 x 705. Inv. 1016. Ashmolean Museum.

80. Francesco Guardi. *The Rialto Bridge*. Pen and brush with brown ink. 224 x 177. Inv. 1013. Ashmolean Museum.

Index of Artists